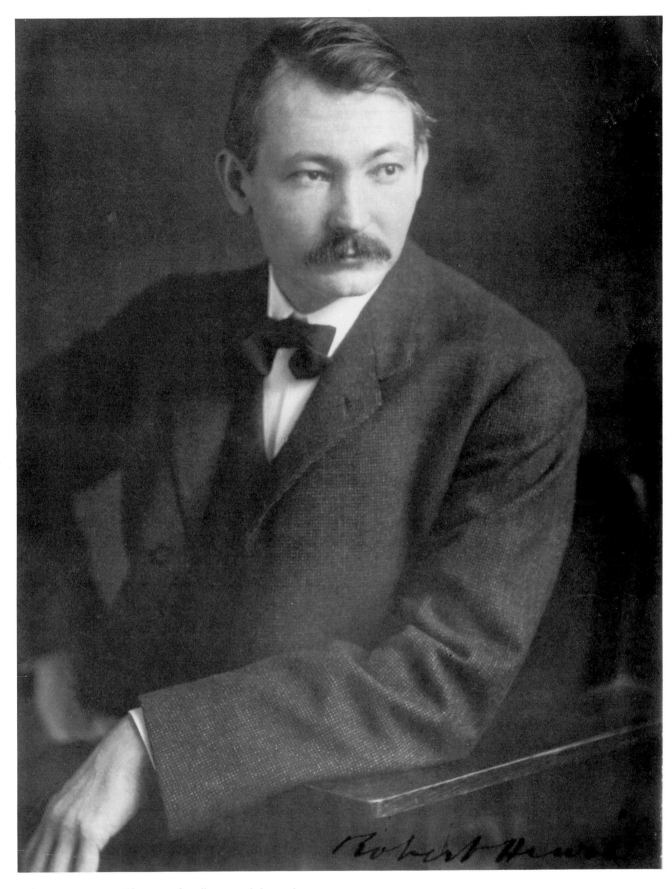

Robert Henri, 1907. Photograph collection of the author.

Robert Henri

HIS LIFE AND ART

by Bennard B. Perlman

DOVER PUBLICATIONS, INC., NEW YORK

To My Loving Wife Miriam
without whose research assistance and moral support
this biography would never have been written

Copyright © 1991 by Bennard B. Perlman.
All rights reserved under Pan American and International Copyright Conventions.

Published in Canada by General Publishing Company, Ltd., 30 Lesmill Road, Don Mills, Toronto, Ontario.
Published in the United Kingdom by Constable and Company, Ltd., 3 The Lanchesters, 162–164 Fulham Palace Road, London W6 9ER.

Robert Henri: His Life and Art is a new work, first published by Dover Publications, Inc., in 1991.

Manufactured in the United States of America
Dover Publications, Inc., 31 East 2nd Street, Mineola, N.Y. 11501

Book design by Ed Cencora

Library of Congress Cataloging-in-Publication Data

Perlman, Bennard B.
 Robert Henri : his life and art / by Bennard B. Perlman.
 p. cm.
 Includes bibliographical references and index.
 ISBN 0-486-26722-9
 1. Henri, Robert, 1865–1929. 2. Painters—United States—Biography. I. Title.
ND237.H5P4 1991
759.13—dc20
 [B] 91-15960
 CIP

ACKNOWLEDGMENTS

THIS BOOK is the result of a meeting between the author and Mrs. John C. Le Clair, heir to the Robert Henri estate, at the opening of the exhibition "John Sloan/Robert Henri: Their Philadelphia Years," at the Moore College of Art in October 1976. Janet Le Clair (Henri's niece by marriage) has provided me with exclusive access to all of the artist's diaries, scrapbooks, record books, correspondence, notes and library. For her never-ending cooperation and encouragement I am forever grateful.

In many ways this biography was begun in 1952 when research was started for my earlier volume, *The Immortal Eight: American Painting from Eakins to the Armory Show* (1962, 1979; reprinted as *Painters of the Ashcan School: The Immortal Eight*, Dover, 1988). Special mention must be made, therefore, of the artists, their relatives, students and friends who shared diaries, correspondence and memories for that book: Edward R. Anshutz, Emma (Mrs. George) Bellows, Stuart Davis, Guy Pène du Bois, Ira Glackens, Dorothy Grafly, F. R. Gruger, Mary (Mrs. Jay) Hambidge, Edward Hopper, Rockwell Kent, Manuel Komroff, Leon Kroll, Richard Lahey, Agnes Young Lay, Mercedes (Mrs. George) Luks, Will and Carolyn Luks, Robert G. McIntyre, Ethel (Mrs. Jerome) Myers, Violet Organ, Walter Pach, Maxfield Parrish, Helen Appleton Read, Edward W. Redfield, Mary Fanton Roberts, Dmitri Romanovsky, Charles Rudy, Margery Ryerson, Harriet Sartain, David Shinn, Everett Shinn, Helen (Mrs. John) Sloan, Eugene Speicher, Edward Steichen and Carl Zigrosser.

Although the vast majority of these individuals have passed on during the ensuing years, continued aid and moral support have come from several, most notably my longtime friend, Helen Sloan.

Many of Robert Henri's relatives provided information essential to this book. I am indebted to Erma D. Chandler, A. Rex Cozad, Clint O. Cozad, Ghlee T. Cozad, Karen B. Cozad, Marilyn S. Cozad, Dr. John Dorwart, Yule G. Dorwart, Robert P. Gatewood, Ruby Cozad George, Thurman Hewitt, Joan Gatewood Miller, Betty Cozad Trout and Craig Weaver.

To the following Henri students, associates and their relatives I wish to express special thanks for their willingness in sharing memorabilia and reminiscences: Ben Benn, Lucille (Mrs. Arnold) Blanch, Elsa Bley, Jean Bellows Booth, Adele Clark, Alice Miller Crump, Mrs. Grove Cullum, Alfred V. Dasburg, Andrew Dasburg, Mrs. Stuart Davis, Virginia (Mrs. Adolph) Dehn, Helen (Mrs. Rudolph) Dirks, John and Mary Dirks, Barry Downes, Dr. Ariel (Mrs. Will) Durant, Joan Gaines, Frances Cranmer Greenman, Mrs. William Gropper, Margaret Calder Hayes, Emil Holzhauer, Loretta (Mrs. Howell) Howard, Dayrell Kortheuer, Yvette (Mrs. Leon) Kroll, Brenda Kuhn, Sara (Mrs. Yasuo) Kuniyoshi, Sidney Laufman, Mrs. Andrew Longacre, Daniel W. and M. Andrea Luks and Peppino Mangravite.

Also Yvonne Pène du Bois McKenney, Alice K. Miller, David R. Morrice, Fred and Edith Nagler, Hon. Justine Wise Polier, Mrs. Charles Prendergast, Laurent and Dorothy Redfield, Robert and Clara Reiss, Edward Redfield Richardson, Mrs. Ansley K. Salz, Dr. Ira Leo Schamberg, Eleanora Benda Shimler, Katherine (Mrs. Yasuo) Kuniyoshi Shubert, Margaret Breckenridge Skinner, Mrs. James B. Skinner, Mrs. Hugh Sloan, Raphael Soyer, Jane Bouché Strong, Julie Sullivan, Sylvia Babcock Tacker, Rico Tomaso, Gertrude Traubel, Adolph Treidler, Susan (Mrs. Jon) Udell, Lore (Mrs. Peter) VandenHeuvel, Julie Chatterton Van de Water, Vaclav Vytlacil and Mrs. Carl Gustave Waldeck.

Among the other individuals to whom I am grateful for supplying data about Henri's life and art are: Philip R. Adams, Joseph Allen, Arthur G. Altschul, Dr. Alta Ashley, James R. Bakker, Eleanor Barry, Avis Berman, Dr. E. M. Bogdanove, Lorimer E. Brackett, Erling B. Brauner, John Cabot III, Dr. Arthur B. Cecil, Robert O. Chadeayne, Barry B. Combs, Douglas D. Connah, Fitzgerald F. Craige, Mr. and Mrs. Nelson Fitzgerald Craige III, Mr. and Mrs. T. Huston Craige II, John Murray Cuddihy, Lucie Dorais, Martin E. Dugan, Jr., Richard C. Edgeworth, Fremont F. Ellis, Mrs. George

T. Ellis, Jr., Betsy Fahlman, Grattan Freyer, Gary Gambuti, Mary (Mrs. Richard) Goff, Helen Goodman, Robert J. Gramer, Ione Quinby Griggs, Tommy W. Hall, Frances Hamerstrom and Carl E. Hiller.

Also Joseph and Olga Hirshhorn, Anne and Edgar F. Hubert, Jacqueline Hudson, Julie Hudson, Keith K. Hunt, Dr. David J. Impastato, Catherine (Mrs. Joel) Jacobs, Carole Klein, Mrs. Alfred Koch, Alan D. Levy, Tom Lymh, Richard Malone, Anne Steele Marsh, Mrs. Stanton Macdonald-Wright, Betty Hoag McGlynn, Charles H. Morgan, William M. Murphy, Mary Carroll Nelson, Robert Pacini, Kathleen Daly Pepper, Walt Reed, Maurice R. Robinson, Norman and Molly Rockwell, Charles W. Ross, Dora Scrutchfield, Kent L. Seavey, Mrs. Joseph A. Seraphin, Polly (Mrs. Potter) Sheffield, Robert Stacey, Jean Stern, Denys Sutton, Susan Telesco, David Traxel, Sally Turner, William C. Weber, Jr., Adrienne Walt, John Alan Walker, Margaret Weymouth, Mrs. Denys Wortman, Brooks Wright, Susan Fillin Yeh, Mahonri Sharp Young and Mrs. Edward Zelazo.

The following persons have been most kind in sharing the resources of their art galleries with me: A. M. Adler, A. M. Adler Fine Arts, Inc.; Gordon K. Allison, H. V. Allison & Co., Inc.; Anne Berman, Christie's; Leroy Davis, Davis & Long Co.; Martin Diamond, Martin Diamond Fine Arts, Inc.; Linda Durham, Fenn Galleries Ltd.; Lawrence A. Fleischman, Kennedy Galleries; Edward Goldfield, Goldfield Galleries; Ruth (Mrs. Dalzell) Hatfield, Dalzell Hatfield Galleries; Frederick D. Hill, Berry-Hill Galleries, Inc.; Norman Hirschl, Hirschl & Adler Galleries, Inc.; Antoinette Kraushaar, Kraushaar Galleries; Richard K. Larcada, Richard K. Larcada Gallery; Sandra Leff, Graham Gallery; Irene Little, Chapellier Galleries, Inc.; Meredith J. Long, Meredith Long & Co.; Richard Lynch, Hammer Galleries; Grete Meilman, Sotheby's; Mrs. M. P. Naud, Hirschl & Adler Galleries, Inc.; Jane Richards, Hirschl & Adler Galleries, Inc.; Georgia Riley, Graham Gallery; M. R. Schweitzer, Schweitzer Gallery; Dorothy Schneiderman, Harbor Gallery; James E. Tucker, Weatherspoon Art Gallery; and Donald S. Vogel, Valley House Gallery.

I also received cooperation and assistance from numerous individuals who are associated with museums, libraries, universities, colleges and schools: J. Richard Abell, The Public Library of Cincinnati and Hamilton County; Elva R. Adams, Warren County (Ohio) Historical Society; Hélène Adhémar, Musée d'Orsay, Paris; Deborah Allen, Moore College of Art; Judith Allen, Archives of American Art, Washington Center; Leon Anthony Arkus, Carnegie Institute Museum of Art; Ronald L. Becker, Rutgers University; Linda Best, Archives of American Art, Washington Center; Dr. Pieter Biesboer, Frans Hals Museum, Haarlem; E. Maurice Bloch, University of California, Los Angeles; P. Boussel, Bibliothèque Historique de la Ville de Paris; Robert Boyce, The University of Nebraska at Lincoln; Adelyn D. Breeskin, National Museum of American Art; Ann Barton Brown, Brandywine (Pa.) River Museum; Kieth Buss, Cozad (Neb.) Historical Society; Lawrence Campbell, The Art Students League of New York; Carol Clark, Amon Carter Museum; Georgianna Contiguglia, The

Denver Art Museum; and Richard Cox, Maryland Historical Society.

Also Carolyn A. Davis, Syracuse University; Violette de Mazia, The Barnes Foundation; Louis Duermyer, The Holland Society of New York; Louise W. Durston, Museum of New Mexico; D. B. G. Fair, London (Ontario) Regional Art Gallery; Jean Favier, Archives de France, Paris; William A. Felker, The Free Library of Philadelphia; Charles B. Ferguson, The New Britain (Conn.) Museum of American Art; Scott Ferris, The Rockwell Kent Legacies; Eleanor E. Fink, National Museum of American Art; Rosina A. Florio, The Art Students League of New York; Eric S. Flower, the University of Maine at Orono; Marc S. Gallicchio, The Historical Society of Pennsylvania; Donald Gallup, The Beinecke Library, Yale University; Eleanor M. Gehres, Denver Public Library; Norman A. Geske, The University of Nebraska at Lincoln; Rose Gilligan, Hunter College of the City University of New York; Susan Goodman, The Corcoran Gallery of Art; John F. H. Gorton, The Rockwell Kent Legacies; Eleanor Green, University of Maryland; Bonnie Hardwick, Denver Public Library; Margaret O. Harrison, Sloan Collection, Delaware Art Museum; Frances C. Hartgen, University of Maine at Orono; and Elizabeth Hawkes, Sloan Collection, Delaware Art Museum.

And Martha Hilligoss, St. Louis Public Library; Darlene M. Holdsworth, Amherst College Library; Thora E. Jacobson, Samuel S. Fleisher Art Memorial, Philadelphia; Mary M. Jenkins, West Virginia Department of Culture and History; Arthur H. Johnson, The University of New Mexico; William R. Johnston, The Walters Art Gallery; Stewart Klonis, The Art Students League of New York; John R. Lane, The Brooklyn Museum; William H. Leary, National Archives, Washington; Robert T. Lentz, Thomas Jefferson University; Gail Levin, Whitney Museum of American Art; Jean F. Margolies, Elkins Park (Pa.) Free Library; Dr. Clark S. Marlor, Adelphi University; Ruth Marshall, Boston Public Library; Ann Matteson, National Museum of American Art; Edward B. Mayo, The Museum of Fine Arts, Houston; Cynthia Jaffee McCabe, Hirshhorn Museum and Sculpture Garden; Garnett McCoy, Archives of American Art, Washington Center; E. Richard McKinstry, The New Jersey Historical Society; Mary Jo McNamara, Vassar College; Alice G. Melrose, National Academy of Design; Norman G. Messinger, Jefferson National Expansion Memorial, St. Louis; Pearl Moeller, Museum of Modern Art; Frederick C. Moffatt, University of Tennessee; and Nancy Moure, Los Angeles County Museum.

Also Bob L. Mowery, Wittenberg University; Dolores Musante, Saint Joseph School, New York; Phyllis Nixon, Delaware Art Museum; Arthur L. Olivas, Museum of New Mexico; Helen G. Olsson, The Newark Museum; Ann Percy, Philadelphia Museum of Art; Martin E. Petersen, San Diego Museum of Art; L. R. Pfaff, Art Gallery of Ontario, Canada; Clive Phillpott, Museum of Modern Art; Ronald G. Pisano, The Parrish Art Museum; Dr. Dean A. Porter, University of Notre Dame; Dennis Reid, The National Gallery of Canada; Ann Reinert, Nebraska State Historical Society; Lyman W. Riley,

University of Pennsylvania; Paul D. Riley, Nebraska State Historical Society; Raymonde Roberts, Community College of Baltimore; Dennis Rowley, Brigham Young University; John T. Runk, Philadelphia Free Library; Arnold T. Schwab, California State University, Long Beach; Darrel Sewell, Philadelphia Museum of Art; Linda Crocker Simmons, The Corcoran Gallery of Art; Donald A. Sinclair, Rutgers University; and Clyde Singer, Butler Institute of American Art.

And Anne Skillion, Columbia University; Dian Spitler, Free Public Library of Atlantic City, Diane St.-Amand, The Montreal Museum of Fine Arts; Bruce Stark, State University of New York at Plattsburgh; Guy St. Clair, The Union League Club of New York; Robert G. Stewart, National Portrait Gallery, Washington; Catherine Stover, The Pennsylvania Academy of the Fine Arts; Lynda Tabron, Community College of Baltimore Library; Lynn Taylor, Denver Public Library; Joseph S. Trovato, Munson-Williams-Proctor Institute; James E. Tucker, University of North Carolina at Greensboro; Richard P. Veler,

Wittenberg University; Ellen Watson, Community College of Baltimore Library; Allen Weinberg, City of Philadelphia Archives; Betty Werner, Cozad (Neb.) Public Library; Richard Vincent West, The Art Museum of the City of Sacramento; Brooke Whiting, University of California, Los Angeles; Barbara A. Wolanin, Hirshhorn Museum and Sculpture Garden; Jane E. Woolston, Cornell University; and Judith Zilczer, Hirshhorn Museum and Sculpture Garden.

Additionally, I should like to thank the staffs of the Archives of American Art's Washington, New York and Detroit Centers; the Frick Art Reference Library; the Enoch Pratt Free Library of Baltimore; and the Whitney Museum of American Art Library for their splendid cooperation during the period of this research.

And, finally, I should especially like to thank Hayward Cirker, president of Dover Publications, and my editor, Alan Weissman, for the joy of our working relationship coupled with their enthusiasm for Robert Henri and this book.

B. B. P.

CONTENTS

LIST OF
COLOR ILLUSTRATIONS

All color illustrations are of paintings by Robert Henri
and appear in an insert following page 48.

LIST OF BLACK-AND-WHITE ILLUSTRATIONS

Unless otherwise noted, illustrations are of paintings or drawings
by Robert Henri.

ROBERT HENRI

As Characterized by His Associates and Students

⸻

"The Abraham Lincoln of American Art."

—John Sloan

"Henri was the most influential teacher I had."

—Edward Hopper

"I never forgot anything that he said."

—William Gropper

"My father in Art."

—George Bellows

"Henri as an instructor, Henri as a leader of revolt against Academic Sterility, Henri as an inspirational influence on American Art, is possibly the most important figure of our cultural history."

—Rockwell Kent

INTRODUCTION

IN THE ANNALS of American Art, Robert Henri (1865–1929) was an immensely significant force behind the change from nineteenth-century academicism to twentieth-century self-expression.

Teacher to a generation of American art students, this classroom catalyst encouraged his legions to replace the slick, formula-like style of painting then in vogue with visions of their own. Henri set them free and, in so doing, helped put an end to the deadly task of merely copying still lifes and plaster casts of the nude.

As the leader of the "Ashcan School," he proclaimed that all life was fit subject matter for the artist. At a time when American painting dealt largely with classical motifs and nondescript landscapes, Henri sent his pupils into the streets of the city—New York's Lower East Side with its immigrant population, its peddlers and its poverty—where life in the raw could be studied and recorded.

With "Art for Life's Sake" as his battle cry, Henri spearheaded the movement to have artists organize their own exhibits when their outlaw canvases were rejected by the staid Academy. It was he who brought about the exhibition of "The Eight" in 1908 and the 1910 Independent, both landmark exhibitions. The Armory Show of 1913, the first large-scale display of modern European art ever held in the United States, was an effort on the part of one of its chief organizers to upstage Henri and his accomplishments.

Henri's prowess as a teacher and artist is legend. He influenced several generations of artists; his influence continues today. Among his students were Edward Hopper, George Bellows, Stuart Davis, Rockwell Kent, Patrick Henry Bruce, Man Ray, Guy Pène du Bois, Morgan Russell, Adolph Dehn, Peppino Mangravite, William Gropper, Adolph Gottlieb, Randall Davey, Moses Soyer, Glenn Coleman, Eugene Speicher and Yasuo Kuniyoshi. It was Henri who urged Vachel Lindsay to abandon painting for poetry, and he also taught Clifton Webb, Ariel Durant and Leon Trotsky.

The story of Robert Henri is the story of the coming of age of American art.

CHAPTER 1

FAMILY TIES

ALTHOUGH ROBERT HENRI and Mary Cassatt were cousins, the relationship, like so much of Henri's personal life, was a guarded secret. He could not boast of his kinship with the socially prominent American Impressionist painter without revealing that "Robert Henri" was an assumed name, adopted when he was seventeen—out of necessity and fear.

Born Robert Henry Cozad on June 24, 1865, he and Mary Cassatt were sixth great-grandchildren of Jacques Cossart, a Dutchman who emigrated to New Amsterdam in 1662 and lived in lower Manhattan, where Wall Street was formed by the path his cows took as they were driven to pasture. He served as the local tax collector and married a niece of Peter Stuyvesant.

Robert Henry Cozad and Mary Cassatt could trace their lineage to French Huguenots named Cazat who fled from Normandy to Holland during the St. Bartholomew's Day Massacre in 1572. One of their American ancestors was Francis Cossart, a member of the Convention that framed the first Constitution in 1776. By that time Jacques Cossart's descendants were spelling their family name in a variety of ways; one great-grandson became Cozad, another Cassatt.

Robert Henry Cozad's middle name was chosen in honor of his paternal grandfather, Henry Cozad, who had fought the British during the War of 1812 and surrendered with General Hull's forces at Fort Detroit. Henry Cozad married four times and Robert's father, John Jackson Cozad, was one of three sons by Henry's second wife, Margaret Clark. When she died, Henry Cozad wed Mary Gregg, who developed into a severe taskmaster. Previously childless, she gave no favored treatment to John, the baby of the family she inherited. One day in 1842 the twelve-year-old John was cutting hay with his cousin on the family farm, when he and his stepmother had a particularly bitter confrontation. "I can make a living easier than this," he shouted, and, flinging his wooden rake aside, he left home and family for good.

He made his way to Cincinnati where he found employment on a steamboat plying the Ohio and Mississippi rivers. The youth became fascinated by the big-time gambling that took place on board and the big-time gambling that took place on board and soon acquired uncanny skill at faro, the popular game that involved drawing cards from a deck and seeing which player could name the final one. Cozad became so expert at it that many of the riverboat captains forbade the game to be played when he was on board.

Always seeking new fields to conquer, John Jackson Cozad traveled to California during the Gold Rush and to South America, all the while perfecting his infallibility in naming the last card at faro. In California he hired a bodyguard to keep an eye on him and his winnings; other card sharks were not always gracious losers, and on more than one occasion the young Cozad had been severely assaulted.

Returning from the West Coast by stagecoach, he arrived one day in the town of Malden, Virginia, and stayed the night at a hotel. It was there that he met Theresa Gatewood, the proprietor's daughter, with whom he immediately fell in love.

Her father had also traveled to California, having gone there as a forty-niner and captain of a wagon train. Upon his return to Malden he engaged in the salt-manufacturing business, and one of the youngsters who would work for him, Booker T. Washington, learned his ABCs by marking salt barrels.

The Gatewoods were an old and respected Southern family; their roots went back to John Gatewood, who had arrived in Virginia from England in 1663, and through him to Eleanor of Castile, King Edward I and other British royalty. Theresa's maternal grandfather also was English; her mother was of French descent.

John Cozad was seven years older than Theresa Gatewood. The tall, dark-complexioned stranger from out of the West was always nattily dressed and dispensed tips generously at the Malden House Hotel. He quickly won the approval of Theresa's family and after the traditional period of courtship the two were wed on July 13, 1857, at the Gatewood home. Then, like Cinderella and her Prince Charming, the newlyweds went off in a coach drawn by six horses to spend their honeymoon at White Sulphur Springs, Virginia, a fashionable resort that had become famous during the preceding decade as the summer home of Presidents Van Buren, Tyler and Fillmore. After a brief stay in Richmond they took up residence in Cincinnati;

three years later their first child, John, was born; on June 24, 1865, their second son was born and named Robert Henry, for his two grandfathers. The day of his birth marked the final event of the Civil War, headlined in the newspapers: "Galveston, the Last Rebel Port, has been Surrendered."

While Robert was still an infant his father conceived a plan for establishing a manufacturing town near Cincinnati to attract Union Army veterans. He made his first land purchases in 1867 around Spence's Station, where a farmhouse was rebuilt for his family into a two-story brick residence with fluted columns, sidelights, a fanlight over the door and an imposing cupola.

John Cozad continued to buy adjoining property for the next five years. A spinning mill, several home industries and a general store were added, and he established a building association to aid home buyers. The town, surveyed in 1871, was proudly named Cozaddale, and the main thoroughfare that ran in front of the Cozad home was appropriately dubbed Saratoga Avenue, in honor of Saratoga, New York, home of the famous gambling casino and the country's first racetrack to allow legalized betting. Cozad had frequented both.

Robert's father, envisioning great success for himself, his family and his town, journeyed to Washington, to Mathew Brady's Photographic Portrait Gallery to have his likeness recorded for posterity, standing proud and erect, as so many of the greats and near-greats had done before him amid the elegant trappings of the studio.

Despite signs of prosperity and well-being, the household was saddened by recurring tragedies. During his first year Robert had been sickly; before he was two another son was born but died less than five months later, and a baby girl was born prematurely and lived for a single day. In 1870 still another infant son died before his first birthday and three years later a sixth baby died at the age of sixteen months.

As a result of these heartbreaking events, the two surviving children were coddled by their mother. Robert was enrolled in a Cincinnati public school at the age of five, but when Mrs. Cozad observed that at the end of each day's classes "a thousand feet came tearing down the stairs," she imagined that her little boy might be trampled in the rush and withdrew him from "that wretched public school." Her diary recorded a real calamity narrowly averted when Robert was nine:

> A terrible catastrophe happened at the Opera House, caused by a false alarm of "Fire." The play was a very special allegory—all children in the play and the audience. I took the boys last night, and they wanted to go again today to the matinee. We were all dressed and ready but after [midday] dinner something made me ask them not to go to the matinee, that I would take them tonight. The terrible thing happened at the matinee. Hundreds of children killed.[1]

The family lived in their imposing home for only a few years. Founded on high hopes, the community faltered despite John Cozad's abundant financial support. After several cottages and a three-story structure had been erected, the building association dissolved and soon the majority of the houses in town stood tenantless. A civil suit was brought against Cozad by a man who claimed he was owed 1,300 dollars. The judge ruled in his favor and ordered foreclosure on some lots still owned by Cozad, which were awarded to the plaintiff in lieu of a cash settlement.

Only a decade after its founding, Cozaddale stood deserted.

GROWING UP IN THE WEST

EVEN PRIOR to the demise of Cozaddale, John Jackson Cozad was planning another city further west, at the site of the 100th meridian in Nebraska.

Cozad had made the trip from Cincinnati, had stood beside the Union Pacific Railroad's single track where a large wooden sign proclaimed: "100TH MERIDIAN. 247 MILES FROM OMAHA," then returned to Ohio and purchased twenty sections of land from the railroad. In December 1873, he and a group of thirty settlers established the town of Cozad, Nebraska, at the 100th-meridian sign. The plain was vast and desolate, the ground frozen and covered with snow. The pioneers survived the winter subsisting on deer and antelope meat while living in makeshift structures, but by summer fifteen homes were completed and monthly excursions were begun from Cincinnati to Cozad. John put every able-bodied man on his payroll; they began producing bricks, built a hotel for his newly arrived in-laws to operate and started construction on a handsome residence for his family.

Beginning in 1874, when Robert Henry Cozad was nine, he and his brother spent their summers at the fledgling community. Ponies were bought for the boys, who spent much of their time exploring the environs. The Oregon Trail and the old Pony Express station were both on the other side of the Platte River but the children were forbidden to cross into what was still considered Indian country.

At the end of the summer of 1875 Robert pleaded to remain in Cozad but to no avail. Even though a brick schoolhouse was nearing completion, his mother insisted that his education be resumed in Cincinnati. He was enrolled at the Chickering Classical and Scientific Institute, "preparing for college," as his mother would say. The curriculum was a formidable one; during the next few years Robert's course of study included Greek, Latin, German, geology, geography and physiology, as well as algebra, composition and spelling. His grades were generally in the nineties except for Latin and German, and his teachers said he was "remarkably bright."

One of his favorite subjects was composition and at the age of ten he began writing a book; at twelve he wrote a play entitled *The Bloody Villain* in which the older boys acted. At that point he thought only of a career on the stage.

Robert's mother sought to nurture his literary bent. Her credo was simple: "Each day—must get books—learning to talk, to think—to read—about common things, Right and Wrong."[1] In a small notebook she listed her goals:

> Love nature and books: seek them and you will be happy; for virtuous friendship, and love, and knowledge of mankind must inevitably accompany these, all things thus repeating their influence in due season.[2]

While John Jackson Cozad was in Nebraska, sometimes for months at a time, his wife had full responsibility for raising the boys. She took them to services at St. John's Church, to the library and to lectures at the Opera House, and she constantly bought them books, including *Don Quixote.* From terse notes one senses her role: "Tired—teaching boys all day—read them *Daniel Boone.*"[3]

When Robert was eleven his mother began a scrapbook, pasting in it all sorts of articles, an encyclopedia of miscellaneous information: "How Indian Names Originate," "Why a Child Loves Sugar" and a "History of the Corset"; pages of poetry by Tennyson and James Whitcomb Riley, and quotes from Emerson and Dickens. Each June, on his birthday, Robert would be presented with a scrapbook of history and current events. And on the flyleaf of each of these volumes he would record his own personal history:

> I am eleven years old. I leave my ma tomorrow to go alone for the first time to school in Cincinnati.[4]

July 4, 1876, marked the inauguration of Cozad's own newspaper, *The Hundredth Meridian,* and it was in this paper, on November 20, that Robert's first

published writing appeared under the heading "A Letter from Young America":

> I have spent three summers here and am now spending my first winter and have never seen a Buffalo nor an Indian, but I have seen droves of deer, elk, antelope, wild horses, jack rabbits, gophers, pole cats and grasshoppers I have a horse and saddle, and have a good time riding over the prairie We see a great many herders and hunters here. They are fine riders and have beautiful ponies. Some of the hunters wear pretty suits of buckskin with fringe all around. I saw one who had rows of gold dollars on his suit for buttons. They wear their hair very long and a belt around the waist filled with pistols, and great spurs on their boots
>
> We have a nice two story school house furnished with Excelsior seats, desks, large globe, maps all around and a large black-board in the wall at each end. Our teacher is a pretty little lady, and wears a gold watch, a fine ring, and has a little bit of a foot, and we love her dearly I have nothing more to say now except that I want all the boys who read this to come out west and we will all grow up with the country.
>
> <div align="right">Bob</div>

The following fall Robert was back at the Chickering Institute, where he won a certificate for improvement in writing "and the teacher said I was the first boy that was left-handed that ever got a prize in his school. I expect to graduate in three years."[5]

In the spring of 1879 Robert was enrolled in Spillses Dancing School, with Friday nights and Saturdays reserved for picnics and dances at Mount Lookout.

The family lived at 44 Hathaway Street in an edifice that Theresa described as "the finest on the street." Although John Cozad owned three more houses on the block, as well as others around Cincinnati, this was the last year in which his name would appear in that city's directories under "Real Estate," for he now found it necessary to devote all his energies to Cozad.

Robert's thirteenth birthday on June 24, 1878, was the last one to be celebrated in Ohio, for during the following summer they moved to Cozad to take up residence there year round. When Robert arrived on the scene, one of his first tasks was to help turn out posters. The previous Christmas his father had given him a printing press, which was installed on the second floor of the Gatewoods' new hotel. There Robert had a desk and his own office in mock imitation of his father's. The two-by-three-foot broadside he printed, with instructions to "Please Hang This Up," read:

Ho! for the Great Platte Valley!
GRAND EXCURSIONS!
An EXCURSION will leave
CINCINNATI, OHIO.
The THIRD TUESDAY in September, at 7 o'clock p.m. and
EVERY TUESDAY thereafter during the year 1879, for
COZAD, DAWSON CO., NEB.

In the fall, Robert used his printing press to produce election tickets for all of Dawson County, being paid twenty cents a hundred for eleven hundred ballots. At the same time he started keeping a diary and the following year began his *Runty Papers*, a fictional account of a minstrel troupe, including tambourine, fiddle and banjo players. He also collected articles from *Demorest's Monthly* and *Harper's* and *Appleton's Magazine* and pasted them in scrapbooks like those prepared by his mother. At the back of each volume he indexed the contents, a potpourri—a series on "Great Inventors," articles about Kit Carson, Benjamin Franklin, Morse and Edison, *Familiar Words and Phrases*, *Uncle Tom's Cabin* and *Facts About the Bible*—and he hand-colored many of the black-and-white line drawings that accompanied the articles.

Because of the various jobs his father assigned him, Robert did not attend school during 1880–81 but continued to be educated at home. An avid reader, he enjoyed Charles Dickens' *Pickwick Papers*, *Nicholas Nickleby* and *Oliver Twist*, and read about the sufferings of the Union soldiers in McElroy's *Andersonville: A Story of Rebel Military Prisons*. Other favorites included Jules Verne, Mark Twain, *The Children's Book of Poetry* by Henry Coates and short stories published in the *New York Ledger*.

Before he was fifteen Robert developed an interest in art, but it was subordinate to his writing. In the *Runty Papers*, he drew small pictures of the characters, and comic figures began to appear in his diary. Most of these spot illustrations were copied from the line drawings by John Leech in *Punch's Almanack 1847–1851*, which he owned. He made no original figure compositions at this time and did no drawings from nature.

In the scrapbooks assembled by his mother, Robert saw popular paintings of the day—still lifes, magazine illustrations, Valentine's Day and Christmas cards, and picture stories such as "A Visit to Doré's Studio" and "The Rise and Progress of Art," featuring the works of Raphael and Giorgione.

The teenager spent a good deal of time writing and rewriting his *Runty Papers* and trying to perfect his drawings:

> On page 13 came Runty's picture. It was the best I ever made of him . . . finished Chapter One. Only 27 pages like this, four pictures, and a "scrip" or emblem for the wind up dash of Chapter 1. It was a crown and a cross, highly colored[6]

By 1880 the region of the Platte around Cozad had been transformed, from its former use as a grazing area for Texas cattlemen, into productive farmlands. One day in September of that year the Cozads noticed cattlemen with a large herd of cattle bearing down on their fields. "Go tell them that your father is the owner of this land," John Jackson Cozad directed his son, "and that we intend to cut the grass on it, so please go up and drive the cattle along the railroad." Robert rode his pony to the boss of the cowpokes and repeated his father's request. The man promised to do as directed but Robert observed: "I have been in Nebraska long enough to know that these cattlemen will promise to move off premises immediately, in a most polite manner and then never make a move to do it."[7] One of the irate Texans even drew his revolver and fired at Robert's dog. Such confrontations were not the only threats to the Cozads' lives, as will be seen.

CHAPTER 3

MURDER AND A NEW LIFE

COMPETITION between neighboring Plum Creek and the community of Cozad over the location of the county seat resulted in a series of ugly incidents: in 1876 a fire was intentionally set in a portion of Cozad, destroying the Gatewood Hotel. Then a hotel in Plum Creek burned to the ground while Johnny Cozad was a guest there; he was jailed and there was talk of a lynching.

Although Theresa Cozad pleaded with her husband that they move to a safer locale, John Jackson Cozad was reluctant to abandon the settlers; however, when their *own* home was devastated by arson, he pulled up stakes and took the family to Denver where Robert, now sixteen, was enrolled in the eighth grade of public school.

The Cozads settled in a boarding house at 661 Blake Street, where Robert was surprised to find "a good many acquaintances," including two former classmates from the Chickering Institute, and John Jackson rented a store at 636 Larimer Street in the business district. He had it partitioned into three offices, one each for himself, John Jr., and Robert. A painted sign on the building announced: "John J. Cozad & Sons" and, according to Robert, it was their intention "to sell or exchange our Cozaddale, Ohio and Cozad, Nebraska property for Denver property."

Several times John Jackson returned to Nebraska in attempts to complete his major unfinished project there: the construction of a sod bridge across the Platte River. Though he gave it his personal attention, the work was destined to remain uncompleted when sections washed away during the spring thaw. Moreover, there was still to be a critical event that would have permanent consequences for the family.

On one occasion Cozad and his employees on the bridge became involved in a dispute, and the latter walked off the job. The following morning Cozad was at the Gatewoods' grocery and dry-goods store when one of the workers, a man named Alfred Pearson, demanded to see him and claimed that Cozad owed him money.

They argued among the rows of brooms, buckets and boxes stacked to the ceiling. Pearson threatened, then shoved Cozad, who tumbled against the pile of cartons. As Cozad fell, he pulled a small-caliber pistol from his boot and fired once at close range. Pearson dropped to the floor with a four-inch bullet hole in his forehead.

That afternoon, October 14, 1882, John Jackson Cozad hastily left town. Afraid that he might be recognized if he boarded the Union Pacific at Cozad, he walked south for miles to the Burlington Railroad and on the way buried his silk hat in a coyote hole.

The shooting had been witnessed by a teenage friend of Robert's who happened to be entering the rear of the store. When he saw the unarmed Pearson fall, the youngster darted, unnoticed, from the building, went home and related the incident to his father. "Never tell anyone what you saw or heard," his father said. And the boy remained silent.[1]

Julia Gatewood circulated the story that her son-in-law had acted in self-defense when his employee lunged at him with a knife. But no knife was ever found. And Pearson, after languishing for some seven weeks, died.

Six days later Cozad was accused in district court of having "unlawfully, feloniously, purposely and of deliberate and premeditated malice" assaulted and killed Pearson.[2] He was indicted for murder in the first degree, and a warrant was issued for his arrest.

In Denver the family, worrying that Cozad would be extradited to Nebraska to stand trial, determined to take extreme action. They adopted new identities. From that moment on the family named Cozad ceased to exist and Robert Henry Cozad became part of a masquerade that he acted out for the rest of his life. In public the boys were introduced as foster brothers and adopted sons.

Robert's father became Richard Henry Lee, the name of a signer of the Declaration of Independence from his wife's home state of Virginia. The Gatewoods had known the Lees of Virginia and, even now,

a cousin, James Gatewood, was the private stenographer for General Fitzhugh Lee of the same family.

At the age of seventeen Robert Henry Cozad became Robert Earle Henri. With French ancestry on both sides of the family his parents must have expected him to use the French pronunciation implicit in a name such as "Henri," but Robert's knowledge of foreign tongues did not include the Romance languages, so he unintentionally anglicized it, insisting that he be called "Hen-rye." His new middle name was chosen in memory of a deceased uncle, Samuel Earley Gatewood.

As for his brother Johnny, he would henceforth be named Frank L. Southrn, for *Frank R. Stockton's Southern* Mansion, a favorite haunt of the Gatewoods when they had lived in Malden, Virginia. "Southern" was changed to the more distinctive "Southrn," reminiscent of, yet different from, the name of Edward Hugh Sothern, an American actor known to the Cozads.

Even with these adopted identities the whereabouts of the various family members were kept secret and ties with Denver were severed. Robert stayed with friends near Colorado Springs and, soon after his eighteenth birthday in June 1883, he realized a longtime dream by climbing Pikes Peak.

That fall the family journeyed East. Robert attended a boarding school in New York, and Richard and Theresa Lee settled in Atlantic City. But it was necessary to make one more trip to Nebraska. In November, Robert and his mother again assumed their former family name when they arrived in Cozad to dispose of the family's remaining real-estate holdings.

To avoid checks and bank drafts made out to "Cozad," payments were requested in cash. The paper money was sewn into Theresa's skirts and petticoats, and Robert's coat and vest were lined with gold dollars. Then mother and son headed East for the start of their new life.

Richard Henry Lee—the former John Jackson Cozad—purchased land at Texas Avenue and the beach in Atlantic City and planned the construction of a guest house. Texas Avenue was just two blocks from the new West Jersey and Atlantic Railroad terminal, where the resort excursions unloaded, and once again the promoter tied his future to a railroad.

Back in Cozad, Robert's uncle Traber Gatewood eventually cleared John Jackson of the murder charge. Nevertheless, he and his family determined to continue their new identities.

Robert left the New Yoark boarding school and joined his parents in Atlantic City. Now all contact between the family there and in Nebraska was carried on between Robert and his uncle. Correspondence that passed between them avoided any mention of dates or specific locations and, whenever possible, Robert's letters were mailed on trains in order to avoid an Atlantic City postmark.

In spite of the strain of their deception, the family was enthusiastic, and by 1885 Robert could report that "Pa sees a great future [in Atlantic City] and already several houses are going up. Yesterday I started painting the outside of one of them."[3] He also created two signs for an ice-cream stand on the beach.

Robert Henri's artistic bent was beginning to reveal itself. His 1884 and 1885 scrapbooks include pen-and-ink copies of caricatures by *Puck* artists Opper, Zim and Gillam, and an ambitious replica of Elizabeth of Austria, whose portrait had appeared in *Harper's Weekly*. He also selected a wood engraving from the November 1884 issue of *Harper's* as the composition for his first painting. The black-and-white illustration was *The Hudson, from Fort Putnam* by W. H. Morse, and Robert dutifully reproduced it using dry colors mixed with beer. The work was created with a sponge in lieu of brushes.

The first art book acquired by Robert was Marion Kemble's 1884 volume *Art Recreations: A Guide to Decorative Art,* and he underscored those portions of the book dealing with drawing a head, light and shade, and charcoal drawing. He also marked such topics as "Rules for Tinting Photographs," "Painting on Satin, Velvet and Muslin with Watercolors" and "Tapestry Painting." The chapters concerning "Oil Painting" and "Composition" either failed to hold his interest or appeared too advanced.

Now Robert's scrapbook illustrations became more elaborate. The frontispiece of one of them is a decorative design in watercolor. Within a square panel is a castle with waterlilies and the words:

Earle Henri
Atlantic City
New Jersey
March 12, 1885

The first recognition of Robert's art had occurred in the fall of 1884. When Grover Cleveland was nominated for the presidency, the budding artist produced a political cartoon that was displayed in the window of a friend's store. Robert happened to be in the store when a customer asked who made the drawing. "That young man," the proprietor responded, pointing to Henri. "Do you intend to study art?" the stranger asked, explaining that he was himself a newspaper artist. When there was no reply, the unnamed visitor remarked: "You should."[4]

While Henri felt "it would be great to be a picture painter," he considered himself unqualified since all accounts he had ever read "were to the effect that artists surprised their parents and the neighbors by doing masterpieces in infancy [and] I suppose I was not in that class."[5]

The compliment for his caricature and the newspaper artist's advice might have gone unheeded were it not for more prodding a few months later. In February 1885 a storm hit Atlantic City. "The tide is way up under the house," Robert reported, the "Southrn & Henri's Cigar Store" was in jeopardy and the cigar cases had to be removed. The storm also damaged the rear of the Lees' home, leaving several walls exposed. Henri was allowed to decorate them; he turned a portion of the kitchen into a museum of his own works, knowing that his color sketches would be obliterated by the repairs.

These pictures were seen by a former art student, James Albert Cathcart, who was delivering milk to the Lee househould. "That boy has talent," he said to

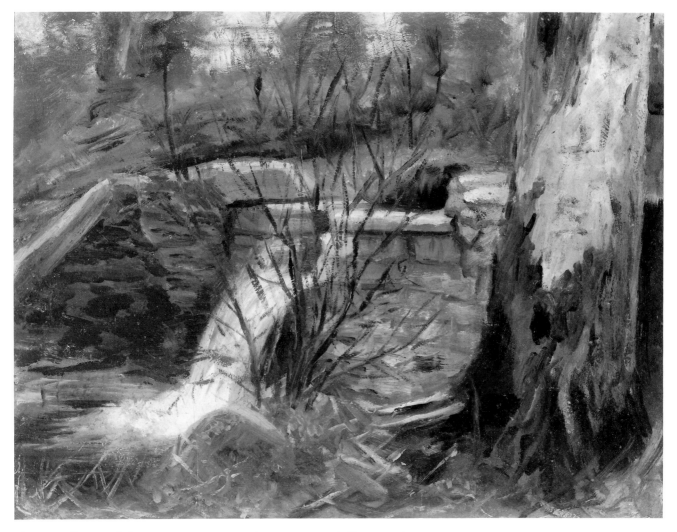

The Waterfall, 1886. Oil on canvas, 10⅜″ × 13″ (26.3 × 33.0 cm.). Photograph courtesy of Christie's, New York. Henri's first landscape painting from nature.

Henri's mother. "He should study at the Pennsylvania Academy," Cathcart's alma mater.[6]

A warm friendship developed between Henri and Cathcart, whose constant encouragement caused Robert to refer to him as his first art critic. Henri purchased a set of oils and in 1885 he copied a color lithograph of a lake in autumn, which he described as a "rather nondescript landscape of trees and rolling hills."[7] On another canvas he reproduced a chromo-lithograph of a young couple in a tender embrace and in February 1886 a copy of a boat landing jutting out from the shore. After several efforts at duplicating magazine reproductions he gave up copying and

created his first landscape in oils from nature, an ambitious composition entitled *The Waterfall,* consisting of a spillway, splashing water, foliage, a textured tree trunk and underbrush.

By the fall of 1886 Robert Henri decided to take the plunge. Gripped by doubt, hope and fear, he traveled the sixty miles to Philadelphia, walked up Broad Street trying to ignore "every glance of the slick city fellows who appeared to know at once I was green," and entered the hallowed halls of The Pennsylvania Academy of the Fine Arts. There, on October 4, the name "R. Earl Henri" made its first appearance in the leather-bound Register of Students.

STUDENT DAYS IN PHILADELPHIA

ON THE SAME DAY that Henri entered the Academy, Edward W. Redfield and Alexander Stirling Calder also registered. Calder was beginning his third term, having been enrolled in Thomas Eakins' life class the previous year when Eakins was forced to resign because of his insistence on the use of the nude model.

Calder remained, but some thirty Academy students departed in February 1886 to establish the Art Students League of Philadelphia with Eakins as its head. When Henri began his art studies the following fall the League was still operating in a building on Juniper Street two blocks from the Academy in an area known as "Bed Bug Row." Henri's knowledge of Eakins had to be obtained secondhand from other Academy students who told tales of Eakins' unswerving adherence to his ideals, of his power as a teacher and the pleasure he took in encouraging his classes. "It was an excitement to hear his pupils tell of him," Henri would say.[1]

On occasion Henri spent the afternoon examining figure studies produced in Eakins' class, which still decorated the Academy walls, and he would go with a couple of classmates to the Jefferson Medical College to view Eakins' still-infamous canvas, The Gross Clinic, which had been purchased by the school's alumni. Henri admitted: "It awed me again as it had the first day I saw it," when his brother Frank (the former John Cozad, Jr.) enrolled there to begin the study of medicine. "I looked with wonder at the great painting that filled the wall before us and I thought it must be one of the greatest pictures ever made."[2] In a letter to his parents, Henri wrote:

> The story goes that Eakins painted this masterpiece just before the Centennial in 1876 and worked to do the finest thing he was capable of for so great an event, and when he was finished he was sure he had. But the jury found the painting so thoroughly inartistic they decided they could not put it in the exhibition of paintings. But rather than reject it they hung it with an exhibit of medical instruments in

another part of the grounds. Eakins was heartbroken when he found where his great painting had been put.

> None of the people who went to the Centennial to see fine paintings saw "The Gross Clinic." I guess artists have to be philosophers.[3]

Eakins had introduced innovations into the Academy's curriculum—study of the nude, clay modeling from life, and dissecting. Although no one now brought a horse into an Academy classroom in order to compare the manipulation of its leg with that of a human, as Eakins had done, his methods and philosophy were continued by instructors, former students of his, who replaced him.

In 1886 admission to the Academy meant admission to the antique class, a process of learning to draw by copying plaster casts of classical statuary. Henri had dutifully submitted the entrance requirement, a drawing of the human figure, and now settled down to a routine that involved over forty hours a week concerned solely with cast drawing—a century-old tradition in Philadelphia, dating back to 1784 when a plaster cast of Venus arrived from Europe and was soon being sketched by students of Charles Willson Peale. In 1806, a year after the Academy's founding, America's Minister to France, Philadelphian Nicholas Biddle, persuaded Napoleon to send casts of classical statuary to the United States; in 1886, the Academy had a plethora of such casts.

Henri labored surrounded by the Greek and Roman past, by replicas of the Discus Thrower, Hercules Strangling a Goose, Mercury and the de Medici Venus. Plaster-of-Paris segments of the Parthenon frieze adorned the walls, with Centaurs and Lapiths poised in mythological combat as students struggled to attain accuracy of detail in their drawings. Henri's initial efforts were unpolished. His technique of using a stick of charcoal or a 4B pencil to shade with short, choppy strokes, rather than the sought-after tonal blending, was characterized by his instructor, Thomas Hovenden, as more like wood engraving than drawing.

Henri investigated other areas of the school. In the modeling room he examined a skeleton and a manikin showing muscles and tendons, and began attending anatomy lectures. While he continued to work from casts he commenced clay modeling to improve his feeling for form. As Hovenden stated, "To draw you must learn modeling, and to model you must learn drawing."[4]

Creating the human form from wads of clay only served to whet Henri's appetite for the dissecting room, which was reserved for those enrolled in the life class. As a substitute he sometimes went with his brother to the dissecting area at the Jefferson Medical College where the students smoked in order to kill the offensive odor while removing flesh from a cadaver.

One day Henri overheard the Academy's curator speaking with a student about burning the remains of a cadaver, and Henri offered to buy it on the spot for eight dollars. He cut away the flesh from the legs and arranged for Frank to help with the rest of the cleaning, but after the grisly job was done he was confronted by Alexander Calder and another second-year student, who claimed the skeleton for themselves. "It looked to me like they had a very good joke, having me working like a trojan cleaning the bones and then coming and taking them away from me." Although his verbal defense failed to prevent this, Henri admitted: "I really feel better now that I am placed in a position where I can express myself."[5]

His ability to stand up to the second-year students was due in part to his age, for at twenty-one he was older than most of his peers and five years older than Calder. Henri's lean body and his height, six feet one-and-a-half inches, were also a factor. He was dark-complected, with brown eyes almost almond-shaped and slanted—a somewhat Oriental countenance—slim hands and long, narrow feet. Self-conscious about the pockmarked skin just beneath his high cheek bones, he washed frequently and doctored his face with medicine provided by his brother.

In his classes, even on days when he worked in oils, Henri was always properly dressed in a black suit and tie. Under Hovenden's tutelage he began his first compositions from the posed figure, using tubes of black and white to mix various shades of gray. Soon he was employing a limited number of colors and painting at night by gaslight, but his teacher was critical of the practice, citing the excess of red and yellow in the work.

During Henri's first semester he was instrumental in organizing a daily, hour-long sketch class at the Academy. Unlike the regular figure classes, this one was coed, with students taking turns posing. Despite the informal air there was a reluctance among some of the females to be drawn by their classmates, even though fully clothed, and occasionally one would feign illness in order to avoid posing, sending a male substitute in her stead.

Henri served as the catalyst for a number of other innovations. "I claim the honor of being the revolutionizer of some parts of the Academy," he noted in November 1886. "It was I who persuaded Mr. Whipple [the curator] to open the Library at night . . . opening the modeling room to the Antique Class and now

getting a cast for the modeling room I am proud of being the prime mover!"[6]

Yet by this same November Henri had not gained admission to the life class. He reported this to his other drawing instructor, Thomas Anshutz, who remarked: "If Hovenden does not admit you, I will admit you to my day modeling class and [James B.] Kelly will admit you to his night life drawing class anyhow."[7] And that is precisely what happened.

Anshutz quickly became the great influence in Henri's life. In the modeling class he performed demonstrations, popularized by Eakins, of shaping clay the size and form of a muscle, then placing it in its proper location alongside the bone. Anshutz was encouraging, indicating when Henri was improving, and supplying valuable suggestions: "You must work more by feeling," Anshutz told him. "When you go home draw the model from your mind. When at leisure notice a man—his position. Draw him. He will move, but go on and finish from memory You will gain great results from it . . . always have a book with you and sketch from nature and memory in your spare time."[8]

Henri was now painting, sculpting and drawing the figure. "It was with a feeling of 'hurrah!' that I took my easel, paper and charcoal box into the Life Class for the first time."[9]

He also found time for his other love, the stage, going regularly to the Chestnut Street Opera House, the Walnut Street Theatre and the National Theatre, where from the twenty-five-cent seats he saw *The Merchant of Venice, The Count of Monte Cristo* and *The Old Curiosity Shop.* When Edwin Booth came to town to play Shakespeare, Henri saw him on consecutive nights in *Macbeth, King Lear* and *Richard III.* And when Booth played *Hamlet,* Henri proclaimed it "the greatest play by the greatest actor. To step from the gallery after hearing such an actor is like stepping from heaven to earth!"[10]

At such moments he did some soul-searching: "Every time I see such an actor I think that art is cheating the stage of an actor by gobbling onto me."[11] When his drawings and paintings were being praised by Anshutz, Kelly or Hovenden, Henri said: "Nothing less than a great play can take me away from my study now,"[12] and on the day he gained admission to the life class, he noted, "I will progress here! Art has taken another grip on me tonight and holds me faster than ever now."[13]

There were occasional diversions. After listening to a lecture on women's rights entitled "Women of France and America," Henri registered approval: "At last the little spark is being fanned, that, when it becomes a flame, will enlighten the whole world and give us an age of reason!"[14]

On December 23, 1886, the students assembled for a Christmas party, billed as a costume affair. Nearly all of the Academy's sixty-nine full-time pupils came in various types of masquerades. But not Henri, who appeared in street clothes. The matter was settled by a second-year student, who snatched a bolt of cloth normally used to wrap cadavers, draped the freshman, fashioned a paper crown and powdered his face white. Robert was encouraged to mount a model's stand and

hold a brown paper torch aloft, and *voilà!*—he was Bartholdi's Statue of Liberty, the original of which had been dedicated in New York harbor less than two months before.

Following the party Henri and his brother Frank left the boardinghouse room they shared at 1009 Vine Street and went home for the holidays. Confident of his ability, Henri decided to seek commissions for crayon portraits in Atlantic City. He had brought along his first such effort, a portrait of a fellow art student, and made arrangements to exhibit it, together with the photograph from which it was copied, in a local art store. A sign placed beside it read: "Crayon Portraits, Frame, complete, only $14.00." Although the display evoked praise, no commissions were forthcoming. Nonetheless, Henri's enthusiasm was running high. On January 1, 1887, he made a New Year's wish: "May I be an artist when '88 comes in!"[15]

With the resumption of school, he was again the activist. He helped organize a portrait class that met three mornings a week and another sketch class open to new students such as Charles Grafly, Edward Coleman and Charles S. Williamson. There were also plans for an evening composition class in which a subject would be announced, then works created to illustrate it, and the finished art displayed and criticized. "Silence" was the initial topic, and Henri pondered a multitude of choices: a graveyard, a still life, a bell without a clapper, a sleeping boy holding drumsticks in his hands, a deserted country house, sailboats on a becalmed sea. He depicted an old man fishing from a pier, who, having just gotten a nibble, holds a finger to his lips to request quiet from three boisterous boys lest the catch be frightened off. Subsequent compositions dealt with "Discord," "Harmony" and "The Seamy Side of Life," the latter causing Henri and another student to "tramp over town" in search of squalid subjects.

He continued to show interest in the Academy's anatomy lectures presented by Dr. William Keen, chief of surgery at Jefferson Medical College, who devoted sessions to bone structure, muscle construction and facial expressions. One of the most revealing demonstrations involved attaching battery wires to a model so that small charges of electricity would cause his muscles to flex. Henri studied an anatomy book by Marshall and his brother's copy of *Gray's Anatomy*, but William Rimmer's *Art Anatomy* was beyond his budget so he copied its illustrations in the Academy library. Perspective was also taught but "I don't like perspective," he admitted. "I hate it. I understand it but can't take interest"[16]

For diversion, he and other students often went into the school's galleries to look at paintings or to other exhibits around Philadelphia, one of them at Memorial Hall in Fairmount Park, the site of the country's first national art exhibition at the time of the 1876 Centennial. Henri initially proclaimed the paintings "fine pictures," although when he returned with classmates George B. Fox and James R. Fisher two months later they "tore the old masters out" and "laughed at the drawings from the Kensington schools of England."[17]

At Hazeltine's gallery Henri found "some fine

pictures" by Jean-François Millet, William-Adolphe Bouguereau, Alphonse de Neuville and Jean-Baptiste Detaille. Steele's saloon at Broad and Chestnut was also frequented because of "the fine pictures there . . . principally nudes." But Henri's favorite haunt was James S. Earle & Sons' gallery on Chestnut Street, with works that typified the popular taste, such as Charles Sprague Pierce's *Brittany Shepherdess*, Mihály Munkacsy's *Christ Before Pilate* and the *Last Days of the Condemned*, the landscapes of Norton Bush and a genre painting of a child with three dogs by Helen Hovenden, the wife of his teacher.

Henri and Edward Redfield made a point of going to Earle's to view a portrait by Émile Renouf "when there was a favorable light on it" and it was there that Henri first saw the work of Henry O. Tanner, an Academy student whom he had met at the gallery on a previous visit.

In the spring there was less interest in extracurricular activities. Both Anshutz and Kelly saw his progress as "very rapid. Their praise makes me work harder."[18] Even Hovenden, who had been his chief critic, now applauded his efforts: "I was Hovey's darling. All the students were called around to see my improvement and the good things I had done."[19]

With the end of classes, his thoughts turned toward Atlantic City. He had been approached by a decorative shell painter named Van Gelder to go into partnership but Henri decided to strike out into the commercial world on his own. "My idea was to go into the 'Hand-Painted Clam Shell 10¢' business, there being prospects of big money in it."[20] He spent a week creating an inventory by embellishing a thousand shells, but sales were practically nil and he abandoned the enterprise.

Henri's compositions about this time included meadows, a breakwater and, on a five-by-thirteen-inch canvas, a simple division of sky and gray sea. Though he painted on-the-spot, the joy of working outdoors was regularly ruined by mosquitoes. From an oil sketch of St. Monica's Church, Henri spent two hours producing a copy on a plaque which he donated to the church fair, and one of his last works that summer was painted from a photograph, a tintype in which he, his brother and two friends posed as doctors and patient in a clinic. In the mock operation, Henri was shown administering ether and the resultant "clinic" painting, as he called it, became his modest version of Thomas Eakins' canvas featuring the clinic of Dr. Samuel Gross.

In the fall of 1887 he was back in Philadelphia living with Frank in the second-floor front of a Vine Street boardinghouse. At the Academy he enrolled for the season in the life class where classmates included Alexander Calder, Edward Redfield, Charles Grafly, Charles Williamson, William Haefeker and James Fisher. But now the art school began to lose its charm. "I have got the Paris fever bad and want to go next year," he said.[21]

Several former students had left to study there and the letters they sent back were widely discussed, as Henri reported:

> Browne . . . is at the Julian School and is working in charcoal. This pleased me when I heard it, for a

charcoal fever has swept over our class. I have only made three or four oil studies this year. I want to learn to draw correctly.[22]

Occasionally some hijinks buoyed Henri's sagging spirits. If a model failed to appear the men would rush one of their number, a vain Adonis, behind the model's curtain where he undressed before posing. When he emerged and took the stance of a gladiator students would toss wads of clay at his naked body, and when he retreated to the model's compound he would discover that his clothes were missing.

This sort of buffoonery was virtually the only socializing for Henri, whose schedule of drawing and studying left him practically no time for seeing women. After he and his brother moved to another boardinghouse at 2107 Arch Street in November 1887, he did become enamored of a "petite, vivacious young lady" who also lived there, but the vision was appreciated from afar. Henri referred to her as "one of those fascinating little irresistibles" who "just keep on irresistible but single to the end."

After the first of the year many of the students were busy producing paintings to submit to the Academy's annual exhibition, but not Henri. "I can't do work as good as I want and don't intend exhibiting til I can do something good," he said. His disillusionment was caused, in part, by a major exhibit of historical portraits then on display at the school. There were over five hundred paintings by such artists as Gilbert Stuart, John Singleton Copley, Benjamin West, Charles Willson Peale and John Neagle, together with a complement of English portraitists including Sir Joshua Reynolds and Sir Thomas Lawrence. It was the first such exhibition to be held in the United States. Henri, however, was disappointed: "Few could be called works of art," he complained. "If people would accept these as works of art, the students would become masters in a short time."[23]

Throughout the spring the preoccupation with Paris continued:

A party of us propose going to Paris next August or September. Fisher, Coleman, Harry Finney, Haefeker and Grafly form the party and Whiteside, Redfield, Doherty and Hall may join. We are to go together and stay together . . . we find that it will be cheaper to live there one year than to live here one year and study, the advantages being so much greater over there, of course.[24]

Henri had already contemplated the wisdom of such a move:

They work eight hours a day on one model there—only three here. They have old students who do excellent work there, we have none here. I have gall enough to think that I am about as good as any here . . . I can't learn much from those about me in drawing.[25]

Despite his impending departure, he circulated a petition to have classes increased from three hours to four, and within a week the institution agreed.

Henri's enthusiasm for portraiture, anatomy and the figure had also nurtured an interest in photography. By 1888 a mass-produced, hand-held camera was on the market and "snapshots" became a national pastime. He would take bicycle jaunts into the country with friends whose cameras were always on hand, and they recorded the figure, just as Eakins had done. Henri acquired, from a former Eakins student, eight sepia photographs of young men, posed singly and in groups, in the studio and out-of-doors. He also became familiar with Eadweard Muybridge's sequential photographs of human and animal locomotion, which he would study for hours at a time.

Thomas Anshutz was himself a camera buff and stimulated his students' interest in illustration as well as photography. Henri had accompanied his teacher into the Academy galleries where Anshutz criticized several pictures for his benefit, including Edwin Austin Abbey's pen-and-ink drawings for *She Stoops to Conquer*. "Anshutz likes Abbey very much," Henri noted.[26]

As the semester drew to a close, he was having second thoughts about the cost of a year in Europe, for although he was nearly twenty-three he was still entirely dependent upon his father for funds: "I now debate in my mind whether it would be better for me to go to Paris with the other fellows, or stay here and get up a class in Atlantic City which I could attend one day every week—Saturday."[27]

He had already given his first art lessons to a neighbor in Atlantic City the previous fall. Now he reasoned that if he could assemble a class of ten students and charge fifty cents apiece he would earn $3.50 each week after deducting the round-trip fare from Philadelphia. "This would be small, but still I'll be able to get revenue from it. This thing of money is a great trouble to me. I want to be self-sufficient."[28] But Paris won out in the end.

Henri spent Easter Sunday, 1888, with student friends sketching along Wissahickon Creek beyond Fairmount Park, where an old monastery served as a subject. It was drawings such as these that Henri hung in the Academy the following month when the students of the antique and life classes held an impromptu exhibition. It resulted in his first press notices. The *Philadelphia Call* reported:

A number of marine and landscape studies by R. E. Henri show a rather labored attempt in both detail and color, and lack the broadness of the surrounding work, but they are good subjects.[29]

The *Public Ledger* said: "R. E. Henri shows several characteristic landscape sketches, which might be worked up into clever pictures."[30]

Three weeks after the show was dismantled he gathered together his paintings and belongings, packed up his year's collection of *Art and Decoration*, *Art Age* and *Art Interchange* magazines, and headed for Atlantic City, where he painted beach scenes and several portraits of his parents and made preparations for Europe. On September 5, 1888, Henri, Grafly, Haefeker, Finney and Fisher took the train to New York and boarded the S. S. *Queen*. Calder and Redfield, who had come to Manhattan to see them off, waved farewell as the ship was eased out into the channel on its European voyage.

AN AMERICAN IN PARIS

FOR HENRI, going to Paris was serious business. He practiced drawing on board ship, making pencil sketches of the passengers and crew. But his resolve was often interrupted by frivolity. He and his friends would play "tug-o'-war" or "follow the leader" on the skylight above the first-class passengers. Sometimes all five of the gang would squeeze into one stateroom and sing their favorite songs while Haefeker plucked on a banjo, and when a large charcoal head appeared on the wall of the dining salon they all acted very innocent.

The ship docked in Liverpool, giving them two days in London. They were awed. Henri sketched the Houses of Parliament from the deck of a side-wheeler on the Thames and observed: "At every turn a picture appears . . . great edifices of marble, encircled by carvings and statuary . . . How weak and cheap would our public buildings in Philadelphia look beside this."[1]

On their one evening in London they saw a production of *Dr. Jekyll and Mr. Hyde* at the Lyceum Theatre. And at the National Gallery, Henri singled out the portraits of Rembrandt as "the greatest things in the collection" and labeled Turner's drawings and watercolors "*very* fine," while at the British Museum he marveled at the Elgin Marbles, Egyptian sculpture and the art of Pompeii. Then it was across the channel to La Belle France and Paris. "This," he wrote, "is what I have hungered for!"[2]

After several unsuccessful efforts at finding living quarters for five, the group decided to disguise its number. Haefeker and Fisher, the two who spoke some French, became the apartment hunters. They kept disappearing and reappearing at all of the building entrances along a street until, at last, a broad grin appeared on Fisher's face. Success. The concierge who rented them a place at 12 avenue Richerand stood aghast when not two but five young men carried their luggage up the narrow spiral staircase.

To Henri the fifth-floor garret appeared charming:

It was a mansard room and it had a small square window that looked out over house-tops, and pink chimney pots. I could see l'Institut, the Panthéon and the Tour Saint-Jacques. The tiles of the floor were red and some of them were broken and out of place. There was a little stove, a wash basin, a pitcher It was a wonderful place.[3]

There was but one element missing: "Oh, how I long for the pretty women I expected—where are they?"

The boys had visited the renowned Académie Julian on their first Sunday in Paris; now they hastened to enroll. Julian's was located in a former dance hall above an arcade that ran from the boulevard Montmartre to the rue St.-Marc. Named the Passage des Panoramas, it was the first of several such constructions in Paris that were the brainchild of American artist-turned-inventor Robert Fulton.

Rodolphe Julian had worked in a bookshop, been a wrestler and studied art under Cabanel before founding the Academy two decades before. He was astute enough to see the need for a school where candidates to the École des Beaux-Arts could work until their admission was granted. For some this meant remaining at his school for years.

Although the nearly six hundred students who studied at Julian's in 1888 represented a multitude of nationalities, Americans were particularly drawn there, for unlike Paris' other private art academies such as the Académie Humbert et Gervex, there was no sign warning: *Nul ne peut entrer dans l'atelier s'il ne parle français* ("No one may enter the studio unless he speaks French").

The Académie Julian was situated at the top of a flight of stairs over a public lavatory. The space was L-shaped and divided into three roomy studios, each with its walls covered by caricatures, portrait sketches and the multicolored paint scrapings from hundreds of palettes.

Each Monday morning at 8 o'clock there would be a mad scramble for places with an uninterrupted view

of the model's stand. Then prospective models were ushered into the studio where they would disrobe and await the verdict of the class. If there was an abundance of catcalls and jeers, the nude knew she stood no chance of being hired at two dollars a day. Americans shouted the few obscenities in their limited French vocabularies.

In each studio there were so many students at easels wedged closely together that two models were required. "It is nothing to see a nude female model standing side by side with a nude male on the stand," Henri related.[4] The class was held from nine A.M. to noon and from one to five P.M. with models posing for fifty minutes, then resting for ten. But with so many individuals in attendance there were bound to be constant distractions during the posing. Some students would burst into song, others loafed and talked in the corners; one would begin lifting weights, another played an accordion. Because a majority of the assemblage smoked, a thick blue haze hung over the room which even the sun's rays, pouring through the dusty skylight, could not fully penetrate.

Although there was no formal instruction at the school, Rodolphe Julian persuaded a number of well-known artists to provide twice-weekly critiques. Henri worked in the corner studio, which was the domain of William-Adolphe Bouguereau and Tony Robert-Fleury. When the masters were not on hand the class was supervised by a monitor who posed the model and called the roll. Henri failed to recognize his name when it was initially called out in French. He wrote:

> At the first rest a crowd of jabbering and grinning fellows gathered around me It's coming, I thought. I had made up my mind that I was to be initiated . . . I made them understand that I did not know what they said so they called up an English-speaking fellow who informed me that we were expected to pay ten francs to treat the class.[5]

A dozen new students were tapped and the multitude quickly departed for the nearest café.

On the day that Bouguereau finally appeared he was ceremoniously ushered into the room by Monsieur Julian. As if on cue all of the French students rose to their feet and respectfully bowed. Then he began his critique—in French. Henri was lost; he had to get some of the comments secondhand from Haefeker and Fisher, and felt humiliated, helpless. "I have often wondered at the embarrassment or touchiness of foreigners in America. I understand it now," he confessed.

Henri, Grafly, Haefeker and Finney sought to break the language barrier by studying French three afternoons a week at the Polyglot Institute. They would sit together on a bench like little schoolboys, conjugating the verbs "to have" and "to be" and chanting French numerals in unison until they burst into laughter to the bewilderment of their French teacher, who found nothing funny in his native tongue.

The Robert-Fleury class in composition was not unlike the composition class at the Pennsylvania Academy. On Saturday mornings he would assign a biblical or historical subject to be drawn during the week. Then they assembled for a critique the following Saturday. The instructor awarded each of the works a number, ranking their quality.

Some of the subjects, such as "Venus Discovering the Body of Adonis in the Woods," enabled students to employ figures they had sketched in the life class. Others, like "Abraham Sending Forth Hagar and Her Son," "Noah Descending from the Ark and Offering Thanks" or "Antony Brought to Cleopatra to Die," necessitated a knowledge of historic architecture and costumes, and each week's topic caused scurrying for books on ancient civilizations. Some of Henri's efforts were paintings rather than drawings, and since the oil was still wet when he brought them forth, those canvases that he or Robert-Fleury judged as poor were simply scraped clean to be used again.

He attempted at least one work from the apartment balcony that overlooked the avenue Richerand. The six-by-nine-inch oil on cardboard contrasted snow-covered rooftops with rose-colored chimney pots and dark smokestacks that pierced a somber sky.

The living quarters were a cooperative in the truest sense. Lots had to be drawn for rooms: Henri, Fisher and Finney shared the larger bedroom, Grafly and Haefeker the other. What they called "The Den" served as a study and dining area, with a circular table barely large enough for the five to gather around. With dining out too costly, the boys worked out a housekeeping arrangement: Fisher did the marketing, Haefeker and Finney the cooking, Henri the washing and Grafly the drying. It was not unusual for their dinner to consist of horse meat and rice; sometimes soup, liver and prunes. The room contained a coal-burning fireplace, the mantel of which held books, a wine bottle or two and a plaster cast of a nude; the walls were covered with sketches, postcards and reproductions of works in the Louvre.

On Thanksgiving Day a sumptuous celebration was held to relieve the daily sacrifice involved in becoming an artist. The table was laden with peas, tomatoes, cherries in brandy, quince jelly and a turkey dripping with gravy. Robert described the evening:

> The first toast was for our folks at home, the second for America; others for the success of Americans in Paris, may they all become Bouguereaus and Chapus, starve until they are thirty-five, then become immensely rich—for France, "Vive la France" Then we sang Yankee Doodle, the Star-Spangled Banner, the Marseillaise, and wound up with a clapping of hands.[6]

As the fall semester closed, students produced their final renderings of the figure, hoping for Bouguereau's approval. The competition, known as the winter *concours,* resulted in the selection of works for display in the classroom and awards of fifty or one hundred francs for the best drawing, painting, composition and sculpture.

Grafly came rushing to Henri with congratulations; his drawing had received eighth honorable mention from Bouguereau. Grafly had won a mention, too. The following day the master himself complimented Henri "on the honesty of my endeavor and my rapid progress." Henri wrote his parents:

I stood before my drawing in the exhibit and looked at that magic but crooked figure 8 which Bouguereau himself probably put there. In the evening I brought my drawing home and tacked it up on the wall where I gaze from my bed upon that crooked figure 8 to my heart's content.[7]

Informed of this initial success, a proud Mr. and Mrs. Lee contacted the Philadelphia newspapers, which promptly ran a notice:

PHILADELPHIANS WON HONORS IN PARIS
Of the five graduates of the Academy of Fine Arts, of this city, who left in September last for a two-years' course of study abroad, two have already won honors in Paris. After two months' competition in the Julian Academy, Charles Grafly received a medal for his work in modeling and R. Earl Henri was awarded a prize for designing.[8]

On January 1, 1889, as was the custom every New Year's Day, pupils at the Académie Julian were invited to attend an open house at Bouguereau's studio. The students met on the steps of the Odéon Theatre, then marched as a body to pay homage to their mentor. Henri and his roommates followed the crowd through an entrance court and up a winding stairway. There, in the doorway, stood the smiling Bouguereau, grasping the hands of the fellows as they filed by.

Easels held paintings in various stages of completion. On the walls were his earlier oils. The rotund host, wearing a black suit with a red Legion of Honor ribbon in the lapel, discussed his work at length, moving from a canvas of the Virgin Mary to an unfinished picture of Christ bearing the cross, to Cupid and Psyche. A classical air pervaded even the religious subjects, which were signed "BOVGVEREAV" in imitation of ancient Roman lettering. How far the master had traveled to this pinnacle of popular success from those early days when he had earned a pittance by drawing labels for boxes of prunes!

There would not be enough time to look at the portfolios of drawings, the collection of plaster casts strewn about the floor or the second, smaller studio built entirely of glass so that models could pose in an outdoor light. Once again Bouguereau shook the students' hands, earnestly wished them a good year and saw them on their way. With visions still dancing in their heads, Henri and the group walked along the Seine where they met a former Pennsylvania Academy student who was just returning from a visit to the studio of Gérome, *his* master at the École des Beaux-Arts. The Beaux-Arts. That was their next goal.

The École des Beaux-Arts, which Bouguereau himself had attended, was entered by examination only, a four-day ordeal that tested a student's ability to portray a figure from the antique, a drawing from the posed model, a memory sketch of a bone complete with muscle attachments and an architectural rendering. For the one in five applicants who passed these tests, a written examination followed, which required a knowledge of world history.

For the coterie of Julian students cramming had already begun. Henri spent days in the National Library poring over books on the history of Greece, Rome, the Gauls, the Punic Wars, the French Revolu-

tion. A pall hung over The Den as each man studied and memorized, interrupting the routine just long enough for meals and an occasional game of tossing sous for a last slice of meat.

Before the exam Henri obtained a letter, required of each applicant:

Monsieur le Directeur:

We have the honor to present to you our student Monsieur Henri, who lives at 12 avenue Richerand, who is asking for admission to the École des Beaux-Arts, and we certify as to his moral character and his ability.

(signed) William-Adolphe Bouguereau
Tony Robert-Fleury[9]

All foreign students also had to request a recommendation from their embassy in Paris.

When the dreaded day arrived, the boys were among nearly four hundred candidates who crowded into the Beaux-Arts for a chance at one of the eighty openings. Each room was supplied with a uniformed guard on hand to discourage copying. Once the drawings began, the only sounds were the scratching of charcoal or the occasional groan of a student. The twelve hours allotted for the figure drawings did not seem to be long enough.

With the examinations completed, the two weeks of waiting seemed almost as torturous. Henri visited the Beaux-Arts to see an exhibition of the examination drawings. The room was full, students milling around, speculating on their chances.

On the appointed day Henri and the others trudged once again to the art school, this time through a mixture of rain and snow, to learn who were the successful candidates. A tense crowd. Then anticipation quickly turned to despair. When the list was read in a singsong French none of the five Americans was called. Henri was destined to apply again in June and twice the following year, with the same negative results.

The group now sought the fun and relaxation they had abandoned for so long. They strolled along the quaint bookstalls looking for bargains and took leisurely walks down the Champs-Élysées to the Bois de Boulogne. In the park the first baseball club in Paris was being organized, inspired by the visit of an American team on a worldwide tour; Henri played centerfield once but was usually content to fill in as scorekeeper.

Several Sundays were spent on boat rides along the Seine to St.-Cloud, a town west of the city where the boys enjoyed picnicking, sketching and keeping an eye out for attractive women. On occasion, when a particularly tall and handsome figure was spotted, Henri would fantasize: "Too bad we could only look at her."

Some evenings they frequented the Moulin Rouge or Folies-Bergère or remained in The Den while a portrait of Henri was sculpted by Grafly. Other students sometimes joined their circle, especially Pennsylvania Academy alumni such as Augustus Koopman, Henry McCarter, William Trego and Frederick J. Waugh.

On March 15 the Americans joined a throng of

students at the Palais de l'Industrie on the Champs-Élysées to witness the arrival of paintings for the annual Salon. It was the young artists' rite of spring. The canvases, many of them huge, were transported in every conceivable manner—by large vans or cabs, carried by a team of men or strapped to an individual's back. Hundreds stood by the entrance to scrutinize works, applauding favorites and jeering at others. Many artists made a mad dash for the building to avoid the criticism; others tipped their hats and bowed or replied in kind.

Gendarmes were kept busy attending to over-zealous students in the crowd, including many women, most of them models. Suddenly someone shouted, "Here comes Sarah," and there was a general rush in her direction. As Henri explained:

> Paris has two Sarahs. One is Sarah Bernhardt, the other is Sarah Brown, the model, who is one of the most notorious women in Paris She is the heroine of the students and is never so happy as when receiving their homage.[10]

Henri witnessed Sarah being conducted toward the crowd. "She acted the queen of folly with kind dignity towards her court," her subjects having begun to dance in several circles about her as she sat, enthroned, under a tree.

In the spring of 1889 another major art exhibit, the Exposition Universelle Internationale, marking the centennial of the French Revolution, would be competing with the Salon. The symbol of the fair, Gustave Eiffel's tower, had been rising on the Champ-de-Mars for nearly two years and now was finally completed. Henri frequented the Exposition grounds to observe the feverish preparations and came to the official opening on May 6. At night the Eiffel Tower, illuminated by electricity, was surrounded by a profusion of flags and thrown into silhouette by fireworks. During the day one could appreciate its varied coat of paint, shading from a deep bronze tone at the bottom to an almost pale yellow at the top, giving the illusion that it was dissolving into the heavens.

Numerous attractions caught Henri's eye, chief among them a Javanese ballet and reconstructed village, beautiful girls, rich costumes and dancing, which he characterized as "peculiar, snake-like, a new poetry in motion."[11]

He spent long hours in the Exposition galleries and was particularly drawn to the works of the Barbizon painters Millet, Corot and Daubigny. Among the Americans, John Singer Sargent's portrait of young girls was singled out; his favorite picture in the entire exhibition was Bastien-Lepage's *Joan of Arc*.

To compare it with the Exposition, Henri visited the Paris Salon where he was overwhelmed by the sheer number of works: over two thousand paintings and nearly that many pieces of sculpture. After five hours he had seen but a portion of the exhibit, yet the quality left something to be desired, for he felt the Salon "contained too much common stuff" when compared with the art at the Exposition.

March 31, 1889, was the final day of the boys' six-month enrollment at Julian's and they decided to dissolve their cooperative living arrangements. All jointly held belongings were auctioned off to one another in the apartment and by week's end Henri and Fisher were established in new quarters at 72 rue Mazarine in the heart of the Latin Quarter.

In mid-April Henri enrolled for four more weeks of classes at Julian's, continuing his study of the figure with Bouguereau and visiting the Louvre in the afternoons, determined to copy a painting there. After obtaining a permit and choosing Rembrandt's portrait of a young man, he set up his easel beside the masterpiece and began. "Lots of people gaping at me—makes it a little uncomfortable," Henri complained.[12] His struggle with the copy convinced him to take a portrait class with François Fleming at Julian's newly opened branch on the rue St.-Honoré, but the critiques proved disappointing.

Julian students traditionally made summer pilgrimages to Brittany, where landscapes painted along the coast offered relief from the year's studies of the figure and historic compositions. In May, Henri and Fisher visited the Paris studio of Alexander Harrison, an artist from Philadelphia who was among the best-known summer residents of the Breton village of Concarneau. Arranging for him to criticize their work there, they embarked on the fifteen-hour train ride to the Brittany coast.

IMPRESSIONISM AND VENICE

CONCARNEAU was a pleasant change from the rainy, gray days of Paris. Henri found dazzling sunlight, reflections, a multitude of sails from the port's tuna fleet and the first sandy beach he had seen since leaving Atlantic City. There was also a sufficient American art colony on hand to make him feel at home; in fact, Henry McCarter and two other Julian students arrived from Paris on the very same train.

Henri and Fisher roomed at the Hôtel de la France, rented a studio for twenty-five francs a month and posed their first model, a boy of ten. Henri drew with a brush rather than charcoal and was encouraged by his good start. He soon went calling on Alexander Harrison, whose studio was in the loft of an old granary. Harrison was not there, but when Henri peered into the darkened interior he saw a canvas of a crouching nude, the painting caught in a shaft of light streaming through an opening high on the granary wall. The picture was executed with broad brushstrokes, and the bright colors were all the more intense in the sun's rays. The effect upon him was immediate. Although the spot of sunlight soon moved beyond the canvas, casting it in shadow, the memory of that image lingered. Even though a change of plans prevented Harrison from spending the summer in Concarneau and giving Henri the promised critiques, his art became an inspiration.

Robert learned that Harrison had habitually painted his models out-of-doors, rather than in the studio, posing them as nude bathers in the surf, so now he positioned his ten-year-old model on the beach and painted outside too.

Henri and Fisher were joined by Eugene Irving Couse, another Julian student, and the threesome began arising at six A.M. to sketch the beach and rocks in the early morning light.

The majority of Henri's Concarneau seascapes were small, ten by fourteen inches or less. Although many of the scenes possessed the simple forms of sea and sky characteristic of his Atlantic City compositions, he now painted figures on the beach as well, plus at least one work showing bathhouses strung along the sand.

These were created with more freedom than any of his previous oils and some portions of the canvas were even left unpainted, a departure from the more finished approach at Julian's.

At the beach, women could be seen in various stages of undress as they changed into bathing suits, and Henri was surprised at their immodesty. He recalled that, by contrast, in Atlantic City "the sight of a lady's leg, exposed, was only to be seen with any show of respectability through one's fingers"; in fact, no refined woman would even dare utter the word "leg" since it was considered "very suggestive of something naughty."[1] He was more sympathetic to the French view.

His fascination with Concarneau was maintained throughout the summer. He enjoyed the women's native costumes, their starched lace coifs and embroidered collars giving them a somewhat medieval air. He loved the pageantry on feast days when a colorful procession would wind to a chapel by the sea, and he was intrigued by the uniqueness of the Ville Close, an old walled portion of the town that had originally served as a fortress, with the ocean as a moat. The drawbridge was always open now and inside the compound were narrow streets and small fishermen's houses, some of them artists' studios.

At the far end of the Ville Close one caught the ferryboat to Pont-Aven just eight miles away. It was generally agreed that American artists found Concarneau more to their liking; the British preferred smaller Pont-Aven. There the narrow river, flanked by water mills, presented landscape compositions reminiscent of Constable. And while Concarneau had been summer headquarters for such popular French artists as Émile Renouf and Bastien-Lepage, Paul Gauguin was holding court in Pont-Aven.

In September 1889, Henri noticed that "many of the fellows are leaving here for Pont-Aven," so later that month he and Redfield, who had just returned from the States, hiked there and stayed the night at Marie-Jeanne Gloanec's pension where the Gauguin circle met. While Henri acknowledged visiting a shop

"haunted by the gaunt looking artists, Impressionists and all,"[2] he failed to recognize the importance of the painters whose company he momentarily shared.

His idyllic summer ended abruptly upon his return to Paris, "back to the old mansard again piled in with all sorts of stuff, upset dusty furniture . . . canvases" and a disconcerting letter from home.

As he had done for the past year, Henri wrote four- and eight-page letters to his family on a weekly basis and they responded in kind. That was how he had learned of his brother's graduation from the Jefferson Medical College, obtained articles from *Century, Scribner's* and other magazines, and was reminded by his mother "to avoid the dangers and pitfalls of Paris . . . and, above all, stand up straight like Redfield." Letters from home had occasionally contained some bad news, but nothing to equal what he would now read.

On September 12 a near-hurricane had destroyed his parents' Cincinnati House hotel in Atlantic City and caused them to abandon their own cottage when the private boardwalk surrounding it was in danger of being washed away. As workmen began shoring up the Lees' remaining buildings, a fire broke out and four of their cottages, a pavilion and bathhouses were consumed by flames. In all, more than a dozen structures in the elevated area below Texas Avenue known as Lee's Ocean Terrace were destroyed. The *Philadelphia Record* carried this account:

> What is exciting the people here is the way the mysterious fire at South Atlantic City was started. The owner of the properties, Mr. Lee, was arrested on suspicion of having started the fire. Lee was said to have been released on bail, but as he cannot be found it is the impression that he is still under arrest, and the police maintain a mysterious silence in relation to the affair. Strange stories are afloat about the fire. It is said that a man refused to assist in trying to extinguish the flames and was nearly murdered. After being tied by two men in a room in one of the burning houses he was left for the flames. His name cannot be ascertained, and neither can the names of the perpetrators of the outrage, but there are suspicions that Lee is one of the men. His loss is $20,000, and the insurance is said to be about $3,000. The city is much excited over the affair.[3]

Henri's mother and brother must have withheld some aspects of these events from Robert for fear he would come rushing home. Thus dissuaded, he enrolled once again with Bouguereau and Robert-Fleury in the fall of 1889, this time at another branch of Julian's on the rue du Dragon. Paul Sérusier, one of Gauguin's admirers at Pont-Aven, served as the *massier*, the student-in-charge, and others of the Pont-Aven group were also studying there.

Inspired by Gauguin, Sérusier had painted a tiny landscape of flat colors on the lid of a cigar box, a talisman to a small group of French students who heard of its transfer back to Julian's with the accompanying advice:

Gauguin: "How do you imagine the sky?"
Sérusier: "Blue, more or less."
Gauguin: "Then paint with the brightest blue on your palette."[4]

Henri's continued study of the French language enabled him to translate Bouguereau's comments for newly arrived Americans, but he was still standoffish and self-conscious among his French classmates so that their enthusiasm for "a kind of genius" named Gauguin escaped him.

Henri's painting was being influenced by Harrison's crouching nude and the summer at Concarneau. He had already begun to see with the eyes of an Impressionist, noticing how a narrow street "sometimes fades into a mist of blue in the distance" or how a river "is hidden in a silvery gray mist," but now he began to utilize their palette as well. He produced a scene of Paris showing figures at the Seine surrounded by yellow and green trees, and rising mauve-colored clouds. The painting's title, *The Blue River*, indicates this new concern for hue.

Bouguereau was not in sympathy with Impressionism and there were heated discussions on the subject among some students when Henri and Fisher held open house each Wednesday evening in their apartment. On such occasions the topic was "thrashed about pretty well," according to Henri.

The weekly get-togethers continued after Henri and Fisher moved two blocks from their old apartment to a new one down the hall from a studio shared by Redfield, Grafly and Haefeker. Though the move was made for economy's sake, Henri enjoyed his new abode—its many corners, low arches and the little windows looking out on a sloping mansard. Here he labored over his drawings in a dim light beneath the past summer's Concarneau sketches, which were tacked up on the soiled walls.

His proximity to Redfield was convenient, since the latter was an early riser whose job it was to awaken the others, for despite Henri's habit of placing an alarm clock on a tin pan just a foot from his head, he had difficulty arising at seven A.M. for classes. His daily routine usually involved dashing down the stairs, crossing the Seine on the Pont des Arts bridge and hurrying through the courtyard of the Louvre to a little creamery on the rue Croix des Petits Champs. There café au lait and two croissants could be had for six sous in the company of many of the fellows from Julian's.

Henri continued to depict religious and historic subjects such as "Christ Blessing Little Children" and "Minerva Goes to Vulcan to Request of Him a Suit of Armor for Achilles," and Robert-Fleury's criticisms in the composition class were increasingly encouraging. When the various versions of "David Before Saul with the Head of Goliath" were viewed at the weekly *concours*, the mentor spoke highly of Henri's, of his feeling for shading, sentiment and the character he had captured in the representation. He awarded the work the number seven out of over a hundred being judged. Henri was overjoyed.

In Bouguereau's class he attempted to conform to the rigors of academic painting but this conflicted with his impressionistic vision—he spoke of a stroll in the Bois de Boulogne where "everything was hazy—delicate mauve and blue effects . . . the vista is always blurred and misty."[5]

In December he journeyed to Brolles, a village in the Forest of Fontainebleau, ostensibly to recuperate

from the flu but also to try his hand at painting the rocks and woodlands that had inspired so many artists. But the landscape was brown and gray with winter and it was only when he took a peasant girl as a model that he incorporated the reds, yellows and blues of the past summer's paintings into her scarf, blouse and apron.

The now elderly Swiss artist Karl Bodmer, a member of the original Barbizon group of the late 1840s, offered free critiques to the students at Brolles, and his first question to Henri, as with each newcomer, was, "Are you willing to work?" followed by the advice to "Draw, draw, draw."[6]

When Henri returned to Paris he found the capital abuzz over the question of whether the men who had received medals in the 1889 Exposition should be exempt from the jury at the spring Salon. Everyone was taking sides at meetings on the subject. Bouguereau headed one party, Meissonier the other, Henri's teacher contending that if all of the Exposition's five hundred medalists were allowed to exhibit jury-free the Salon would be inundated with their work, leaving no room for the younger men.

Pitted against Bouguereau were most of the famous French academicians, who insisted that the medalists deserved the same jury-exempt status they would enjoy had they received awards at the 1889 Salon. Henri saw the conflict as "the aristocrats of art against the strugglers" and admired Bouguereau for "cutting loose from his contemporaries" and demanding a place for the younger artists.

The opposing points of view were irreconcilable. A new organization was formed, the Société Nationale des Beaux-Arts, and its exhibition was held in the Champ-de-Mars. This Salon eliminated the awarding of medals altogether as well as the limiting of entries to only finished works of art. When Henri made his initial visit to the new Salon he was "most agreeably impressed," finding it better than the old and surely more interesting. Among his favorites were Sargent's *Ellen Terry as Lady Macbeth* and the paintings of Alexander Harrison, Puvis de Chavannes, Alfred Stevens, Frédéric Montenard and Paul-Albert Besnard.

By comparison, the old Salon, which he had seen the previous day, was lined with many hundreds of pictures displaying a degree of finish of which he was increasingly critical. He came away from the experience physically and mentally exhausted. He had originally considered submitting work to the Salon but after starting a portrait of Grafly and one of a young boy two weeks before the March 15 deadline for entires, he realized there was insufficient time to complete them and abandoned both canvases.

If Henri was more favorably impressed by the "modern" Salon than the traditional one, he was unable to cope with some of the avant-garde work presented in the Salon of the Independents. This third major show replaced the Salon des Refusés, which had ceased to exist a few years before. The exhibitors were known as "the Malcontents" because most of them had been continually rejected by the established Salon. Their exhibit was organized without benefit of a jury and Henri was struck by the "distorted compositions—queer drawing—frantic color" of what he saw.

A self-portrait by Henri Rousseau "had the artlessness with which a child might see the world" and in the van Gogh room the crowd exchanged "nudges and chuckles of amusement at his squirming trees and pinwheel clouds Smiles of derision were general."[7]

Although Henri characterized some of the work as "eccentric, childish, wild, even crazy," he called the van Goghs "good impression pictures" and he found the Impressionists' room "not of such wild, rebellious conception." In contrast to the old Salon, where the favorite subjects were "women peeling potatoes and farmhouses," the Impressionists' canvases were rendered "with striking original diversity of form, color, composition."[8]

Inspired by them, Henri, Redfield and Haefeker left in May for another visit to Brolles and the Forest of Fontainebleau. Abandoning Julian's before the end of the term was perhaps a symbolic act, just as Monet, Renoir and their confreres had left Gleyre's studio some twenty-five years before to paint in the same forest. The combination of birches, pines and unusual rock formations was an inspiration to them, as it would be to Cézanne and others a few years later.

Henri had now begun painting shadows thinly, owing to a suggestion by Charles Fromuth, a former Eakins student enrolled at Julian's, that his reflections were not sufficiently transparent. He also began mixing colors on the canvas as he painted, in the manner of the Impressionists. One day he and Haefeker walked the five miles to Barbizon in order to visit Millet's studio and see his sketches, not because he represented an inspiration for their art but simply out of admiration for his rural genre subjects. Back in Paris a few weeks later, Henri was pleased to note that the Louvre had just acquired and hung Millet's *Gleaners.* "All Millet's work looks fine after coming from the country," he said.[9] And when he compared his own recently completed canvases with his last study produced at Julian's Henri proclaimed the new work as much stronger. As for the classroom compositions, he resolved that he would never paint like that again.

Henri had also enrolled in an evening class at the atelier of Paul-Louis Delance, a pupil of Gérome's who was a frequent Salon exhibitor. Henri attended the three-hour sessions several nights a week and worked from "one of the best male models I ever saw."

During free afternoons and evenings he would read the novels of Charles Paul de Kock, Émile Zola's *Nana* and the journals of Marie Bashkirtseff, often choosing volumes in French to improve his knowledge of the language. He also read Browning and selections from Thomas Paine's *Age of Reason.* "Like the Paine selections best, but we are past his object now with Emerson," he concluded. "Reading Emerson has taught me two great lessons. The first, to believe implicitly that it is worthwhile to do our best . . . second, to have self-confidence, to trust our own convictions and gifts . . . without echoing the opinions of others"[10] He also read passages from Bret Harte's *Argonauts of North Liberty*, which stirred boyhood memories of a trip to Denver through the wilds when the night calls of the coyotes made him shudder.

Plans for the summer of 1890 had been formulated at the time of the old Salon, when a Julian student named Nardi was awarded a medal for his landscape painting. Interest was expressed in the locale of the work, which happened to be near Nardi's hometown of Toulon on the French Riviera. Henri became "filled with yearnings for color and sunlight and the joyous clime of the blue Mediterranean," so on June 3 he, Redfield, Haefeker and T. Dart Walker left Paris by train for the inspiring destination.

On the way they observed peasants hoeing in the fields, the valley narrowing between Dijon and Lyons, and little towns climbing the sides of hills, bleaching and baking in the sun. They passed through Avignon and Arles and finally arrived at Toulon.

Their hotel faced the quay, where palm trees added a touch of the exotic to the little fishing boats that moved in and out of the port. Their love of the picturesque country caused the four men eventually to settle a few miles down the coast at St.-Nazaire, and after drawing lots for rooms, which matched Henri with Redfield, they set to work.

During the next four months Robert painted hard, depicting fishermen tending their lines, boats in the harbor, orchards of fig trees and the little white houses with red tile roofs. When he sketched boats at dockside people always gathered to watch, making him feel self-conscious, so he found it necessary to go up on the cliffs. With the scene bathed in sunlight, it was only natural that he should revert to working quickly, before the light changed, "after the Impressionist manner."

At times in the evening he would rush outside to capture the setting sun, painting rapidly for fifteen minutes to catch the intensity of the varicolored sky. Painting outdoors was a new experience for artists, made possible in the latter part of the nineteenth century by the development of ready-to-use oil paints available in tubes. The pigments were slow-drying and easily blended, encouraging an impressionistic approach.

In July, Henri began to apply paint with a palette knife, stating that "it gives me a better effect than I've had with the brush,"[11] and he also started to produce *pochades*, oil sketches on small wood panels as spontaneous records of visual impressions. To cut expenses he tried using homemade canvas but found that it was too coarse, soaking up too much pigment, and impeded his progress. He sought to capture the impression on the initial try, becoming impatient if he "did not hit a bull's eye with the first shot."[12]

On days when it rained or was too windy to work outside, Henri painted in his room from sketches or from memory. Sometimes he and Redfield went to Toulon to visit the museum, with its decorations and canvases by Frédéric Montenard and Eugène Dauphine. "Monet was the rage, but for us, we were interested in Montenard," Redfield said,[13] and Henri agreed that "Montenard is my favorite painter of sunny subjects."[14] At the Marseilles Museum, the Montenards and Corots made the strongest impression.

In the fall the weather turned foul and so did their dispositions; virtually all of the canvases Henri started he considered unsuccessful. "Will I go back to Paris—to the others and face them with nothing done?" he asked. "Many hopes shelved. The salon picture not painted."[15]

The roommates grew irritable. They argued. Redfield pulled out, headed for Monte Carlo and a try at earning funds for a trip to Rome, only to return a few days later minus 470 francs and with a request that Henri lend him some money.

Then the son of the gambling man left to try *his* luck. As his father would have done, Henri packed a revolver, just in case. In Monte Carlo, commenting that there was "a big mountain to jump off and a blue sea to drown in for players completely broke," he headed straight for the gambling tables to play his favorite game, *rouge et noir*.

Henri planned to wager fifty francs and bet no more if he lost. Twice he was down to his last franc when his luck changed. Throughout the evening he remained in the casino amid distinguished-looking foreigners and bejeweled women, quietly amassing his winnings. When the amount reached five hundred francs he quit, stuffed the bundle of bills into his socks and returned to St.-Nazaire with his own travel plans.

Early in November 1890 he set out alone for Rome. With his Baedeker in hand he visited the usual tourist attractions: the Forum, the Pantheon, the catacombs, Trevi Fountain and St. Peter's. He studied Michelangelo's *Moses*, which he came to consider "the most noble piece of sculpture anywhere," and was equally awed by the Sistine Chapel frescoes: "Should I see nothing else I am well repaid for my visit." He found Filippo Lippi's *Annunciation* one of the most beautiful works of the Florentine School and was also impressed by the paintings of Nicholas Poussin, Claude Lorrain, Leonardo, Andrea del Sarto and Velázquez. On the final evening of his two-week stay in Rome he sat alone in the Colosseum, staring in wonderment as the moonlight poured down over the ancient ruin.

In Florence he toured the Uffizi Gallery and the Pitti Palace, and the art again overwhelmed him. He listed his favorites as Botticelli's *Birth of Venus* and *Madonna and Child*, and Michelangelo's *Holy Family*, plus works by Bronzino, Vasari, Ghirlandaio, Correggio, Titian and Rubens. He was moved to purchase a new sketchbook to record the Ponte Vecchio, buildings in the Piazza Santa Croce and Michelangelo's house, and also drew an old beggar with his child on the steps of a church. He went on to Milan to see *The Last Supper*, which he found nearly obliterated; the walls surrounding the famous fresco had been repaired so that there was "no ruin except in the picture itself."

Returning to Paris in January, Henri chose to live alone, renting a sixth-floor room at 1 rue de Bourbon-le-Château, so that the chore of climbing thirteen flights of stairs to his garret was rewarded by solitude. Back at Julian's he grew restless. "The school has lost so much, there is not the same spirit, not so much crowding, much less noise, smoke and horseplay."[16] Now the most hilarious individual was a fellow named Dumas who sang incessantly and whose greatest failing, according to Henri, was being the son of Alexandre Dumas *fils*, from whom people expected too much.

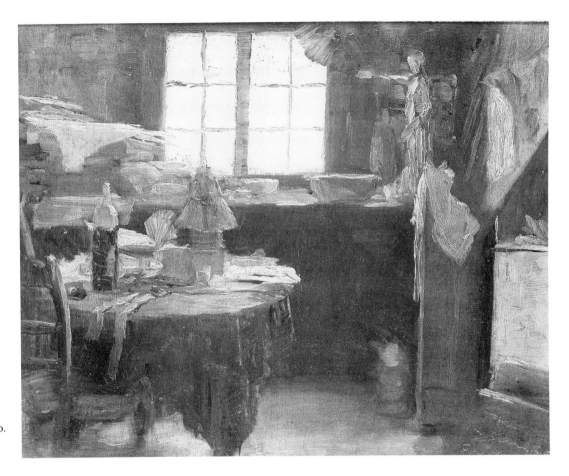

In the Rue de Bourbon-le-Château, No. 1, 1891. Oil on canvas, 13″ × 16″ (33.0 × 40.6 cm.). Collection of Mr. and Mrs. Julian Foss. Henri's Paris studio.

In Bouguereau's class Henri painted a view of the Arno from a pencil sketch, trying to recall the color in the shimmering light. But extensions of Impressionism did not sit well with the master. His usually good-natured "Pas mal" ("Not bad") now became biting criticism: "All those purples! There is nothing true in the study. A fashion that will not endure long."[17] When Henri was criticized for careless drawing he complained: "I am working for the big impression—but he demands the careful completeness."[18]

One of the few bright spots at Julian's was the influx of another group of Americans, including Colin C. Cooper, Gari Melchers and Thomas Corner, and in January Henri happened upon Henry O. Tanner in a neighborhood café. They had met in Philadelphia but now they had something else in common; one of Tanner's last paintings before leaving the States was entitled *Sand Dunes in Sunset, Atlantic City.*[19]

Tanner visited Henri's studio on a number of occasions during his first few weeks in Paris and they lunched together. Once at Tanner's studio Henri reported seeing "a cleverly drawn charcoal quay subject—one that he expects to paint."[20] Henri encouraged him to enroll in Bouguereau's class at Julian's St.-Honoré branch. The friendship that Tanner found in Paris was in contrast with his tenure at the Pennsylvania Academy a decade earlier, when this lone black art student had been the butt of bigotry, culminating in his being tied to his easel in the middle of Broad Street.[21] Now Henri helped to change Tanner's travel plans and his life, for instead of proceeding to Rome, which had been his original destination, Tanner stayed on and made the French capital his home.

Another acquaintance newly arrived was Ernest Thompson Seton.* He accompanied Henri and Redfield to Brolles, where he produced animal paintings. Henri sought to convert him to Impressionism while he was painting a wolf against a background of rocks, and they argued about "the dead, sooty brown of the wolf," which Seton insisted was the color. Henri maintained that the hue "should be a sort of rainbow brown composed of sunlight, blue sky, shadows of tree trunks and lurking reds of the fur."[22]

When a group of students became embroiled in a discussion of capital punishment, only he and Seton were against it, Henri reporting: "Our opponents would not consider the fact that criminals are the victims of unbalanced brains" who should be "suppressed for the safety of society . . . and confined, not killed." And when the subject was about Chicago anarchists who some thought should be hanged, Henri and Seton were once more in the opposition because "even though we are against their philosophy, we might hang under other conditions; in fact, all Democrats in America might hang after a Republican election."[23]

In March, when Bouguereau and Robert-Fleury had a falling out, the latter exchanged places with Gabriel

*The artist-naturalist, then named Ernest Seton Thompson, later transposed his middle and last names.

Ferrier, who gave Henri the most complimentary critique he had ever received. Since Robert-Fleury had been adopting Bouguereau's line, judging Henri's color as "too violet" and his painting as resembling a night scene, Henri was buoyed by Ferrier's reassurances. But when he submitted two landscapes to the old Salon jury, both were rejected.

Disheartened, he went to the Folies and the Chat Noir café on successive nights, trying to lighten his sorrow. Ironically, the previous month he had attended the annual Julian Ball the night before the Beaux-Arts examination with just the opposite results. At that affair revelers wore costumes as all sorts of characters—a Roman general, a Spanish bullfighter and artists' models masquerading as Adam and Eve. Henri appeared in a woolly wig, dressed in a bright green coat with fluffy lace cuffs around the wrists, a striped vest and red-and-white striped pants, all bought secondhand for the occasion.

The following morning he tried once again for admission to the École des Beaux-Arts, taking the usual grueling tests over several days—and finally succeeded. "It was not the old hurrah—," Henri noted, "the list was up and only a hundred or so fellows there. Holy smoke. There was my name! I got in—squeezed in, No. 76 Somehow it was so unexpected—so unhoped for."[24] His acceptance was based on total performances: writing about Alexander the Great, modeling a bas-relief sculpture, producing a perspective drawing of a vase on a pedestal, designing an interior court in the Doric order for the architecture exam and making an anatomically correct frontal view of the humerus bone.

He said: "I will be a Beaux-Arts student—will have a good free drawing class and will have the good word to write home."[25] On his way to his first afternoon session within those hallowed halls, his excitement turned to dismay at the initial subject—a plaster cast of the Venus de Milo!

As if demoted to the antique class at the Pennsylvania Academy, he questioned the value of one with his experience working from copies of Greek and Roman statues. Yet what was he to expect from this academic island beside the Seine? Competition panels for the Prix de Rome hung about the building, paintings from the 1840s which could just as easily have been produced several hundred years before. No breath of Paris air from the year 1891 seemed to penetrate the windows that fronted on the Quai Malaquais.

On alternate weeks his class had a model, always male, but the strict adherence to finish was even worse than at Julian's, where he still attended classes each morning. And although his Beaux-Arts studios involved working primarily in black-and-white, his desire for impressionistic color was intense. One day he spotted a pastel figure study by Paul-Albert Besnard in a window and described it as "a beautiful thing . . . complete and yet there is no Meissonieresque detail." He kept returning to gaze upon that drawing.

He and Redfield had discussed the prospect of going to Venice, the City of Light, during the coming summer. Just before their departure Henri went to an exhibition at Durand-Ruel's of Claude Monet's recently completed paintings of haystacks:

> There were about a dozen pictures of the self-same bit of landscape—a very simple bit—a haystack, sometimes two, and beyond in the distance, over a field of stubble, a mass of trees. They all seem made to demonstrate light effect—some were made in spring— others in summer, fall and winter. Each effect is most strikingly lucid, the peculiar quality of light at such times strikingly rendered. On close examination the work is but masses of rough, pure color layed on as if with no method—but stand back from it and what realism and sentiment.[26]

In Venice, Henri set to work at once. Using the same light-keyed palette prompted by his *plein air* painting in Brolles and St.-Nazaire, he found a spot on the roof of the hotel and began a small *pochade* of Santa Maria della Salute across the canal, then several other panel paintings of canal scenes plus pencil sketches of Venetian life in the marketplace and the alleys where the bead workers toiled. "No place could be better than this," he remarked.

He might have tended to adopt Monet's technique had it not been for his meeting with an American artist named Gedney Bunce, a long-time resident of Venice who was an avid Impressionist but got his affects by blending colors with a palette knife and his fingers. This encouraged Henri to experiment with palette-knife painting as well.

The Americans soon succumbed to the magic of Venice and their production diminished. Henri read Ernest Thompson Seton's new book, *Birds of Manitoba,* sent him by the author, and works by Edward Bellamy and Rousseau. Sometimes Redfield would talk about his family and his past, but for Henri the past was still too painful to reveal, even to his best friend. Although his real life could not be matched by fiction, when pressed Henri told Redfield he had been born on a boat headed for Cuba.

In the evenings they would join the promenade in the Piazza San Marco, enjoy the concerts or be entertained by the searchlights from British warships anchored in the lagoon. When they engaged a gondola and in cushioned comfort let the gondolier take them over the moonlit waters, Henri regretted that his partner was not a beautiful girl: "One ought to be in love. That would make Venice perfect."

Although his longing for a mate was heightened by the romantic aura of the city, the desire was nothing new, having haunted him during his entire stay in Europe. When Eugene Couse announced his wedding plans a year and a half earlier, Henri fantasized:

> I wish I was getting married myself. I would like to have someone to confide in, someone who would treat my faults kindly and encourage me in better ways, rout my dark moods with her tender consolation.[27]

And when his brother Frank married earlier in 1891, Henri pondered:

> Ah, I wonder if even poor little Bobby will some day be the possessor of a nice little wife—guess not—guess I'll have to continue making my solitary macaroni and café of Bachelordom and struggle on in paint, lonesome-like. Art! you are a cruel spouse.[28]

By the end of July Redfield prepared to return to Paris, saying that Venice "was a dreamy experience with nothing accomplished, unless killing bed bugs and catching lizards off the walls with a fish hook counts."[29] Henri, alone, began producing canvases larger than his earlier *pochades*. Among his subjects were a bridge at the embankment of San Biagio, a courtyard, an Italian training ship and a steamboat landing. He also depicted the piazza in sunshine and rain, and Gedney Bunce's favorite subject, a cluster of boats with their colorful sails.

One of the reasons for his being in Venice was to paint the large Salon picture that he had not accomplished the previous summer. His parents had hoped for his return to the States in May but he had convinced them of the importance of his mission. Now he labored at a composition of two women in a room but the setting was devoid of the sparkling sunlight that had recently served him as inspiration. He found himself caught between the desire to paint spontaneously with a light palette and the classroom approach at Julian's and the Beaux-Arts. He acknowledged that the proposed Salon canvas possessed "scarcely any of the qualities that I have studied so hard, that I have sacrificed so many other qualities for. It is terrible to look at the thing and see it so lacking in what I see and feel in nature."[30] An August festival, with its colorful costumes and flags and an impressive regatta, was a temporary diversion but the problem of the painting was not to be resolved.

On September 12, 1891, Henri sat in the piazza eating ices and awaiting the departure of his evening train for Paris. "Leaving Venice is sad," he noted, "but I'm glad, too, to get off. I am homesick"[31] He had experienced nearly three years of separation from his family and friends in Atlantic City. He spent two weeks in Paris, just long enough to settle his affairs, pack his paintings, books and other belongings, tidy up the apartment and be guest of honor at a farewell dinner on September 24. The next day he sailed for America.

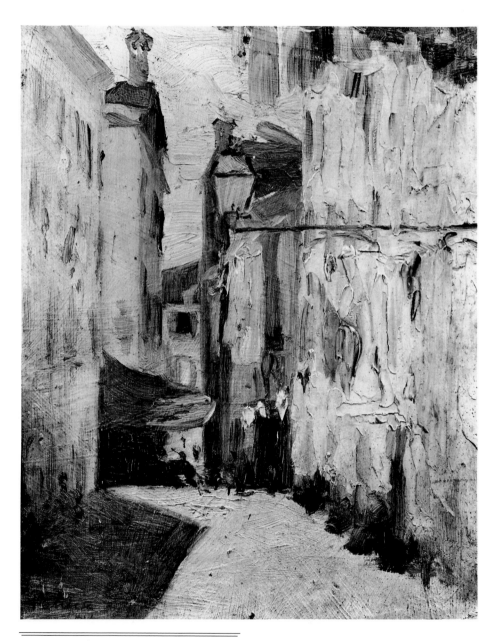

Venice, 1891.
Oil on canvas, 9½" × 7½"
(24.1 × 19.0 cm.).
Private collection,
Chattanooga, Tennessee.

RETURN TO AMERICA: NEW FRIENDSHIPS

FOR SEVERAL WEEKS Henri remained with his parents in Atlantic City but by the end of 1891 he was back in Philadelphia, staying in his brother's home at 628 North Sixteenth Street. Less than a year before, Frank Southrn had been married to Jane M. (Jennie) Jenks of Rhode Island, a nurse he had met when he was an intern. Ten years younger than Frank, who was now twenty-nine, she was said to be an heiress to the Clark Thread fortune.

Henri, at twenty-six, was still supported solely by his father. To reduce expenses he had moved in with his brother and sister-in-law but he found their company somewhat less than stimulating:

> The evening tenor of their life has no greater change than from chops to steak, etc., from reading Dickens in the evening to medicine. Jennie reads, Frank looks in the microscope, or plays solitaire. When I drop in later there is my chair, with a piece of drapery which eventually I shall wear to pieces and the margins of the daily paper to draw on.[1]

The paintings that Robert had brought back from France were hung on the walls of Frank's house, seven in the parlor, one in the dining room, two along the stairway and eight in the office. Frank wrote:

> They are all great. We are a picture gallery but we can stand more Will you do a fish, duck or something of that sort for the long frame with the plum branch in it . . . the more we see of the pictures the more we like them.[2]

In January, Robert enrolled in life and portrait classes at the Pennsylvania Academy with Anshutz, Kelly and Robert Vonnoh. Vonnoh had just taken over as chief instructor, and Henri found him sympathetic to Impressionism, for although he, too, had studied at Julian's, his own painting was of the *plein air* variety.

Henri submitted two of his canvases to the Academy's 62nd annual exhibition and when the show opened in January 1892, he described it as the "best I've seen in Philadelphia, rather impressionistic."

Both of his paintings were accepted and hung along with "the 'blue' Impressionists together in a corner of the main gallery." Vonnoh was represented by three portraits, and several paintings by Monet, borrowed for the occasion, were placed nearby.

Some of the local art critics were no more receptive to the new style than Bouguereau or Robert-Fleury had been. The *Philadelphia Item* described a Monet landscape as "a burlesque on nature The uncertainty of everything is amusing If Monet is right then all the other artists are wrong."[3] And the *Philadelphia Times* stated that Henri "is not at his best in 'Venetian Canal' and 'Venetian Girl,' both of which are faulty exaggerations of an extreme mannerism in color."[4]

Other exponents of Impressionism included in the Academy show were Redfield and Henry McCarter, the latter having been quoted in one review as saying: "There is no end of clatter about Impressionism just now. It is more talked of than understood."[5]

According to Henri, Philadelphia was "in the early agony of Impressionism. All the art gossiping world is talking about it—getting paddled, kicking against and howling for it."[6] The men who had recently returned from Paris sought each other's company in part as a defense against aesthetic attacks. Redfield wrote:

> Dear Henri
>
> Don't fail to be at McCarter's next Tuesday night. I suppose Paynter wrote you all the old stock will be there and we'll have a great time.
>
> Reddy[7]

Henry was approached to teach a life class to begin in the fall. It was his first teaching opportunity and he reasoned that it "would take very little time and would pay well"; he would "be assured a financial footing and a foundation for a reputation." On the other hand, he had been considering returning to Paris almost from the moment he landed in America. "A success in Philadelphia is not much," he told his parents, "Art is

of the least consequence here—no wonder Phila-
delphia artists . . . begin to wonder if their lives are
not wasted. How different in Paris where the artist is
the *Great Man*."[8]

The lure of the French capital was heightened by
letters to him from Ernest Thompson Seton:

> I assure you that at each and every special dinner at
> the Palais Royal our first toast proposed by me is
> always in this view—we solemnly clink our glasses
> together over the water bottle and drink 'over the
> water to Henri'—Why don't you come back, man,
> your hole is still unfilled, is still indeed an aching
> void—come back—we have the biggest atelier in
> Julian's, 70 feet × 140. We only fill one end and the rest
> is utilized by the Julian's Academy Repose—interval
> and dinner hour baseball club Tell everyone you
> are coming back soon—don't make me a liar.[9]

Henri was still undecided in May of 1892, but
shortly thereafter, following a meeting with Emily
Sartain, principal of the Women's School of Design, he
accepted the teaching job and determined to forgo
Paris at least for the moment. For classes in drawing
and composition three mornings a week his salary was
fifteen dollars.

Henri joined his parents in Atlantic City and pro-
duced more than a dozen landscapes during the
summer, some painted almost entirely with a palette
knife, other featuring short brushstrokes. Like
Monet, he recorded the same scene in varied light,
such as the Boardwalk bathed in sunlight and also on a
rainy day. *Figures on Boardwalk* (see color plate) is
reminiscent of Eugène Boudin's clusters of people on
the beach while the sand, sea and sky in *Beach at Chelsea,
Atlantic City* recall Alexander Harrison's sweeping
vistas of empty shoreline.

In September, Henri appeared for his first class at
the School of Design for Women. The school cata-
logue stated:

> Antique Class . . . under the charge of Mr. Robert
> Henri, recently returned from Paris art schools. Mr.
> Henri also gives his pupils instruction in Artistic
> Anatomy, and gives practical lessons in Composition,
> with criticism upon original sketches made by the
> pupils on subjects announced in advance.[10]

The morals of proper Philadelphians would not yet
tolerate a male instructor conducting a life class at an
all-girl school. The young ladies who desired drawing
from the nude model had the "unique advantage of
pursuing this study under the guidance of one of their
own sex," according to the catalogue.

The School of Design, founded a half-century
before, was established "to give women an oppor-
tunity to gain thorough and systematic instruction in
practical design as applied to manufactures."[11] From
what was originally a single class of twenty women
held in a private home, the institution had grown to
enroll some two hundred in the former Forrest
Mansion at Broad and Master Streets. Emphasis was
still upon the industrial arts, including classes in china
painting and the creation of designs for carpets, silks
and wallpaper, but the fine arts were now equally
represented.

Besides Henri and McCarter, the faculty included

Alice Barber Stephens, a former Eakins student who
taught portraiture, and Samuel Murray, instructor in
modeling who was also on the staff at the Philadelphia
Art Students League, Eakins' school, which was then
in its sixth (and final) season.

In instructing drawing from the antique, Henri
relied upon his experiences with similar classes at the
Pennsylvania Academy and the École des Beaux-Arts.
The School of Design had over two hundred casts
from classical sculpture, and Henri had his pupils
producing pencil and charcoal renderings of the *Dying
Gladiator*, the *Venus de Medici* and portions of the
Parthenon frieze, the very same Greek and Roman
figures he had drawn as a student a few years before.

Henri's training in Paris, his youth and enthusiasm
made him a natural attraction among the young
women, seventy-seven of whom enrolled in his
classes the first term. Tall and thin, he had a slow and
deliberate way of talking which was not unlike Eakins'
relaxed and lesiurely pace. His sluggish speech had
been ridiculed by Haefeker: "I would certainly get the
St. Vitus dance in my legs attempting to follow the
drawl, drawwwl, drrrr——, dr———r."[12]

In the antique class Henri's directive was that the
renderings be "free from detailed treatment" and in
composition he similarly encouraged his students "not
to finish up the work by putting in the small details."[13]
Teaching was rewarding to him from the start, and
soon after the initial class he informed his parents that
he was a "considerable success" with his pupils. He
undoubtedly enjoyed being the center of the girls'
attention, having them detain him with questions and
"cast admiring glances on the manly form of this
young artist fresh from the perfume of the Latin
Quarter."[14]

What he gave in return was a sense of confidence in
each student as an individual, taking the efforts of
each seriously. For him the ability to think was as
essential as one's proficiency, an attitude counter to
the prevailing notion that women's study of the fine
arts was a refined, premarital pastime.

He continued his own studies in portraiture and the
life class at the Pennsylvania Academy, where he now
attended on an honorary scholarship. Among the nine
other students in the men's life class were William
Glackens, Maxfield Parrish and James Preston. Some-
times Henri's painting of the model included a fellow
artist in the composition; at other times he would
forgo the model altogether and sketch classmates
amid a sea of easels.

On occasion Henri would visit the night life class.
Before he appeared, F. R. Gruger, a member of that
class, had "heard him spoken of and I realized his
return was somewhat eagerly anticipated." Gruger
found Henri very friendly and unassuming:

> He talked about the paintings he had seen in Europe
> and then proceeded to do a charcoal sketch of the
> model. That first evening when I did a charcoal sketch
> of the model, I sat directly opposite him so he got into
> the picture, too.[15]

Just before Christmas, 1892, Grafly invited Henri
and nearly forty other Academy alumni and students
to a studio party which, like those they had held in

Paris, was strictly stag. Younger pupils came dressed in suits and ties but a dozen of the alumni in costume attempted to recreate the atmosphere of the Julian Ball. Henri dusted off his attire of two years before and wore the same striped vest and pants, jacket and fluffy lace cuffs, adding a top hat and pipe for the occasion. Grafly combined a flowing cravat with fur-covered cowboy chaps, Redfield came as a bearded sheik with an oversized ring in his nose, Hugh Breckenridge in a striped shawl and Elmer Schofield with a bib and fake beard. Other former classmates who attended were Charles S. Williamson, Edward Coleman and William Parker; among the current students were Glackens, Preston and John H. Weygandt.

Also on hand that evening was John Sloan, who, like some of the others, was working in the art department of a Philadelphia newspaper. Henri and Sloan met for the first time and spoke of their mutual admiration for Walt Whitman, who had passed away the previous March. Although Henri already possessed a copy of *Leaves of Grass*, Sloan called on him a few days later and presented him with another, finer edition.

Soon after Henri's sister-in-law became pregnant he began searching for new quarters and moved out of his brother's home to a studio on the top floor at 806 Walnut Street, where he had a skylight installed to provide north light. The fourth-floor walk-up was a sign of financial independence for Henri, and it quickly became a gathering place for alumni and students who welcomed his philosophy of art.

Henri was getting to know more of the younger men at the Academy: Glackens, Parrish and Guernsey Moore were enrolled with him in the men's life class; Sloan and J. Horace Rudy studied in the antique class; Gruger and Joseph E. Laub were members of the night life class. Two of the three courses had been taught by Anshutz, who now, at midyear, left for six months' study at the Académie Julian. Some of his former students, dissatisfied with his replacement, discussed forming a cooperative art class of their own. Further impetus was the Academy's fee of four dollars for twelve evening sessions, which some thought excessive.

Sloan and Laub, who shared a studio a block from Henri's, became the organizers of what was dubbed the Charcoal Club. Henri encouraged them and they in turn invited him to give criticisms. With a half-dozen easels and chairs, a model's stand and a large table in rented quarters at 114 North Ninth Street, its initial session was held on March 15, 1893. Vernon Howe Bailey, one of the members, an artist for the *Philadelphia Times*, saw to it that a story appeared in his paper.

Under the skylight, in a room formerly occupied by a crayon photographer, the club holds its nightly sessions. Composed as it is of members engaged in industrial art work, the meetings are devoted to practice and mutual criticism of immediate practical value.

On three evenings, Tuesday, Thursday and Friday, of each week, a paid model is posed. The remaining nights are given up to sketch work. Compositions are submitted each Monday evening, when all the members of the club sit in judgment of the results. Criticisms are freely given and the interchange of ideas kindles and sustains a lively interest. The successful competitor is chosen by vote of the club.

Three subjects thus far have been assigned for competition, Dawn, Spring and Ophelia. For the best composition of the latter the award was made last Monday evening to Robert Henri. Twenty-seven members are now enrolled, although the club is only three weeks old.

The officers of the club are: Robert Henri, president; John F. Sloan, secretary; Joseph Laub, treasurer.[16]

Because the sessions were held at night, the members invested in Welsbach lights (an advanced type of gas burner) to lessen the strain on the eyes of newspaper artists who had been drawing all day and to provide stronger highlights on the model.

Henri spoke out for "subordination of so-called 'finish' to broad effects, simplicity of planes, purity and strength of color, force of effect and particularly the preservation of that impression which first delighted the sense of beauty and caused the subject to be chosen." He called for "the experience of many studies direct from nature" to provide "the power to select and render those most essential characteristics."[17]

When he tired of drawing or criticism, he would glance about the crowded room and record the club's nightly activity:

Lizzie Armstrong posing. The class at work Farraday is making a picture in watercolor. Sometimes he looks at the model but not often Weider smokes a pipe, sits in a state of most comfortable repose, draws with ease. Thoughts float through his mind . . . some of them he puts into words for the amusement of the rest of us. Murphy is sitting on the floor . . . mixes paint with house painter trait—heredity to his art in the night from his trade in the day. Worden . . . settles down to draw and then the idea again strikes him—wants a list of those to buy portfolios—always in business . . . then, when sat upon, "to draw" again becomes his verb for a moment until overcome by thirst. A visit to the water pail first brought up by the now busy Rudy suggests other visits on subjects of conversation. He unites in company with Wright to make sketches . . . Wright—the ex-Eakinsite—the painter of glutei maxima—man of good nature and ideas but no industry—getting his education by pure influence of the atmosphere[18]

When it became known that the Charcoal Club cost two dollars a month, attendance increased from twenty-seven in March to thirty-eight in May. There had been an attempt by some pupils at the Academy to discourage the plan, contending that it would affect the parent institution. And so it did. Although formed largely for economic reasons, the club now posed a threat to the Academy, where total enrollment had dropped from one hundred twenty-seven students in March to seventy-six in May. The club membership was half that of the entire school!

In addition to Henri, Sloan and Rudy, regulars at the Charcoal Club included Glackens, Gruger, Everett Shinn, Edward Davis, Albert Adolph, William Gose-

wisch, Harry Ritter, W. E. Worden and Carl Lundstrom.

The Academy's dean, Milton Bancroft, was rightly concerned. To thwart the competing organization, he offered Henri a teaching position for the following season. But first the question of his connection with the apparent insurrection had to be resolved. After all, he was listed as the club's president.

Henri visited the school to discuss the subject but Bancroft was not in. He communicated with Charles Grafly in order to make known his loyalty to his alma mater and so divorce himself from the Charcoal Club's seeming spirit of competition:

Dear Grafly:

When I went to the Academy I found Bancroft out, but among the fellows there was considerable talk about the Charcoal Club. I immediately went down to see some of the leaders of the club, intending to resign the membership I had promised if there was any intention of rivalry, or antagonism to the Academy—this in consideration of the kindly feeling and courtesy always shown me by the Academy.

I have talked things over. The situation is exactly as I told you this morning.

There has been no thought of rivalry or antagonism and the original designer of the club was in hearty sympathy with me. The club is to be like the Sketch Club—except that it intends to go in more for art than for beer. The nights for the sketch have been arranged so as not to conflict with the nights at the Academy. The working membership is composed of men who cannot work regularly—and by such condition are not in a position to become Academy students.

Others will be Academy students who wish to work every night and so fill in at the club the nights when there is no class at the school.

It is true that there are a few who are not content—with paying $4.00 for twelve nights' work.

The club has social and outside-of-school aims which are the reasons preeminent for its organization. This is the understanding given me by its originators.

Henri[19]

Although Henri was earning 520 dollars a year at the Women's School of Design, he now sought double that to teach at the Academy. On June 5, Bancroft responded to the request:

. . . impossible to offer you more than $100.00 for the month of three afternoons each week. This is much more than we are paying the other teachers engaged, for, in fact, in many of the departments, the teachers are giving their services free.[20]

Henri might have been willing to compromise but time was on the side of the Academy. The summer of 1893 saw the country in an economic depression and membership in the Charcoal Club began to wane; even before its final class was held on September 14, the Academy job offer was withdrawn.

Shortly after the *Philadelphia Times* printed its story about the Charcoal Club it ran an announcement that "Robert Henri is now forming a summer school" Once the class began at nearby Darby Creek, a local paper referred to the pupils as "charming young ladies from all over the United States" and to Henri as "one of the leading American artists."[21]

During the spring Henri had painted little, but he produced several landscapes at Darby, at least one composition of the students in sunlight, and one notable portrait of his pupil Alice Mumford (see color plate). With face uplifted and eyes downturned, the head is skillfully suggested with direct brushwork, some so thin as to reveal clearly the weave of the canvas. Miss Mumford was a striking redhead, a color of hair that Henri always found intriguing. Once in Paris he had painted "Judith Killing Holofernes" only to be "called down by the fellows for making her red-haired. But I like red-haired women," he admitted, "their color fascinates me."[22]

Henri had agreed to teach at the Avalon Summer Assembly on the Jersey coast and had already escorted a group there during the spring: "We went down for the day and sketched on the beach with all looking on," a student recalled.[23]

The announcement of the Avalon Summer Assembly listed its professors as William A. Mason, lecturer on the pedagogy of art; Frank F. English, watercolor instructor; and Henri as the teacher in oil. Among others was the name of Milton Bancroft; his topic, "Modern Impressionism."

By the Fourth of July, Henri had taken a room at the Avalon Hotel and although his first class consisted of two students, by month's end the course was booming. When he was not providing criticisms or supervising students, who worked under umbrellas in the broiling sun, he painted alone on the beach, often posing a solitary female figure near a tree or on a dune. These canvases, with their wistful, pensive moods and short, blended dabs of paint represent some of the crowning achievements of his impressionistic style. *Girl Seated by the Sea*, with the head turned toward a distant sailboat, combines a romantic atmosphere with the light palette and purple shadows of Impressionism, while his *Young Woman in Landscape* shows a figure dressed in white reaching for a flower on the gentle slope of a hill. By contrast, when Henri painted such compositions as *Beach at Atlantic City* later that summer, the pigment was applied more swiftly, the figures were less defined and a colorful beach chair or umbrella replaced the subtlety of previously blended variations of warm and cool hues.

During the winter of 1892–93 Henri had been engaged in another type of painting, the decoration of the Chapel of Our Lady in Philadelphia's Church of the Evangelists on Catharine Street. This church had been completed in 1886, its proportions and style derived from the cathedrals of Pisa, Orvieto and Venice.

Henri first met the church's Episcopal minister, the Reverend Henry R. Percival, in October 1892, and was shown the sanctuary to be embellished and the themes to be painted. He produced several subjects in scaled-down compositions, then mounted a ladder to paint directly on the walls. The following April the *Philadelphia Inquirer* reported that the artist had been at work for several months, and the murals, nearly finished, were "eminently successful."[24]

Along the west wall, interrupted by three windows, was an adaptation of Benozzo Gozzoli's *Adoration of the*

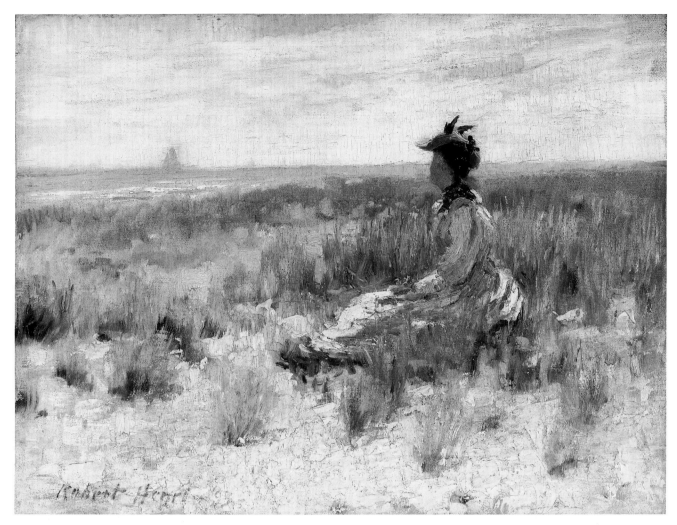

Girl Seated by the Sea, 1893. Oil on canvas, 18″ × 24″ (45.7 × 60.9 cm.). Collection of Mr. and Mrs. Raymond J. Horowitz. Photograph by Malcolm Varon.

Magi, painted in 1459 for the Palazzo Riccardi in Florence. The principal figures from the original fresco, said to be portraits of the Medici family, were retained in all of their delightful stiffness, while Henri took some liberties with Gozzoli's landscape, interpreting it in more luminous tones.

At the north end of the chapel, over the altar, he copied the fresco of *The Annunciation* by Fra Angelico from the Convent of San Marco in Florence. Then, on the south wall, he painted an original composition representing the *Flight into Egypt*—a back view of the Holy Family, the Virgin and Child upon a donkey and Joseph walking beside them, with the sky lit by a pale new moon.

Henri worked from reproductions in addition to improvising, but unlike Gozzoli and Fra Angelico, whose wall decorations were frescoes executed in wet plaster, he used oil paints on the finished wall surface; this resulted in the colors darkening within a few years and appearing even more somber in the subdued light of the chapel.

The church commission suggested another activity to him, and late in 1892 he had created an eighteen-by-seventy-inch oil of *Christ Entering Jerusalem* as a sketch for a future decoration. Unlike those for the chapel, whose style was determined for him, on this compo-

sition Henri worked in an almost impressionistic manner. The figures of Christ and His Apostles were bathed in sunlight as they advanced toward the entrance in the city wall, with a group of figures to the right standing among the shadows. The subject was one familiar to him, for he had previously depicted it in the composition class at Julian's.

America's major art exhibition during 1893 was held at the World's Columbian Exposition in Chicago, which marked the four hundredth anniversary of the discovery of America (the Exposition opened a year late). Perhaps through the recommendation of Emily Sartain, chairman of the Exposition's Art Committee on Woman's Work for Pennsylvania, Henri's *Christ Entering Jerusalem* and one of his sketches for the church mural were included in the World's Fair's architectural display.

In January 1893 his two entries were exhibited at the Academy along with work by other Pennsylvania artists that would be shown at the Fair, and because of the nature of Henri's entries, his name appeared in an article as "among the architects represented."[25] He visited Chicago and the Exposition in September and there found his two paintings, which were listed in the catalogue as:

#2624—Christ entering Jerusalem. (Study for mural decoration, in oil colors).
#2625—Study in oil colors for mural decoration, Church of the Evangelists, Philadelphia.

Henri received no mural commissions as a result of the display and today the Chapel of Our Lady decorations stand as his only example of religious art.

"The most popular picture among those painted by American Artists" at the Exposition was how the *Chicago Tribune* referred to Thomas Hovenden's *Breaking Home Ties*,[26] and the figure in the center of the composition, a young boy bidding his family farewell, has often been mistakenly identified as Henri. Despite the resemblance, Hovenden's model was actually a neighbor of his.

When Emily Sartain attended the World's Columbian Exposition she met a Japanese artist and art teacher, Beisen Kubota, and invited him to the Women's School of Design, where he made large ink drawings before the student body, impressing them with the power an artist gains through training his memory.

Henri was responsive, having heard a similar suggestion from Anshutz during his own student days. In October Kubota was a guest of Henri's and drew a portrait of him, using dry-brush shading within freely drawn outlines.

Henri had first been introduced to a Japanese artist's materials in the summer of 1890, at St.-Nazaire, where a resident presented him with a small Japanese box containing a cake of color and a bamboo brush which her husband had brought from Japan. But it was only upon meeting Beisen Kubota that Henri saw the materials in actual use; henceforth he began carrying brush and ink in his pocket, making on-the-spot sketches and signing his name with a decorative monogram in the Oriental manner. A few months after Kubota's visit Henri wrote a former Academy classmate that there is "more art on a page of good Japanese rice paper than on yards and yards of Academy canvas. Back, back to Japan," he advocated.[27]

Beginning in September 1893 Henri's studio was shared with Sloan and Laub. Tuesday evenings began as gab sessions but were quickly transformed into meetings where Henri dominated the proceedings. There was never any announced topic; he spoke as the spirit moved him, stressing what it means to be an artist. Although attendance varied, among the regulars were Grafly, Calder, Redfield, Schofield and Breckenridge, plus the newspaper artists Sloan, Glackens, Preston, Gruger, Laub and Davis. George Luks and Everett Shinn were also there on occasion.

Henri was probably aware of Stéphane Mallarmé's Tuesday-evening gatherings in Paris which had been frequented by Monet and the Impressionists, for his sessions were similarly concerned with literature and art. The newspaper men were especially receptive since most of them were avid readers who purchased numerous books sold by solicitors each payday.

Henri was moved by the opinions of William Morris Hunt, whose *Talks on Art* he owned, and he incorporated Hunt's ideas into his discourses:

When I say great Frenchmen, I mean great painters—Géricault, Delacroix, Millet, Corot, Diaz, etc. Do not confound them with Gérôme, Cabanel, Bouguereau, and the like.

Art is the doing. Literature is the talking about it.

In your sketches *keep the first vivid impression!* Add no details that shall weaken it! Look first for the big things!

Think all that you can! Put in as little hand-work as possible, and as much intelligence. Permit yourself the luxury of doing it in the simplest way!

Put in what you need to express the thing! *Everything* is beautiful! That's what's the matter! People wouldn't see the beauty of this floor, with its light and shade of color. They would only see dirt and spots.[28]

Additional inspiration came from George Moore's *Modern Painting*, which Henri had received for Christmas in 1893. Throughout the volume pencil marks indicate areas of special significance to him, such as:

Just as the musician obtains richness and novelty of expression by means of a distribution of sound through the instruments of the orchestra, so does the painter obtain depth and richness through a judicious distribution of values The colour is the melody, the values are the orchestration of the melody[29]

In a chapter entitled "Our Academicians" the author discusses paintings at a National Academy of Design exhibition and criticizes *Forging the Anchor* by Stanhope Forbes because the artist "copied the trousers seam by seam, patch by patch," providing "a handful of dry facts instead of a passionate impression." And of a composition entitled *Labourers*, Moore said: "Looking at this picture, the ordinary man will say, 'If such ugliness exists, I don't want to see it. Why paint such subjects?' " To which Moore replied "Why not? For all subjects contain elements of beauty."[30]

This philosophy was one to which Henri was already committed; the very first cityscape he painted upon his return to Philadelphia two years before had been a churchyard that appealed to him because of the splashes of sunlight dancing over the grass and tombstones.

Sometimes the Tuesday evening sessions concluded with a visit to Horn and Hardart's for a snack, or seriousness was shattered when the crowd "lapsed into card tricks." The get-togethers in Henri's studio were not limited to Tuesday evenings, as reported in the local press:

On Saturday night, February 24 [1894] Mr. Benjamin Horning, the artist, will give a reading at the studio of Mr. R. E. Henri, at 806 Walnut Street. The selections will be from Shakespeare and Tennyson, including the first acts from "Hamlet" and "As You Like It," and from "Enoch Arden"[31]

Henri was once again enrolled at the Pennsylvania Academy on scholarship, attending Henry Thouron's composition class and the night life class taught by Anshutz who, back at the Academy, sought out his former students: "I have not seen anything of Breckenridge. But think that he will come into the class at night if he finds the other men—Henri and Calder are

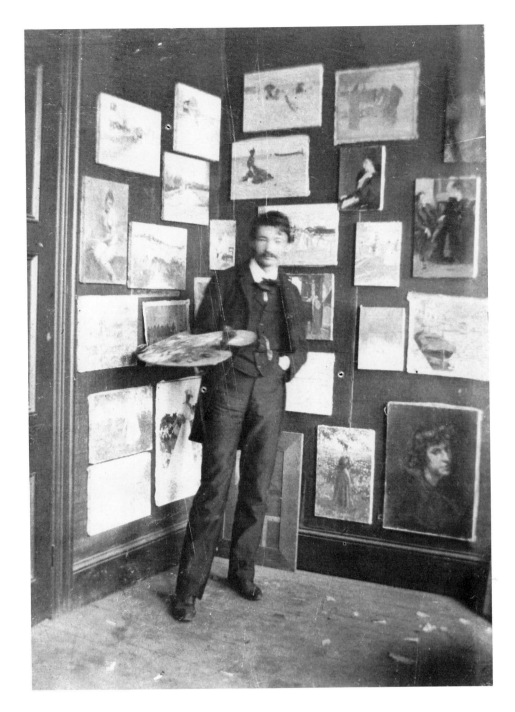

Henri in the studio at
806 Walnut Street, ca. 1894.
Photograph courtesy of
Janet J. Le Clair.
The uppermost canvas in
the center row is *Beach
at Atlantic City.*

going to be there."[32] Anshutz had returned from Paris convinced that "the most interesting of all the men of today to me is Besnard,"[33] who was already one of Henri's favorites.

Because of the crowded conditions in his studio, Henri produced only a handful of oils during 1893–94. One, entitled *Street Corner*, was a bird's eye view of Walnut Street painted from the fourth-floor window; the tops of horsecars, awnings and groups of pedestrians were represented impressionistically with the thinnest of oil washes in purples and blues.

On March 5 Henri was among the students who produced caricatures of works in the Academy's galleries for a "Fake Exhibition" in the dissecting and smoking rooms. He chose Henry Bisbing's *Siesta on the Beach*, which depicted the serenity of cattle grazing along the water's edge. As a newspaper reported:

What a place for the vegetation of a brilliant idea! [In Henri's painting] the contented bovines have all disappeared, the beach remains, and along it stalks a solitary pair of legs, whose owner has gone off and forgotten them All that remains of him is his shadow cast on the beach in rich purple hues and— Bisbing's Calves![34]

The caricatures were auctioned off for the benefit of the school, with Henri's bringing three dollars. Similar sums were paid for works by Sloan, Glackens and Maxfield Parrish.

A Henri pen-and-ink, included with those of other Philadelphia artists in the March 25 Easter issue of the *Philadelphia Sunday Times*, was titled *In Fairmount Park*, and

contained two figures on the extreme left and a background of trees merging with the shapes of carriages and hansom cabs. It was one of his most asymmetrical compositions up to that time.

When the School of Design installed an exhibition of work by Japanese schoolchildren as yet another outgrowth of the Columbian Exposition, Henri renewed his interest in brush-and-ink drawing, as recorded when he and Sloan attended a comic opera at the Academy of Music. "We sketched. I have at last found a sympathetic medium for sketching," Henri reported, "use French ink and small brush a la japonese. Like it very much."[35]

The following week he made a quick ink sketch of Jacob S. Coxey's Army, showing wagonloads of the poor starting out from Philadelphia on their way to Washington to protest mass unemployment. They were "ridiculed and laughed at generally. I imagine it's no laughing matter—these moves are likely to have serious effects," Henri observed.[36] That evening he and Sloan drew with brush and ink during a performance of *Adonis* at the Chestnut Street Opera House, although the actors "moved a little too rapidly" for Henri. He also attended a performance of the then-popular ballet *The Black Crook*, where he produced ink drawings backstage during and after the production.

In April the Tuesday evenings at 806 were given over to preparations for a theatrical. Henri noted that the group "lacked the usual spirit of discussion and lapsed into . . . desultory conversation, winding up late with practice of jig steps—anticipation of the 'great show!' that is to come."[37] The "great show" occurred at a stag party, with a melodrama, *Two Pounds, Four and Six* presented in Henri's studio. As reported in the local press:

It goes without saying that with all the talent represented in the Academy, the scenery was gorgeous. The beautiful, bright tints with which the Impressionist loves to dally, were seen in profusion. Trees with red bark, blue leaves and purplish limbs shook in a perceptible breeze. Even the costumes of the characters were designed in the modern school.[38]

Henri, Sloan and Glackens helped with sets, costumes and makeup, and Redfield worked the curtain. The studio was transformed into a little theater, with rows of seats—benches, chairs and window shutters placed upon carpenters' horses. Beer and crackers were provided during intermissions, which consumed more time than the play.

During the final month at the School of Design, Henri exhibited the work of his students, illustrations of *Aladdin*, the *Good Samaritan*, Andersen's *Fairy Tales*, Poe's *The Raven*, Guy de Maupassant and the Bible, together with examples from his private outdoor sketch class of the previous year. In June about twenty young women registered for his 1894 summer session, and Henri taught them at a spot called Fisher's Station in the Philadelphia suburbs. He then sailed for Concarneau in the company of Eustace Lee Florance, a writer for whom he would make a series of comic illustrations.

Henri found Paris "desolate of old friends," but in Concarneau he stayed at the same hotel and painted from the same three models he had employed five years before. In addition to canvases involving the figure posed in sunlight or in a darkened interior, he produced a hundred brush-and-ink sketches of Brittany, the result of "five weeks of the hardest work for me." He allowed himself only a few days of leisure, bicycling and blackberry picking, and on September 17 he sailed once more for America.

Paris, 1894. Brush-and-ink, 3¼″ × 5″ (8.2 × 12.7 cm.). Photograph courtesy of A. M. Adler Fine Arts, Inc., New York.

CHAPTER 8

ABROAD AGAIN:
THE PALETTE DARKENS

DURING HENRI'S STAY in Concarneau there had been trouble in Atlantic City. The New Jersey Legislature passed an act that allowed cities along the Jersey coast to condemn and purchase beachfront property for parkland. This posed a threat to Richard Henry Lee, who was operating an outdoor bar requiring ten bartenders along the entire frontage of his Texas Avenue property. Actually the property was in Henri's name, having been thus deeded ten years before so that his father could masquerade as manager of the place on behalf of the absentee landlord. (For reasons unknown, Mr. Lee now began identifying Henri as his nephew rather than his adopted son.)

Lee had rebuilt his Ocean Terrace after the destructive storm of '89 and he was steadfast in his resolve not to permit the extension of the Boardwalk across his land, at least not without a fight. With the Boardwalk halted a few hundred feet away, he set up two six-inch soil pipes mounted on wheels to resemble artillery overlooking the approaches. Lee patrolled the property packing a pair of six-shooters. Thus defended, the complex acquired the nickname of "Fort Lee." Henri considered forsaking Philadelphia for Atlantic City so he could stand by his embattled father, but brother Frank and his family had already relocated there and the situation seemed well in hand.

During the summer, Henri subleased 806 Walnut Street to Sloan and Laub, and by fall all three were sharing the studio and living space. When that arrangement proved unsatisfactory Henri rented a new studio at 1717 Chestnut;[1] then William Glackens moved in with him, releasing *his* former studio to George Luks.

Henri and Glackens had become close friends the previous spring. During April 1894, they spent a weekend in New York making the rounds of the exhibitions, and Henri observed that the Society of American Artists' annual was "superficial and sometimes clever," containing many light-keyed canvases by Tarbell, Reid and Robinson. One work that did impress him, though, was William Merritt Chase's portrait of a general.

Henri showed little enthusiasm for what he saw in New York except for the Metropolitan Museum's two Manets, their Rembrandts, Halses and Van Dycks, and "a little private exhibition on Fifth Avenue in which there were a number of [Arthur B.] Davies"[2] Davies, already known to Henri through the artist-writer Sadakichi Hartmann, was included in a group show at William Macbeth's gallery.

By contrast, Henri found the National Academy of Design's 1894 spring annual an "array of ignorance, presumption, old academicians." It was there that he observed "art is not free—liberty only a dream"; the rooms at the Academy were akin to "cemeteries of natural art instincts! Galleries of imitations, fads! Commonplaces!"[3]

He expressed more moderate disappointment with the annual Art Club exhibition in Philadelphia. Although he was represented in the show by two works, the entry he considered most worthy was rejected. "Damn Art Club," he wrote, "no more of them for me without them having a good jury to replace the 'old hats'!"[4]

When classes resumed at the School of Design in September, Henri was considered its foremost instructor. His name headed the list of eleven faculty members in the catalogue and praise was heaped upon him by his students. Marianna Sloan, John's sister, spent her first two years at the school under Henri, and her principal joy was his composition class: "Mr. Henri always encouraging me by an interest in my work."[5] Another student, Adele Hess, told Henri "all that I know about Art . . . I owe to you." Such words of flattery, she said, "are not mine alone, for they also feebly voice the feelings of the entire portrait class."[6]

During the fall and winter Henri continued to frequent his former studio, 806, as did the newspaper artists, but now his thought-provoking talks on art were replaced by rehearsals for another gala theatrical. This one, billed as the "Third Grand Christmas Effusion" of the Pennsylvania Academy students, was scheduled for December 29, 1894.

The art world was abuzz over the novel *Trilby*,

written by George du Maurier, himself an artist turned author. The red-hot story of how the innocent Trilby succumbed to the evils of Paris' Latin Quarter was already under attack by Anthony Comstock, self-proclaimed censor and head of the League of Decency. The 806 playwright Charles Williamson penned an uproarious parody dubbed *Twillbe* in which Henri was cast as the villain Svengali; Sloan as Twillbe; Glackens as Gecko, "a fiddling genius"; and Everett Shinn, the expatriate painter "James McNails Whiskers."

At one juncture of the play Twillbe jumped onto a table at the sight of a mouse and the violent action caused the heroine's padded breasts to fall out. Unruffled, Henri kicked them into the wings and the play continued. *Twillbe* was no impromptu production, for it had been written in rhymed couplets and all of the actors were provided with scripts. In the grand finale of Act Three, Henri met a fate befitting the villain:

Twillbe: I go my lord! Sleep well til I return (exit)
Svengali: Now I will sleep, for a good bed I yearn
(takes out pistol)
Let no base skeeter hover o'er my bed
Or wiz eis pistol I will shoot him dead.
(Humming of mosquitos heard without, enter several who fill
themselves with Svengali's blood and fly away).

(Enter Twillbe with basket)
Twillbe: Here is the gent. Come dear one and be fed.
(shakes him) Get up Svengali! Oh my eye he's dead!

The illusion of Svengali being bitten to death by Jersey mosquitoes was accomplished by stringing red balloons on wires and manipulating them offstage.

Despite the joy of such activities as *Twillbe*, Paris continued to beckon to Henri. The first lure from the French capital was A. Stirling Calder, who married in February 1895 and left immediately for Paris, where he and his bride established themselves on the Left Bank. Then Charles Grafly followed suit by announcing his intention to marry in June and set up housekeeping there as well. And Ernest Thompson Seton's stream of letters from Paris were invitations for Henri to spend a fortnight or more: "I have two beds—two coffee cups and lots of atelier with a fine light."[7]

Henri had been following an exhaustive teaching schedule, and when his stamina began to ebb a doctor advised complete relaxation and outdoor activity. To Henri the medicine was Paris. He convinced Glackens that he should experience Paris too, so after a bon-voyage party in Sloan's studio, at which Luks entertained by sketching caricatures, they sailed from New York.

Henri announced that he and Glackens would be visiting the Paris salons and then heading for Venice, but once in the French capital they decided to go to Holland and Belgium by bicycle instead, Henri conceiving of it as "a valuable trip for health and for knowledge gained by seeing the great portraits." Together with Elmer Schofield they cycled and sketched along the way, stopping in Amsterdam and other cities to study the masterpieces of Rembrandt and the Dutch School, and in Brussels, where Henri had his first look at a representative group of the canvases of Frans Hals, "worth alone our coming to see."[8]

Once back in Paris they rented studios and set to work in earnest. Henri chose street people and neighbors to pose: an Italian peasant, a Spanish dancer, a Paris waif and the youngster who worked in the creamery next door. He also painted professional models, clothed and nude, and even used Japanese prints to inspire compositions of Oriental figures. Obeying the doctor's orders to take fresh air, he produced *In the Garden of the Luxembourg, Autumn, Houses on Quai in Bouloigne* [sic] and other cityscapes out-of-doors, capturing the hubbub of shoppers on the rue de Rennes or a sunlit scene of the Pont Neuf bridging the Seine. Looking out over the river, still an Impressionist at heart, he observed how "the sun dazzles the calm water and the little boats lose themselves in the glare."

The artists made a pilgrimage to the Académie Julian, but neither enrolled. They visited the Louvre and Luxembourg museums where Henri shared a new enthusiasm for Manet with Glackens. At the Graflys' little abode, once part of the servants' quarters for the Luxembourg Palace, they argued art and religion, pitting the Bible against Thomas Paine's *Age of Reason* or discussing Tolstoy, Emerson and Hamlin Garland, whose books Henri's mother had sent him.

Now he and Glackens were joined by the Canadian artist James Wilson Morrice, a kindred spirit. A former student at Julian's, he too was an advocate of painting outdoors. He had been so directed by the prominent landscapist Henri Harpignies, who opened his Paris studio to students and encouraged spontaneity in art by directing: "Meditate for two hours, draw for one and three-quarters hours and paint for fifteen minutes."[9] Henri's own art and teaching was built upon a similar premise, partially suggested by William Morris Hunt in his *Talks on Art:* "I am always hoping to paint a portrait in one day."[10]

Morrice was used to painting *pochades*, but he carried the tiny wooden panels together with brushes, palette and a few tubes of oil in a small box that fitted neatly into a pocket. Now Henri began to follow the practice. Sometimes he and Morrice would sit at a table at the Café Versailles in the Place de Rennes and paint the bustling street beyond, one of Henri's favorite subjects. They traveled the Seine to the Paris suburbs, or to Bois-le-Roi on the edge of the Forest of Fontainebleau, recording scenes in the parks and cafés and along the river on their small painting panels, employing the so-called "soup" method of Whistler, which involved covering the entire surface with a single tone, then working the subject matter into it. They painted and sketched each other as well.

Early in 1896 Henri learned of an important Velázquez exhibition in London and went, eager to view the artist whose works had influenced Manet. "His pictures seemed to me clear of all the truck of the art of the salons," Henri noted. "Simple and direct, about man rather than about the little incidents which happen to man."[11] He returned to Paris "full to the

brim" and soon afterward painted a life-size portrait of a fellow American artist, Carl Gustave Waldeck, in which he incorporated the qualities he found in Velázquez.

He had another Velázquez-inspired painting accepted for the Champ-de-Mars Salon when his portrait, *Suzanne*, shared the honors with Morrice's Whistler-like nocturne and a view of the Luxembourg Gardens by Glackens.

During the previous winter, Henri had organized a small class and in June four of the pupils joined him in a summer class headquartered at Moret-sur-Loing, a scenic town south of Paris. An older student of Henri's named Emilia Cimino had a garret studio in Moret and he gave her individual critiques as well. She would shortly become private secretary to Auguste Rodin.

Moret was where Impressionist Alfred Sisley lived and painted, a spot popular with American artists that Henri found to be a "picturesque but too sleepy old place."[12] Nonetheless, along with his flock, he painted the long, low bridge leading to the town gates, the village church embraced by a cluster of houses, and figures in brightly colored dresses beneath trees hanging low with full foliage.

When the class ended in August, Henri postponed any further teaching in favor of a trip through Germany and Italy in the company of his brother, who had just arrived. They viewed the castles along the Rhine and saw Heidelberg and Nuremberg before heading for Milan, Venice, Florence and Rome. Henri painted again the rooftops of Venice and visited the great monuments, the works of Leonardo, Michel-

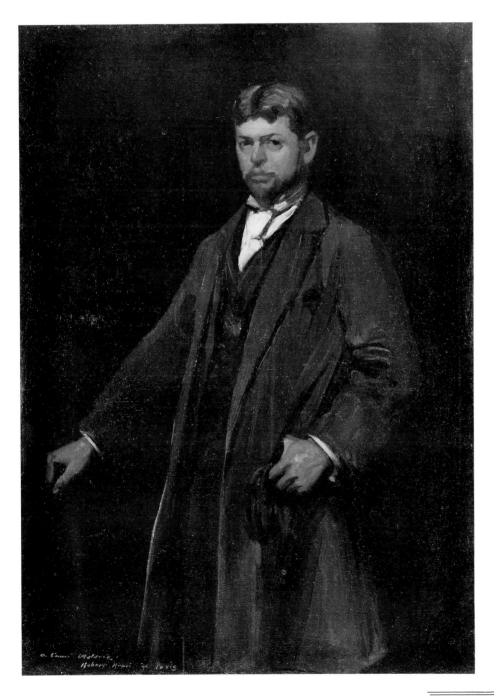

Portrait of Carl Gustave Waldeck, 1896. Oil on canvas, 55½" × 39¾" (140.9 × 100.9 cm). The St. Louis Art Museum, Gift of Mrs. Carl G. Waldeck.

Abroad Again: The Palette Darkens 33

angelo and Raphael. But Pompeii was a new experience for him, and when he climbed Mount Vesuvius to the summit, where a suffocating vapor swirled about him and the sound of molten lava and falling rocks could be heard below, Henri likened the experience to standing before the gates of Hell.

Back in Paris, his students were attempting to interest others in his forthcoming class. In June he had written his parents in triumphant anticipation: "If it goes this winter it will mean that I have a genuine school of my own in Paris."[13] The class of thirteen had an international flavor, with pupils from the United States and England and one each from Ireland, Holland, Italy, Sweden and Russia. They met in a large studio Henri rented at 9 rue des Fourneaux, where he offered criticisms and painting demonstrations on Wednesdays and Saturdays for a fee of thirty-five dollars a month. The class met for the next half-year.

During this time he viewed several major exhibitions: a Manet retrospective at Durand-Ruel's in December 1896, where he singled out as "one of his best" the girl with cherries, and cited especially *Luncheon on the Grass,* the *Bar at the Folies-Bergère, Nana,* an old beggar, bullfighters and Venetian sketches. But when he returned to the same gallery the following month to view an exhibit of "Modern French Painters," he found only a woman's head and some landscapes by Courbet to applaud among the "vulgar and common" which included paintings by Gérome resembling colored photographs, "a sorry show on the walls where hung a week or so ago so many masterly Manets."[14] At the annex to the Luxembourg Gallery he approved of a Monet composition of the St.-Lazare Railroad Station, together with canvases by Manet, Degas, Sisley and Pissarro.

For relaxation he turned to reading Flaubert's *Madame Bovary* and Oscar Wilde's essays *The Decay of Lying* and *Pen, Pencil and Poison.* Entertainment was provided by Morrice, who played the flute or recited poetry. Henri often met him and Augustus Koopman for

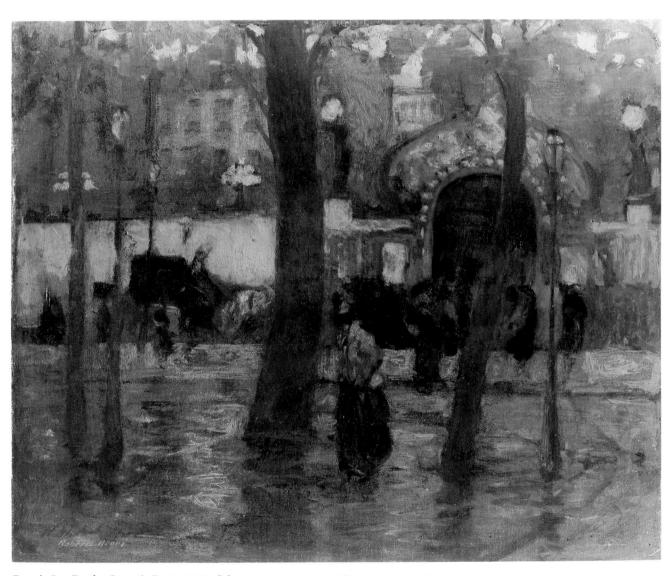

Dans la Rue (In the Street), Paris, 1897. Oil on canvas, 26″ × 32″ (66.0 × 81.2 cm.). Photograph courtesy of Janet J. Le Clair.

billiards at the Closerie des Lilas, a popular café on the edge of Montparnasse, where, after an aperitif on a terrace under chestnut trees, they would go across the street to the famous dance hall with red facade and sparkling lights named the Bal Bullier. They attended concerts or the theater, and witnessed the five dancers known as the quadrille perform the can-can at the Moulin Rouge. There were evenings when Henri had other friends drop in, such as Frank Vincent DuMond and his wife, or Eustace Lee Florance, or stayed at home to examine his growing collection of sepia photographs of paintings by Velázquez, Hals, Rembrandt and Rubens, pictures "so valuable for me to look at in the evenings."

During the fall and winter of 1896–97 Henri painted hard. While the weather was still suitable for working outside he produced a great many street scenes, from the Champs-Élysées to the boulevard St.-Michel, from the throng in a marketplace (see color plate) or at the Tuileries lake by day to dimly lit streets in front of the Bal Bullier or the Paris Observatory by night. But when the days grew rainy and cold he turned once again to the figure, now with an increased emphasis on spontaneity and dash. He completed the preliminary painting of a model in Japanese costume in a single afternoon, and the likeness of an actress model in but two hours.

A canvas of a woman in a brown dress was repainted from memory. Correcting the face, inventing a new costume and transforming the full-length portrait into a fresh, vigorously brushed, very dark composition, he considered it "undoubtedly the very best thing yet—although it would never do to tell . . . that it was all done in four hours and without a model. It has not been suspected—and everybody speaks of it as very fine." Then he mused: "I suppose I shall have to send it to the Salon although it will cost me still another frame. If I don't get in at the Salon it will be a collapse for me."[15]

A portrait of Francis Vaux Wilson, one of his American students, was completed during March in time for submission to the Champ-de-Mars Salon together with the *Lady in Brown*, and both entries were accepted.

In May, he headed for Normandy, alone, locating near the village of Vétheuil on the Seine, where he produced many canvases of peasants, of which *A Normandy Fireplace* is typical: a young woman dressed in brown sitting before a great fireplace, the shape of which parallels the sides and tops of the composition. The scene is somber and dark with the exception of a subtle shaft of light that originates in the upper right-hand corner of the picture and passes through the diagonal outline of the woman's leg, culminating in a spot of light on the floor before her. Like the peasants of Millet, this figure turns away as she stirs the contents of a large, black kettle that seems to symbolize her daily, monotonous chores.

Henri also painted some farmhouses and hay wagons; their colors, dull and dark as well, represent his final break with Impressionism.

In July he rented quarters on the rue du Val-de-Grâce adjacent to the Luxembourg Gardens, which encouraged his return to painting on-the-spot *pochades*. But Paris had begun to lose its charm for him after two years. He was lonely for companionship, worried about the family and property in Atlantic City and upset by news of an impending war between the United States and Spain over Cuba. Even word from his brother of plans to pay him another visit that fall was insufficient enticement for him to remain. In September 1897 he boarded the S.S. *Karlsruhe* at Boulogne and headed for home.

MARRIAGE AND EXHIBITION SUCCESSES

HENRI'S REPUTATION preceded him to America. A New York newspaper review of the Champ-de-Mars Salon in April singled out his canvases from among the twelve hundred paintings in the exhibit as "displaying technical skill and good qualities."[1]

As a result of his years of study and painting abroad, he now felt he was ready to apply for a one-man show at the Pennsylvania Academy; before leaving France he had enlisted the aid of Alexander Harrison. "The fact that Harrison wrote them of me is going to be a strong word in my favor," he observed. "What Harrison says goes."[2]

In Philadelphia he renewed his friendship with Sloan, then arranged to display his recent canvases in the old studio at 806 "so that I can show work to Academy people."[3] He must have had some trepidation, not due to a lack of confidence but because he had turned down the Academy the previous year when they approached him to paint murals in the Student Lecture Room. "I have again refused to do the work," he had noted at the time. "They have no right to ask me to do a decoration for them for nothing. If I want to do something for glory I can do it and own the thing myself."[4] Sloan, Glackens and two other Academy alumni did the paintings instead.

Of course, Henri still had friends at the Academy, including director Harrison Morris and Hugh Breckenridge, who now served as secretary to the faculty and had been a member of the jury that had accepted Henri's painting *Suzanne* for its annual show.

When approval was received for the one-man show, Henri had less than a month to prepare. He borrowed money from his parents in order to buy frames and enlisted the aid of Redfield and Sloan, both of whom worked with him "day and night on the frames and the thousand and one things I have to do to get ready."[5] Eighty-seven paintings and thirty *pochade* studies were arranged in the Academy's main gallery. Two-thirds of them were scenes of Paris and Normandy, the rest portraits and figure studies. Even before the opening on October 23, reviews of the show began to appear that were nearly unanimous in their praise: "His sense of color is rich and individual and his feeling for the beauty of masses is extraordinary," a critic wrote in the *Item;* the *Inquirer* cited Henri as "a prophet of the new"[7] and the *Record* suggested that his paintings "constitute a remarkable collection . . . extremely interesting."[8] The *Ledger* labeled the show "one of the most interesting if not one of the most important exhibitions held in the Academy . . . during the last few years."[9]

Because the halftone photograph had not yet been adapted to the high-speed presses of the dailies, the only illustrations reproduced were those sketched in line. Sloan, working for the *Press,* made a careful copy in pen-and-ink of Henri's painting *A Peasant,* which accompanied that paper's review.

The sole art critic with a dissenting view stated, in a second article in the *Item,* that Henri's paintings "are a direct appeal to the artistic tastes of artists only" and that he "will come to realize that the general public do not and never can be made to understand."[10]

Though Henri was pleased with the acclaim for his first one-man show, not a single sale resulted. John Sloan tried to ease the pain with a limerick:

> Said a rising young artist named Henri
> Whose favorite grog was Rock n Rye
> Since my painting won't sell
> I'll step down to Hell
> And paint Sacred Subjects from mem'ry.[11]

All was not despair, however, for an exciting aspect of the exhibition had been the praise by William Merritt Chase, as reported in the *Philadelphia Item:*

> I [Riter Fitzgerald, the paper's art critic] met Mr. Chase, the head teacher of the Academy, in Gallery F, where the exhibition is held. Chase was enthusiastic to the point of ecstasy over Henri's work, and I venture the assertion that Henri will care more for that opinion than the combined opinions of all the lay Art lovers in the city put together"[12]

And indeed he did. Henri met Chase at the exhibit and heard the words of adulation repeated. Chase's admiration led to a request that ten of the paintings be

sent to the Chase School of Art in New York for a few days' exhibition from the end of November to early December. On December 1 Henri went to view the exhibit, then called on Arthur B. Davies, who discussed the prospect of interesting the art dealer William Macbeth in showing his paintings. "I took Davies to see my work," Henri wrote his folks, "and as he seemed so much taken with it what he must have said to Macbeth was of a nature to interest him."[13]

Davies had already had two one-man shows at Macbeth's in the spring of 1896 and 1897; Henri had been invited to both but was in Europe on each occasion. Now Macbeth agreed to show Henri's paintings, and within a few days twenty of his works were delivered to the gallery. On December 9 a New York newspaper announced that "several paintings by a Frenchman named Robert Henri" were being shown at Macbeth's Fifth Avenue gallery.[14] The *New York Times* reported his canvases as "having much originality and strength, and [being] essentially artistic."[15]

Henri's oils shared the space with watercolors by Pamela Colman Smith, who a decade later would become the first painter to exhibit at Alfred Stieglitz's 291 Gallery. At this time her art, bearing such titles as *Our Pets* and *Hark! Hark! The Dogs Do Bark*, was referred to as having "a remarkable decorative quality."[16] Once again Henri was to realize no sales, but when Davies visited him in Philadelphia a month later he brought the news that "Macbeth had in no way weakened about [your] work and is confident he can find buyers."[17]

Meanwhile another dividend of Henri's Pennsylvania Academy show was a private art class to begin in mid-November 1897. "It's not bad—can make my expenses and will be at work which is an important thing—am delighted to be at it again," he wrote.[18]

Henri arranged to have the class meet at 806, which now served as John Sloan's studio, in exchange for which Sloan was allowed to observe the sessions. It was then that Sloan started painting seriously, producing portraits influenced by Manet, Velázquez and Hals and creating his first cityscapes of Washington Square, a subject similar to Henri's *Old Square, Philadelphia* of the same year. Sloan employed the dark palette used by members of the Henri class: yellow ochre, light red, blue and black, and he began painting two or three mornings a week. Henri tried to prod him into working rapidly but his methodical pace, which had kept him from becoming a quick-sketch newspaper artist, caused Henri to quip that "Sloan" was the past participle of "slow."

With Henri once again on the premises of his old studio, the pranks of years past were renewed, even though he was now over thirty-two years old. Some of the antics were reported in the Philadelphia papers: one article revealed how Henri had lowered a note on a string from the window of 806 until it swung near the ground along Walnut Street. It read: "To any kind friend: I am locked in. Sloan has the key. He's at the Press—Henri." He waited for hours. Finally, late at night, Everett Shinn got the key and liberated the prisoner.

On January 15, 1898, the annual Academy stag was held at 806. This time Charles Williamson outdid his previous efforts by producing a play with five acts and ten scenes called *Silvester Warren Atkinson or Soaked in Sin*. Tickets were fifty cents. Henri was once again cast in a key role, playing "G. Washington Smith, President, Vice President, Secretary, Treasurer (especially Treasurer) of the Consolidated Syndicate of Sin." Sloan was chosen for the part of the colonel's daughter, and the cast also included James Preston, Guernsey Moore, J. J. Gould and Edward Davis, whose three-year-old son, Stuart, would one day be a Henri student.

Earlier in the month Henri served on the fifteen-man jury for the Academy's annual exhibition, together with Redfield, Colin C. Cooper, Frank Benson, Edward Simmons and Maxfield Parrish. Henri considered the awarding of the coveted Temple Gold Medal and the Lippincott Prize of three hundred dollars "all quite a farce."[19] He was satisfied that an acquaintance, Wilton Lockwood, received one of the awards, though his own preference would have been either Glackens, Davies or Fromuth, "all of whom it seemed ridiculous to propose to the others of the jury—except Redfield, who was at least with me on Fromuth and appreciative of the other two."[20] Henri prophesied: "Ten years from now this winner will probably be a butcher. Glackens will still be painting good pictures."[21]

But that was not his only complaint. A newspaper article, "Why Henri Objected," told the rest of the story:

. . . it is here that Mr. [John] Lambert, as a prominent member of the Hanging Committee, made a serious mistake . . . perpetrated in the big gallery against Mr. Robert Henri, and Mr. Henri had the courage to protest.

They hung a portrait by him in a low tone in such close proximity to Cecilia Beaux's grand "Portrait of Michael Cross" that it makes the Henri portrait look like a mud bank.[22]

He was unhappy about the shoddy treatment, especially since his picture, *Lady in Brown*, had been included in the Paris Salon the previous year. He wrote Glackens, now an artist for the *New York Herald*, about the failings of the Pennsylvania Academy show and Glackens replied: "Don't bother yourself in the least about my 'execution,'" and added: "So it [Henri's painting] was drawn with the 'mud' school was it? To put you down they put you up, a paradox."[23]

Glackens invited Henri to stay with him in New York but three weeks later the battleship *Maine* was blown up in Havana harbor and Glackens left immediately for Cuba as a freelance artist for *McClure's Magazine*.

That winter, war was declared in the art world as well with the secession of "The American Ten" from the Society of American Artists. Davies, who had ceased sending to the Society the previous year, mailed Henri some newspaper clippings from New York "to give you an idea of the situation here." Before he left, Glackens had labeled it "atrocious."

Despite these negative references to the New York art scene, when William Merritt Chase met Henri again at the Pennsylvania Academy and suggested he

submit several paintings to the National Academy of Design annual, Henri took the advice. Chase was a member of the jury that year and must have had a hand in the acceptance of Henri's *Old House in Normandy*, which was hung ignominiously in a corridor.

Henri suddenly found himself preoccupied with the exhibition game. The private art class had become a chore: "The class goes along as usual—takes more of my strength and time than I like to take from my own work—I hope things will arrange themselves soon so that I can change that."[24]

The group of three students who had begun studying with him in the fall had now grown to a class of eighteen, and Henri decided to sublet Anshutz's studio for the morning sessions. The most redeeming factor was a redheaded student named Linda Craige, who, following a secret six-month courtship, would become Mrs. Robert Henri.

Born on January 19, 1875, Linda Fitzgerald Craige was a sixth-generation Philadelphian whose paternal ancestors had come to the Colonies from Scotland in 1700. Her great-great-grandfather had been the first manufacturer of cotton goods in Philadelphia and her great-grandfather had served as a member of the Pennsylvania Legislature and president of a Philadelphia bank.

Linda was no newcomer to Henri's classes when she began studying with him in November 1897; following her graduation from the Academy of the Convent of Mercy in 1892, her artistic ability caused her to enroll in Henri's drawing class at the Women's School of Design. Two years later she transferred to the Pennsylvania Academy, where her fellow classmates included Everett Shinn and Florence Scovel, the future Mrs. Shinn. There Linda drew from the antique and took other beginner's courses until she again came under Henri's tutelage.

Her father, T. Huston Craige, was involved in real estate, having accumulated a great many mortgages over the years. As a result the family had several homes: in the Philadelphia suburb of Ashbourne, in Atlantic City and in Black Walnut, near Scranton.

Henri's courtship of Linda was kept strictly under wraps. In March he met her family at their home in

Linda Craige, ca. 1897.
Photograph by Krips;
courtesy of T. Huston and
Ruth I. Craige II.

Ashbourne and in April she was introduced to his parents in Atlantic City. "I am so glad, missus, that you liked her," Henri wrote his mother. "Perhaps she showed best her appreciation of you when she said later 'I hope that when we get along in years we will be just such a couple as they are.' "[25]

His only paintings during the spring were several portraits of Linda, but these drew no suspicion since he often used students as models. The canvases of the petite, fragile, auburn-haired beauty wearing a tan suit with feathered hat or an old-fashioned dress with a brooch were in sharp contrast with his last paintings in 1897: a nighttime view of a streetcar, sparkling lampposts and crowded sidewalks entitled *Sansom Street, Philadelphia* and somber scenes of the factories at Manayunk on the outskirts of Philadelphia. In a *pochade* of the latter, light permeates the sky and street but the larger oil of the same composition grew considerably darker, as if blackened by the industrial scene. Only a red shawl on one of the figures in the foreground provides a note of intensity and warmth.

During May, Henri expected to teach an outdoor sketch class at Fisher's Station, probably to supplement his income prior to marriage, but the plan fell through because of inclement weather and hard times brought on by the Spanish-American War. "No one has any money—that is the cry everywhere in Philadelphia," he lamented.[26]

Henri was married to Linda on June 2, 1898, at Ashbourne, and two days later they sailed for France. The honeymoon and subsequent stay in Paris, like Henri's previous years there, were financed by his father. Before departing for Europe he wrote a farewell note to his parents, acknowledging their substantial gifts, then added: "As for the blooming preacher, he went with us on the same train to Jamestown and there insisted on waiting with us three quarters of an hour for the next train and we could not shake him until he had seen us on."[27]

Linda's parents were impressed by their son-in-law, who was considered quite a catch, and Mrs. Craige wrote her daughter in Paris about the laudatory words of several acquaintances: a Mrs. Levy referred to Henri as "a celebrated man. I heard his paintings spoken of when I was abroad,"[28] while one Nannie Ferguson, a former Henri student, asked a friend of the Craige family: "Do you know Linda Craige? All the girls at the School of Design as well as myself are crazy to know what kind of girl she is and whether she is worthy of Robert Henri."[29]

For Linda's part the man she had married was the epitome of her fantasies and desires. She wrote lengthy descriptions of him as though he had appeared before her from out of a cloud on high, despite the fact that his apparel was something less than godlike:

Imagine a young man, over six feet high, slender, strong, dark hair, long and turned up at the ends, good forehead, broad between eyes, pointed nose, liberal mouth, good teeth, a struggle for a moustache, small chin, a few hairs on it, thin cheeked and rather high cheek boned face badly marked, high stiff hat, several dents and broken places, color faded to a terra cotta shade, this on top of all.
Celluloid stand up collar, old gold neck tie with a

gold pin representing a pen—with all the gold worn off it. Soiled blue calico shirt underneath hardly visible, cutaway coat, of black cloth rather soiled, worn carelessly. Seal brown broadcloth vest adorned with gold watch chain, two pairs of pants, the outside ones being the cleanest, their color is black, same pattern as coat. The knee with holes sewed up—relics of the roller skating rink last fall[30]

The Craiges, their lineage going back six generations, must have been a bit uneasy about Henri's ancestry, whose line appeared to be anything but straight. Perhaps his explanation satisfied them but it did not prevent some investigating; before the wedding a friend of Linda's confided to her: "I have been to the Lee Library learning the hidden mysteries"[31]

The honeymooners left New York "a very happy pair," in Henri's words. He wanted his wife to know Paris just as he had, so they settled at 49 boulevard Montparnasse in the studio adjacent to the one he had occupied. With the purchase of an easel, bed, stove, tables, lamps and two bicycles, Henri was ready to pick up his Paris career where he had left off nine months before. While he painted the omnibus station Linda sketched the rooftops from the window; when he made drawings of street scenes in the evenings from memory she would read aloud to him—Kipling or Carlyle and, on Sundays, selections from the Bible.

He bemoaned the absence of old friends and former students: Emilia Cimino was visiting Italy, Eustace Lee Florance and Francis Wilson had returned to America and Andrew Law to Scotland. Morrice was still in Paris but living in Montmartre. Henri lost no time in having calling cards printed that listed Wednesday as their visiting day. On the occasion of the Henris' first "at home," a poet named William Theodore Peters stopped by to renew acquaintances, having known Henri and Glackens three years earlier. He offered to lend Henri some of his costume collection of early-nineteenth-century dresses, several of which were chosen for Linda to wear when she posed. Henri painted her in a white gown, in a yellow one with black lace and in a tailor-made dress with opera cape.

On Bastille Day the Henris strolled down the boulevard St.-Michel to Cluny, noting the rows of red lanterns that sparkled and swung above the crowds. The several versions he painted of the nighttime celebration, all done from memory, employed the familiar Whistler "soup" method, the canvases in this case being first covered with a very dark earth tone. In *Night, Fourteenth of July*, earth colors of yellow, brown and green dominate an awning-covered pavilion and figures as well, with the darkness relieved by a double row of bright red lanterns. *Illuminations: The Fourteenth of July, Paris* takes a more distant vantage point; here a blue-clad figure provides the color emphasis while the lanterns, hung among the trees on both sides of the avenue, form a varied pattern.

Henri noted that raucous celebrations connected with the great French holiday were being repressed this year, 1898, because of a reconsideration of the Dreyfus verdict, and that the army was guarding against any chance of a demonstration.

Henri had thoughts of organizing another class but

the opportunities for teaching in Paris had lessened. There was stiff competition for students now; Whistler was planning to open a school and Henri suspected that "it would be just that sort who choose me as teacher who would be among the first to hurry to him." Even one of Henri's former students, a good publicist for him in the past, decided to initiate a class of his own. "I have a strong inclination to weather the winter on what we have—without a class," Henri concluded, "and continue to study and develop undisturbed."[32]

He spent the summer and fall painting cityscapes along the boulevard Montparnasse and the rue de Rennes, then turned to a series of Luxembourg Garden compositions. In the studio he posed professional models and waifs, as well as the poet Peters as "Pierrot" and, of course, Linda. Though he occasionally treated his wife to the nightlife of Paris, from Wagner at the Opéra or a concert at the Jardin de Paris to the Moulin Rouge and the Bal Bullier, the Henris often stayed at home reading or writing letters to their parents and friends.

Henri shunned the social scene. When his student, Miss Cimino, invited him to meet Rodin, Henri graciously declined, saying, "those who want to do something themselves can't give up much time to the basking in other people's sunshine." And when a former pupil presented him with a calling card as an entrée to "make it possible for Mr. Henri to pay his homage to Madame Manet, Mr. Henri being himself one of the greatest painters in the Manet School," he never pursued the introduction.[33] Instead he channeled all his energies into painting. "I am working awfully hard these days," he wrote Sloan, "never worked more in my life—and, well, I have hopes to accomplish something before the winter is over." In the same letter he mentions having purchased the October issue of *McClure's* in order to see Glackens' war sketches, which he enjoyed immensely: "I should like to see the veteran himself I can imagine Glack kicking for more hard tack and objecting to bullets riddling his paper as he sketches."[34]

Henri was painting, all right, but his art was not producing income. By fall the Henris found themselves in a financial crisis; Robert was forced to request an additional 250 dollars from his parents and revive his art class even though it attracted only a half-dozen students. The scarcity of pupils prompted him to visit the Whistler School to check on the competition:

> I went in—more of course in curiosity than after a model. It was a great many flights of stairs and not very big studio—very small in fact for a class, although I hear other rooms are to be opened shortly, as fast as they fill up. A homely, ugly Italian woman was posing nude and among the shafts of easels I saw the serious faces of about a dozen Americans, men and women— but recognized none of them. I have been told the studio is run by a Madame Rossi—an old model of Whistler's.[35]

Henri continued to seek inspiration through frequent visits to the Louvre, which he referred to as "that great advantage of Paris," yet he discovered nothing new there and his favorites remained un-

changed: Manet, Velázquez, Hals and Titian. In October 1898 he was excited by another find. Visiting the studio of his friend Augustus Koopman, he viewed a number of his monotypes, oil paintings done on porcelain or glass that are then transferred onto paper. Henri noted the many interesting effects and shortly thereafter tried his hand at monotypes too. This resulted in a few fine examples, including a promenade along the Seine and a street scene at night, both of which were given the title *Paris Street Scene.* They belie the fact that they were his initial experiments with the medium. Despite such success, Henri halted his production of monotypes; of printmaking he could only state: "Am very sorry that the great mediums of etching and lithography are so far from reach in practice and expense."[36] As if to underscore his feeling for lithography, he sent Sloan a gift of several Daumier prints from *Charivari.*

Henri commenced painting intensely, beginning a series of portraits of a new redheaded model named Berthe Terrier. But when Linda became ill the work was interrupted for a trip to the country. The Henris spent a week in November in Brolles, taking daily walks and making small sketches in the forest. Returning to Paris he proceeded to paint a half-dozen landscapes of birches and paths through the woods from the Brolles drawings. Henri considered the paintings he was producing now "much stronger in light, color, drawing." As he wrote his parents: "I have gone far ahead of where I was before. I must send good things to the Salon If I do make a success there the work will sell and the terrible stress of affairs will be lifted."[37]

In a subsequent letter he did some soul-searching:

> My work is not saleable now . . . it is unusual and not like other work. I am confident that it won't be long before selling will commence. It must be by those landscapes and figure pieces that I must make my money and the name must rest on both these and the portrait work. As a professional portrait painter I see no immediate success, and while I want to paint portraits more than anything else I don't want to be tied hand and foot in portrait painting, as I would be should I work professionally. To succeed as a portrait painter, the artist must combine a certain distinction of work with concessions to the taste of his sitters, for he who pays must be pleased. The artist must also dine and make tea and otherwise waste time, for his clients not only want a good workman to interpret them but also a lion to exhibit.
>
> I want to paint better portraits than can be done that way. It's hard enough to do portraits even when there are no other tastes to please.[38]

During the next few months he produced several cityscapes, all in one-point perspective, of the nearby rue de Sèvres with an omnibus lumbering down the street and buildings looming large on both sides. When the first snow of winter arrived in February he painted a *pochade* of the same scene, then a twenty-six-by-thirty-two-inch canvas, a long view, brown in tonality, where the fresh snow on rooftops and shop awnings is in marked contrast with the melting snow in the muddy street below. He called the composition *La Neige* ("The Snow").

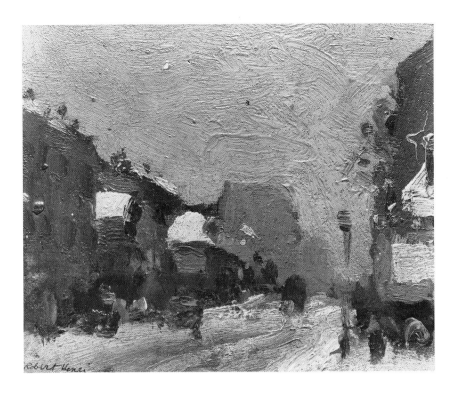

LEFT: *Snow, Paris* (pochade), 1899.
Oil on wood, 5″ × 6½″ (12.7 × 16.5 cm.).
Collection of the author.
Photograph by Walter Russell.

BELOW: *La Neige* (The Snow), 1899.
Oil on canvas, 25⅝″ × 32¼″
(65.0 × 81.9 cm.).
Louvre Museum (formerly Collection
of the Luxembourg Museum).
Photograph by Giraudon.

In the studio his strenuous efforts to prepare entries for the 1899 Champ-de-Mars Salon were interrupted by a visit from his in-laws, who remained during much of March, leaving just two days before the deadline. He submitted eight paintings of which two were completed in those final forty-eight hours: one of Linda titled *The Red Scarf* and a portrait of Alfred Collet, a three-year-old ward of Miss Cimino. When the canvases were delivered the pigment was still wet on several of them, so Henri paid a man ten francs "to look after the wet pictures."[39]

No work was accomplished during the eight agonizing days before the jury's decisions were announced. Miss Cimino had arrived with the rumor that several of his canvases had been accepted; now he was more anxious than ever. On April 2 the results were received: four of his paintings *had* been accepted, including *The Snow, The Red Scarf*, a portrait of his cleaning woman's son titled *A Little One*, and *Woman in Cloak*, depicting a seated model clothed in a loose black wrap.

He went to the vernissage, the day for retouching and varnishing paintings prior to the opening, and found his three portraits hung at eye level and *The Snow* slightly above. And there, on page ninety-six of the catalogue, appeared his name and a list of the four.

The triumph at the hands of the Salon jury was tempered by Linda's becoming ill, lying in bed for a week and eating virtually nothing. In May, Henri prescribed his usual remedy of a trip to the country, and the couple departed for Concarneau. There Linda's health was restored and she was able to enjoy the sights and quaint costumes of this fishing and canning center in Brittany. Robert was prevented from painting for a week by the lack of art supplies, but when work did begin he produced ten landscapes, including *Quay at Concarneau*, where women in white coifs and black dresses are silhouetted against the yellow ochre ground, and fishing nets blow from the masts of sailboats moored in the distance.

The Henris had planned to spend the summer there but when a spell of wet weather set in and both caught

Quay at Concarneau, 1899. Oil on canvas, 25¾" × 32" (65.4 × 81.2 cm.). Sheldon Memorial Art Gallery, University of Nebraska, Lincoln: Collection of Nebraska Art Association, Gift of Chapellier Galleries, Inc., New York. Photograph by Brenwasser.

colds they left on June 24, Robert's birthday, and returned to Paris. Under the door to their apartment was an official-looking letter, the nicest birthday present he could have received. "I still can hardly believe what I am about to tell you," he wrote his parents. "La Neige, one of the paintings I sent to the Salon, has been bought for the Luxembourg [It] will hang in the same room with Whistler's portrait of his mother."[40]

But then a terrible thought; according to the post-mark the letter had been gathering dust on the floor for nearly a month. Henri feared that his silence was being mistaken for indifference and that the government's offer to buy the painting would be withdrawn. He dashed off an explanatory response, which resulted in an appointment at the Luxembourg Gallery and arrangements for his canvas to be purchased for eight hundred francs (160 dollars). On August 3 he triumphantly delivered the painting to a building on the Champs-Élysées, the depository for works of art owned by the State. At the time La Neige was acquired Henri was one of only a few Americans to be represented in the Luxembourg; among the others, besides Whistler, were Sargent, Winslow Homer and Henri's distant cousin Mary Cassatt.

Before they left for Concarneau, articles about the Champ-de-Mars Salon appeared in Paris publications and some referred to Henri's paintings. As soon as La Neige was purchased the news spread to the United States, where one Philadelphia paper announced that Henri had been awarded the Legion of Honor! Henri shared the good news with his dealer, William Macbeth, "hoping that such information will be of advantage to you in the managing of those pictures you now have of mine."[41] And when he sent an illustration of the painting to Thomas Anshutz, his former teacher responded:

> It seems impossible that the original La Neige could be more beautiful than the reproduction. I am inclined to think the French got a fat one. There is good logic underlying your work. I discover some of it slowly. I am not apt to be on the next jury [at the Pennsylvania Academy], but the time has gone by when you need a well posted jury.[42]

Henri was still preoccupied with his success when Linda became ill once again, but this time with more serious consequences; in August she had a miscarriage, "all unexpected and with only such forewarnings as one remembers afterwards. She suffered terribly for a time but then it was over" She had been in poor health just previously, but this had been true for nearly a year. "There was a faint and a fall to which no importance was attached, she had formerly so often fainted," Henri confided to his parents. "It was however well advanced, about four months the doctor said . . . we will be long in forgetting—if in fact we ever do. It was a boy."[43]

As a result of the Salon success, the Carnegie Institute of Pittsburgh invited Henri to exhibit Woman in Cloak and the Art Institute of Chicago requested the portrait of A Little One, both shown in the recent Champ-de-Mars display. Frederick Pfeiffer, a Philadelphia art dealer, offered to purchase ten of his

canvases outright for five hundred dollars. And the counsellor of the Royal Court of Bavaria, impressed by his Salon paintings, sought eight pictures for exhibition the following March at the Schulte Gallery in Berlin.

Still the sadness of Linda's losing the baby hung like a pall over their apartment, so in September 1899 Robert once again planned a country sojourn; this time he leased a place at Alford in the southeastern outskirts of Paris, at the confluence of the Marne and the Seine. Edward Redfield and his wife had also just taken an apartment there, and the two men painted the environs, Redfield concentrating on river scenes looking toward Paris and Henri depicting the quai and the bridges leading across the river to Charenton. Sometimes his composition would be the result of a bird's-eye view, as in On the Marne, painted from a fourth-story window. Small boats are tied up alongside two houseboats, which dominate the undulating shoreline and the land beyond (see color plate).

Henri enjoyed the convenience of Alford, just half an hour by boat from the Louvre, yet on the edge of the country. And despite the idyllic setting, he did not abandon his concern for current events, noting in his diary that "up to the end of the trial in Rennes a week ago we took great interest in the Dreyfus affair."[44]

Returning to Paris, he embarked on a series of night scenes inspired by the Closerie des Lilas. Each composition involves a rearrangement of the same elements: groups of people dressed in black seated at café tables, earth yellow spotlighting of the ground and the wall or street beyond with a touch of white to highlight a woman's hat, a blouse or a menu. And, as in past pictures that were Manetesque in feeling, such paintings as Café Terrace, Sidewalk Café and A Café—Night contain the inevitable spot of red in a woman's skirt or a soldier's epaulets.

By mid-December Henri's thoughts returned to cityscapes and to another triumph comparable to that of La Neige. "It has looked like snow for about a week—keeping us constantly expectant—," Linda wrote her folks, "for Bob is very anxious to paint it when it comes—you see his last snow scene was such a success that he wants to try it again."[45] The weather continued to be dreary, threatening snow and raining instead. When it grew too dark to paint, Robert and Linda would read to each other, taking turns with Dickens' A Tale of Two Cities. Henri reminisced about his enjoyment when his mother had read that book to him as a boy and spoke of how much more meaningful the writing was now, with the streets and monuments of Paris all around him.

Besides a private art class inaugurated soon after the first of the year, Henri was asked to give criticisms to a newly formed composition class at the American Students' Club. For the first project he assigned the creation of a frontispiece for A Tale of Two Cities; for the second the subject was "Silence." One of the students, Lydia Longacre, who had been studying with Whistler and abandoned his class in favor of Henri's, explained her reaction:

> Mr. Henri was most interesting and instructive and helpful in the best way. He came at half past seven and stayed until ten, talking all that time. He was both just

and severe in his criticisms. He found good things in all of them He believes in individuality above all things. He says that the first law of composition is to tell the story, beyond that there are no set rules. There must be harmony of line, and all that sort of thing, but that must come from the sensitiveness of the painter What impressed me more than anything else he said was that we must make every composition and paint every picture and study as if it were to be a masterpiece; do the very best we can every time, and that in the superlative degree. It must not be a composition or study, but *the* composition or study. Only as we throw ourselves into it with such force will we really make true progress.[46]

During the week that his classes began, he had to complete works to submit to the Paris Exposition of 1900, where the exhibit would replace that year's Champ-de-Mars Salon. Henri entered four portraits and one of the night café scenes. "Oh I trust he will be accepted—," Linda wrote home, "for if any man's work is given space his should be—for with only one or two exceptions I know of no artist so great—."[47] But when the results of the jurying were revealed, all his works had been marked "Refusé." Henri, who had been considered a sure choice by his friends, sought to rationalize the rejection: "One of the unfortunate things was that during the judgment of the pictures it was always dark, either fog or rain—a very bad condition for dark-toned pictures to be seen in. I prayed for clear weather but it came too late."[48]

He was especially disappointed because he had banked on another success before going home to America. Now there would be no triumphal return. The next letter from home served to dissipate Henri's melancholy, for it contained five hundred dollars to finance a long-contemplated trip to study the old masters in Madrid.

With the exception of two figure studies and three small canvases of Notre-Dame, little painting was done during the rest of the winter, Henri's time being consumed by his classes and learning the rudiments of the Spanish language. On April 30, 1900, the Henris departed for Madrid, arriving on a festival day that provided a lively welcome—an array of bullfighters and a military parade that passed beneath the little balcony of their room overlooking the Plaza de las Cortes. Henri had been apprehensive about going to Madrid so soon after the conclusion of the Spanish–American War, but he experienced no hostility. He was treated cordially and even granted special favors

through the courtesy of the director of the Prado Museum.

He spent most of the next six weeks in the Prado, studying its sixty-three paintings by Velázquez. With permission to make copies of some of the master's major canvases, Henri eventually reproduced in oil *The Surrender of Breda, Portrait of Maria Anna of Austria, Pablo de Valladolid* the actor, *Menippus* the philosopher and *Sebastián Morra*, one of the court dwarfs. The copy of the latter work was begun by Linda.

Enamored as he was with Manet, it was only natural for Henri to turn now to Velázquez, for Manet had been similarly inspired and had copied a Velázquez in the Louvre.* Manet once wrote of a Velázquez portrait: "The background disappears; it is made up of air which surrounds the gentleman, all dressed in black and lively."[49] Manet then proceeded to blur the dividing line between floor and wall in many of his own works.

Henri had other models to follow: Eakins had been captivated by Velázquez in both the Prado and the Louvre, and when William Merritt Chase had visited Madrid in 1896 he had also copied several paintings by Velázquez in the Prado. Henri's interpretation is so skillful, so carefully proportioned on a canvas ninety-one inches high, that it is difficult to differentiate between his version and the original. While he worked on the painting, Madame Jean-Louis Forain, wife of the French artist, was making a copy beside him.

Henri purchased a book about Velázquez and bracketed the following lines:

[Velázquez] wished any scene that he looked at in nature to be so treated in art as to express the quality and the distribution of the attention it had received from him in real life. Only thus could he hope to record the personal impressions which were his chief interest in the world.[50]

This concept, still nearly revolutionary in 1900, became the cornerstone of Henri's philosophy.

Although he did little painting in Madrid besides the copies, Henri managed two bullfight scenes. While at the Prado he also saw a major exhibition of Goya's work and promptly sent a group of his aquatints to John Sloan. Once again Linda became ill; they headed back to Paris in June and finally sailed for home in August.

*The copy was of *The Little Cavaliers*, believed to be by Velázquez at the time but since attributed to Juan-Bautista Mazo.

THE NEW YORK SCENE

HOPING TO SETTLE somewhere near New York, Robert went househunting while Linda remained in Atlantic City with the family. Joined by Glackens, he visited New Rochelle and Glen Island but found nothing suitable. One location in Brooklyn had "a beautiful view of the river, harbor, boats, New York steaming and smoking . . . but only for millionaires." Staying with Glackens, and separated from Linda for the first time during their marriage, Henri wrote her: "I wish my little girl were with me now and I am anxious about her I love you, Linda."

Toward the end of August 1900, the move was made, as a New York newspaper later reported:

> Mr. Henri has taken a house on East Fifty-eighth Street [no. 512] overlooking the East River, and is making some interesting studies of the neighborhood, which seems to have been passed unnoticed by other artists. He expects to make a series of studies of New York street scenes.[1]

Two months before they could occupy the house, Henri received a telegram from Arthur B. Davies about a teaching position in Manhattan. He quickly returned there and borrowed Davies' Fifth Avenue studio, above the Macbeth Gallery, for an interview with a committee from the Veltin School, a finishing school for girls. Madame Louise Veltin, the founder and principal, and Isabelle Sprague-Smith, the vice-principal, were impressed by Henri's accomplishments as painter and teacher and, since there was great emphasis on French at their institution, by his many years in Paris. They agreed to hire him to teach on Tuesday mornings and afternoons for a hundred dollars a month.

The school limited its classes to a dozen students, and though it included grades one through twelve, art was available only to the older pupils. Not all came from wealthy families, but they had to have a proper background; Madame Veltin was constantly reminding her flock that they must be well-bred and well-groomed. Many of Henri's students were indeed of the elite in society, among them Elizabeth Averell and

Mary Harriman, cousin and sister of W. Averell Harriman. Henri must have been struck by the irony of his teaching the niece and daughter of E. H. Harriman, then chairman of the board of the Union Pacific, which railroad had exploited the Cozad family in Nebraska.

He was self-conscious about living on the wrong side of town. While the exclusive girls' school was located on Seventy-fourth Street, near Central Park on the Upper West Side, he lived only a block from the grime and pollution of the Burns Brothers' coal-loading piers along the East River and not far north of the slaughterhouses and the city's garbage dump.

The first paintings Henri produced in his new Fifty-eighth Street studio were sketched from the windows looking north and south. As he wrote to William Macbeth on September 10, 1900, the location was "not the most fashionable quarter I'll admit but with such a view of the river from both ends of the house that I shall never be in want for something magnificent and ever-changing to paint." In such canvases as

Untitled, n.d. Pen-and-ink, 5" × 6" (12.7 × 17.3 cm.). Photograph courtesy of A. M. Adler Fine Arts, Inc., New York.

Blackwell's Island, East River Snow and Ice; East River Embankment, Winter (see color plate); *Cumulus Clouds—East River;* and *The River—Evening,* he showed fog and snow, with tugboats puffing steam, two- and three-masted schooners being loaded at the docks and the river choked with ice. Other artists had of course depicted the East River before him—Chase as early as 1886—but their paintings of the sailing ships and the blueness of water and sky emphasized "the beautiful"—idyllic scenes with little of the pulsating life along the shoreline. In Henri's works the color and mood are gray, with commerce portrayed in the raw.

In his Paris cityscapes, the small *pochades* were often done on the spot, and larger compositions produced from them in the studio. Now, with a variety of views available from his windows, he could paint directly on the bigger canvases in the comfort of indoors.

Henri soon became reunited with old friends. In New York he saw Frank Vincent DuMond and Ernest Fuhr, the former Philadelphia newspaper artist now on the *New York Herald.* During a visit to Philadelphia he went to a party at Sloan's, an all-night affair attended by Redfield, Grafly, Calder, Schofield and Breckenridge. Henri was quoted in the *Press* as anxious to "keep up my relations with Philadelphia,"[2] meaning his professional ties, and accordingly he submitted three of his Paris paintings to the Pennsylvania Academy annual in January 1901. All were accepted and, of equal importance, "well placed, thanks to Redfield," who served as chairman of the jury. With the galleries still lit primarily by daylight, the only canvases guaranteed to be seen were those placed "on the line," at eye level. The fact that all three of Henri's—*The Green Cape* and *Young Woman in Old Fashioned Dress,* both portraits of Linda, and *The Café Terrace*—were well placed seemed to even the score, for in the Academy's previous annual his entries had been poorly hung. Schofield had written him about it in Paris and Henri had observed: "A bad place in an exhibition is killing to a picture no matter what its merits may be."[3] When the Society of American Artists opened its spring annual, Henri wrote to Sloan:

On the East River, 1900–2. Oil on canvas, 26″ × 32″ (66.04 × 81.28 cm.). Mead Art Museum, Amherst College (Mass.), Gift of Mr. and Mrs. Richard Rogin.

. . . you are on the line in corner, but light is quite good Reddy has excellent place on line, one of the first things to be seen on entering gallery. I have one on line, one above [*A Café—Night* and *The River Bank*]. The one above at great disadvantage and the other badly surrounded.[4]

Simultaneously another exhibition was being held a dozen blocks away at The Allan Gallery. The announcement read:

You are cordially invited to view a few pictures by
Mr. W. Glackens Mr. Robert Henri
Mr. E. Fuhr Mr. Van D. Perrine
Mr. Alfred H. Maurer Mr. John Sloan
 Mr. Willard Bertram Price

It was Henri who "pulled the group together," according to Sloan, and what made the exhibit unique was how the works were hung. "The gallery is a nice little one but with dark ends and corners . . . ," Henri noted. "Everybody is equally arranged half in light and half in dark . . . [on the main wall] the 'line' is hung down within about 15 inches of the floor so that both upper and lower lines are equal"[5]

The exhibit evoked a single review, by Charles FitzGerald, newly appointed art critic for the *New York Evening Sun*. He found the display "interesting because the pictures are mainly the work of painters seldom seen at the regular annual shows," and referred to Henri as "among the most interesting of the younger men and if he continues to progress at the present rate he ought soon to receive the recognition he deserves."[6] On April 27 the show closed without benefit of sales or large crowds, but the "little exhibit of our own," as Henri put it, was the precursor of things to come.

Three of Henri's four works in The Allan Gallery consisted of landscapes produced in France, and in an exhibit at the Veltin School the following month he had more European works: *A Little One*, shown in the 1899 Salon, *The Green Cape* and his copy of Velázquez' *Menippus*.

During this period he was producing paintings of

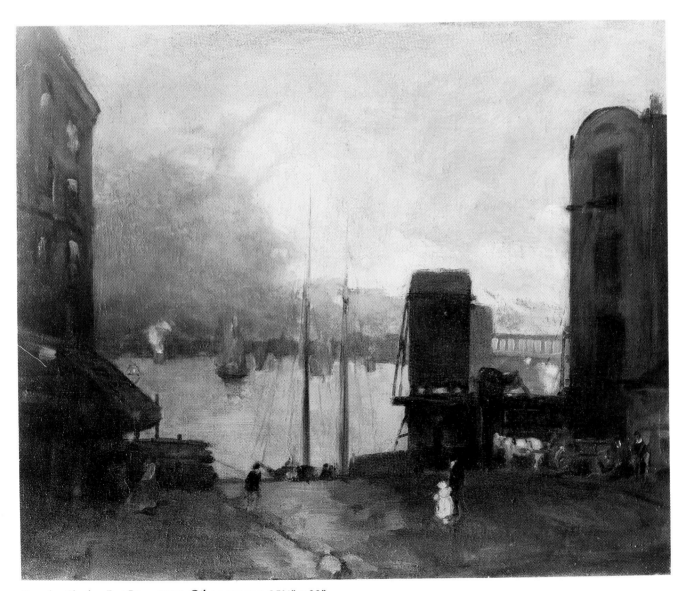

Cumulus Clouds—East River, 1901. Oil on canvas, 25¼" × 32" (64.1 × 81.3 cm.). Private collection.

the East River as well as Central Park, and there was also the inevitable procession of models: a redheaded youngster who posed holding a fife, a curly-haired tot whose portrait he titled *Little Girl of the East Side,* an old mender of tin objects and, of course, Linda.

His income from the Veltin School allowed him to consider renting a studio separate from his living quarters, so when Frank Vincent DuMond decided to move, Henri agreed to assume his lease at the Sherwood Building, at Fifty-seventh Street and Sixth Avenue, which housed the first artists' cooperative studios in New York. He was delighted with DuMond's roomy fourth-floor space and lost no time posing Linda for a full-length portrait, one of many life-size canvases he would do during the remainder of 1901, including those of Grace Freeman Eldridge, the actress, and Sadakichi Hartmann, the writer.

During the summer Linda again fell ill, and spent two months being treated by a doctor and recuperating with the family in Black Walnut, Pennsylvania. Robert dispelled loneliness by making memory sketches of Central Park in brush-and-ink and producing a series of nude drawings and paintings of a French model named Valerie.

Just prior to Linda's return he received word that his entries in the Pan-American Exposition in Buffalo had been awarded a silver medal, the first prize of his career. His three Exposition paintings were *The Café Terrace, The Green Cape* and *Young Woman in Old Fashioned Dress,* all painted two years before in Paris. Silver medals were also awarded to Davies, Morrice, Schofield, Mary Cassatt, Henry O. Tanner and Albert Pinkham Ryder. Redfield and Breckenridge won the bronze, and Chase, Eakins and Winslow Homer were among the gold-medal winners. At the Exposition a thousand oils, watercolors and pastels were hung in the traditional manner, two, three and four rows high.

In anticipation of a second year at the Veltin School, Henri was visited by Madame Veltin and Mrs. Sprague-Smith "just as we had got the studio cleared of the great pile of canvases . . . the first moment [it was] at all presentable."[7] A newly varnished portrait of Linda, its frame regilded, was prominently placed and made a considerable impression. Henri was told that the students were eager to commence work with him; his classes were already filled, and among his pupils were Katherine Rhoades, Constance Knowles, Marian Becket, Helen Ballard, Josephine Paddock and Louise Havemeyer.

Once classes had begun, Henri was approached by some of the students for private instruction, to which he agreed only if they would not interfere with his own use of his studio: "Mrs. Bois . . . asked if it would be possible for her to come and study with me . . . and she never expected a criticism or a word from me except when I was inclined to give it."[8] Louise Havemeyer also paid Henri a visit, showed him her pictures and asked for private lessons one afternoon a week; and when Mary Harriman left for a trip to Mexico, Henri arranged to criticize her sketches by mail.

The convenient location of his new studio encouraged a procession of fellow artists, with Glackens, Fuhr, DuMond and Davies becoming more than occasional visitors. Glackens began posing on October 30, 1901, for a full-length portrait by Henri, an arrangement made the previous evening when "Glack" had arrived with Maurice Prendergast. That had been Henri's initial meeting with the Boston artist, but he said that he had "known much of him through his work, Morrice and others."[9] Prendergast, in town on a visit, had begun painting scenes of the East River and Central Park, and was exhibiting at Macbeth's. Henri admired his oils and watercolors, and the Bostonian was similarly appreciative of Henri's work. Within six months Henri would declare: "Prendergast is one of us—a very special personal and original painter—quite unlike anyone else."[10]

Sharing an appreciation of Velázquez and Goya, Henri and Davies began dropping in on each other a couple of times a week and their friendship developed rapidly. When Davies found a particularly good model, such as Sidna Nouvelle, he would direct her to Henri for his consideration. Discovering that their tastes in music were similar, they attended a Boston Symphony concert at Carnegie Hall and a program of Negro folk songs with an address by Booker T. Washington. In November, Robert and Linda braved a snowstorm to visit Pratt Institute in Brooklyn where Davies was having a one-man show. And it was through Davies that an arrangement was made for a Henri exhibit there, too, at the end of the year. Henri then reciprocated by scheduling a Davies exhibit at the Veltin School.

Meanwhile, Henri was actively exhibiting elsewhere. During the last four months of 1901 he submitted paintings to the Carnegie Institute, the Chicago Art Institute, the Philadelphia Art Club, the Pennsylvania Academy and the National Academy of Design annuals, as well as the City Club of New York and the Charleston, South Carolina, Exposition. Only at the National Academy were his entries rejected outright. He attended the Academy's private viewing and acclaimed works by Eakins, Chase and Redfield as "saviors of the show The prizes," he said, "have gone to commonplace, to ordinary and bad things." As for the rest, he labeled it "superior mediocrity."[11]

When a representative of the Cincinnati Museum was impressed by Henri's work in the Pennsylvania Academy annual, arrangements were made for five of his canvases to be exhibited there during the summer, after which they were sent on to the St. Louis Museum. And when William Macbeth visited Henri's studio in March 1902, the result was an invitation for a one-man show, Henri's second at Macbeth's, to open in a month.

Many of his canvases were either retouched or repainted during the intervening weeks. Henri delivered seventeen works and after helping with the hanging, returned the next morning to rearrange them. The Macbeth Gallery display window at 237 Fifth Avenue contained *The Salt Wind,* a view of rolling cumulus clouds above a yellowish cliff and beach. The exhibit included several of his East River scenes, a couple of scenes of the dunes and hills on Long Island, a few of Normandy, Brittany and Fontainebleau and

On the Marne, 1899. Oil on canvas, 26" × 32" (66.0 × 81.2 cm.). Collection of Spanierman Gallery.

TOP: *Figures on Boardwalk*, 1892. Oil on canvas, 12″ × 18″ (30.48 × 45.72 cm.). Private collection. BOTTOM: *Market Place, Paris*, 1897. Oil on canvas, 10½″ × 13¾″ (27.10 × 34.93 cm.). Photograph courtesy of Chapellier Galleries, Inc.

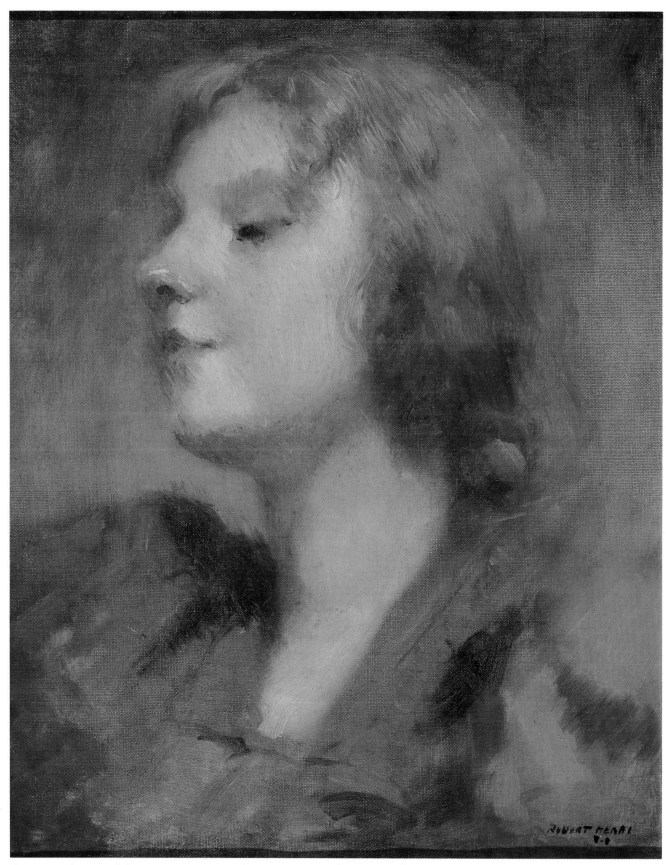

Alice Mumford, 1893. Oil on canvas, 16″ × 14″ (40.64 × 35.56 cm.). Private collection.

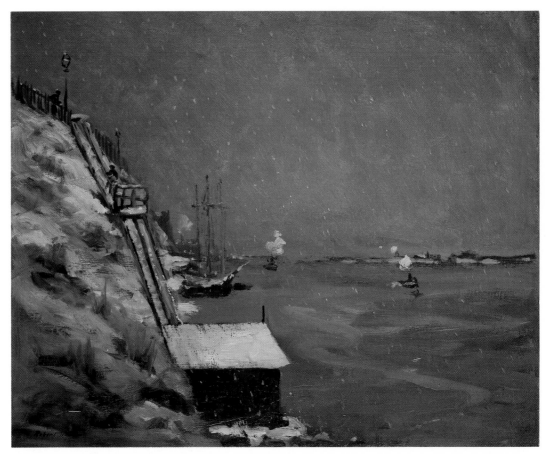

TOP: *East River Embankment, Winter* (New York), 1900. Oil on canvas, 25¾" × 31⅞" (65.4 × 80.9 cm.). Hirshhorn Museum and Sculpture Garden, Smithsonian Institution, Washington, D.C. Photograph by Lee Stalsworth. BOTTOM: *The Rain Storm—Wyoming Valley,* 1902. Oil on canvas, 26" × 32" (66.04 × 81.28 cm.). Collection of Bernice and Joseph Tanenbaum. Photograph courtesy of ACA Galleries.

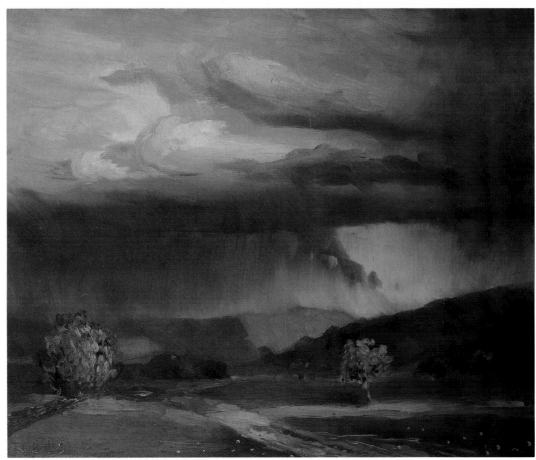

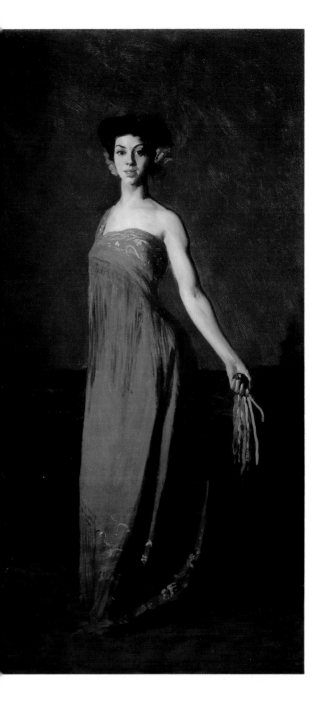

LEFT: *Spanish Dancer—Sevilliana*
(Marianna Bustamenta), 1904.
Oil on canvas, 85" × 45" (215.90 × 114.30 cm.).
Collection of Abby and Alan D. Levy.

RIGHT: *Salome (No. 2)*, 1909.
Oil on canvas, 77" × 37" (195.58 × 93.98 cm.).
John and Mable Ringling Museum of Art,
Sarasota, Florida.

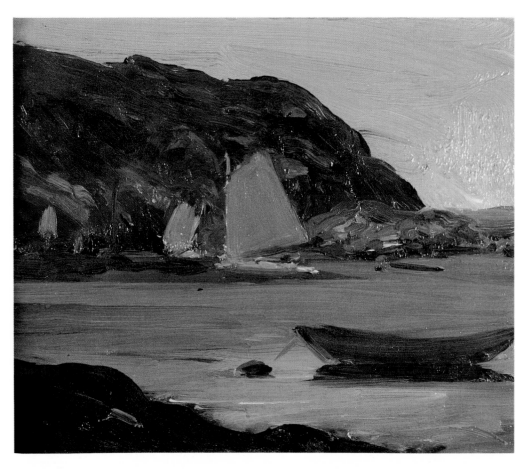

TOP: *Monhegan*, 1903. Oil on wood panel, 8″ × 10″ (20.32 × 25.40 cm.). Photograph courtesy of Chapellier Galleries, Inc. BOTTOM: *Soir au Luxembourg* (Evening in the Luxembourg), 1896. Oil on canvas, 25½″ × 32″ (64.7 × 81.2 cm.). Hope Davis Fine Art, New York.

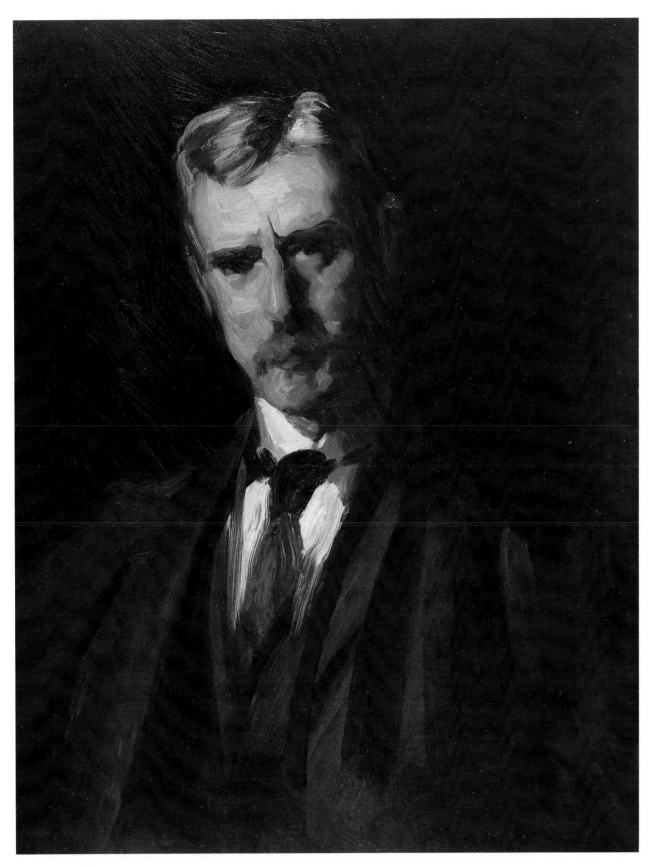

Portrait of Thomas Anshutz, 1906. Oil on canvas, 28½″ × 21½″ (72.39 × 54.61 cm.). Collection of William F. Richardson. Photograph courtesy of Hirschl & Adler Galleries.

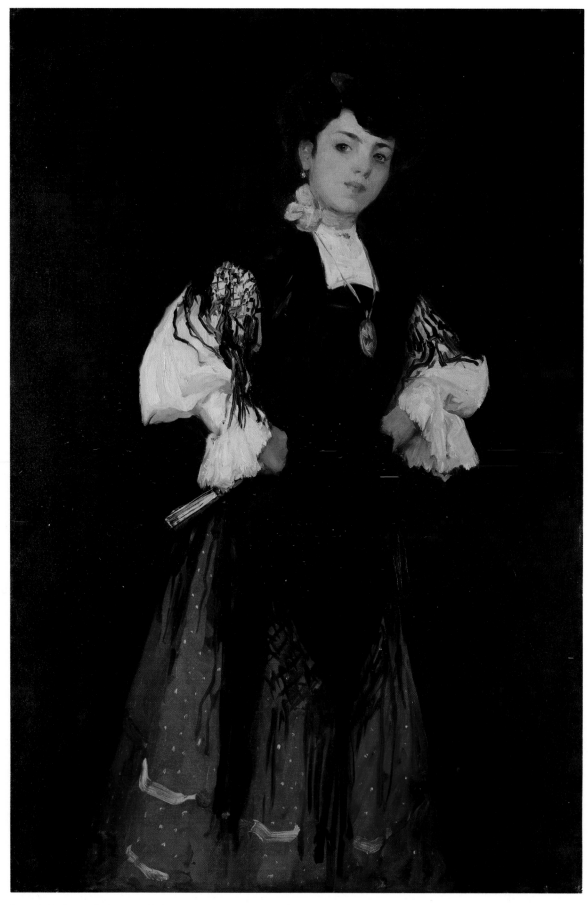

Spanish Girl of Madrid, 1908. Oil on canvas, 57½″ × 38¼″ (146.05 × 97.16 cm.). Collection of Mr. and Mrs. Howard L. Weingrow.

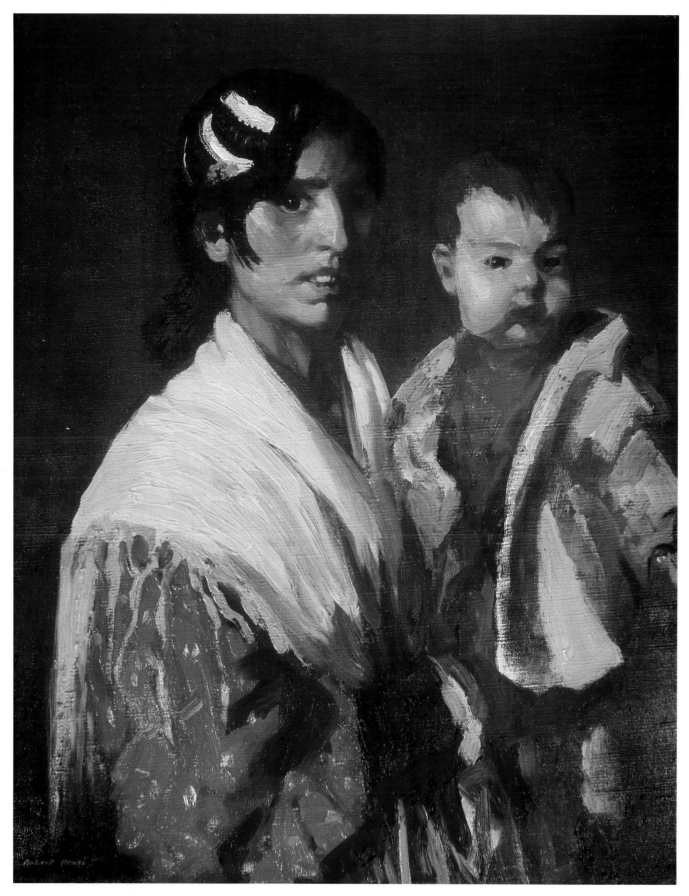

Maria y Consuelo (Maria and Consuelo) (Mother and Child), 1907. Oil on canvas, 32″ × 26″ (81.2 × 66.0 cm.).
The Regis Collection (Minneapolis).

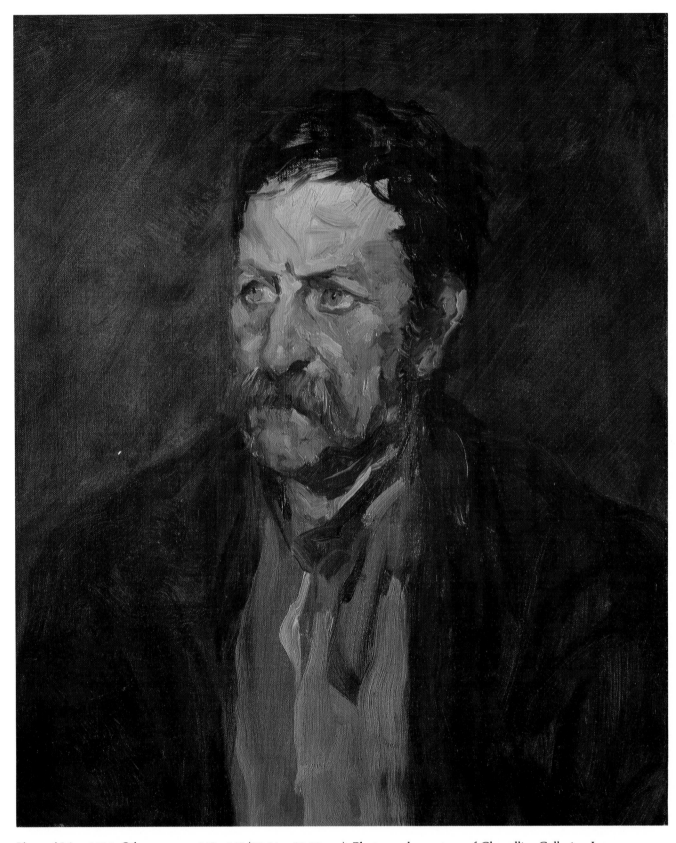

Blue-eyed Man, 1910. Oil on canvas, 24″ × 20″ (60.96 × 50.80 cm.). Photograph courtesy of Chapellier Galleries, Inc.

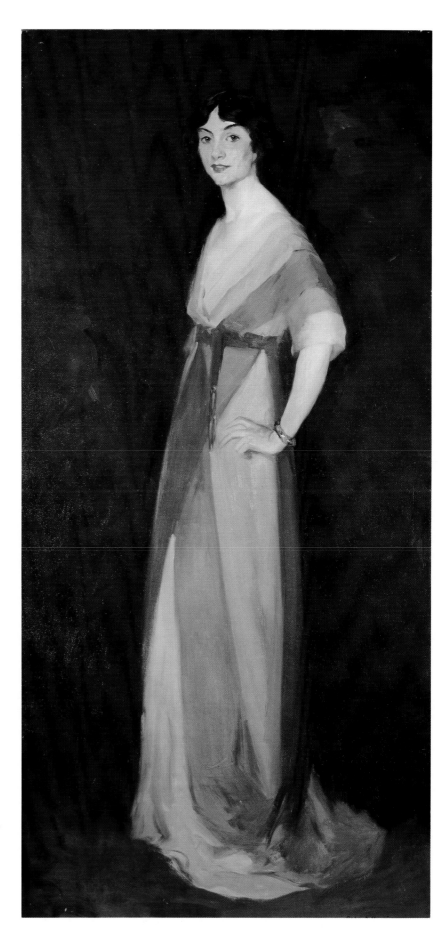

Girl in Rose and Grey
(portrait of Carmel White), 1911.
Oil on canvas, 77" × 37"
(195.58 × 93.98 cm.).
Photograph courtesy of
Chapellier Galleries, Inc.

Segovia Girl, 1912. Oil on canvas, 30" × 25" (76.20 × 63.50 cm.). Courtesy of Sotheby Parke Bernet Inc., New York.

Miguel of Tesuque, 1917. Oil on canvas, 24″ × 20″ (60.96 × 50.80 cm.). The Anschutz Collection, Denver. Photograph by James O. Milmoe.

Fay Bainter as the "Image" in the "Willow Tree," 1918. Oil on canvas, 66⅛" × 45" (170.82 × 114.30 cm.). Private collection. Photograph courtesy of Hirschl & Adler Galleries.

An Irish Lad, 1927. Oil on canvas, 24" × 19⅞" (60.96 × 50.44 cm.). Private collection. Photograph courtesy of Joan Michelman Ltd.

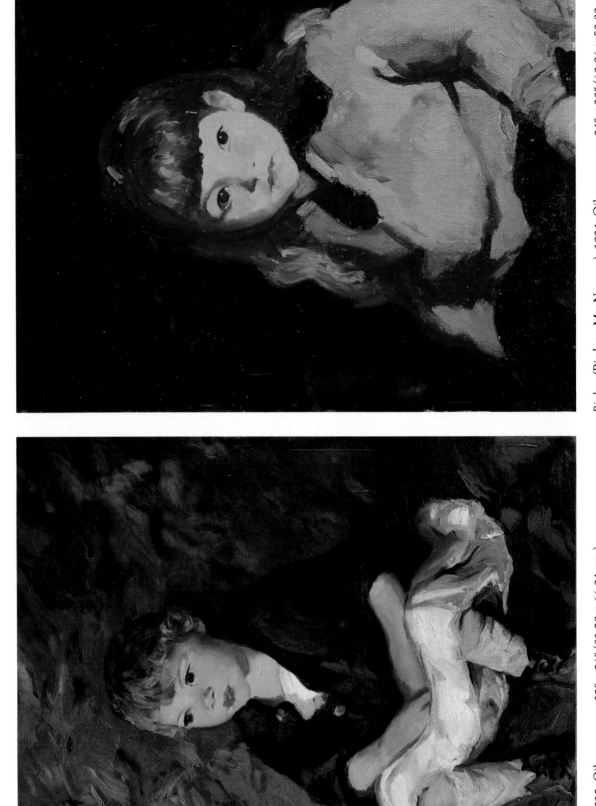

Birdeen (Birdeen MacNamara), 1924. Oil on canvas, 24" × 20" (60.96 × 50.80 cm.). Collection of Janet J. Le Clair.

Little Country Girl, 1915. Oil on canvas, 32" × 26" (81.28 × 66.04 cm.). Courtesy of Sotheby Parke Bernet Inc., New York.

one of Spain. The European landscapes were not old works but had been created from *pochades* or from memory during the preceding weeks. Three portraits were arranged on the wall opposite the entrance.

A profusion of reviews appeared. Charles De Kay wrote in the *New York Times:* "In his brushwork, so in his coloring [of the portraits], Mr. Robert Henri utters an individual note" and his "landscapes are often remarkable for the vigorous character of the cloud painting."[12] Samuel Swift, writing in the *New York Mail and Express,* called him "a skillful handler of the brush";[13] the *Brooklyn Eagle* said: "The impression of the whole show is vital and strong."[14]

Negative comments came from only two quarters: though "Henri gives a good account of himself," *Tribune* critic Royal Cortissoz opined, "he is more interesting in what he promises than in what he has actually achieved thus far,"[15] and in the *Commercial Advertiser,* Arthur Hoeber wrote: "It cannot be said the result is invariably satisfactory, for not infrequently Mr. Henri leaves off where the real difficulties of picture-making begin."[16] Such criticism was addressed by Charles FitzGerald:

> Among our many landscape painters Mr. Henri stands as one of the few who has a definite attitude toward nature, the majority being engaged in the translating business, or rather in the adaptation of foreign ideas to their own purposes It is a curious thing that a certain mechanical polish is commonly associated with the idea of finish, and from a few remarks dropped by casual visitors to Mr. Henri's exhibition, it is evident that his landscapes are regarded by many as sketches, or thoughts half-expressed. What does not seem to be understood, is that the eye that saw "The Hill-Top" and mind that grasped and realized so vividly the idea of "A Sudden Shower" . . . are worth all the hands that ever niggled over a surface for the sake of explaining and polishing what from the first conception was meaningless and worthless[17]

Despite the reviews, only a single sale resulted from the twelve-day exhibition: *Normandy Farm House* was purchased by an art dealer from Washington. When Henri received Macbeth's check for 250 dollars he calculated that frames alone had cost him $27.50 more than that. "Oh the irony of things," he noted: "It's been a success however for all the excellent publicity and the splendid appreciation of almost all the critics." Yet he could not help being upset by the knowledge that Americans were still paying exorbitant prices for so much bad foreign art, "miserable puny little pictures, imitations of all that has been done before and of much not worth doing over again, being sold in New York every day."[18]

During the weeks before Henri's one-man show, his wife was unavailable to provide moral or physical support. She became ill again and was confined to bed for the rest of the month. When her face and body became swollen and inflamed and the malady was diagnosed as erysipelas, her mother took her back to Philadelphia, where the illness developed into pneumonia.

In his loneliness Henri often dined with Luks and Davies at their apartments or with Glackens, Fuhr, FitzGerald and Byron Stephenson, art critic for *Town*

Topics, at Mouquin's restaurant. He also visited his parents at Far Rockaway, where they were now living, having disposed of the Atlantic City property, and twice went to see his wife recuperating in Philadelphia.

Linda wrote every day, but her letters lacked support for her husband, his work or his solitary existence. She detailed her visits to the dentist, the filling of cavities and the capping of teeth or, as she grew stronger, her shopping expeditions with her mother:

> I changed my corsets for a pair better fitted to my figure She [her mother] brought me a walking skirt—it is splendid—so you needn't stick up your nose—and say I can't wear it out with you—for that is just what I am going to do sir—it will make walking so easy— so that now I can walk miles and miles with you this Summer and we can explore together all the environs of New York—my long skirts was [*sic*] always what made my shoulders ache—that was bad enough then my neck and back would get tired—and I shift from arm to arm—and all the inconvenience— made me feel tired and cross—but now with this skirt that is all past and I can walk free as air Here is another interesting letter filled with dressmaking and dentistry again—but I can't help it[19]

When Henri admonished her for the tenor of her correspondence, she replied, "I am sorry you think I complain so much" and "Bobbie you scold me in every letter."[20] Sometimes she introduced another sore subject:

> . . . do you remember those walks we had in the Forest [of Fontainebleau] ah me I wish we were over there again—if we only had money—money is almost everything—so much more happiness is possible with money than without.[21]

She also reported that she had been fitted for glasses because of what was diagnosed as acute astigmatism and, most sadly of all, regarding her loveliest asset, she wrote, "oh, my hair—Bob it makes me feel like crying—when I see how thin it is getting."[22] After celebrating her twenty-seventh birthday, she had to be fitted for a wig.

But there were letters that were tender and loving:

> . . . some most beautiful flowers—among them four great passionate red carnations—a red of a Titian or a Tintoretto—deep—almost black—but they will not last for me to bring them to you—so I will have to bring to you my lips instead—very eager lips they are—both to give and to receive—and more responsive than the flowers. . . . I am longing so much for us to be together again and loving each other—I want to kiss you and feel your arms around me . . . I want to paint with you—and walk and read with you—but above all I want *you.*"[23]

During the time of the one-man show at Macbeth's, the Society of American Artists' annual was being held, and although Henri was to be represented by two paintings, one of them was returned, rejected by the hanging committee after having been accepted by the jury. As was often the case, a jury chose more

works than the galleries could accommodate so that the committee that installed the show was, in effect, a second jury.

The previous year he had also received shoddy treatment from the Society; two of his four entries were accepted and hung but poorly placed above the line. Now, on Varnishing Day, he viewed the Society show at the American Fine Arts Society Building on West Fifty-seventh Street and discovered his full-length figure in one of the small side rooms. The seventy-seven-inch-high canvas could hardly be viewed in the confined quarters, an observation of several reviewers, including FitzGerald:

> Mr. Robert Henri's "Figure of a Girl." [His title was *Girl in White Waist*]. The Society did well to accept this; if only it had had the courage of its convictions we might say it did very well. But it was not to be; for what the jury did in its name was undone by the hanging committee, and a contribution of real worth banished to the East Gallery. This was a piece of stupidity that is quite inexcusable.[24]

Henri's painting of a young Swedish girl holding her black skirt tight against her body and wearing a dark hat with a touch of green beneath the brim, was also applauded by *New York Times* critic De Kay, who said it "deprives the little east room of much of its mournfulness It is so odd, so graceful, so simple in coloring, so powerfully marked out upon its background." In a second article FitzGerald remarked that "the exhibition is better than last year's . . . what are the names that remain in the memory for one reason or another after it has been visited? Whistler, Ryder, Blakelock, Henri, Homer, Sargent, to name half a dozen."

Henri was the youngest of those cited, a full generation behind Whistler and Homer. For him the sides were already drawn in the age-old struggle:

> I really do believe that the big fight is on and I look for a great change in the attitude toward the kind of art I have been doing in the coming year. There are a number of us here now and all working on independent and personal lines—our own individual lines. Glackens, Davies, George Luks, Redfield, and a few others, each different from the others.[25]

It was this, the uniqueness of the individual, that set him and his friends apart from the Academy. In 1902 Henri's words were sounding an alarm, representing the first call to arms in the fight for artistic freedom. It was he who planted the seed for a revolution in American art.

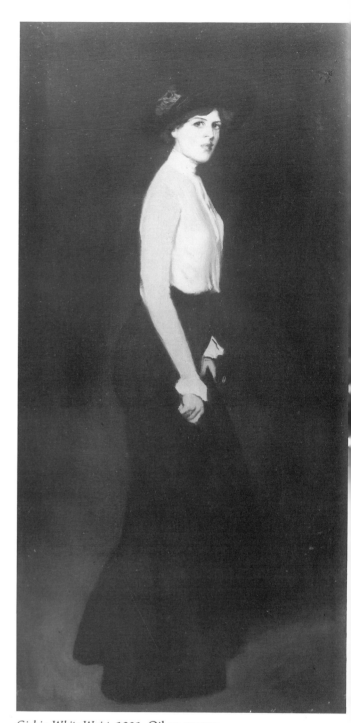

Girl in White Waist, 1901. Oil on canvas, 77¼″ × 38″ (196.2 × 96.5 cm.). Photograph courtesy of Janet J. Le Clair.

THE ARTIST–TEACHER FASHIONS A FOLLOWING

THE DAY AFTER THE OPENING of Henri's show at Macbeth's on April 1, 1902, he paid a visit to Arthur B. Davies. The next afternoon he met with Glackens and Luks and a couple of days later went to see Glackens again to "talk of [an] exhibit of four of us."[1] It was exactly one year earlier that Henri had organized the show at The Allan Gallery. But an exhibition of "The Four" failed to materialize within the next month, by which time Luks had left on a trip to Europe, so the plan was temporarily shelved.

Just before Luks departed, Henri painted his portrait in a single afternoon. His impish face emerges from a dark impasto background, hovering over a yellow necktie. Luks, the storyteller, entertained during the sitting and as usual there was laughter. He shared with Henri his outlandish scheme to produce a meticulous academic-style painting, sign his name and submit it to the Society of American Artists; as a result, all the jurors with weak hearts would drop dead. It was well known that he was yet to have one of his own compositions accepted in a Society exhibit.

The Saturday evening before Luks's departure, he and his wife were given a bon-voyage party at Mouquin's by Henri, Glackens and Charles FitzGerald. Ever since Linda's absence from New York, Mouquin's had become her husband's favorite restaurant; the friends with whom he dined there usually included Glackens and FitzGerald, Jimmy Preston (when he came over from Philadelphia) and Prendergast (when he was down from Boston). Another *Evening Sun* critic, Frederick James Gregg, often enlivened art discussions that sometimes continued into the night. "It was at Mouquin's that the crowd really became intimate," Everett Shinn observed, although, being a teetotaler, he was not one of the regulars there.[2]

Around this time Linda arranged to spend the summer at her parents' home and Robert agreed to join her in June, after completing his classes at the Veltin School, as well as portraits of Leora Dryer posed in a riding habit, Mrs. Joseph Laub with her pet parrot, and the writer Carlton Noyes.

On June 10 Henri closed up shop and departed for the Wyoming Valley of northeastern Pennsylvania and the Craiges' summer mansion at Black Walnut. Within a week he was producing a flood of paintings of the rolling hills and lush valleys dominated by clear blue skies or threatening thunderheads—his first rural landscapes in two years (see color plate). Most were *pochades*, convenient for carrying on hikes. Fields that appeared yellow-green one minute turned gray the next as shadows from clouds raced across the terrain, as if challenging him to capture the moment. When he hit his stride he was producing several paintings a day.

On the Fourth of July he and Linda attended a community picnic in nearby Meshoppen. A quick sketch was transformed three months later into *Picnic at Meshoppen, Pennsylvania*, a composition of dozens of well-dressed men and women lolling away the sunlit afternoon. The contrast of white dresses and dark blue jackets dot the sunny ground glowing green in the distance—an unusual, if not unique, subject for Henri.

In a month he left by train for the city; Linda remained behind. As if to signal his return to the urban scene he drew a coal-processing plant in his sketchbook during an hour layover in Wilkes-Barre. The next day in New York he painted *The Coal Breaker*, in which industrial forms loom large over a group of figures whose reflections are seen in a curving, rain-drenched road. Later that week Henri visited his parents on Long Island and, in contrast, produced *Beach at Far Rockaway*, a brilliantly colored picture dominated by a bright, cloudless sky, an intense yellow beach pavilion and people placed in the sun and shade before a strip of blue sea.

Soon after his return to Manhattan he met Douglas John Connah, the director of the New York School of Art, who asked him to take over a class in the fall previously taught by Frank DuMond. Henri accepted. The weekly criticisms would not conflict with his teaching and, besides, the New York School of Art was located just across the street from his studio.

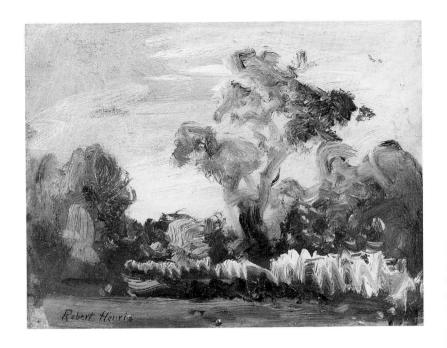

RIGHT:
Landscape at Black Walnut, Pennsylvania, 1902.
Oil on panel, 5¾″ × 8″ (14.6 × 20.3 cm.).
Photograph by Geoffrey Clements.

BELOW:
Picnic at Meshoppen, Pennsylvania,
July 4, 1902, 1902.
Oil on canvas, 26″ × 32″
(66.0 × 81.2 cm.).
The Westmoreland County Museum
of Art, Greensburg, Pa.,
the William A. Coulter Fund.

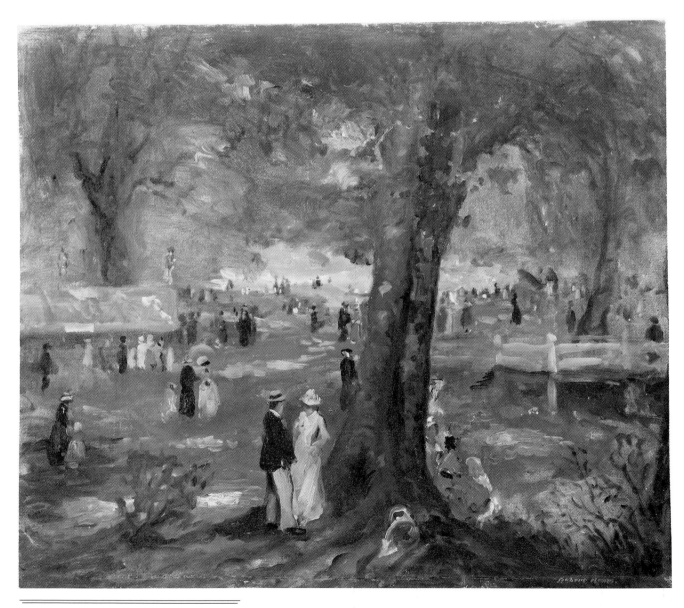

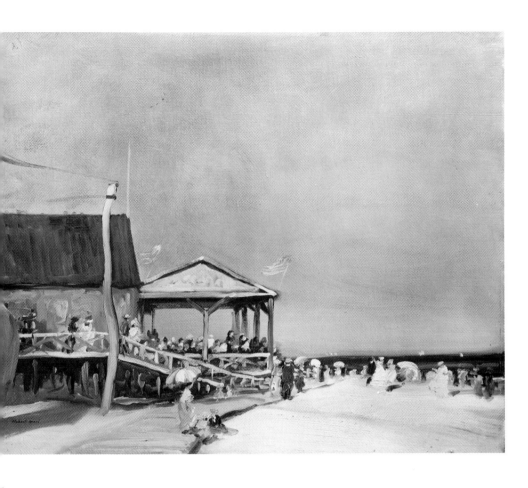

Beach at Far Rockaway, 1902.
Oil on canvas, 26″ × 32″
(66.0 × 81.2 cm.).
Photograph by William
McKillop; courtesy of
Janet J. Le Clair.

Later that summer there was another visit from Mr. Connah, who suggested an additional class. Henri turned this one down, reluctant to cut further into the time available for painting. Even when Louise Havemeyer and her mother requested private lessons he would make no commitment. But when a contract from the Veltin School was not forthcoming by late October, he contacted Mrs. Sprague-Smith only to discover that she had "made other arrangements." A few days later he learned just what these other arrangements were when he heard that John W. Alexander had become his successor at the school.

Henri immediately informed Connah of his availability, and was engaged to teach a class the very next morning. Ironically, a week later Henri was approached with a proposition from the Art Students League to instruct a morning class, but felt he could not accept "on account of the New York Art School being in competition."[3]

Henri's sudden popularity was brought about by several factors. William Macbeth had aided the cause by writing about his teaching prowess in the foreword of the catalog for his one-man show, stating that "those who come under [Henri's] influence will lose no individuality or be in danger of passing out as mere echoes of their master." Everett Shinn, who had tried his hand at teaching drawing at the New York School of Art during 1901–2, mentioned Henri as a possible replacement. And William Merritt Chase, founder of the school and its chief instructor, was known to think highly of his art. At least partial credit for Henri's

being hired also belongs to May Ethel Klinck, the school's assistant director. The future wife of artist Jerome Myers, she claimed responsibility for Henri's being added to the faculty, and quickly enrolled as one of his students.

Soon after he commenced teaching at the school, a novel was published purporting to be about his courtship of Linda. The romantic teaser was written by Alice Woods, a New York School of Art student and friend of Ethel Klinck's. She illustrated her book with her own Gibson Girl-type drawings. Publicity for the volume heralded it as "true-to-life" and stated that it "includes Henri, Glackens, Shinn, Sloan, Maxfield Parrish and others . . . the younger generation of artists are portrayed in it with a fidelity that is not always flattering."[4] Henri pasted the clipping in his scrapbook and beneath it wrote: "!!!!! well! well!"

The title of the book, *Edges,* comes from a passage describing what the lonely artist saw when he happened upon a red-haired, green-eyed beauty asleep on a beach: "A girl's figure topped by a mass of hair very bright at the edges and spread flat on the sand like an open fan." Although Henri is never mentioned by name, the hero, like him, had studied in Paris, admired Manet and Velázquez, had a painting in the Society exhibition and read Whitman, Emerson and George Moore.

The culmination of the book has the couple in the Forest of Fontainebleau with the artist saying: "Dear girl, you know very well that you hold the very life and hope of me in your hands," at which point "for the

second time that day she held her two hands out to him, only this time she raised her face, and the man took her into his arms and kissed her."[5]

The Henri mystique thrived on such reading, then considered risqué, as it had several years before when a newspaper article appeared about him and his adoring followers at the Philadelphia Women's School of Design:

> "Strive for an indefinite something" was the advice of Artist Robert Henri . . . impressionable young ladies cast admiring glances upon the manly form of the young artist who is fresh from the Art atmosphere of Paris, and who has not yet been able to rid his habiliments of the perfume of the Quarter Latin.
>
> "Twenty Lovesick Maidens We" was the air which came involuntarily to the ears of the observer as he saw about a score of the "sweet young things" watch him [Henri] ascend the stairs[6]

Henri made quite an impression, too, when he began teaching at the New York School of Art, but his impact on the all-male life class was considerably different, as Guy Pène du Bois, one of those present, reported:

> I shall always picture the entrance as a rock dashed, ripping and tearing, through bolts of patiently prepared lace. Tall, six feet at least, dressed carelessly, the head slightly Mongolian, the hands long and slim Life certainly did that day stride into a life class.[7]

Walter Tittle, another member of that class, noted in his diary:

> Robert Henri, student in Paris at Julian's, Bouguereau for years, criticized this morning. He is simply burning with art enthusiasm, and is the most original man I've yet had as instructor. He talks in a forceful, animated manner, and can be heard all over the room. My drawing possessed a quality pleasing to him, but was a little "tight," etc. I had expected him to "tear me up," he is so severe in criticisms. I showed him my last nude . . . and told him that I had never taken lessons until 2 months ago. He said, "You're all right there. A fellow who can draw like that in two months is all right Now, for God's sake, go on as you have started!" Nearly took all the wind out of my sails.[8]

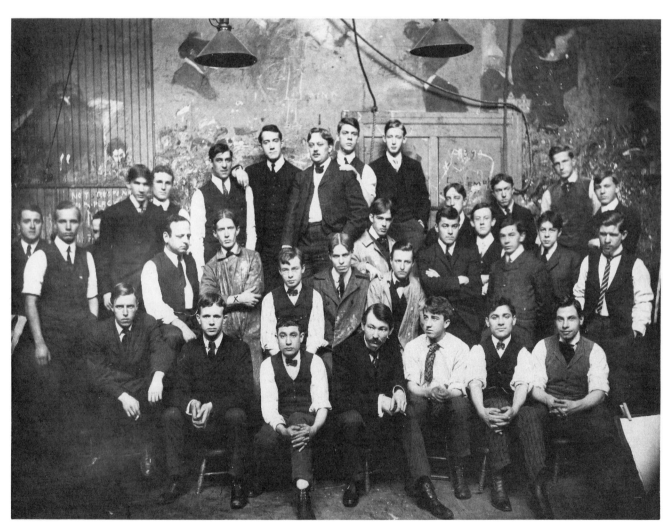

Henri's men's afternoon life class, New York School of Art, 1903–4. Photograph courtesy of Mrs. John M. Van de Water. Henri is seated at center of front row; at his left (camera's right) is Guy Pène du Bois; behind Henri, slightly to his right, is Edward Hopper. At Hopper's left is C. K. Chatterton; two persons to Hopper's right is Arthur Cederquist. Standing second from left side of picture is Rockwell Kent; seated at left, bottom row, is Glenn O. Coleman.

C. K. Chatterton, beginning his third year at the school, recalled:

> Almost from the first moment, Henri became the dominant influence in the School. With a few exceptions, he was to all of his students the unquestioned Master. His teaching seemed revolutionary at the time We hung on his every word.[9]

And Edward Hopper, another returning student who enrolled in his class, stated: "Henri was the most influential teacher I had. Men didn't get much from Chase; there were mostly women in the class I was in the Life and Portraiture classes of Henri. He was a magnetic teacher."[10]

Teaching a roomful of young men was a fresh experience for Henri, one that allowed him to prod the group into action in a new way. During his second week a student observed:

> Robert Henri criticized in Life [Class]. He gave a long talk on art to me, personally, raising his voice so that the class could hear . . . 'When you see a friend coming down the street on a misty day you know him a block away even though you can't see his face. Draw in your pictures the thing that makes you recognize him, and you have the man.' He talked to me for about half an hour, getting so excited that he sweated profusely, and talked in a rapid, high pitched voice His criticisms are marvels of wisdom . . . "An artist must use his brains. Maybe you think it is not hard work to criticize a class. Some of you ought to be sweating over *your* work as I am now."[11]

It is doubtful whether Henri would ever have uttered the word "sweat" in the polite and proper confines of the Veltin School.

The New York School of Art was beginning its seventh season when Henri joined the staff. Still referred to by many as the Chase School, after its founder and guiding spirit, it had been established in 1896 in a building on West Twenty-third Street that had formerly housed the Art Students League. After two years, the school's director, Douglas John Connah, acquired ownership, changing its name and eventually its location.

The school was modeled after the Académie Julian, allowing admission directly into the life class without requiring attendance first in a class for drawing from the antique. Like its French counterpart, the school held *concours* several times a year and even awarded a scholarship to Julian's, the winner being selected by a jury of teachers at the Paris institution.

If the New York School served as Manhattan's Académie Julian, then William Merritt Chase was its Bouguereau, similar in physique and dress, from an upswept mustache, Vandyke beard, pince-nez, winged collar and the fresh gardenia in his lapel, down to his immaculate white spats. The portly, elegant Chase was a contrast to the lean and often unkempt Henri.

They were opposites in their teaching as well. According to Chase, "delicate detail" was the essence of art while Henri insisted: "Never mind bothering about the detail The camera reproduces the best likeness, but it is only the artist who can produce the temperament of the model." And while Chase stressed technique, believing that ideas come in time, Henri maintained: "There can be no delight in considering a technique that is without a motive."[12] Ironically, they were both inspired by Manet, Velázquez and Hals. But Henri emphasized their spontaneous recording of everyday life, whereas Chase produced Manet-like still-lifes of dead fish during his regular painting demonstrations.

When Henri joined the art-school faculty in 1902 he was thirty-seven, brimming with enthusiasm and the epitome of a new era, while Chase, with graying hair at fifty-three, could be said to represent the old. Chase looked and acted the part of a kindly grandfather, one to be revered and respected; Henri became a pal, a prodding older brother. "Henri was casual and informal," a student of both men recalled, while "Chase . . . was a showman . . . Henri didn't tell you how to do it. He was an influence, a mental influence."[13]

By coincidence, Henri and Chase had reversed the nature of their own painting during the preceding decade. Chase had been schooled at the Munich Academy, where the dark palette prevailed, but by the mid-1890s his colors became lighter and brighter under the influence of Impressionism and painting out-of-doors. Henri, on the other hand, was initially enamored with Impressionism during his student days in Paris but, after discovering Manet and Frans Hals in 1895, his palette turned dark.

For Henri the change was an abrupt one. In 1891, after having viewed Monet's canvases of haystacks at the Durand-Ruel Galleries in Paris, he adopted "the peculiar quality of light" and the use of short brushstrokes and dabs of paint. Later that year in Atlantic City, he saw the beach and boardwalk through the eyes of an Impressionist, duplicating the then-scandalous practice of painting shadows blue and purple. Dazzling sunlight permeates his landscapes, and several early Philadelphia street scenes illustrate the same sunny ambience.

But Henri's European trip of 1895–96 changed all that. The paintings of Hals that he discovered in Holland and the Manets in the Louvre and Luxembourg museums revealed a solidity of form that Impressionism lacked. A trip to London in February 1896, made in order to view an exhibit of Velázquez, Manet's spiritual master, was all the evidence he needed to embark on a new style, one that was "simple and direct." And so it was that Henri's first large-scale figure painting, the life-size likeness of fellow American artist Carl Gustave Waldeck, incorporated the rich, dark palette he so admired in Manet, Velázquez and Hals.

During the ensuing half-dozen years, Henri painted both portraits and cityscapes, but even the latter were relatively dark and subdued, as though always created under the gloom of overcast skies.

When Henri turned from East River subjects to paint the streets of New York toward the end of 1902, two canvases resulted that are among his best portrayals of Manhattan: *Snow in New York*, a view of the somber brownstones lining West Fifty-fifth Street, looking toward the taller structures of Fifth Avenue;

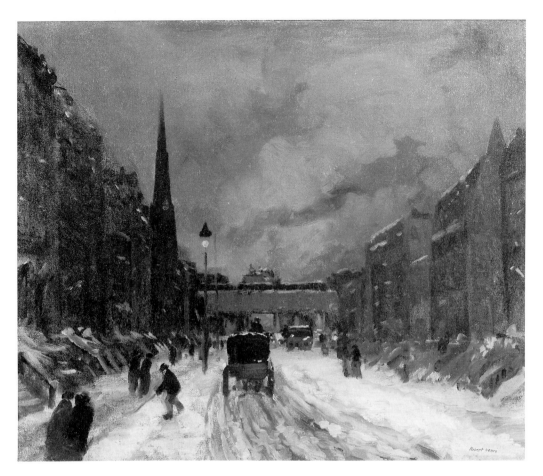

West 57th Street, New York, 1902
Oil on canvas, 26" × 32"
(66.0 × 81.2 cm.).
Yale University Art Gallery,
New Haven, Conn.,
The Mabel Brady Garvan
Collection.
Photograph by
Joseph Szaszfai.

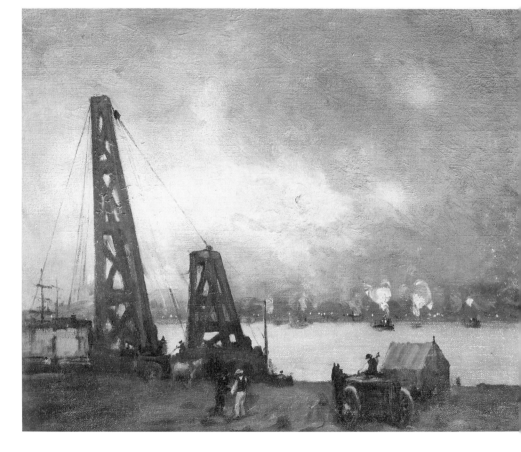

Derricks on the North River, 1902.
Oil on canvas, 26" × 32"
(66.0 × 81.2 cm.).
Santa Barbara Museum
of Art, Cal.,
Museum purchase for the
Preston Morton Collection
with income from
the Chalifoux Fund.
Photograph by
Peter A. Juley & Son;
courtesy of Janet J. Le Clair.

and *West 57th Street, New York,* a similar scene two blocks further north. They are Manhattan equivalents of his Paris triumph, *La Neige,* with the same one-point perspective, brown tonality, horse-drawn conveyances and figures trudging through the snow.

A pristine snowfall over a hushed countryside was considered appropriate subject matter for the art-buying public, but the snow on the streets of Manhattan, turned into slush and covered with grime, was unfit to be immortalized in oils. Henri felt compelled to paint portions of the city scenes outdoors, amid melting snow and chilling winds, and paid the price, coming down with a bad cold that lasted a month and nearly turned into pneumonia.

He also depicted the Hudson (North) River at Twenty-second Street in such compositions as *Derricks on the North River* and *North River Coal Pier,* likewise regarded as inappropriate subjects because they not only included but featured ugly industrial forms and members of the working class. At the same time, he was producing his first full-length canvas of Jesseca Penn, a ravishing redhead with green eyes, a tiny waist and long, slim legs, who quickly became his favorite model. She was a Ziegfeld Follies dancer who announced that she intended to become "the greatest dancer in the world," but to Henri she was "one of the finest nudes I have ever seen."[14]

His initial effort was *Young Woman in Black* in which the model wears a black hat, velvet jacket and tan blouse and holds a full black skirt in her gloved hand. Such a life-size likeness was considered radical in its day, for it was unlike the typically ornate and pretty salon portraits. Henri refused to include the usual props: furniture, flowers or even carpet. Thus in *Young Woman in Black* the figure exists not against space but in it, emerging from the canvas without benefit of background objects or compositional gimmicks.

Henri had said, "If there were two [of me] I could then paint both the people and the landscape,"[15] but he made the choice to concentrate on portraiture. It is somewhat ironic that Henri, who inspired a generation of art students to focus on painting the city, did himself abandon such subject matter so early in his career. The reason may well have been his limited knowledge of perspective since virtually all of his cityscapes involve the simplistic, straight-on view, providing few possibilities for variety. In any event, his New York scenes of late 1902 were also his last attempts at recording such an urban theme.

In November, Henri was given another one-man show at the Pennsylvania Academy, which Sloan, still residing in Philadelphia, sought to publicize with a full page of Henri's paintings in the *Sunday Press.* But the editor was unenthusiastic, claiming that "there is no excitement to hang the story on . . . nothing yellow in it." However, the *Press's* review did say that "in a little over a dozen years Mr. Robert Henri has placed himself among those with whom one must reckon in American Art."[16] A cutting criticism was written by the reviewer for the *Philadelphia Item:*

> A few years [ago] Mr. Henri had an exhibition of his works at the Academy, and they were so foggy and incomprehensible that several of them were hung upside down, and until the artist requested that they

be changed no one seemed to observe the faux-pas This was Mr. Robert Henri's Art in the past. But since then he has married, and his Art has grown more cheerful, which shows that married life has been a success for him. I can only hope that his wife will insist upon her beloved "hubby" casting aside all Impressionistic gloom and allowing the sunshine to illuminate his pictures[17]

While making preparations for the exhibit, Henri recalled that his previous show at the Academy had had an excellent press but no sales. He could not leave New York for the two-week duration of the exhibition, so arranged with Joseph Jackson, a former art

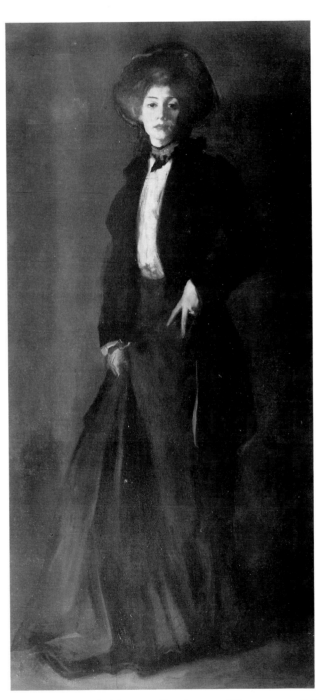

Young Woman in Black (Jesseca Penn), 1902. Oil on canvas, 77" × 38½" (195.5 × 97.7 cm.). The Art Institute of Chicago.

editor of the *Philadelphia Ledger,* to serve as his salesman with the promise of a ten-percent commission. There were thirty-one landscapes and cityscapes, together with eleven portraits and figure compositions, and once again no buyer interest. An offer for *The Ice Floe,* for considerably less than the 550-dollar sale price, was rejected. Three days before the show closed, Jackson wrote Henri:

> Artistically the exhibition is all that even you could desire——Financially it has so far proved to be a flat failureIt is poor consolation to tell a man he is ahead of his time yet, so far as Philadelphia collectors are concerned, it seems that you are far in advance of them with your ideas.[18]

Three weeks later all forty-two canvases were put on display at Pratt Institute, but again no sales resulted. One critic, pointing to the inconsistency in his work, called him "an uneven or uncertain painter" and the criticism seems partially justified, for now Henri, devoting so much of his time and energy to teaching, sought to produce scenes not only rapidly but increasingly from memory.

Though painters such as Sloan, Glackens, Luks and Shinn, among the group of former newspaper artists, had developed a creative bent by sharpening their powers of observation, Henri seldom succeeds when he seeks to fashion French cityscapes in his New York studio or compositions of snow-covered Central Park from within the same confines. In such canvases there are often errors of scale involving a figure in relation to trees or buildings, and disturbing, unresolved portions of the landscape where brushstrokes go awry. Yet in comparison to the academic productions of the day, with their classical motifs and meticulous renderings, even these Henri failings were preferable.

The disappointing receptions of his one-man shows were partially rectified by the annual exhibits. At the National Academy of Design in January 1903 one writer referred to his *West 57th Street, New York* as second only to a landscape by Leonard Ochtman that won the Inness Gold Medal. Later that month a review of the Pennsylvania Academy annual concluded: "Of all, not even excepting the Sargents, there is nothing better than Robert Henri's portrait [*Young Woman in Black*]";[19] when the same canvas was accepted by the Society of American Artists, critic Henri Pène du Bois of the *New York American* called it "the masterpiece of the show";[20] and in April, Henri received the announcement of his election to membership in the Society, of which Charles FitzGerald wrote:

> The election of energetic men like Mr. Henri and Mr. Redfield is encouraging at first glance, but they have killing odds to contend against. Some of good instincts and not without fighting ability have been elected before, but either because they were too lazy or because they found themselves in a hopeless minority, they have done nothing towards redeeming the Society of American Artists from degeneracy. Perhaps the only possible redemption depends on the coming of a powerful chief. . . .[21]

During March and April 1903, the Colonial Club of New York held its annual art show titled "Exhibition of Paintings Mainly by New Men." About twenty artists were represented, among them Henri and his friends Glackens, Sloan, Luks and Ernest Lawson, plus Jerome Myers, Van D. Perrine and Gifford Beal. Henri's two landscapes of the Wyoming Valley stood out well against the soft-gray wall; his third work, *Portrait,* a painting of his father, was called "one of the best works he has ever done" by the *Mail & Express* reviewer.[22] Another contributor, with six pictures including a portrait of Beethoven, was a painter and "amateur photographer" named Edward Steichen.

A writer for *Town Topics* noted that many of these artists "have for several years been rejected from other exhibitions It is regretted that such an exhibition as this has nothing from Arthur Davies and Everett Shinn, two men in their different ways that have got the shackles off"[23]

Henri's attention to his work was constantly diverted by his wife's fragile health. In April she was ill again. This time she went to Saranac Lake, New York, to one of the Adirondack Sanatorium's recently opened "cure cottages" for tuberculosis, where she remained for nearly five months. To keep secret her whereabouts from others, letters to her husband were sent to the family at Black Walnut and then remailed. In her absence Henri lost himself in his teaching. The school across the street became a haven from his loneliness and despair.

Upon entering the two-story brick building that housed the New York School of Art one could easily relive the student days at the Académie Julian. A large stairway on the Fifty-seventh Street side led to four roomy second-floor studios where many caricatures, drawings and globs of discarded pigment covered the dark green walls. To the ever-present odor of paint, turpentine and tobacco were added the fumes from a pot-bellied stove in each classroom. And the noise! The men's and women's life classes were still segregated according to sex, but this did not prevent fraternization, for when the model rested, students congregated outside in the hall.

The young ladies wore aprons or smocks to cover long skirts and high-necked blouses, and sat on tall stools at easels, but in the room for men, upturned chairs sufficed as supports for drawing boards. Henri gave critiques to each of his classes twice a week.

He encouraged an esprit de corps that resulted in hijinks in his absence. As at Julian's, a student entering Henri's life class would be earmarked for a treat. Within a day of the newcomer's having been cast into a sea of forty or so others he would hear someone call: "Well, Jack, do you see a new sail on the horizon?" From another corner of the room was heard: "Yes, I think I do." The next day another "new ship" was sighted and, by day four, two more. "Does it look like a treat?" one of the veterans asked. "What did you have in mind?" replied another. "Oh, a little more beer . . . crackers, cheese."

By the next morning the class would break into song, to the tune of "My Country 'Tis of Thee," with the words; "Who's going to set them up/ Who's going to set them up/ For us today?" Each new recruit was asked for two dollars and the herd would charge down the stairway to a nearby bar.[24]

Sometimes an older student would impersonate Henri, heaping mock praise on a newcomer's efforts. Once, when a young Adonis arrived in the classroom saturated with perfume, everyone pretended to be overcome by the aroma and at a given signal fell to the floor in a faint. And there were races; they would straddle the backs of chairs and jump about the room until the druggist on the floor below pleaded for them to stop because plaster was falling from his ceiling.

The horseplay came to a halt when Henri was present. When he moved from one student to another about half of the class would lay down their brushes and trail after him; others listened as they worked. "Pretend you are dancing or singing a picture," he would say:

> Work with great speed. Have your energies alert, up and active. Finish as quickly as you can. There is no virtue in delaying. Get the greatest possibility of expression in the larger masses first. Then the features in their greatest simplicity in concordance with and dependent on the mass. Do it all in one sitting if you can. In one minute if you can[25]

According to the monitor of the men's life class, Guy Pène du Bois:

> Henri set the class in an uproar. Completely overturned the apple cart: displaced art by life, discarded technique, broke the prevailing gods as easily as brittle porcelain. The talk was uncompromising, the approach unsubtle, the result pandemonium.[26]

Students were driven to paint enormous, full-length portraits and complete them in a day or two in imitation of their teacher. When Henri's life-size *Young Woman in Black* was exhibited at the Society of American Artists annual, his pupils rushed to see it.

His dynamic approach was in direct contrast to that of his predecessor, Frank Vincent DuMond, who was kind and likeable but lacked forcefulness. Within two months of Henri's arrival another instructor, Kenneth Hayes Miller, complained: "Henri's teaching methods are radically different from mine."[27]

Henri was also criticized by his peers for not emphasizing the importance of anatomy in the traditional sense, for he preferred to speak about the "anatomy of the picture" or a love affair between the parts of the human form:

> In your painting think of the neck, head and body as having a liking for each other. There is a love of the hand for the head. No cold lack of sympathy between the parts of a human being, but a beautiful fellowship exists. The parts are joyous in their play together, and an absolute confidence exists between them.[28]

When classes ended in May, William Merritt Chase prepared to take a group of students to Holland for the summer under the school's auspices. He had taught at Shinnecock, Long Island, likewise an extension of the New York School of Art, in previous years but now Henri was named as his replacement there. Henri had agreed to provide critiques twice a month starting in June; then Connah requested he not begin until mid-July, when most of the students would have arrived.

The change of plans was welcome to Henri, who had been invited to share a cottage at Boothbay Harbor, Maine, with Edward Redfield, who had written: "I think possibly you may be able to do something in the portrait line as there are some swell families in the vicinity.[29] Linda was still undergoing treatment at Saranac Lake when Henri left on June 22 to join his friend. They stayed at the end of town overlooking the harbor, where Henri enjoyed gazing from his window at the two-masted fishing schooners. Though the portrait commissions never materialized, he produced three dozen *pochades* and a few larger paintings of the lobster dock and fishing shacks along the water's edge, low-lying hills covered with spruce, and the dramatic effect of swift-moving clouds announcing an approaching storm.

In July they took a ship to Monhegan Island, fifteen miles out to sea, and here Henri was ecstatic:

> I have never seen anything so fine—cliffs to sea 200 ft. high—about 50 houses in the village—and from the great cliffs you look down on a mighty surf battering away at the rocks—pine forests, big barren rocky hills and a building of rocks It is a wonderful place to paint—so much in so small a place one could hardly believe it. I am already wondering if it may not be possible to have a summer studio here.[30]

"Why do we love the sea?" Henri once asked. "It is because it has some potent power to make us think things we like to think."

After three days on the island he and Redfield returned to Boothbay, where a letter from Connah canceled plans for the summer criticisms at Shinnecock altogether. Bad weather and mosquitoes had cut attendance.

Henri was enamored with Monhegan as a place to paint, and the air would do wonders for his wife. Informed of his find and having completed her treatment, she joined him in Manhattan, they left for Maine and in three days they were on Monhegan. Henri introduced her to the grandeur of soaring granite cliffs pounded by the sea and the tranquility of a virgin forest of spruce and fir balsam. They tramped the two-mile length of the island, considered the properties near the dock and lighthouse, which were placarded with for-sale signs, and decided to purchase land on Horn's Hill, overlooking the harbor, with a four-hundred-foot frontage facing nearby Manana Island.

They remained on Monhegan for six weeks, taking long walks and painting together. He produced a series of *pochades*, spontaneous statements with impasto brushstrokes of the barren tranquility of *Cliffs and Sea, Monhegan*, the churning cauldron-like waters in *Rolling Sea* and the raw force of *Cloud Effect—White Head*. "I painted a whole batch of things and feel pretty good over a lot of them," he wrote Sloan.[31] (See color plate.) When he commenced teaching at the New York School of Art that fall his enthusiasm for Monhegan kindled a spark in at least one student, Rockwell Kent, who visited the island and purchased a lot adjacent to his mentor's.

At the school Henri continued to grow in popularity. His critiques "made no pretence to such showmanship as Chase delighted in," according to Kent. "They were earnest and, at times, impassioned"[32] In contrast to Chase's guise of pomposity,

Henri appeared as a warm, friendly, Southern-gentleman type. His success as a teacher was based both on what he had to say and the way he said it. He had a slight drawl, "a Southern brogue" he called it, skillfully modulated for emphasis. An article found in his scrapbook probably influenced his delivery:

> That the American voice is nasal and disagreeable, especially when raised for public speaking, is an acknowledged fact. That it can be improved is also true When you are addressing an audience in a very large hall it is only necessary to speak a little slower, to lay a little more stress on the vowels, and to be certain the end of every word is finished. The pitch of the voice is of great account, for there is nothing more uninspiring than a monotonous speaker and the cultivation of a natural conversational pitch or note is desirable.[33]

Sometimes his voice was gentle but then it would gain strength, rushing along with the urgency of his message. He captivated his audience by reading from his favorite books; it was a liberal education. One day it would be Whitman—perhaps the same copy Sloan had given him a decade before—and he would begin: "Walt Whitman was such as I have proposed the real art student should be. His work is an autobiography—not of haps and mishaps, but of his deepest thought, his life indeed . . . ," and then he would read from *Leaves of Grass*.[34]

On another occasion he brought his worn volume of Emerson's *Essays*, which had been opened to page fourteen many times:

> All history becomes subject; in other words, there is properly no History; only Biography. Every soul must know the whole lesson for itself——must go over the whole ground. What it does not see, what it does not live, it will not know.[35]

The New York School of Art had several notable artists teaching illustration, including Walter Appleton Clark and Howard Chandler Christy. Chase frowned upon students forsaking painting for commercial art; when Christy was a pupil of his and turned to illustration, Chase refused to speak to him for several years. When a student of Kenneth Hayes Miller's expressed an interest in becoming an illustrator, the instructor asked whether he "wouldn't like to be something higher."[36] Henri, on the other hand, welcomed all comers. Speaking of Edwin Austin Abbey in the classroom, he said he would "rather be the artist who drew those illustrations like the one of 'She Stoops to Conquer' than to paint fifty miles of decorations like those at the Boston Public Library [by Sargent]."[37]

His comparison was not only an elevation of the illustrator but an affront to Chase, who sanctioned the facile brushwork of his friend Sargent. Henri attracted, taught and encouraged such future magazine artists as Walter Biggs, E. Ward Blaisdell, W. T. Benda and Adolph Treidler, but let it be known that "I am not interested in art as a means of making a living, but I am interested in art as a means of living a life."[38]

He encouraged students to seek part-time employment to tide them over; Rockwell Kent dug wells and cleaned privies, Glenn Coleman served as an usher at Carnegie Hall and Arnold Friedman was a postal employee. To help students, Henri sometimes loaned them money or purchased their classroom studies as he did for Carl Sprinchorn, who began studying with him a few days after he arrived from Sweden.

When Patrick Henry Bruce left his class for Paris late in 1903, Henri asked to keep his portrait of classmate Warren T. Hedges, which he much admired, in order to have it framed and submitted to the National Academy annual. In January, Bruce's painting was accepted, along with Henri's oil *The Coast*, which was called "a work of captivating originality" by a reviewer[39] and hung in the central gallery's place of honor. Bruce's, in an adjoining gallery, was singled out by Charles FitzGerald as "by long odds the best in the room."[40] When Henri mailed Bruce the complimentary notice and offered to crate and ship his portrait to an exhibition in St. Louis, Bruce wrote:

> Such kindness as you have extended to me makes me truly glad and grateful, . . . I can only accept with pleasure, and trust that I may be able some day to show you a substantial gratitude and in the meantime profit by your encouragement and live up to your hopes——.[41]

In January 1904 the Carnegie Institute purchased Henri's *Girl in White Waist* from its annual exhibition for two thousand dollars. The full-length portrait was his first canvas to enter a museum collection in the United States.*

Despite Henri's regular inclusion in the established exhibits, he said: "I regard the . . . big annuals as institutions detrimental to art Art should be persistent; exhibitions should be small" A similar stand was taken by art critic Charles De Kay:

> Regular exhibitions must demand certain standards, from which they cannot derogate at the peril of their own existence as organizations. Therefore it is that we must look to private, one-man shows or to club exhibits for the work that we miss at the annual gatherings[42]

The remark was prompted by a group show organized by Henri at the National Arts Club, which, coincidentally, had been founded by De Kay some years earlier. The exhibitors, referred to by another critic as "half a dozen of the most forceful and vigorous of this country's young painters"[43] included Henri, Glackens, Davies, Sloan, Luks and Prendergast. The forty-six works were displayed in two rooms at the club's brownstone headquarters on West Thirty-fourth Street, most of them in a single row, "on the line."

Henri said: "Think the show looks remarkably fine and satisfying."[44] He was represented by four Monhegan landscapes and five portraits; a half-length painting of his brother had been completed within the week. The *New York Evening Telegram's* review began: "Easily first among them as a painter, at least, if one may venture on anything so ungracious as compari-

*The painting was later destroyed, along with several by other artists, when a train in which it was being transported caught fire on its way to the Art Institute of Chicago for an exhibition of old-master and modern portraits.

sons, is Robert Henri. Mr. Henri paints with sureness and something approaching distinction"[45] But the press in general was less perceptive. "Startling Works by Red-Hot American Painters" said one headline. Arthur Hoeber in the *Commercial Advertiser* categorized the show as one "where joyousness never enters, where flesh and blood are almost at the vanishing point, and where unhealthiness prevails to an alarming extent."[46] De Kay wrote: "Discussions are violent If the end of the month is reached without duels the club is in luck."[47]

Criticism centered on such works as Luks's *Whiskey Bill*, not the sort of jovial drinker portrayed by Hals but a melancholy alcoholic. "What a surprise straight, simple paintings about straight, simple things are to the cultured public!" Henri wrote him. "I am shocked."[48]

The exhibition closed with no sales. Within days Henri created a full-length portrait of Luks, a heavy imbiber himself, but depicted him as the equal of his upper-class detractors, painting the pinky of his right hand noticeably raised.

When John Sloan came to see the show, Henri painted him too, a penetrating likeness with strong highlighting on the face in marked contrast to a black suit and a dark gray background. Sloan was the last of the old Philadelphia gang who still lived outside Manhattan but that was about to change; within three months, he and his wife Dolly moved from Philadelphia into the Sherwood Building, where they rented a studio on the same floor as Henri's. Sloan acknowledged that Henri, an avid admirer of his etchings, "wanted to give me a thousand dollars outright when I moved to New York in 1904, so I could feel free to do the city etchings without the interruption of looking for magazine work."[49] Uneasy about such a sizeable gift, Sloan accepted half that amount as a loan.

In May, when Henri produced his first etching, it was Sloan who became the teacher. Using a ten-year-old sketch, *Street in Paris*, for the composition, Henri guided an etching needle across a copper plate, rendering mansard-roofed buildings and a bustling thoroughfare. The result was *Street Scene in Paris*. But the linear shading was a slow process, too slow for him, and the five trial proofs and edition of twelve prints are the only evidence of his foray into that medium.

During the winter and spring of 1904, Henri was enormously busy on all fronts. He produced a variety of portraits: some of friends, such as Grafly and Preston; others of professional models, including Bertha Morrelle and Eugenie Stein posed as *Girl with Red Hair* and *Woman in White*; and several of Linda. In April he painted a serious, manly likeness of Willie Gee, the black youngster who delivered his newspaper. Willie is depicted with dignity; the blue-gray coat shows none of the tears or patches found in paintings of bootblacks and waifs considered "picturesque" in the nineteenth century. This canvas rings true.

In May Henri completed a full-length portrait of Mrs. Glackens, begun in 1902 when she was still Miss Edith Dimock, a socialite from Hartford who had sought to study with him. Now, with Glackens and his

bride established in a studio in the Sherwood Building, Henri finished the canvas, painted a matching likeness of her husband, and presented them both as wedding gifts.

Henri had served as a juror for the Society of American Artists' annual during March. Although accepted works had to receive approval from a majority of the thirty-man jury, his persuasive voice was sufficient to insure the inclusion of canvases by Sloan, Glackens, Lawson and Shinn. He tried to have a portrait by Luks accepted too, but there was a polite exchange of words and the painting entitled *Martin*

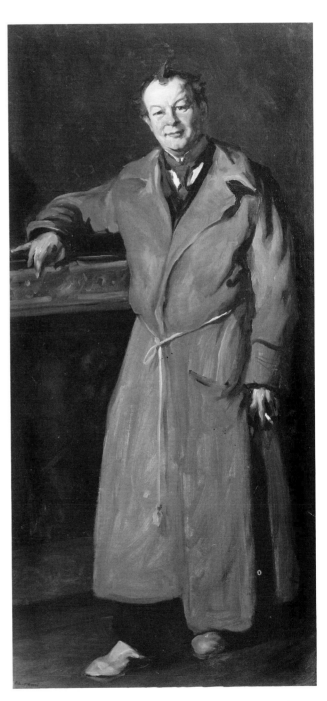

Portrait of George Luks, 1904. Oil on canvas, 76½" × 38¼" (194.3 × 97.1 cm.). The National Gallery of Canada, Ottawa.

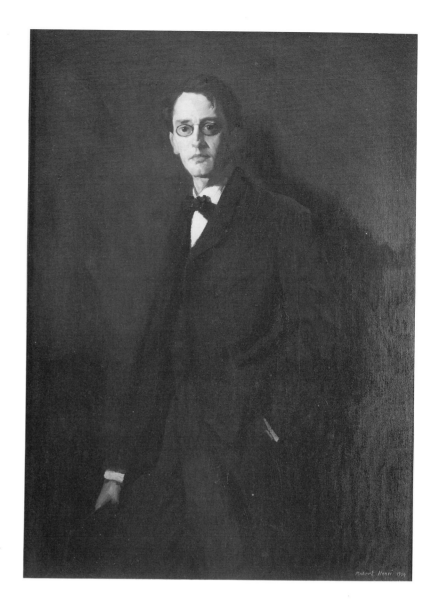

Portrait of John Sloan, 1904.
Oil on canvas, 56½" × 41"
(143.5 × 104.1 cm.).
The Corcoran Gallery of Art,
Washington, D.C.;
Gift of Mr. and Mrs. John Sloan.

was cast out. (The following month it appeared on the walls of the Macbeth Gallery.) Henri was represented by a portrait of Byron Stephenson, art critic for *Town Topics*, jury-free by virtue of Henri's membership in the Society, and by a second portrait, that of a young woman, as well.

That month he was invited to exhibit at the Union League club as one of "Eight Representative American Portrait Painters" and also had a Maine seascape in the Minnesota State Art Society's first annual exhibition, where the *St. Cloud* (Minnesota) *Times* referred to him as "The Little New York God."[50] In April he crated two of his full-length paintings plus Patrick Henry Bruce's portrait of Hedges and shipped them off to St. Louis for the Louisiana Purchase Exposition, held to commemorate the hundredth anniversary of the acquisition of the Louisiana Territory. There was general excitement surrounding the Exposition and the country's first Olympic games, in which nine thousand athletes would participate. The good news for Henri came when he learned that his *Young Woman in Black* and *Lady in Black*, a portrait of Linda, had been awarded silver medals.

Things had also been going well for him at the New

York School of Art. Just before the spring 1904 term he was approached once again by the Art Students League, its board having "moved and seconded that Mr. Henri be offered the Women's Life and Morning Portrait Class at $1000.—for the season 1904–1905."[51] As a countermeasure, the New York School of Art asked him to provide a few criticisms for its women's life class on Wednesday and Friday mornings, in addition to his usual teaching schedule. By April the school wrote him that "the Women's Life Class are most enthusiastic over their criticism last Wednesday—and Oliver-like, are crying for 'more.'" Mr. Connah felt that "if it is not too much work, a few criticisms from you would give the class life and health again."[52]

By now his men's life class included Arthur Cederquist, Tod Lindenmuth, Arnold Friedman, Julius Golz, Walter Pach, Glenn Coleman and Vachel Lindsay.

Henri was, as du Bois called him, "the greatest friend of youth," an encourager, a catalyst. But he was sometimes too lavish in his praise, using the word "genius" too often. "You burst out in a dash of genius," he would say. Even this idiosyncrasy was memorialized in good spirit by the students who

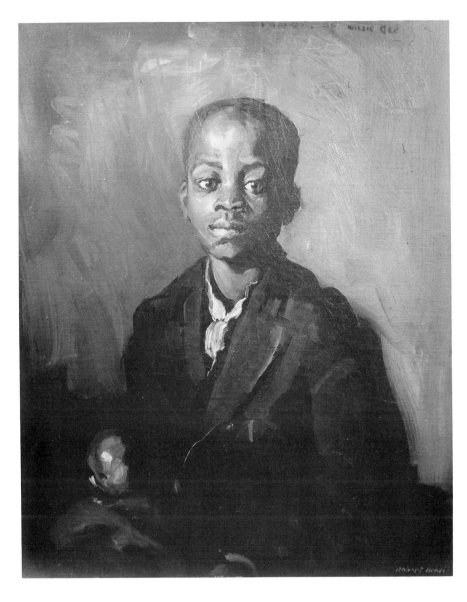

Portrait of Willie Gee, 1904.
Oil on canvas, 32³/₁₆″ × 26³/₁₆″
(81.7 × 66.5 cm.).
The Newark Museum,
Newark, New Jersey.

composed lyrics to a popular vaudeville song of the day called "I am a Voo-Doo Man":

Mr. Henri for many years
Would look at my work and then shed tears
He did not know where he was at
For all of my genius I couldn't tell that.

(*refrain*)
I am a genius
I am a genius
I am a genius man.[53]

"Genius man" or not, when the *concours* were held and prizes given, the majority of the awards went to pupils of Henri's. He had a simple procedure for designating his students' best work for *concours* consideration; just as Eakins used to place a small "E" in the corner of a classroom composition, so Henri would paint a red dot at the bottom of the canvas. Edward Hopper's portrait of Guy Pène du Bois received just such a mark.

In June, Henri was offered a portrait class at the Pratt Institute but replied that "I could not give up more time with the present New York Art School arrangement."[54] With Chase off again to Europe escorting another student group, Henri was scheduled once more to give critiques at the Long Island location; this time they materialized. The summer also provided an opportunity to relax with the Sloans at Coney Island, produce a few monotypes and paint portraits in Cooperstown, New York, of Bishop Henry C. Potter in his vestments and F. Ambrose Clark, his stepson, in riding togs.

Henri established a temporary studio in the Cooperstown Y.M.C.A., where the bishop posed wearing his purple tasseled cap, red cape and black-and-white robes. In September the Archbishop of Canterbury, Randall Thomas Davidson, viewed the portrait during a visit and, to Henri's gratification, was much impressed by it.

Returning to New York that fall, Henri made his first appearance at the school a week after classes had begun. One of the new students in his men's life class was a conspicuously tall, athletic type from Columbus, Ohio, named George Bellows. He had brought along a portfolio of sketches and Henri looked on patiently as the twenty-two-year-old, with an air of self-confidence, displayed one ink drawing after another, poor

imitations of Charles Dana Gibson and James Montgomery Flagg. "Haven't I seen these before?" was Henri's only comment at the time.

Bellows quickly became one of his most responsive and devoted pupils; the influence was so immediate and all-encompassing that he said of his first contact with Henri: "My life begins at this point." One of Bellows' early portraits in the life class, which demonstrated his true ability, was of a fellow student named Webb P. Raum, a fifteen-year-old who posed, dressed fit to kill, in a black coat with silk scarf and gloves. The young dandy would retain this image throughout his life, abandoning art for opera, theater and the movies, and changing his name to Clifton Webb.

Bellows, being a practical joker, fitted right into the merriment of the class. At the time of his graduation from high school he was one of a trio of boys who deposited a cow in the principal's office. Now he helped to set a fire under the chair of A. B. Frost, Jr., in order to "thaw his name." Then Frost discovered that a painting of the sun had mysteriously appeared on the back of his smock because he was the *son* of Arthur Burdett Frost, the illustrator.

In December 1904, the faculty held its regular semester exhibition, a two-day display where students could view the canvases of Chase, Henri, Kenneth Hayes Miller, F. Luis Mora and others. The shows were always something of a popularity contest, but nothing like the event that some of the pupils were planning. At a meeting on December 23, in connection with student elections, it was recommended that the two leading instructors become candidates to see which one would be voted the most well liked. When Henri learned of the idea, he was furious and asked Rockwell Kent, chairman of one of the student groups running the election, to denounce it. A broadside was printed over Kent's name and placed around the school. In addition to stating his party's platform, the pink sheet contained the following statement:

> The public mention at the Friday meeting of two of our instructors as candidates for first place in the popular estimation, menaces our enterprise. Comparisons are odious at all times, but when students go so far as to announce their instructors' names, one against the other, the result cannot be other than that of rousing a partisan rancor destructive of all school spirit.[55]

The Kent party won the election but Henri maintained the good will of Chase and the dignity of the faculty.

From time to time Henri would be called upon to present a free evening lecture on composition; such talks had become extensions of his composition class, the school's most popular course. Each Saturday morning Henri's followers would gather to hear his comments about their week's work; simultaneously, in an adjoining classroom, Chase conducted his lectures. Although a crowd was always on hand to watch the entertaining Chase, his presentations were more structured; students were required to present questions in writing before each session. Yet even Chase's showmanship and flair for the dramatic were no

longer a match for Henri's hypnotic verbal outpourings. "It was the composition class that was the essence," a Henri student remarked. "It was simply breathtaking!"[56]

Most composition classes of the day laid stress upon design, color and chiaroscuro. Henri touched upon these, too, obtaining some of his ideas from Henry Rankin Poore's 1903 volume *Pictorial Composition and the Critical Judgment of Pictures,* which he annotated, with passages underscored and tiny sketches in the margins. Beside a reproduction of Botticelli's *Birth of Spring* he wrote: "Poore finds this lacking both circular cohesion and the stability of cross adhesion. No union. No structural union. A group of separate ideas. Not a composition, but addition." But such an analytical approach was not Henri's style any more than his life class was concerned with the teaching of anatomy.

In the composition sessions, forty or fifty works by students would be placed against a wall. First he encouraged discussion but when it had run its course the students grew silent and watched as Henri assessed cityscapes and figures while wisps of smoke from his Ricoro cigar curled toward the ceiling.

One week he took his cue from several paintings of the Hudson River, talking for nearly an hour about the sweep of the shoreline, the placement of boats along the river, the proportions of water to land and to sky. After dwelling on a Bellows interpretation he finally pointed a three-foot maulstick toward a large canvas by Carl Sprinchorn, saying "All of you have shown boats going up and down the river. Only this painting demonstrates that they go *across* the river as well."[57]

Although the crowd was always large, his message appeared to be personal; he would direct his comments toward individuals, looking right at them. He repeatedly minimized technical proficiency: "The idea and the emotion were all-important, the manner of conveying them negligible," C. K. Chatterton quoted him as saying. According to George Bellows:

> No one who has not felt the magnetic power of Henri, when he had before him an audience of ambitious students hungry for the master's moving words, can appreciate the emotional devotion to art which he could inspire as could no other teacher It required . . . his fervor, his passion for the verbal communication of his ideas, to place before a vast succession of eager youth the new world of vision.[58]

Henri encouraged his class to form a baseball team in the spring of 1904; now, the following year, they had Bellows, a former shortstop at Ohio State, to add to the roster. Seeking an opponent, they challenged the Art Students League, which turned down the invitation until the Henri men marched on the League and delivered the challenge in person. It was finally accepted, but not before Henri's rowdy bunch caused a riot and "accidentally" shattered the pane of glass in the League's front door. Before doing battle on the ball field, League students retaliated by making a shambles of one of the classrooms at the rival institution.

Playing its games at Bronx Park in borrowed Y.M.C.A. uniforms, the New York School of Art's

lineup included Bellows, Kent, Glenn Coleman, Guy Pène du Bois, Julius Golz, Oliver Chaffee, Edward Keefe, Carlos Scovell and Arthur Cederquist. Backed by a vigorous rooting section, the Henri men won, and finished the season 5–1.

When fights broke out on the playing field and a Henri student suffered a black eye or a bloody nose, the injury was displayed with a sense of pride, as evidence of the teacher's directive that a strenuous life is of the utmost consequence in producing a vital work of art. American art, after Henri, would never be called anemic again.

Not all of his students, however, were inspired in this manner. Vachel Lindsay arrived in the Henri portrait class early in 1905 with the announced goal of becoming a magazine illustrator. His diary records the instructor's first critique:

Told me of the undiscovered mystery of the figure and face. Told me my faces were too doll-like, my figures lacked action. I ought to get same mystery in my face I did in my designs. Then ought to study Beardsley faces and figures. I believe Henri has the simplest way out for me. Richardson (mag. editor) recommended the Academy, Henri the human face. Richardson is right, but Henri is righter. I see that man Henri is the man I need'[59]

On March 21 Henri received the following note:

My Dear Sir:
When can I come to see you? I have a bit of verse I would like to read you at some proper time. The verse is about ten minutes long. It is called *The Tree of Laughing Bells.*

Very sincerely
Nicholas Vachel Lindsay[60]

A few days later Lindsay visited Henri's studio, and on the basis of that reading was advised to abandon drawing and painting for poetry. He was prompted to write in his diary: "He certainly gave me a brotherly boost and braced up my confidence a whole lot"

The next month Lindsay wrote him again:

I attended the Society of American Artists Exhibition yesterday I was completely your slave again, especially in the matter of the soul of the woman in the shawl [Henri's painting, *Spanish Dancer;* see color plate]. The memory of it puts a multitude of words into me, but I have written a great many of them to my father this morning, and you are accordingly spared the flood I have enlisted in your army. Every prestige or heritage is made of units, and you can count me one. You might really count me a veteran, for it was last year at the portrait show I enlisted, under the banner of a woman with glorious red hair I have enlisted for several more years—for the rest of the war[61]

For Henri at this moment, the exhibition front was his battleground. He had just completed serving for the second year on the Society of American Artists jury, had fought the Establishment and won a great success; two paintings by Glackens had been accepted, four by Prendergast and single works by Sloan, Shinn, Redfield and Schofield. Even Luks was finally honored by the admission of two of his canvases, though one of

them, his masterpiece, *The Spielers,* was "stuck in a corner where nobody can see it." Henri was represented by *Willie Gee,* the *Portrait of F. Ambrose Clark* and his *Spanish Dancer.*

The inclusion of paintings by artists he had championed could be attributed to Henri's having been elected chairman of the Committee of Invitation, an influential post. When that offer had come to him, he noted: "Accepted with the idea that I might get them to invite pictures by A[rthur] B. Davies who has not been sending to the S.A.A. [Society of American Artists] because of previous bad treatment."[62] Henri's proposal was rejected, however, owing to a rule that no artist residing in New York could be invited since "others would kick or hold out for the same honor."

Reviewing the show in the *Evening Sun,* Charles FitzGerald observed that "some few good pictures" had been "carried in with the crowd," a reference to the acceptance of paintings by "Mr. Henri and his group." He noted Henri's rapid progress from the days when his canvases were inconspicuously hung in a side gallery, to the present, when they were prominently located in the prestigious Vanderbilt Gallery:

In another year we may expect to see him where he deserved to be this year, in the place of honor. There seems to be a widespread feeling outside of the Society that his "Spanish Girl" was entitled to that distinction, such as it is . . . we are heartily at one with those who think it should have taken the place of John Alexander's portrait this year.[63]

The 1904–5 exhibition season represented a number of additional successes for Henri. In the fall his paintings had been displayed at the Minnesota Art Society, the Art Club of Rochester, the Rhode Island School of Design and the Art Institute of Chicago. In November a portrait of Zenka Stein and a Monhegan study were submitted to the Pennsylvania Academy Fellowship annual; not only were they accepted, but he was requested to send thirteen additional paintings of the Maine coast, which were hung as a group.

In January a letter from the Detroit Museum of Art informed him that "the front wall of our spacious main gallery has been given to your pictures" and "a movement is on foot to secure funds for the purchase of one picture of your collection."[64] The previous month, Harry Watrous, secretary of the National Academy of Design, visited Henri's studio "to ask me for something for the N.A.D. and was carried away with a desire to have the standing portrait—in robes— [of Bishop Potter] for exhibit"[65] Although Mrs. Potter was unwilling to release the painting, Henri's full-length portrait of Marie Adele Manly titled *Brown Girl* was included and was singled out by Henri Pène du Bois as "the best work of the show."[66]

Certainly such praise influenced the National Academy's decision, announced at its annual meeting in April, to elect Henri an associate member. Although he would never boast of the honor by signing his paintings, as was the custom, with "A.N.A." (Associate of the National Academy) after his name, suddenly finding himself part of the Establishment offered opportunities for change from within and he was quick to veer off on this new tack.

CHAPTER 12

TRAGEDY AND
A NEW BEGINNING

IN THE SUMMER of 1905 several familiar themes were replayed. Linda left New York for Black Walnut and additional treatments at Saranac Lake. She had undergone surgery the previous November, from which recovery had been slow. Henri was involved with the New York School of Art's classes on Long Island, but on a very limited basis; Chase had taken another aggregation to Europe, this time to Spain, leaving but a small colony for the summer school at Bayport. Connah's budget allowed for only monthly critiques by Henri, which provided the students with too little stimulation and him with too little income.

With only four paintings done since the end of April, Henri decided to leave New York and join his parents at Saratoga Springs, where they were vacationing in celebration of their forty-eighth wedding anniversary. In August, Linda was well enough to join them, and when the Henris returned to the studio, his first painting was a full-length portrait of her. This time, however, Linda could not sustain a standing pose so he positioned her reclining on a sofa.

Now he learned that A. Stirling Calder was suffering from tuberculosis too. Redfield wrote him that Calder was "down and in a fair way to be out unless he goes to Arizona."[1] Henri sent an immediate response:

> He should go west without delay! I can be counted on for all in my power—cash or anyway whatever the scheme may be I don't know how his finances are but I am sure we can make up the deficiency if there is any I should think a fine thing would be for a number of us to put together cash and buy one of his works. Ten or fifteen at a hundred dollars each and present the thing to the Academy[2]

To avoid the embarrassment of an outright gift, he arranged for Mrs. George Sheffield, whose portrait he had painted, to purchase a Calder sculpture.

In October he served on the jury for the tenth annual Carnegie Institute exhibition together with nine others, among them Eakins, Schofield, J. Alden Weir, John W. Alexander and Ben Foster. He suc-

ceeded in having paintings by Sloan and Glackens accepted for the show, and each was also awarded an honorable mention. Henri was represented by his full-length *Spanish Dancer*, which was reproduced on a poster displayed on streetcars to publicize the exhibit.

Upon his return to New York, he received a telegram from the Art Institute of Chicago; his *Lady in Black*, the portrait of Linda, had won the five-hundred-dollar Norman W. Harris Prize. With awards given for only two out of nearly four hundred accepted works, this had to have been a notable achievement; the same painting had won a prize at the St. Louis World's Fair the year before. A reviewer of the Chicago exhibit referred to it as "unquestionably the finest single canvas in the show," and Henri Pène du Bois wrote in the *New York American*: "I am sure he is a great artist, one of the greatest of all times." Such praise caught the attention of other writers, including Theodore Dreiser, editor of *The New Broadway Magazine*, who asked him for a photograph and biographical information to accompany a color reproduction of one of his works.

These events would have been cause for joyful celebration in the Henri household, but Linda's frail health had suddenly taken a turn for the worse. The new illness was diagnosed as gastritis and by the end of November she had a nurse and the family doctor constantly on hand. Henri wrote Sloan that he was unable to attend a dinner for the critic Byron Stephenson because Linda "has been ill and it now looks as if she will still be in bed—though much better—on Saturday."[4] By that Saturday, December 2, her condition seemed to improve, but she asked for "our doctor," and when Frank Southrn arrived he determined that she was gravely ill.

On the morning of December 8 Henri and his brother rang the doorbell to their parents' apartment. "Dr. and Bob are both here," their father announced. From another room their mother was heard to say: "Oh, then Linda is better and they have left her"

"No," Henri's father said, "Linda is dead."

The terrible shock devastated the family. "To think

one so lovely, so beautiful should have to die," Henri's mother wrote in her diary. "I think of those lovely eyes, her beautiful hair and hands. Oh so sad, we are so distressed God grant that she is a bright and happy angel."[5]

On December 9 the two brothers removed Linda's body from the Sherwood studio and the grieving Henri selected a casket and accompanied his thirty-year-old wife back to Philadelphia, where she was buried in her family's plot at the Laurel Hill Cemetery.

Then he undertook the unbearable task of packing Linda's clothing, jewelry and paintings to send to Mr. and Mrs. Craige; he selected one of his portraits of her to present to them as well. And for the forthcoming annual at the Pennsylvania Academy, he wrote the director:

> Since you were here I have thought that I would send you the portrait of Mrs. Henri for the exhibition. The times it has been exhibited and what success it has received gave her so much pleasure that I feel she would have me send it now to our old academy The title is "Lady in Black."[6]

When the show opened in January 1906, the painting was hung in one of the places of honor in the large west gallery, and Henri learned how close it had come to being awarded the Temple Gold Medal, receiving votes from Eakins, Redfield, Breckenridge and DuMond out of a total of nine.

His *Spanish Dancer* was accepted at the Art Institute of Chicago and two portraits at the National Academy of Design, but the achievements seemed empty and meaningless. The studio was a constant reminder of Linda: "Work not thought of. Can't work," Henri noted, and he moved in with the Sloans. Thoughts and conversations continued to turn to Linda, and in mid-January John Sloan commenced a composition of the two Henris, his wife Dolly and himself for an etching to be called *Memory*, showing them seated around a table in Henri's studio with Linda reading aloud. At one point Henri made a portrait sketch of Sloan in order to help him with his own likeness.

Henri sought desperately to relieve his grief by distractions: playing cards with Sloan, or golf on the municipal links at Van Cortlandt Park with Sloan and James B. Moore, a restaurateur who operated the Café Francis. The artists often held their nightly rendezvous at Moore's home rather than his restaurant, their jovial host referring to his four-story brownstone as "The Secret Lair Beyond the Moat," perhaps an appropriately romantic designation from the grandson of Clement Clarke Moore, author of "'Twas the Night Before Christmas."

The first-floor parlor resembled a museum, housing paintings, bronzes, tapestries and fine examples of Sheraton and Chippendale furniture, but it was the subbasement that held the greatest interest, with artistic appointments that caused it to be called "the most remarkable cellar in New York." Its walls were covered from floor to ceiling with canvas, on which decorations had been painted by Henri, Sloan, Glackens, Lawson, Luks and Rudolf Dirks, creator of the renowned comic strip *The Katzenjammer Kids.*

Henri's contribution consisted of a portrait of Moore with a group of his friends, an appropriate backdrop for the men as they played shuffleboard and quoits or took target practice at a rifle range.

Immediately after Linda's death Sloan was pressed into service as a substitute at the New York School of Art, but by late December Henri was back in the classroom, in body if not in spirit. The following month he invited Thomas Anshutz to come over from Philadelphia to present weekly lectures on anatomy, an arrangement that Henri had inaugurated the year before because of his aversion to teaching the subject.

While in New York for one of the talks, Anshutz became the subject of Henri's second painting since Linda's passing (see color plate). The first had been *The Art Student*, a portrait of Josephine Nivison:

> She was standing in her old paint-spattered apron at the close of a lesson, with her paint brushes clutched firmly in her little fist, listening to a conversation. She seemed a little human question mark, and everything about her, every line of her dress, suggested the idea. I wanted to paint her just as she was, and I asked her to pose for me the next day. I was afraid she couldn't assume the same pose and the same look, but it happened that as she entered my studio she fell into the same energetic, questioning attitude. I had to paint very rapidly to get it.[7]

Years later Miss Nivison, who married Edward Hopper, wrote to Henri that "to us who haven't been able to keep up the painting much—it's all the same— we're painters . . . [with a] tribal sense of having belonged Whenever any two of the old crowd meet, it's the meeting of spiritual kin . . . of faith transmitted The churches do not have that to give. . . ."[8]

The canvas of *The Art Student* contains an unusual display of color, as if to signal a new beginning. A red blouse with white linen collar is revealed above a dark blue painting apron, with the edge of a light blue skirt showing along the bottom. Even the background is more spirited, the somber grays and blacks of so many of Henri's previous paintings having given way to a large expanse of yellow-gray. The life-size figure topped by a mass of disarranged hair also reveals the spontaneous brushwork that had briefly disappeared from many of his larger canvases.

Henri was coaxed back into exhibiting in February 1906 by the opening of the Modern Art Gallery on East Thirty-third Street near Fifth Avenue, whose first show included works by six of the Henri group: Sloan, Glackens, Luks, Shinn, Lawson and himself. Although the gallery was short-lived, it enabled Lawson to make his exhibiting debut with the coterie. He had originally been brought into the fold at Mouquin's and the Café Francis by Glackens, whose studio on Washington Square was just a block away from Lawson's in MacDougal Alley.

Three months had passed since Linda's death, yet Henri was still bereaved and lonely. At times he questioned his effectiveness as a teacher, wondering whether "I had lost my grip on them."[9] Now Mrs. George Sheffield, who had purchased the Calder sculpture at Henri's urging, offered him a commission

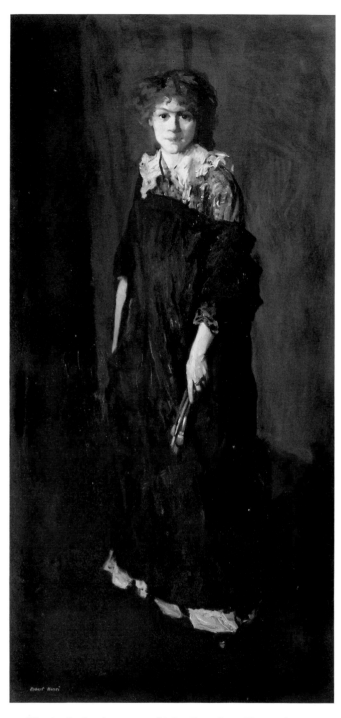

The Art Student (portrait of Miss Josephine Nivison), 1906.
Oil on canvas, 77¼" × 38½" (196.2 × 97.7 cm.).
Milwaukee Art Museum Collection.

to paint her three children at the family home in the winter resort of Aiken, South Carolina. Henri asked Sloan to take over his classes while he was gone, and in mid-March he left the heavy snows of Manhattan for a sunny clime and Southern hospitality, complete with dress suits and formal dinners, a butler, servants, horseback riding and tennis. Henri wrote Sloan:

> I have been playing tennis—enough to know. But it is not a philosopher's game like golf. Lacks the romance. It's made up too much of sun on a flat yellow bottom of

a wire cage you jump about in. A net always so high and in the same place. A certain kind of shoes, white trousers, taste in socks. No hills to go over to other views, no crush of grass under foot, no spring to drink at at the end of that long stretch. Golf might have its Izaak Walton. Tennis could only have a Beau Brummel.[10]

The painting of three children in a single composition was a challenging undertaking, especially since two of them were "too young to do any posing other than to be present for a short while in the room while I worked—kept more or less on a chair where I could see them in many attitudes and moods."[11] The final result was a seventy-by-fifty-inch canvas depicting the two girls and the boy standing on a path in the garden, their white clothing and fair hair in sharp contrast to a tall hedge of Japanese quince containing a pattern of light red flowers.

"Everybody in the house calls it a masterpiece . . . ," Henri wrote his parents, "Mrs. Sheffield heading the others in the verdict. Visitors from outside have been in and so far the success continues. Today Mrs. Harry Payne Whitney is to come to see it"[12] Gertrude Vanderbilt Whitney, a friend of Mrs. Sheffield's younger sister, was in Aiken for a brief stay before sailing for Paris. The chance meeting was Henri's initial contact with her.

A month in Aiken allowed "rather too much time for sad thoughts," as Henri put it. "I may have laziness in me but I never have been able to enjoy eating lotus. Sweet and dreamy peace—beautiful still moonlight— inactivity—standing still. I would rather be damming a creek, just to give it the pleasure of cutting a new bed."[13]

Henri had indeed been "damming a creek" for many months previous as he worked to bring about the amalgamation of the Society of American Artists and the National Academy of Design. The S.A.A.'s annual exhibition was held while he was in Aiken: "I wish I could see the opening of the Society," he wrote Sloan. "Would like to see how things are received by the public"[14]

The Society had been born in 1877 as a revolt against the National Academy's exhibition policy, but during the intervening years the annual shows of the two organizations gradually grew more and more alike. Membership in one was often followed by election to the other; by the turn of the century all but two of the twenty-two artists represented in the Society's initial exhibition had become Academy associates or academicians. The connection was officially sealed when Frederick Dielman, a Society founder, was elected president of the Academy, and beginning in 1900 the annual exhibitions of both organizations were held at the same location, the American Fine Arts Society Building on West Fifty-seventh Street, where their nearly identical nature became all the more apparent. As early as 1902, Charles FitzGerald had written:

> There was a time when the exhibitions of the Society had a meaning Nowadays, in its dotage, it has opened its arms to the Academy Now, as there is no longer any valid reason for separation, and as the

present arrangement leads only to a futile sort of rivalry and a superfluity of exhibitions, why not end the farce at once in the usual way—with a marriage?[15]

Whether this notion had been suggested by Henri we shall never know, but discussions were initiated in 1904, and the following year each organization appointed three members to work toward that end. President Dielman, Harry Watrous and Charles Yardley Turner represented the Academy, while Henri, Kenyon Cox and Samuel Isham spoke for the Society.

On January 12 the committee members signed the report calling for an amalgamation, it was approved by the two organizations' councils and voted upon by the membership. On April 7, 1906, while the Society's twenty-eighth annual exhibition was still on display, the merger became official.

Henri served on the thirty-man jury for the Society show before leaving for South Carolina. Once again he managed the acceptance of works by his friends, Glackens, Lawson, Redfield, Schofield, Calder and Jerome Myers. This time it was easier, thanks in part to his membership on the solicitation committee, a group of three jurors that traveled to Philadelphia before the New York judging to select works from the Pennsylvania Academy annual.

The New York judging was a bit more challenging. Thirty jurors gathered in the Vanderbilt Gallery at the American Fine Arts Society Building and sat on wooden benches or stood in groups before the stacks of paintings, fifteen hundred in all. One by one a team of shirt-sleeved workmen placed each canvas on an easel, where it was quickly appraised, voted upon and marked with a number: 1 for unanimous acceptance, 2 for a majority in favor or 3 for at least a one-third favorable vote. The letter R, for "Rejected," meant a less than one-third vote.

All works receiving a number were reexamined, and by a two-thirds vote the rating could be changed; a secretary seated at a large desk beside one of the huge circular radiators kept tally of the decisions.

The process consumed three full days and by Sunday evening the show was chosen. Henri had encouraged his students to send, and Bellows and Kent were among those accepted, but as might be expected there had been the usual minor frictions. Glackens' full-length portrait of his wife, *Lady with a Basket of Fruit,* was rejected on grounds that the basket of fruit removed the composition from the realm of portraiture. Henri objected, but to no avail; at least he was consoled to know that the Glackens canvas he had chosen from the Pennsylvania Academy exhibit would be included. And after two of Sloan's paintings were accepted by the jury, they were eliminated by the hanging committee, which was obligated to include only the number-1 selections and to use discretion in placing the others.

Henri was represented by three portraits: the full-length of Josephine Nivison and smaller canvases of Edward W. Davis and Jesseca Penn, but there is no indication that he ever saw the show before it closed on April 22 and the Society passed into limbo. He had mailed his two fifty-cent admission tickets to Sloan,

who felt the amalgamation "narrows things down."[16] But Henri had favored the union; after all, the Society was never a social power like the Academy, nor did its members ever participate in the financial rewards that were known to academicians. Henri stated his position:

> Change opens chance; as things were they stood still. Better take the chance of moving either right or wrong than to stand still. This rearranged Academy will be equal to the stuff of which it is made, no more, no less, and it will receive the chastisement of its rebels, or those outside, according to the stuff there is in the rebels.[17]

At the National Academy of Design's annual dinner, Henri was among those announced as having been elected academicians. Although he could continue to consider himself a rebel, he was certainly no longer an outsider.

A further effort to combine the Establishment and the Henri group had been attempted a week before with the suggestion to found a Society of Artists that would be expected to hold annual exhibitions of watercolors, drawings and prints. The impetus for the proposed organization was the American Water Color Society's failure to exhibit a complete set of Sloan's etchings of New York City, four of which were considered "too vulgar" for public display. That occurred on May 2, 1906. The next day the Society of Artists' organization meeting took place at the Players Club, attended by Henri, Sloan, Glackens, J. Alden Weir, Willard Metcalf, William T. Smedley, Albert Sterner and Robert Reid. It was proposed that the new Society have no officers; that its membership, once established, not be enlarged. Unanimous consent would be required to invite other artists to join. Additional names mentioned included Davies, Lawson, Shinn, Luks, Prendergast, Myers, Winslow Homer and Childe Hassam. But a second meeting of the group never took place and the proposed exhibitions never began. The initial show had been scheduled for that fall at Pisinger's Modern Art Gallery, but on May 22 that facility closed. The Henri group would wait another six months for a second such opportunity.

Henri's last art activity of the spring was participation in an auction to benefit artists who had suffered losses in the San Francisco earthquake. He donated a half-length portrait entitled *Young Woman in White.* The two-day auction was held at the American Art Galleries but "it was not properly conducted," according to Henri, "and brought only $12,000, about half or a third of what it should have brought."[18] When only a hundred dollars was bid for his own painting he quickly offered 105 dollars and bought it back.

The summer of 1906 found Henri and Chase switching roles; Chase, who had led his classes to Europe for the past three years, remained at the Shinnecock school and Henri instructed a class of nineteen in "A Tour of Study for Artists and Students" in Spain, assisted by Louis Gaspard Monté, of Columbia University's Teachers College. They sailed on June 6 for Gibraltar. Some of the group, such as

Walter Pach, Edith Bell, Louise Pope and Helen Niles, had been Henri students; others, like Dean Babcock, came under his spell for the first time on board ship:

> . . . Henri is the soul of the party; and I think he is the keenest, wittiest man I ever listened to . . . he will get to talking art with the four of us in the smoking room, and talk with such power and interest, that commercial men in the room will stop their card games to listen to him, and after he has gone will come over and ask us who that great man is.[19]

The ship paused in the Azores just long enough to afford a glimpse of Ponta Delgada, with its winding, narrow streets, tropical vegetation, bare-footed Portuguese natives and pastel-colored houses, and then it was on to Gibraltar, Algeciras, the cathedral and dance halls of Seville, the Alhambra in Granada, and finally Madrid. The first full day in the Spanish capital was June 24, Henri's birthday, and he celebrated by going with the class to the bullfights.

The students were quartered in two boarding-houses fifteen minutes from the Prado. Their mornings were to be spent painting in the studio from a model and afternoons sketching out-of-doors for the composition class or making copies of Velázquez in the museum. There were side trips to the Escorial and Toledo, where the "particularly wonderful" El Grecos could be viewed. "The class is getting on finely and everybody is happy, which state of mind did not occur with the Chase class that was here last year," Henri noted.[20] There was merrymaking too; Henri, Monté and the students danced in the garden at night, sang Sevillian songs, visited a cabaret or theater and attended the bullfights regularly. And to demonstrate a spirit that he had not known in seven months, Henri imitated a monkey climbing the bars of an old Spanish window, an event recorded in a snapshot by Helen Niles.

At the end of six weeks he hung an exhibit of student work on the walls of his studio on Calle San Marcos. "I doubt if there was ever an equal show by a class in Madrid—or abroad," Henri wrote with overwhelming pride, and "all were different." On August 4 the class departed for Paris with Mr. Monté in charge, leaving Henri behind to paint and act as chaperon for Helen Niles and Louise Pope, who remained with him.

Henri had already done some painting of his own; in fact, his full-length portrait of *Felix Asiego—Matador* had been hung in a place of honor during the student show. He was particularly proud of that canvas, having made the acquaintance of the young Asiego in a café and then watched him fight on several occasions in Madrid's Plaza de Toros. Henri described the event:

> Before the bullfight we were admitted among the fighters who were waiting to enter the ring and there Asiego posed for a couple of snapshots which I will use to start my canvas of him. Tomorrow at three o'clock he is to pose for me[21]

Within a week the painting was completed. Henri wrote:

> . . . he is in full costume as he appears just before the grand entry into the ring—the procession across to the president's box where he salutes and makes his

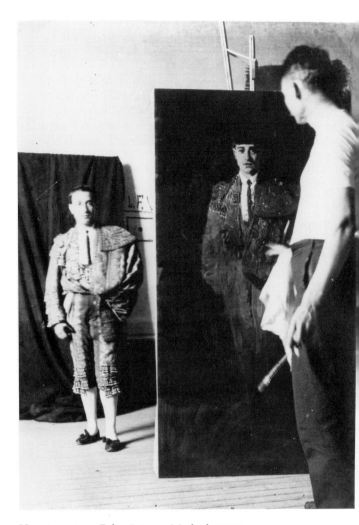

Henri painting Felix Asiego, Madrid, 1906. Photograph courtesy of Janet J. Le Clair.

short address (which no one hears) . . . before the blast of the trumpets which signals the entry of the first bull. He (in the portrait) appears before a dark background—full face with his right hand hanging at his side . . . in my portrait I think I got the sense of that look on the face I noticed particularly in Asiego. He said when I asked him afterward, that he was always a bit nervous before the fight and that he remained so until his first meeting with the bull's charge[22]

The matador's left arm and hand are lost in the folds of his purple and gold cape, and his green costume, with touches of gold, the brilliant red tie and pink stockings, stand out against the stark, dark brown background. Before Henri left Madrid he presented Asiego with a smaller portrait, and the matador gave him a sepia photograph of a triumphant pose in the bullring, inscribing it:

> A mi distinguido amigo Mr. Robert Henri.
> 8 Septre 1906 Felix Asiego

Henri had also met a band of Gypsies and engaged several of them to pose. One day while awaiting the arrival of his model, another woman, a Gypsy with a babe in arms, entered his studio, presented him with a

paper containing his name and address, sat down at his feet and proceeded to nurse her child. When his hired model failed to appear he commenced a half-length painting of the young woman and baby, to be followed by another and then a full-length version. To him such street people were more than anonymous models; they were figures in the tradition of Velázquez "through whom dignity of life is manifest."[23] Whether he painted a poor dressmaker or a law student, a Gypsy strumming his guitar or a Spanish officer in uniform, Henri found in them a common bond:

> . . . My people may be old or young, rich or poor, I may speak their language or I may communicate with them only by gestures. But wherever I find them . . . my interest is awakened and my impulse immediately is to tell about them through my own language—drawing and painting[24]

He had fallen in love with Madrid. His summer output consisted of nine full-length portraits, fourteen of half-length and two dozen landscape *pochades*. Painted in about three months, they averaged one work completed every other day. Before departing for home he purchased four sets of Goya etchings for himself and as gifts for Sloan.

When he arrived in New York in mid-October one of his first acts was to sell his land on Monhegan Island. After a summer in Spain, Maine, with its tranquility and its link to Linda, no longer appealed to him. He moved from the Sherwood Building to the Beaux Arts Studios, a ten-story structure at Fortieth Street and Sixth Avenue, facing Bryant Park. John and Dolly Sloan helped him with the furniture, shelves and painting racks, and within two weeks he began his first portrait there, of Jesseca Penn, full-length.

Henri anxiously awaited his crates of paintings from Madrid to choose works from them for the National Academy annual. He had sent compositions to the Art Institute of Chicago, Carnegie Institute and the National Arts Club, and when his Spanish canvases failed to arrive by mid-November he was forced to select other oils for this show as well. "I may send last year's production and a bust of a girl with red cheeks and a blue corsage [*Girl in Blue*]—the latter I have given to the National Academy of Design as my Academician picture which has become overdue."[25] One of his entries, *Spanish Girl,* had been painted in New York two years before.

The Academy's thirty-man jury for the 1906–7 season was chosen on November 14, and according to Henri:

> The jury selected was about the same as the usual Society of American Artists jury—to serve both winter exhibitions. I was elected by 22 votes. There were 60 some cast Notable incident was the continued refusal to elect [Charles] Hawthorne.[26]

Henri was on hand when the Academy jurors convened to choose the first exhibit since the amalgamation. All three of his entries were accepted, and some by several of his students, including Walter Pach and Louise Pope, received the necessary votes. Sloan

and Lawson also had all three of their works pass the jury. Lawson was nonplussed: "It seems strange to have these three hung," he wrote Henri, who had sent him a diagram showing where his paintings were placed. "Hope to see you on varnishing day if not before."[27] Sloan was not quite so fortunate, for although two of his canvases were hung "on the line," the third was eliminated by the hanging committee.

A newspaper reported:

> The expected has happened for the show takes on the qualities of both the old and the new societies, looks in short much as the recent academy displays looked, with its sprinkling of good and bad, the artistic things being placed cheek by jowl with inanities by the older academicians who have the divine right of wall space[28]

The judging had taken place at a time when Henri was preoccupied. His father had become ill a few days before and as his condition worsened Henri had to be in frequent attendance, at a time when he was burdened by the melancholy of memories of Linda with the anniversary of her death only a couple of days away.

For a week he dined with his parents at their residence in the Golden Gate Apartments on One Hundred Eleventh Street, joined by his brother, the doctor, who came over from Philadelphia. By December when Mr. Lee, plagued by a persistent cough and cold, complained that his legs and feet were swollen, Frank prescribed exercise: "Thought a walk would do him good as he had not been out of the house . . . ," wrote Mrs. Lee in her diary; "he and Bob went downtown for two or three hours to Bob's new studio." The next evening conversation turned to plans for a spring vacation: "Dr. and Bob . . . sat by him on the bed and talked of what we would do in Atlantic City—sit in the sun parlor and . . . push him in a roller chair—get a good boarding house"[29]

About two A.M. Henri received a phone call from his mother. He raced for the elevated train and was soon at the apartment. Frank turned to their seventy-six-year-old father and said "Here is somebody to see you." John Jackson Cozad looked up into the gaunt face of his younger son. "Bob is a good boy," he said in a near murmur, then closed his eyes and died before the first light of morning. Death was attributed to pneumonia, which had induced heart failure. He was buried in the Union Cemetery at Mays Landing in New Jersey, a graveyard often used by residents of Atlantic City, twenty miles away.

Arrangements were made for Mrs. Lee to stay with her younger son for a couple of weeks at the Beaux Arts Studios before going to live with Frank, and Robert disposed of his parents' furniture, presenting the larger pieces to Sloan. Unable to paint during the period of mourning, Henri once again lost himself in his teaching.

The New York School of Art had moved the previous fall to Broadway at the corner of Eightieth Street, where Henri's classes continued to operate at white heat. His inspirational directives to the men and women of the composition class could make anyone a

believer. "The best thing an artist does is not usually the thing he works longest on," he said. Using words such as "vigor" and "boldness," he would charge up his audience by saying: "Put activity into it Get proportions, drawing, construction, life, simplicity, strength. Think! Always begin a thing by working quickly, and go for the big curves and actions"[30] Bouguereau, his former teacher, became his whipping boy: "Judging a Manet from the point of view of Bouguereau, the Manet has not been finished. Judging Bouguereau from the point of view of Manet, the Bouguereau has not been begun."[31]

He spoke out against Bouguereau's brand of perfection, contending that it made his work "tame and unlifelike." Life, indeed, was the essence of the Henri class, with emphasis on the pulsating reality of the inner city rather than the refinement of Upper Fifth Avenue with its fashionable mansions of the Goulds, Vanderbilts and Carnegies, or the gastronomic excesses of "Diamond Jim" Brady and Lillian Russell.

To Henri's following, life was revealed in the humanity of the Lower East Side and "Hell's Kitchen." His students were taught that no spot on God's green or soot-stained earth was forbidden subject matter. As a result, his flock, including the women, rented rooms in Greenwich Village for six months in order to be properly inspired. They snooped into saloons and the lighted windows of rooming houses and recorded scenes of pushcart-lined gutters, immigrant peddlers, elevated trains, piles of trash and manure-stained cobblestones, all the while emphasizing the beauty of the commonplace. Their credo was provided by their teacher:

> Artists are sometimes asked, "Why do you paint ugly and not beautiful things?" The questioner rarely hesitates in his judgment of what is beautiful and what is ugly His conception is that beauty rests in the subject, not in the expression. He should, therefore, pay high for Rembrandt's portrait of a gentleman, and turn with disgust from a beggar by Rembrandt[32]

Henri lived vicariously through his pupils, for since he had abandoned the cityscape as subject matter he seemed somehow fulfilled each Saturday morning when the week's production of the composition class was spread out before him. Here was Adele Clark's drawing of a crowd pushing at a subway entrance; Bessie Marsh's interior of a tenement bedroom; the Salvation Army marching past the light of a penny arcade, by Louise Pope; street corners in Chinatown, by Stuart Tyson and Glenn Coleman; and Carl Sprinchorn's street scene in winter, painted from the third floor of an old building at the corner of Eleventh Avenue and Fifty-sixth Street, which showed four tall smokestacks and factories as a backdrop for street cleaners working in the snow. Henri discussed this canvas in a newspaper article titled "New York's Art Anarchists: Here is the Revolutionary Creed of Robert Henri and his Followers":

> Here is the work of a boy named Sprinchorn . . . New York whitewings cleaning east side streets after a

snowstorm—not an idealized study but just as we have seen themTruthful, isn't it? Well, a couple of years ago that boy came to me with a study in still-life to show as a specimen of his work—fruit, I think it was, or a glove and a water pitcher—you know the kind. It was one of the worst I ever saw, and I told him so. He stopped studying bananas and water pitchers and went out to look at life—plain New York life, as he could find it anywhere. Now he paints that kind, and his work has more virility and character to it than years of academic puttering over mush could give it.[33]

Henri was the first teacher to provide American art students in any sizeable numbers with the belief that there was inspiration to be found in the native subjects around them. Even their part-time jobs were looked upon as opportunities to store up visual images: Glenn Coleman earned money one summer as a traffic policeman, Julius Golz as an express-company messenger. And Bellows, who played semiprofessional ball for five dollars a game, sang on Friday nights and Saturday mornings in a synagogue and on Sundays in a church.

Henri's emphasis on the city did not come from reading Hamlin Garland or Thorstein Veblen, though his students' work closely parallels their literature, but rather from such volumes as Charles H. Caffin's *American Masters of Painting*, published in 1902. Henri's copy was well worn on a page dealing with Winslow Homer: ". . . his art has grown out of and into the circumstances of his environment, the most reasonable and fertile way of growth both in plant life and in the life of man."[34]

There was also the statement from Emerson's 1933 *Journal* that "Not a form so grotesque, so savage, nor so beautiful but is an expression of some property inherent in man the observer"[35] Henri simply applied these words to the life on the sidewalks of New York, leading students away from the studio interiors and still-lifes stressed by Chase and others, and opened their eyes to the scenes about them. As A. B. Frost, Jr., wrote to Henri in the fall of 1906: "I am very much obliged to you for the start you gave me last winter and I wish I could get the benefit of your advice again The simplest way to say it would be that I did not know that I had any ideas until you told me I had."[36]

A week after the death of his father, the crates of paintings arrived from Spain, just in time for submission to the Pennsylvania Academy annual in January 1907. He sent three full-length canvases: *The Matador*, his portrait of Felix Asiego; *La Reina Mora*, a composition of a richly costumed Spanish dancer; and *Young Woman of Madrid*, a figure engulfed in a black shawl and holding a fan. All three were accepted. He had anticipated such a reception, since Redfield was chairman of the jury and Glackens a member, but then he learned that for the second year he had just missed being awarded a prize. Glackens reported he was one vote shy and that he had not received Redfield's vote. Four years earlier, when Henri was a juror for the same exhibit, he saw to it that Redfield received the

Temple Gold Medal. Where was the justice? Redfield's explanation seemed simple enough:

> This was the first year that a prize was given for a figure composition and I imagined that it meant an arrangement of figures. Both Hassam and Glackens were agreed that Henri's Matador should have the award and they wanted a ruling from me as to whether it was eligible. I ruled that it was not![37]

Henri was pleased, however, to learn that Lawson had won the Jennie Sesnan Medal for the best landscape. It was Lawson's first prize in a twenty-year art career.

With the New York School of Art's move, a gallery was established. The new facility held its inaugural exhibition in mid-December 1906, featuring Sloan's ten New York City etchings and a group of fifteen oils, pastels and red chalk drawings by Everett Shinn.

Shinn had drifted away from the Henri group, having been involved with interior decoration in the style of Watteau; he was employing the eighteenth-century style to paint elegant figures on a mantel and buffet for the actress and decorator Elsie de Wolfe, on a piano for the playwright Clyde Fitch and across the proscenium arch and orchestra walls of David Belasco's Stuyvesant Theatre. But the majority of the drawings and paintings Shinn exhibited now were street scenes of New York.

In January, Henri's canvases were hung in the school's gallery, and in February Lawson showed. Henri attended the Lawson opening and was generous in his praise: "This man is the biggest we have had since Winslow Homer." The remark was intended to be overheard by an art critic who obligingly repeated it in his column the next day. "It is true," Henri added. "How these pictures . . . escaped the greedy fingers of the connoisseur and dealer is a wonder"[38]

Henri's noble gesture was meant to encourage sales, for Lawson's impressionistic views of the Harlem River and High Bridge had found few buyers thus far. Henri also sought to promote sales of his students' works; the same month he sent Glenn Coleman to a wealthy collector with a letter of introduction:

> You will remember that I told you of Mr. Glenn Coleman who presents this letter . . . to see you personally with his drawings of sides of life he has seen and studied in New York City. I have told you of my very great appreciation of his very personal work I think it is significant that there are men in New York who in spite of the fashion determine to make records of phases of life which interest them. I am sure you will be interested.[39]

Also in February 1907 Henri attended an exhibit in the studio of four of his pupils, a private viewing given by Edith Bell, Marion McClellan, Mary Knowlton and Adelaide Magner of works rejected from the recent National Academy show. Henri always encouraged his students to send paintings and when they were turned down he offered solace by reminding them that "throughout the whole history of art, committees and juries, whoever compose them, have failed to pick winners." Another student, John Koopman, had approached him just after the Academy's Winter Exhibition opened in December with plans for a more comprehensive salon des refusés, but Henri, while expressing interest, indicated that there was little chance of Koopman getting the people together.

When he resumed painting after his father's death, one of his first canvases was a portrait of a retired army officer with the Ninth United States Cavalry: Brigadier General David Perry, the cousin of Clara Greenleaf Perry, a student who had obtained the commission for her teacher. The full-length canvas showed the soldier in dress blues with gold epaulets, light yellow gloves and a sword by his side. The general, an old Indian fighter with gray hair and beard, reminded Henri of Grandfather Gatewood because of his "good-humored story-telling" and "most genial disposition."[40] The seven-foot painting was completed on February 17, just in time to send to the National Academy of Design's eighty-second annual exhibition. His other two entries were Spanish Gypsy Mother and Child and The Matador, the latter to be sent directly from the Pennsylvania Academy at the conclusion of its show.

In the days before the Academy judging, Henri's attention focused on the trial of Harry Thaw, accused of killing his wife's lover, architect Stanford White, in the roof café of Madison Square Garden. The night before the selection process began, Henri and Sloan relaxed in the studio and read aloud parts from Twillbe and the Widow Cloonan's Curse, reminiscing about the days at 806 Walnut Street.

The following morning Henri left the Beaux Arts Studios in plenty of time to be on hand for the Academy jurying when it commenced at nine A.M. And so the stage was set for an event that would alter Henri's life and change the course of American art as well.

CONFRONTATION AND LEADERSHIP

ON MARCH 1, 1907, the first day, the thirty-man jury faced an arduous task. Nearly fifteen hundred works had been submitted, delivered to the basement entrance on West Fifty-eighth Street and then handed up, one by one, through the two three-by-eight-foot trap doors in an adjacent room and brought into the Vanderbilt Gallery. The two-story gallery space with its warm, cream-colored walls and ideal north light was a 100,000-dollar gift of George W. Vanderbilt, whose carriage houses had once stood on the spot. Now the thirty stately gentlemen of the jury exchanged pleasantries; all were former members of the Society of American Artists and the same group that had judged the Academy's December show. The only jurymen of even casual acquaintance with Henri were Chase, F. Luis Mora and Louis Loeb; the rest were the academic Establishment, those seeking to perpetuate the status quo and, to Henri's mind, stagnation.

The jury chairman was Kenyon Cox, who typified the majority of those present. As a student he had painted breezy little pictures with loosely handled brushwork, but with middle age came conservatism and a style based upon the lingering Neo-Classicism of David and Ingres. For a recent issue of *The American Student of Art* he had written an article concerning the construction and arrangement of drapery, illustrating it with his own meticulously drawn formula sketches. Yet Cox's ability as a speaker had made him a dominating force in the Academy's jury room, and now he was ready for business.

The men spoke and chatted as they viewed the works in a procedure repeated over and over again: each painting was taken from a stack against the wall, placed upon an easel in the most favorable gallery light and voted upon. An occasional hissing noise emanated from the large, circular radiators, as if to dispute a decision. What were Robert Henri's thoughts as he gazed at the collection of classical themes and bucolic landscapes interspersed with a rare work of vitality and significance? The shiny brass doorknobs in the gallery and throughout this bastion of conservatism, the American Fine Arts Society Building, carried the initials AFAS, which many a young student of his took to mean "Art for Art's Sake," the prevailing philosophy which Henri opposed with his own credo, "Art for Life's Sake." He was obviously on hostile ground.

As the jurymen settled down to the monstrous task, each work was viewed and marked with the number 1, 2 or 3, or the letter R. As the hours dragged on and the jurors showed signs of fatigue, their eyes strained from the haze of smoke and the reflected glare of a large battery of lights, each sought his own momentary diversion, with Mora making profile sketches of Henri, Cox and others in his tiny two-and-one-half-inch pocket diary.

The paintings were being brought forward in alphabetical order, and Henri experienced an early sense of satisfaction as works by Bell, Bellows, William Beymer and Homer Boss, the first of his students to be considered, received favorable votes. Yet as the day wore on he became chagrined at the fate of paintings by Glackens, Luks and Sprinchorn, among others. Their canvases either barely gained a number-3 vote or were rejected outright. At the end of the first day's jurying, Henri reported to Sloan that one of his works had been given a number 2 and the other one "fired."

On day two, a Saturday, the jury reconvened to review their decisions. All works voted into categories 1, 2 or 3 were seen again, and where the vote was altered, most slipped to a lower category. Henri sensed an honest difference of opinion in some instances, but he also witnessed the ruthless decisions of the narrow-minded. Luks's *Man with Dyed Mustachios* was a case in point. As the vigorously painted portrait was placed upon the easel few comments were heard. Grimaces and the negative shaking of heads told the story. Then Kenyon Cox shouted, "To hell with it!" and it was voted out. Objection to his remark appeared fruitless.

During the afternoon Henri rose and asked to exercise Rule V, which had been adopted at the time of

the amalgamation the previous year. It stated that "At the request of any member of the jury, made immediately upon the taking of the vote, works marked R may receive a second vote." Henri explained: "I got the impression that some painters, not all of them young, who had brought into their work new and original notes, individual expressions of life and its philosophy, were not faring as they should."[1] The works he sought to have reviewed were by Glackens, Kent, Luks, Shinn and Sprinchorn. He further requested that the reconsideration take place in another gallery, amid different surroundings. Although the procedure was contrary to past practice, no one voiced opposition to it.

The paintings, including one that another juror, Will Low, asked to have reconsidered, were placed in a line along the wall of the adjoining room. Henri followed but none of the others bothered to re-examine the works. When each canvas was voted upon again, the verdict remained unchanged.

On the third day the jury met for its final determinations. So far Henri's *Portrait of General David Perry* and *The Matador* had each received number-1 ratings—unanimous acceptance—while the *Spanish Gypsy Mother and Child* was voted a number 2. But on the final round, the full-length likeness of Asiego, with its areas of intense color, seemingly casually placed brushstrokes and lack of carefully modeled forms, proved too much for some of the jurors. It too dropped to a number 2.

Piqued by the embarrassment and obvious affront, Henri requested that both of his number-2 entries be withdrawn. Frederick Dielman suggested that a further vote be taken on *The Matador*, and another juror, protesting Henri's action, assured him: "Oh, they'll be hung all right,"[2] but Henri declined.

That evening he dined with Sloan and revealed the day's proceedings. John was noticeably upset:

> The puny puppy minds of the jury were considering his works for #2, handing out #1 to selves and friends and inane work and presuming to criticize Robert Henri. I know that if this page is read fifty years from now it will seem ridiculous that he should not have had more honor from his contemporaries.[3]

Henri took the indignity in stride, as revealed in a letter written to his mother the following day: "I have just gotten through with the N.A.D. jury—lasted all Friday, Saturday, and Sunday—tired out. I have only one picture—the General—I had sent two others but withdrew them."[4] But the Battle of the Jury was not over.

Prior to the private reception and formal opening of the show on March 15, the full jury of selection reconvened to approve the work of the hanging committee. The original three members—Chase, Loeb and Francis C. Jones—had inexplicably resigned and were replaced by Charles Yardley Turner, Frederick W. Kost and Frederick G. R. Roth. As was the custom, the paintings were grouped to create a so-called "mural effect," and the task of the hanging committee was to arrange them harmoniously upon each wall. Henri's full-length portrait, for instance, was flanked by four smaller works of similar size, subject and tone. Festoons of greenery drooped lyrically from the ceiling with some hanging vertically to set off certain clusters of paintings.

Strolling from gallery to gallery, Henri noticed the canvases of Sloan, Lawson, Bellows, Edith Bell and Julius Golz. In the revered Vanderbilt Gallery hung his own *Portrait of General David Perry* plus works by Glackens and by Henri's students Arnold Friedman and Homer Boss. But where were Sprinchorn's *After a Snowstorm** and Luks's *Macaws*, both of which had been voted number 3? Of course, Henri was well aware that the inclusion of the number-3 paintings was at the discretion of the hanging committee, which had eliminated some two hundred of the accepted works for what it contended was lack of space. But he was not convinced and pointed out to Charles Yardley Turner an area on the west wall of the Vanderbilt Gallery where the two paintings in question could be hung. Turner challenged his intent. Did he mean to improve the wall or simply see the work of certain men hung? Henri replied: "I don't care for the wall, I only care for the men."[5]

Perhaps sensitive to Henri's feelings, which had already caused the withdrawal of two of his own works, the hanging committee hunted up the Luks and Sprinchorn canvases and had them placed in the show. But the very next day they were eliminated once again, this time because it was felt that "the two paintings in question spoiled the mural effect of the other pictures hung nearby."[6]

The entire jury episode might have remained mere studio gossip but Henri explained to his mother why it did not:

> Things have been pretty lively these two days on account of that matter of my withdrawing two of my pictures from the Academy exhibition. There has been a good many columns in the papers about it. It was nothing, but someone unkindly disposed gave a false story to the Post about it, which the editor did not believe and so I was seen and was asked to give the true account of the matter and along with it there was some considerable general impression about the way the more original artists have been steadily treated by the juries. The matter has caused some very considerable excitement among the Academy people but it looks as if there are a great many people in a great state of satisfaction over it, and to date the matter has done probably little more than draw attention to the fact that there is a National Academy show about to open. I am having quite a time responding to requests for interviews, mainly from the editors themselves[7]

An article in the *New York Evening Post* was the first one to alert the public:

> It was expected that Mr. Robert Henri's election to the Academy would prove an opening wedge for the representation of the younger element in our art The violent denunciations of the Academy's juries . . . can be remedied by the painters themselves Let the younger faction start a new organization. The time is ripe[8]

*Sprinchorn's painting was a scene of Eleventh Avenue from Fifty-sixth Street, on the West Side, but Henri's repeated reference to it as the East Side caused the artist to retitle it *A Winter Scene on the East Side, New York, 1907.*

Support came from all sides. A "Letter to the Editor" of *American Art News* asked: ". . . is Mr. Henri's attitude a nail in the coffin of the present jury system?"[9] while a letter from artist Albert Sterner in the *New York Sun* said:

> I have myself often been a sufferer through the methods he [Henri] decries. They hamper seriously the newer notes or movements in American art and prevent them from ever reaching or being taken up by the public.[10]

Even the popular magazine *Collier's* commented:

> Mr. Robert Henri's protest against the standards of the American Academy was an excellent and healthy act. . . we hope American artists will continue to fight and to accuse one another of fundamental error.[11]

Of Henri's statements to the press, one in *American Art News* best reveals the measure of the man:

> I believe in encouraging every new impulse in art. I believe in giving every American artist a chance to show what he can do, no matter whether he abides by the conventions or not. I do not believe that these exhibitions every year should be selected pictures, but rather of something broader in its scope, something that will reveal the true progress of art in America. If it is necessary to have an exhibition of selected pictures, let us have it by all means . . . I will assist in that movement, too, but these exhibitions should be kept separate from the annual show.[12]

When reporters asked Henri the reason for withdrawing his two paintings, he said it was to impress upon the jurymen that they were "placing a premium upon the commonplace to the exclusion of work of higher conception, work not necessarily his own, but of all who had come before the jury with something vital to say and had been cast out."[13] Henri admitted that the thirty jurors frequently differed and that few of the entries had been accepted unanimously.

A rebuttal came from Kenyon Cox: "Thus it appears that there are many dissenters to almost every selection made by the thirty. Mr. Henri's case is not unique; it differs from the others in that it has been made public."[14] And Frederick Dielman, president of the Academy and a member of the jury, said:

> It looks to me like the insistence of one man as against twenty-nine, probably just as well qualified as he, on his judgment Of course, the twenty-nine may have been wrong and Mr. Henri right, but we did the best we could[15]

The following month the Academy held its annual meeting; at such meetings new associate members were selected and juries chosen for the next season. Henri sought to avoid further friction by staying away, but the Academy vindictively eliminated his name from the following year's jury list. Then, in unparalleled ill temper, the academicians rejected thirty-three of the thirty-six nominees being considered for associate membership. Among the rejected were Lawson, Davies, Breckenridge, Myers, Albert Sterner, Colin C. Cooper and Charles Hawthorne. Newspapermen rushed to record Henri's reaction:

To a TIMES reporter Mr. Henri said last night . . . "In its action of Wednesday night the National Academy of Design shows that it is going to stick to its old rut. There are some few men on the list of rejected nominees whom I would have voted against had I been present, but there are also men there who are among our best and strongest artists The painter who follows in the old rut is much more certain of popular acceptance than the man who strikes out on his own account and reproduces life as he sees it . . . many of the painters who are referred to as belonging to the young school are in reality old painters who have been working for years in obscurity."[16]

Under the headline "Doors Slammed on Painters," the *New York Sun* reported:

> "Perhaps rejection isn't just the word," said Robert Henri, the painter, yesterday afternoon, "because although every man of the thirty-three rejected had the indorsement of the seven members required, still many of them did not even know that their names were being considered. Some of those who failed of election would not have accepted if the academy had voted to make them associates. Let me add that the list was the best, in quantity as well as quality, that has come before the academy in a long time"

Then, referring to the exhibit that was still on display, Henri added:

> "The academy rejects good work right and left and the result is that the exhibitions are dull because they are—dull. There are many, many good painters in the country whose work is never seen on this account.
> "You know how George Luks is rejected time and again. Look at this reproduction of one of his pictures I have here. Why, it might have been done by one of the masters, but the academy won't let him even exhibit. A splendid painter like Arthur B. Davies has been so badly treated that for years he has refused even to submit pictures to the jury"[17]

The *Sun* article was written by its new art critic, James Gibbons Huneker, and in a story the next day he became the first to reveal the immediate result of the Academy's stand: "Probably there will be, as suggested, group exhibitions of a few men from time to time next season."[18]

Even before the two recent events, Henri and his "little coterie in New York," as they were being referred to in print,[19] had begun exploring the possibility of small group shows. As early as January 1906, Henri, Sloan and Lawson engaged in "talk of the exhibition next year—each of say some seven of the 'crowd' puts in $10 per month for a year—makes a fund of $840."[20] However, they had not been motivated by an anti-Academy sentiment.

Following the dispute over the removal of the Luks and Sprinchorn paintings, Henri spoke with Davies concerning the possibility of a group show at Macbeth's. On March 9 Davies replied:

> I have just had a talk with Mr. Macbeth regarding our exhibition and he said he did not feel able to give a reply *now*, but that he felt very favorably toward the exhibition and would let us know what he would do. I think we can certainly count on his two galleries for two weeks next February.[21]

The day after, Henri, Sloan and Glackens met to discuss "the advisability of a split exhibition from the National Academy of Design." At another get-together, attended by Henri, Davies, Luks, Lawson, Glackens and Sloan, Henri was delegated to take care of correspondence and Sloan to serve as treasurer. It was agreed that everyone would contribute fifty dollars to an exhibition fund.

On April 15 another meeting was held at Henri's. Sloan and Glackens were already on hand when Shinn arrived toting a bucket of cold water to throw on the exhibition idea. Memories of the horseplay at 806.

After several attempts to find a permanent location, the group was told by Davies that the Macbeth Gallery was theirs for two weeks that fall or winter. Henri's selection of the artists was Sloan, Glackens, Luks, Lawson, Davies, Shinn, Prendergast and himself. There were, of course, other names considered. Jerome Myers had been exhibiting at Macbeth's, too, and was Sloan's friend. As early as 1903 Henri attended an exhibition of his, pointing out to a student "the picture by Myers which he [Henri] admires so much,"22 and as recently as December 1905, Henri and Myers had exhibited together at Macbeth's. However, Myers was neither a disciple nor a close associate; his canvases were sentimental views of the Lower East Side, his poor were always dressed in Sunday finery. "We all loved Myers as a person," Shinn explained, "but his paintings presented a softness, a sweetness, which were no better than an old idea."23

Years later Henri reminisced about two other artists "who might have been of the '8,' had one of them been younger or the other older." They were Albert Pinkham Ryder and George Bellows. An article titled "Revolutionary Figures in American Art" appeared in the April 1907 issue of *Harper's Weekly,* mentioning Ryder, who was twenty years Henri's senior. "The only time I met Ryder he expressed himself as strong for the '8' and spoke with enthusiasm of several members of the group," Henri stated.

As for Bellows, "George would naturally have been of the group but it antedated him."24 Inclusion of Bellows and Ryder would have presented another difficulty: the "American Ten" was still an exhibiting organization, having held its tenth annual show at the Montross Gallery during March.

On May 2 another meeting of "the crowd" was held at Henri's, with all but Prendergast in attendance. Davies disclosed Macbeth's terms for the show: a guarantee from the exhibitors of five hundred dollars plus twenty-five percent of the sales. The proposal was briefly discussed and quickly accepted, and, after Prendergast approved it, Henri went to the press with the names of the eight. He revealed plans for "a noteworthy secession from the old organization" to his pupil Guy Pène du Bois, recently appointed art critic for the *New York American,* thus allowing him to "predict" the formation of the group and scoop the other papers. The story broke on May 14, 1907, in the *Evening Mail* under the headline "Academy Can't Corner All Art":

> The new group which has no name nor formal organization, will make its first appearance in public

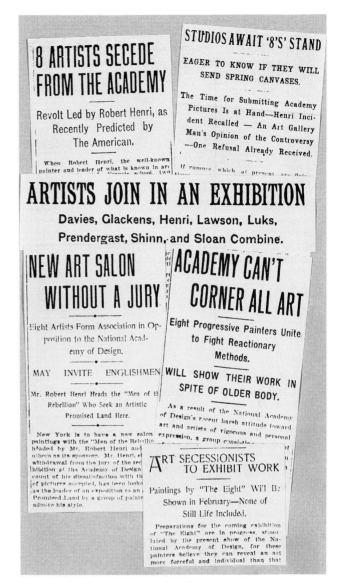

New York City newspaper headlines concerning the formation of "The Eight," May 1907.

next February . . . [in] the Fifth Avenue Galleries of William Macbeth, the art dealer. Each man will send five pictures and there will be no jury By the season of 1908–09 this group hopes to have a gallery of its own None of the dealers' galleries is large enough for a show of, say, 100 or 200 canvases, or of sculpture or other work in any quantity.25

The next morning James Huneker labeled them "The Eight" and referred to Henri as "the well-known painter and leader of what is known in art circles as the Café Francis School." Henri admitted to their being called "devotees of the ugly," while the *Herald* dubbed them the "Men of the Rebellion." The *Evening Sun* reported the event with sympathy, the *Times* with sarcasm; articles and editorials appeared in all the papers and each took sides.

It was inevitable that other artists would seek to join The Eight. Albert Sterner, who supported Henri's Academy stand and had written several letters that were published in the New York press, requested inclusion in the group:

I have read in the Sun of the banding together of the men for the purpose of being able to show untrammeled their work. You know my sympathies are all with you and I want to know if you won't let me call myself one of you. If you do I shall be happy in the knowledge that I may work and show after my own fashion with men of my own way of thinking[26]

Henri replied:

Had it been possible in the matter of gallery space we should have increased the number . . . but we concluded not to make any increase . . . for this exhibition over the number of our original show at the National Arts Club about four years ago. We did add however Lawson and Shinn, who while not exhibitors at that time were indirectly connected with the matter then. With this number—8—it is possible to show about five pictures each at the Macbeth Gallery.[27]

The New York School of Art Gallery provided a partial preview of The Eight during April 1907 when Davies, Luks, Lawson and Sloan were included in a group show there. That was followed by an exhibition of fifteen Henri students, among them Bellows, Kent, du Bois, Sprinchorn, Boss, Friedman, Pach and Golz. Although Patrick Henry Bruce was in Paris, Henri saw to it that he was represented by his *Portrait of Warren T. Hedges*. Other works included Bellows' *Pennsylvania Tunnel Excavation* and Laurence T. Dresser's *Chinese Restaurant*, *Toiling on the Sea* by Kent and the infamous *After a Snowstorm* by Sprinchorn. The show appeared to some as a vindication of Henri, Sloan noting that he was "as proud as a hen with a brood of ducks."

For obvious reasons, Henri painted few works—less than two dozen—during the first six months of 1907, of which half were of his favorite model, Jesseca Penn. Now he planned to correct all that by leading the New York School of Art students to Europe again, this time to Holland, where organizational matters could not interfere with his painting.

A few days before sailing, he, like the other members of The Eight, sat for a portrait in the photographic studio of Gertrude Käsebier, a founding member of Alfred Stieglitz's Photo-Secession group. Unlike the traditional, stiffly posed likenesses with the ever-present painted backdrop and potted palm, her photographs were of people in natural positions against a plain background; they had some of the same qualities as Henri's paintings. The proof he chose was of a seated side view with his head turned full-face. In one hand he holds his felt hat and the umbrella which he happened to carry into her studio.

Henri and his students left for Haarlem, the home of Frans Hals, on June 15. As their ship eased away from the Hudson River dock, its mighty whistle blowing and a band playing, John and Dolly Sloan and Henri's mother became smaller and smaller specks among the ocean of people who had come to say goodbye. As soon as his flock had established headquarters at the Hotel De Leeuwerik, Henri led them to the marketplace in the center of town. There at one corner stood the great Gothic cathedral where Hals was buried, and on another side the town hall with its collection of eleven portraits by the Dutch master,

who had painted them in that very building. Of course, Henri had been here before, in 1895 with Glackens and Schofield on a brief visit, but now he had the full summer to study Hals. He was moved by the implied detail of the portraits—the bravura of a guardsman's sash, a pair of boots or a gloved hand, and by the many variations of dark gray and black apparent in the well-lit gallery.

While his students sketched almshouses, the fish market and scenes along a canal in the chill of an unusually cool summer, or worked from a model in their studio over Brinkman's Café and Restaurant, Henri commenced paintings of his own. Unlike the summer in Spain, when he produced many full-length portraits, now he employed only small canvases to capture the features of children. Taking his cue from the animated expressions of many works of Hals, he sought the fleeting glimpse of a spontaneous smile or a serious expression. For the childless artist his sitters provided a summer of warmth and adoration.

Henri wrote Sloan about "his little Dutch children":

The number of my models have been but two. I could have many more, but I found two at once so interesting that I have not desired to change but have painted day after day new heads of the same one I get at 4 every day and have until 7, the other from 2 to 4 on Wednesday and Saturday One of my two models is a little white-headed, broad-faced, red-cheeked girl of about eight, always laughing. I have painted her laughing many times—the other is just the opposite but just as Dutch—white, delicate, pathetic.[28]

He painted the smiling Cori Peterson nearly two dozen times, with her hands folded behind her or on the back of a chair, holding a hat or a cat or a litter of kittens, but always with that infectious grin. Because he had to work with great speed to capture her smile, the paintings of Cori are generally more spontaneous and broadly brushed than his portraits of Martche, the older, sad-faced model who could hold a longer pose.

Henri did produce a few landscapes of windmills, including one painted on the train to Volendam, but he did not depict the streets or houses of Haarlem. Each Sunday he and the class would travel the twelve miles to Amsterdam to see the works of Rembrandt and Hals in the Rijksmuseum or walk through the Jewish quarter with its narrow streets and "everybody out of doors, eating, playing cards, scratching fleas." They would spend the evening in a café or at a variety show at the theater before returning to their home base.

By mid-August the class was over and Douglas Connah left with some of the students for Paris and Italy. When Chase had his class in Haarlem in 1903, they placed a wreath in front of the statue of Frans Hals in Flora Park, but the Henri group did not engage in such formalities. Several of them, including Hartman K. Harris, Clara Perry, Louise Pope, Helen Niles and Elizabeth Fisher, stayed on with Henri.

Before returning to the States, he made a side trip to England, where he painted the portrait of Miss Fisher's sister, Mrs. George H. Smith, wife of the former Lord Mayor of Halifax. The three-quarter-

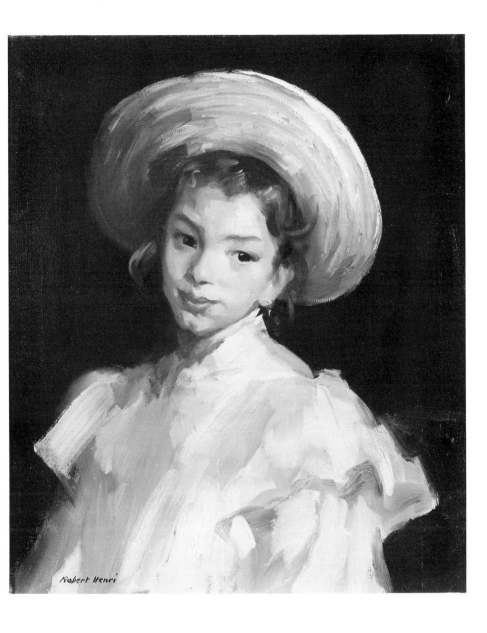

Dutch Girl in White, 1907.
Oil on canvas, 24" × 20"
(60.9 × 50.8 cm.).
The Metropolitan Museum of Art,
Arthur H. Hearn Fund, 1950.

length canvas, completed in four sittings, is of a seated figure resplendent in a diamond necklace and earrings, white lace and a black silk bolero and skirt, and holding an ostrich-feather fan, her brown fur draped rhythmically over a Chippendale chair. During his stay, Henri made an ink sketch of the house in which Laurence Sterne had written *Tristam Shandy*, and visited the homes of Daniel Defoe and Charlotte Brontë. He wrote Sloan about being on "a great moorland which was once covered by the Sherwood Forest where Robin Hood held forth" and enclosed a sprig of heather as a souvenir.[29]

Before his departure from New York, Henri had arranged to give up his studio in the Beaux Arts building on West Fortieth Street and take a top-floor space in a converted church on East Fortieth. When it became apparent that he would not return by September, he wrote Sloan that "it looks as if you are in for the moving"[30] and his obliging friend assisted five men in transporting his belongings. The Sloans cleaned and arranged his furniture; then Dolly and Mrs. Lee sewed a set of curtains. Upon his arrival in October, Henri presented Dolly with some of Linda's

lace handkerchiefs and Sloan with an art book and reproductions of Rembrandt etchings.

Order had always been characteristic of Henri's studio. The painting racks were tailor-made, and the kitchen table he used as a palette was always tidied up after work. In one corner were rows of art books and the scrapbooks from his youth, in another the record books in which he made a pen-and-ink sketch of each of his finished paintings, complete with descriptive notations. An inveterate letter writer, sometimes wordy to a fault, he kept careful track of his correspondence. His studio often contained a crate or two of paintings sent by former students seeking his opinions; he would record his comments and ship the boxes back.

Vachel Lindsay, for instance, had just written Henri from Springfield, Illinois, that he had "evolved some colored designs which I hope to submit to your approving disapproval about the first of November . . . ," adding, "your censure is worth more to me than the praise of the foolish."[31] Students in the United States and abroad kept him informed of their progress: Patrick Henry Bruce wrote of his inclusion

in the Autumn Salon in Paris; Walter Pach reported his translation of a book about Velázquez and wrote that Henri's painting in the Luxembourg Museum was admired by Monet.

In the fall of 1907 Henri again began teaching at the New York School of Art but without competition from Chase. It had become common knowledge that Chase, after several years of seeing his classes diminish while Henri's grew, was leaving the school he had founded to teach at the Art Students League. Henri commented:

> There is going to be a desperate fight I guess to knock out the N.Y. School of Art but I have no doubt but that—if the N.Y. School manages the business end all right, that my reputation as a teacher will carry against all that they will do. It appears that Chase is very bitter about the way the students of the school have flocked to my classes[32]

The story spilled over into the pages of the *New York American* under the heading: "Wm. M. Chase Forced Out of N.Y. Art School; Triumph for the 'New Movement' Led by Robert Henri." Chase was quoted as saying:

> I warned the students who still leaned toward my way of thinking that there was danger in mistaking violence for strength, vulgarity for caricature, and that such mistakes could not lead to triumph in art As to Mr. Henri, I have nothing to say. His influence was not like my own upon the pupils. Art is draughtsmanship. Without it nothing can be accomplished. Color is the natural gift of the artist, but without drawing and a thorough understanding of it, no supremacy in art can be obtained[33]

Henri, as always, replied courteously:

> Mr. Chase has done a great deal of valuable work for the students There is nothing new in my philosophy but truth, which is always new. I think the student profits by working with many instructors, for we learn from everybody Because I do not require my student to draw a map of the model and keep his ideas subordinate to the sense of outline, I am criticized. But I believe that proportion has no part in moulding the character and spirit of the sitter with the brush. I do not teach my students to lean on what I say or what I see. I want them to see for themselves. I want them to be independent.[34]

"And so," he wrote one of his pupils soon afterward, "the turmoil goes on and the little things, squabbles, jealousies, misstatements crowd into one's existence and one is disturbed from the simple big thing of doing one's work."[35]

Once again Henri had little time to paint. He spoke of "how free we were to work and think in dead old Haarlem" where, during the summer, he had produced over sixty compositions; after his return and through the end of the year, he completed little more than a dozen. Again, many were of the red-haired Jesseca Penn, and there were two canvases of a fourteen-year-old black girl named Eva Green, one of which he painted on Christmas Day. He posed her so that a bright red ribbon showed behind a fluffy, black tam-o'-shanter, her smiling countenance like a beacon above a boldly painted dark blue coat.

On the formation of The Eight the previous May, Henri was quoted as saying: "Please let it be understood that those of us in the habit of sending to the Academy will continue to do so,"[36] and in the fall a letter was circulated among the group that participation in The Eight did not preclude further attempts to show at the Academy. Although at one point Henri had about made up his mind not to, he did ultimately submit *Girl in Yellow Satin Dress*, a full-length portrait of Jesseca Penn, and because of his status as an academician the canvas was accepted and hung jury-free. One evening in December, following dinner at Mouquin's, Henri and Sloan visited the show, which Sloan found had "almost no bright spots" except for Henri's painting, two by Bellows and one by Ben Ali Haggin. No more than a dozen gallery-goers were present. Returning to Mouquin's, the two men collaborated on the following "Letter to the Editor," signed "Citizen" and sent to the *Evening Sun*:

> I visited the winter exhibition of the National Academy of Design. During my stay, from 8 o'clock to the time of closing, the galleries were visited by no more than a dozen persons.
>
> I have read that the Academy desires to secure funds for the erection of galleries two or three times the size of the present.
>
> If they succeed I suppose they would attract two or three dozen out of a population of 3,000,000. But it's so lonely! So lonely now! I know that I could not endure the vast vacancy of the galleries of that future day.
>
> Oh no! Croesus, hold the purse till the *Visitors* demand more space; heed not the plaintive cry of those who sit behind such unattractive wares.[37]

The catalog for the National Academy show allowed William Macbeth to add a bit of fuel to the fire; he increased his customary half-page ad to a regal full page, and though The Eight were not mentioned by name, it proclaimed:

> *Paintings by American Artists*
> Choice Examples Always on View
> Frequent Special Exhibitions
> WILLIAM MACBETH, 450 Fifth Avenue, New York

On January 4, 1908, the National Arts Club opened a "Special Exhibition of Contemporary Art" organized by John Nilson Lourvik, an art reporter for the *Times*. All of The Eight were included, plus Sprinchorn, Kent, Steichen, Eugene Higgins and several others. Henri was represented by *Lady in Black* and *Willie Gee*, which the *Evening Post* referred to as "works of merit if not of great distinction." And the *Evening Mail* pointed out that "it seems to be a pretty complete anticipation of the show of the great innovating Eight . . . which is to take place at Macbeth's next month. It takes the wind out of the sails of that exhibition."[38]

The day after the opening, Henri left for Wilkes-Barre, where he was to paint a portrait. Such a commission should have taken a few days but dragged on for the rest of the month because the sitter, a devoutly religious man, would not consider posing on Sundays and Henri had to return to New York each Monday for his classes.

Between trips, he and The Eight met at Mouquin's or his studio to work out final details for their show. It was announced that Macbeth had reduced the guarantee from five to four hundred dollars, but with the cost of printing and mailing the catalog it was agreed that an additional forty-five-dollar assessment would be required from each man. The figure was later reduced to thirty dollars.

Henri worked on a mailing list, Davies purchased twenty-five hundred envelopes and Sloan, in order to conserve funds, consented to photograph paintings for the catalog. Glackens kept spoiling the canvases he was attempting to complete for the show and, frustrated, announced that he was "already sick of the damn exhibition." When Sloan went to Luks's studio he spotted a recently completed painting, *The Wrestlers,* and thought it a masterpiece. He extolled its praises only to learn that Luks had no intention of including it in the Macbeth exhibit. "I'll keep it 'til I'm invited to send to some big exhibition," he announced. "Then this will show Kenyon Cox, Will Low and the other pink and white idiots that we know what anatomy is. I painted it to vindicate Henri in his fight for my work on the National Academy juries."[39] Luks mailed Henri a postcard on which he drew "Henri and his 8" in the guise of a chorus, with Henri conducting and treasurer Sloan pounding a bass drum with dollar marks drawn on it.

Since Henri was commuting each week to Wilkes-Barre, Davies planned the catalog. It was decided that while the names of The Eight would appear in alphabetical order on the cover, the double-page spread inside devoted to each artist would follow Henri's arrangement for the hanging of the show. The two galleries at Macbeth's new location were identical in size, so the wall space in each was divided equally. Upon entering, a visitor was expected to turn to the right and walk around the first room, seeing the

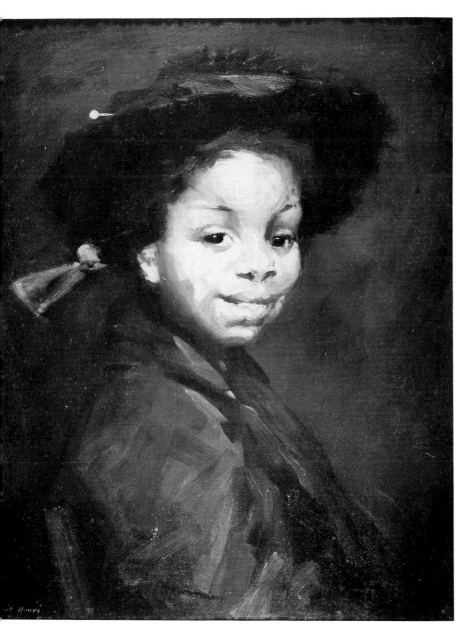

Eva Green, 1907.
Oil on canvas, 24⅛" × 20³⁄₁₆"
(61.2 × 51.2 cm.).
Wichita Art Museum, Wichita, Kansas,
The Roland P. Murdock Collection.

paintings of Shinn, Lawson, Sloan and Prendergast in that order; then through the archway for the canvases by Luks, Henri, Glackens and Davies.

The original idea that each artist would exhibit the same number of works was abandoned in favor of equal wall space of twenty running feet. Lawson was represented by four large canvases, while Prendergast had seventeen small oils and watercolors on display. Henri, Davies and Sloan discussed the advisability of hanging all the pictures in a single row, in obvious opposition to the discriminatory tiers in Academy displays, and they did except for Prendergast's small studies of Saint-Malo, which were double-hung. Lawson arrived from Philadelphia, where he had served on the Pennsylvania Academy jury; he had proposed Henri's *Spanish Dancer* for the Temple Gold Medal but his choice was not even seconded. Bellows had been voted the Lippincott Prize, then after lunch the decision was reconsidered and the prize awarded to another.

Henri's diagram of the placement of works by "The Eight" in the Macbeth Gallery. Pencil. Collection of Janet J. Le Clair. From Henri's diary, January 1908.

Henri was working at a frantic pace. Portions of three days were absorbed by classes; more time was taken by an exhibition by eighteen of his students from the women's life class at the school. An article about The Eight, scheduled to appear in the February

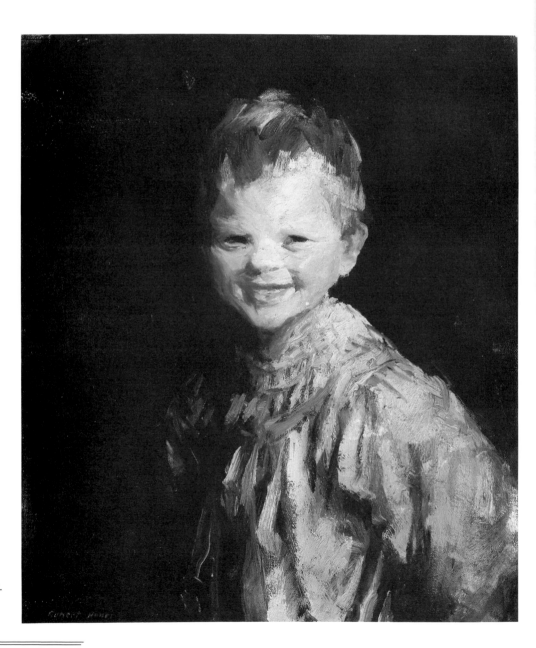

Laughing Child, 1907.
Oil on canvas, 24" × 20"
(60.9 × 50.8 cm.).
Whitney Museum of
American Art, New York.

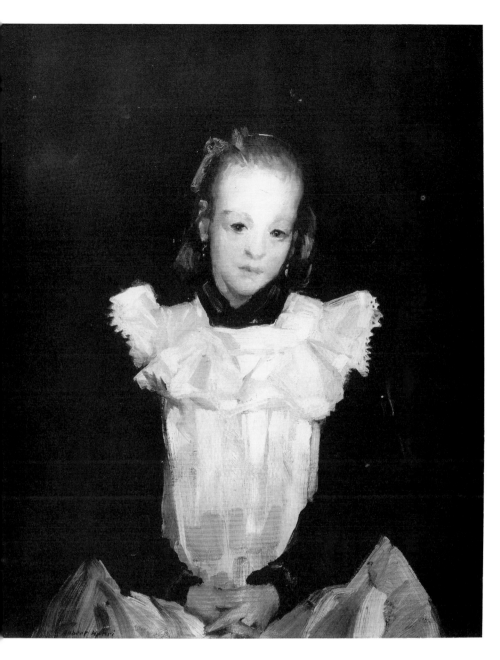

Martche in White Apron, 1907.
Oil on canvas, 32″ × 26″
(81.2 × 66.0 cm.).
Collection of Mrs. Linn H. Selby.
Photograph courtesy of
Peter A. Juley & Son Collection,
Smithsonian Institution,
Washington, D.C.

issue of *The Craftsman*, had been sent him by Mary Fanton Roberts, the managing editor. He continued to read and reread it, correcting the proof and contemplating modifications of his quoted words.

On January 27, when he returned to Wilkes-Barre, he wrote Sloan that "I can't get back—expect to finish the new second portrait of Mr. Smith tomorrow morning—practically done now . . . will commence a portrait of Mrs. Smith at once—I fortunately brought with me an extra canvas"[40] Another letter said: ". . . would like to be in New York now to do more of my part in attending to the exhibition at Macbeth's and having the fun of it all"[41]

When Henri did return two days before the opening, he was quick to voice his displeasure to Sloan over the quality of the reproduction of his painting in the catalog. It was an unkind cut for Sloan, who had assumed much of the burden of the show and was

teaching Henri's classes in his absence to boot. Restricting a reply to the pages of his diary, Sloan wrote: "It is not very good—but as usual in these affairs, one or two do the work and the rest criticize."[42]

On February 1, The Eight gathered at Macbeth's to hang their work. Six of Henri's nine paintings had been produced in Holland the previous summer, including a portrait of Cori entitled *Laughing Child*, one of Martche named *Little Girl in White Apron*, and *Dutch Soldier*, a half-length study of a stern-looking military man with a ruddy complexion, wearing fur headgear and a blue uniform with silver buttons. A small panel painting of Monhegan, another of Segovia, Spain, and a half-length *Portrait of a Girl*, Jesseca Penn, rounded out his portion of the exhibition.

With the gallery in readiness and plentiful newspaper announcements, The Eight awaited their Monday opening.

CHAPTER 14

"THE EIGHT" AND A WELL-KEPT SECRET

ACCORDING TO SLOAN, Henri seemed nervous over the exhibition when it opened on Monday morning, February 3, 1908. William Macbeth, the bearded, blue-eyed Irishman, began welcoming the first visitors to his domain. Both of the nineteen-by-twenty-three-foot rooms were filled with the curious. Soon three hundred people an hour were estimated to be filing past the sixty-three works. "The show . . . is creating a sensation," observed an elated Henri. "It was packed like an Academy reception from early morning to night . . . It looks fine to me."[1]

Beginning at nine A.M. the gallery-goers took a continually crowded little elevator to the upper floor, then traversed a narrow corridor to the doorway. Henri's *Laughing Child* faced them upon entering, but many of the spectators failed to smile back. "Of course, a loud chorus of disapproval—mostly honest—on the part of many artists and laymen, was heard . . . ,"[2] Macbeth confessed, yet the throng continued, unabated, until closing time at six P.M., undeterred by the frigid and snowy weather.

Each exhibitor had opinions, too. Davies criticized the hanging, which appeared a little crowded; Prendergast thought they should have prepared more expensive catalogs and charged ten cents apiece for them. Sloan failed to attend the opening altogether, feeling that his clothes were too shabby. That evening the artists celebrated at the Prestons. Henri, Lawson, the Sloans, the Glackenses, the Shinns and Maurice Prendergast and his brother Charles all attended, as well as Charles FitzGerald and Frederick James Gregg. The noisy gathering lasted well into the morning. Viewers continued to surge through Macbeth's all week and it was estimated that seven thousand people saw the show.

Reviews of the exhibition were divided. It was censured: "Bah!" one critic wrote. "The whole thing creates a distinct feeling of nausea."[3] And praised: The Eight were called "excellent"; their paintings "escaped the blight of imitation."[4] None of the artists was spared criticism: Henri's portraits were likened to "a collection of masks";[5] Lawson's *Floating Ice* showed a "wilful lack of design";[6] Glackens' *Shoppers* had an "anemic color scheme";[7] Luks's *Macaws* would "stab you in the optic nerve."[8] Prendergast's Saint-Malo watercolors were described as "crazy quilt sketches"[9] while an oil was characterized as "a jumble of riotous pigment . . . like an explosion in a color factory."[10] The *New York World* devoted an entire page of its Sunday edition to "New York's Art War and the Eight 'Rebels.' "

The severest condemnations were leveled at Luks's canvas *Feeding Pigs*, depicting seven of the animals at a trough with a red-haired boy throwing a bucket of slop in their direction. One critic wrote: "I defy you to find anyone in a healthy frame of mind who wants to hang Luks' posteriors of pigs"[11] The voice of that kind of authority would not have been affected by Henri's argument that the subject may be beautiful or ugly, but the beauty of a painting is in the art itself. Could the writer ever have seen Rembrandt's *Slaughtered Ox*?

For every slashing review, there was one of praise. Guy Pène du Bois wrote enthusiastically in the *New York American*, and complimentary reviews appeared by Huneker of the *Sun* and Gregg of the *Evening Sun*. Unfortunately for The Eight, Charles FitzGerald had been promoted to editorial writer and did not cover the show.

James B. Townsend of *American Art News* sounded a warning to those individuals who were leading the attack:

> That "The Eight" have among them strong painters cannot be denied, and the impulse and impression their first show may have upon present art conditions who can say?[12]

On the final day, Macbeth revealed that sales had amounted to nearly four thousand dollars, a "remarkable success," according to him, because of the poor financial climate brought on by the recent currency panic in New York. In the one-man show by Jerome

Myers immediately preceding The Eight's, there was not a single purchase, but at their exhibit seven paintings were sold: Gertrude Vanderbilt Whitney acquired Henri's *Laughing Child* and works by Luks, Lawson and Shinn, a brave act indeed, for at that time buying such unfashionable pictures was nearly as revolutionary as painting them. Henri's *Coast of Monhegan* was also sold, as were two works by Davies.

When the exhibition closed in February, Henri delivered seven additional canvases to Macbeth's, mainly portraits of Cori and Martche, in the event of future inquiries. In the meantime, he had received a request from the Rowland Gallery in Boston that The Eight exhibit be sent there. While negotiations over payment of shipping costs were under way, the Pennsylvania Academy offered to take the show, pay half the transportation and "place at your disposal two good rooms during the month of March."[13] The Eight agreed and substitutions were made for the paintings sold. Henri sent *Merry Child,* another portrait of Cori, and *Maine Coast.*

The Philadelphia version of the show opened on March 7, 1908, and the press was more favorable, perhaps partly because four of The Eight were remembered as newspapermen from that city. A week prior to the opening Henri wrote the following to the Academy's manager:

It may be useful to say something on the subject of publicity as there has been so much printed that is and is not fact. I give the following for your personal information, and write it therefore in a form not ready for a reporter's eye. The name "The Eight" is not of our making nor do we desire that or any other name. We are not a society and are not organized for any other purpose nor for a longer time than the duration of this exhibition. It is most likely that should another gallery or institution offer, the collection would be kept intact for exhibition. We have made no plans for continuation as a body—If it should happen that the same men reunite for an exhibition in the future it must be entirely a new affair. There has therefore never been an organization of a society called "The Eight"[14]

Ironically, the Pennsylvania exhibit of The Eight was followed by one of "The American Ten," which had just been shown in New York as well. At least one member of The Ten looked upon The Eight as merely "an attempt to boil the egg over again,"[15] yet in comparison to The Eight, The Ten was now old hat.

Back in Manhattan a group of Henri students, realizing that their mentor had been fighting their battle, held an exhibition of their own. It opened on March 9 purposely to coincide with the National Academy of Design's spring exhibit. Fifteen Henri men rented the top floor of the Harmonie Club Building on West Fifty-second Street and announced the show as an "Exhibition of Paintings and Drawings by Contemporary Americans." The brainchild of Arnold Friedman, Glenn Coleman and Julius Golz, it included their work as well as drawings and paintings by Bellows, Hopper, Kent, du Bois, Sprinchorn, Edward R. Keefe, Howard McLean, George McKay, Harry Daugherty, Stuart Tyson, LeRoy Williams and Laurence Dresser. Henri visited the two-room display

and "was all for it," applauding the art as well as the manner in which flaking paint had been masked by covering the walls with unbleached muslin gathered in a great festoon beneath the ceiling. The exhibitors looked upon the pioneering effort as having "assumed the proportions of a warrant, a death warrant to the Academy, no less."[16]

At the Academy show further uptown it appeared as though the barriers had suddenly vanished. The paintings of Henri, Lawson, Davies, Sloan, Bellows, Kent and W. T. Benda, also a Henri student, were given a wall to themselves. Henri observed:

. . . they made a group of what they considered the "modern movement" or the "8" movement and took much credit to themselves for it—the wall was the worst lighted of the whole exhibit and the hanging was horrible. I found one picture overlapping mine and all else bad hanging and overcrowded.[17]

He had become, as one paper put it, "the most pronounced figure in the art world at the present time"[18] Although Henri's biography had been included in the *American Art Annual* since 1900, the first year it listed artists, and he had been chosen for *Who's Who in New York* in 1906, he was now elected to membership by the National Institute of Arts and Letters and in April was honored at the Comic Artists Beefsteak Dinner together with other luminaries, including Mark Twain.

Henri was asked to serve on the Carnegie Institute jury, and when he arrived in Pittsburgh found himself in the company of Chase and Kenyon Cox. Henri and Schofield voted the first prize for Sloan's painting of *The Cot* but not one of the remaining seven jurors agreed, whereupon Henri recommended it for second place, with the same result. When third prize was considered, John Alexander and Charles H. Davis sided with him and Schofield, but the four votes were still one short of a majority. "I came near it again— near it!!"[19] was Sloan's reaction.

Early in 1908 Henri painted the last of several dozen portraits of Jesseca Penn, the model who visually filled the void left by the death of Linda. He had never really overcome the loss and had written to Linda's parents the previous fall:

I look back on the happy life we led together—for it was as few lives are happy in spite of the illness of which she was victim—and I feel as though I am put out in the world without half of myself—to keep going but never be settled.[20]

Now that situation was about to change. In March 1908, Henri began a portrait of yet another redhead named Marjorie Organ, and within five weeks they would be married.

Marjorie Organ was born in Ireland in 1886, one of five children. Her father was an artist of sorts, creating wallpaper designs for a living, a profession he continued after he brought the family to the United States when Marjorie was thirteen. They settled on Waverly Place in New York and she went to St. Joseph's School on Washington Square for a year. As was the custom at the time, Marjorie entered the Normal College, later Hunter College, at the age of

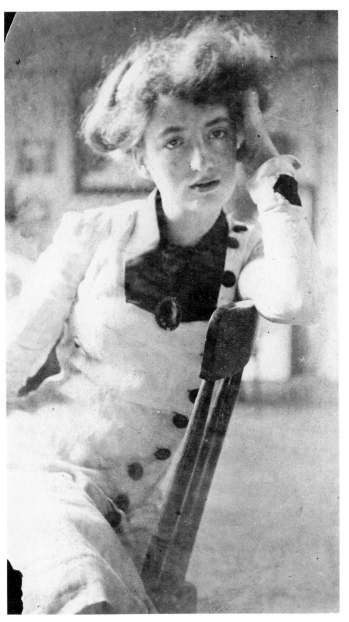

Marjorie Organ, ca. 1907. Collection of Janet J. Le Clair.
Photograph courtesy of Delaware Art Museum, Wilmington.

fourteen, but left after a month to become a pupil of
Dan McCarthy, a cartoonist who ran a school near the
offices of the *New York Journal*. Rapidly developing a
flair for pen-and-ink figure drawings, she went to
work for the *Journal* as a cartoonist in the fall of 1902
and originated several comic strips, including *Lady
Bountiful* and *The Man Haters' Club*. Another of her
comics, *Reggie and the Heavenly Twins*, involved the
misadventures of two young girls and was modeled
after Marjorie's day-to-day escapades with another
redhead, Helen Marie Walsh, her closest friend ever
since they had been classmates in parochial school.

The *Journal's* art room housed a dozen cartoonists,
including Rudolph Dirks, who drew *The Katzenjammer
Kids;* Richard Felton Outcault, originator of *The Yellow
Kid;* and Paul Bransom, artist for *The Latest News from
Bugville*. Marjorie Organ was the only female on the
art staff. When the men told off-color jokes she

merely smiled politely, maintaining her dignity and
charm, for she had a good sense of humor and was a
maverick as far as the mores of the day were con-
cerned.

Marjorie met Henri at Mouquin's on February 3,
1908, after the opening of The Eight exhibition, to
which she had been invited by Rudolph Dirks. She had
brought along Helen Walsh; it was also the first
meeting of Dirks with his future wife. Henri, dining at
another table, walked over to greet Dirks and compli-
ment him on the painting he had sent to the Pennsyl-
vania Academy. Immediately attracted to the red-
haired, blue-eyed Marjorie, he was even more in-
trigued when he learned that she was the creator of
one of the comic strips he so enjoyed. He suggested
she join his class, which she did, teasing him during
the initial critique by sketching a caricature of him
with enlarged feet. The teacher reciprocated by asking
her to pose for a portrait in his studio, and it was there
that the romance blossomed.

Henri was scheduled to return to Spain that sum-
mer. Perhaps because of the possibility that an eligible
bachelor who suddenly married would discourage
female students from enrolling, he kept the wedding
secret until after the ship left New York harbor. The
marriage had actually taken place on May 5 in Eliza-
beth, New Jersey, and Sherman Potts, the newspaper
artist, was witness to the civil ceremony, which was
held in his cousin's home. When Potts finally broke
the news on June 2, the day Henri and the class sailed,
it became top gossip. The story appeared in the *New
York Times* and Florence Shinn wrote to Edith
Glackens:

> Wouldn't it jar you to think you were sailing with an
> eligible parti, (first having invested in a becoming
> steamer rug, a seashore bang and scented soda mints)
> and then be confronted with a golden-haired bride,
> just as the gangplank creaked its goodbyes to the
> gaping crowd?[21]

Many of Henri's close friends were surprised. It had
been assumed that another of his students, Louise
Pope, would become the second Mrs. Henri. Tongues
had also begun to wag each time he had taken
Elizabeth Fisher to dinner or was seen holding hands
with Mary Perkins, both also pupils of his. Even
brother Frank had been kept in the dark about the
wedding; he met Marjorie for the first time twenty
days after the wedding had taken place.

Sloan received a letter from Henri written on board
the S.S. *Moltke* and mailed just before sailing:

> Forgive silence but a bargain is a bargain and we
> agreed to keep silent. It was to prevent newspaper
> notice, etc.—and we agreed on absolute silence. You
> know perhaps the Journal and World drawings of
> Marjorie Organ, so in a way you know who I have
> married.[22]

For Marjorie, whose only travel had been her trip
from Ireland, the experience was overwhelming.
Henri attempted to relive the summer of 1906,
staying at the same pensión, attending the bullfights
and enjoying the same cafés—now all with Marjorie.

Sometimes his student Randall Davey accompanied them, replacing the female pupils who had served as Henri's companions in previous years.

The surprise marriage was still the talk of art circles when Henri returned to New York. The July 19 Sunday edition of the *American-Examiner* carried a story about his supposed courtship, headlined: "The Romance of a Girl with Red Hair," which placed his meeting with Marjorie at a masquerade ball. Some students had supposedly gone to his studio to urge him to attend and there "they found him painting a 'Sunset in Spain.' His easel stood directly beneath the pall-draped portrait of the late Mrs. Henri. His face wore a mantle of profound gloom."

At the ball he impersonated a Spanish nobleman and then spotted "The Red Haired Girl." On bended knee he pleaded his cause until she remarked "Oh, please get up. Why should the great Robert Henri kneel to poor little Marjorie Organ, the great painter to the beginner?" The article reported him as saying: "Love is the supreme leveller, dearest," and he pressed her hand inside the pocket of her coat. The story concluded: "In his eyes there is no master. All are beginners."[23]

Henri was sent a copy of the newspaper story, complete with pictures. "Not one word of it was true," was his only comment, and that included the location of the marriage in Connecticut.

During the summer in Spain he reverted on occasion to his earlier, Manet-inspired style, especially in such imposing canvases as *Spanish Girl of Madrid*, where the black hair and shawl of the model melt into a consuming black background, thereby isolating the light head, white blouse and red skirt (see color plate). The resultant two-dimensional illusion is akin to that in Manet's *Portrait of Émile Zola*.

This work is in marked contrast to *The Picador*, a likeness of Antonio Banos where a strong highlighting of the costume creates a greater three-dimensional sensation. Portions of the jacket in both full-length and half-length versions are brushed with such abandon that the gold decoration of the deep red sleeves becomes more interesting as shape than as realistic detail. Despite the Velázquez and Manet influences in his work, Henri's greatest inspiration now came from Frans Hals; such paintings as *Celestina*, an old Spanish woman smiling, and that of *Cinco Centimo*, the *Spanish Gypsy Child*, demonstrate the skill and bravura associated with the Dutch master.

On the way home from Spain the newlyweds stopped in Paris just long enough for Henri to show Marjorie his painting in the Luxembourg Museum, to visit the Louvre, attend performances at the Folies and the Bal Tabarin, and view the Autumn Salon. If Henri found it difficult to comprehend Prendergast's excitement over an artist named Cézanne, his liberal attitude suffered a total lapse when he happened into a roomful of thirty Matisse drawings, paintings and bronzes, for he characterized them in his diary as "strange freaks."

This blind spot was to persist, ultimately having a negative effect not only upon his painting but on that of his students as well. When Henri visited Sloan in November, he described what he had experienced at the Autumn Salon and suggested that "the Eight exhibition was much more notable."[24] Although he encouraged his pupils to see a Matisse exhibit as early as 1910, Henri would never voice the same enthusiasm for *his* art as he did for that of Manet, Velázquez and Hals, always acknowledging that Matisse and Cézanne were "highly intelligent men" yet "along a different line."

Back in Manhattan, Henri adjusted to married life with more socializing and theatergoing. In contrast to his first wife, whose health was fragile and interests often self-centered, Marjorie was outgoing and entertaining, with a good sense of humor. Though she was a liberated woman who smoked and even let her Titian hair down in public, she was willing to do menial chores for Henri, whom she referred to as the "Boss"; these included shopping for his paints and brushes, feeding his youthful models and running errands.

Because of the twenty-year difference in their ages—Marjorie was twenty-two, he forty-two—they decided against having children and for the first year Henri maintained a careful record of the peaks of Marjorie's fertility cycles by noting them with a dot within a large "O" in his diary.

The canvases produced during that fall were mostly portraits of Marjorie or schoolroom demonstrations in the men's and women's life classes. A few seascapes, bearing such titles as *Maine Sea and Headland* and *Stormy Sea*, were painted in his New York studio from memory or inspired by some of the Monhegan compositions he had on hand.

While the Henris had been honeymooning in Madrid, Sloan was mapping plans for The Eight traveling show, assisted by Carl B. Lichtenstein, a former manager for a book publisher who maintained numerous museum contacts. When the exhibition closed at the Pennsylvania Academy in March, it appeared that the Toledo Museum would book it for April, until a telegram was received: "Sorry but are full. Could take exhibit in fall gladly."[25] The Detroit Museum was also approached and replied: "The season is too late however to take the matter up at this time, but I would be pleased to have them [The Eight] with us some time during the next season if arrangements can be made to that effect."[26]

In June 1908, plans were concluded for the exhibit to open at the Art Institute of Chicago on September 5. Sloan had written Henri in Europe:

> The latest information from Lichtenstein in the West is that he has arranged for Chicago, a month—Toledo, a month, Detroit, a month, and Indianapolis. He will also, if things come right, fix it for Grand Rapids and Milwaukee, but he is waiting [to bring] Cincinnati and Buffalo into line first, thus working back East with a view to start in the West next year. He is certainly a brick the way he has taken hold for us[27]*

*The Eight's traveling show would ultimately go to the following cities between September 1908 and May 1909: Chicago, Toledo, Detroit, Indianapolis, Cincinnati, Pittsburgh, Bridgeport and Newark.

As usual, the organizational details fell to Sloan by default; he took on the task of reassembling the paintings from the Macbeth show and, with Henri away, gathered up the canvases from his studio.

At the Art Institute the exhibition was called "Paintings by Eight American Artists in New York and Boston." That title remained throughout the tour. When it opened in Toledo in mid-October, the *Toledo Times* headlined its story: "Big Sensation at the Art Museum." One woman was overheard to say: "Really, I am beginning to feel there is something wrong with my eyes," and another: "I feel real creepy, but it's fine, and I like it, after I've been here awhile."[28] Helen Niles, a former Henri student and a Toledo resident, gave a museum talk about the art of The Eight.

Although the Corcoran Gallery in Washington did not schedule the show, its director wrote Henri about the forthcoming Biennial: "We have invited for our exhibition one picture by each artist included in the organization called 'The Eight' in order that each of these men may be sure of representation"[29] As early as the fall of 1908 the immortality of The Eight seemed assured.

The exhibit continued on its nine-month circuit; Henri, Sloan and Lichtenstein hung the last show in the Newark Public Library, and on June 7, 1909, the paintings were returned to the artists without a single sale. After that date The Eight as an exhibiting organization ceased to exist.

There had been thoughts of a second exhibition in New York the following February, but it never materialized. In October 1909 Luks inquired of Sloan: "Are the 'Eight' going to have a show this season? I think we should—as there naturally will [be] anxiety on the part of our admirers, what we'll spring on em—."[30]

Sloan, having just completed the task of preparing the traveling show, was willing to let the subject ride. However, six weeks later Henri entertained the same idea:

> Talked with Glack and Sloan about an 8 show at Macbeth's. Want to know what the desire is so that if there is not to be an 8 show, then I may make other arrangements for exhibits. Glack for it. Sloan ditto. To call a meeting at my studio Thursday [December 16].[31]

But Henri learned from Macbeth that his exhibits were booked through May. "Macbeth said he would be sorry to see the 8 anyplace else. There will probably be no 8 show therefore this winter in New York."[32]

With The Eight exhibition Henri and his associates had opened the door to artistic freedom, to the concept of invitational shows without a jury. And they were quickly recognized as the leaders of a truly American school of art.

Repercussions were most noticeable within the National Academy of Design itself, where the spring 1908 annual, which followed on the heels of the Macbeth show, included a larger percentage of works by young and unknown artists. In an unprecedented move, the Academy hired Harrison S. Morris, the former director of the Pennsylvania Academy, to organize the next winter exhibition. Morris sought the cooperation of Henri, who set forth his conditions:

> . . . to be on the line, north wall or east wall of the Vanderbilt Gallery, as I was regularly before the split In last spring's exhibit, although they made a group of what they considered the "Modern Movement" or the "8" movement and took much credit to themselves for it—the wall was the worst lighted of the whole exhibit and the hanging was horrible Now, as in this and many other ways, the N.A.D. seems disposed to "punish"—not openly, but in a well-covered manner—I have decided not to exhibit there unless they agree to hang my pictures equally as well as in former times I know that it is hardly possible for them to do this, nor do I ask anything—Things have been brought to the present pass by their own actions . . . they must now make assurances or I will not send them my pictures.[33]

When the exhibition opened in December Henri was not represented. From among The Eight only Lawson (elected an associate the previous winter), Glackens (already an associate) and Davies were included. Henri students who were accepted included Bellows, C. K. Chatterton, Homer Boss and Hilda Belcher.

Henri had returned to New York and to teaching at the School of Art the previous October. While his pupils gave him a warm welcome, presenting him with a sterling-silver service for twelve as a wedding gift, his relations with the school's administration were somewhat strained.

As far back as January 1908 he had found it necessary to serve an ultimatum to the owner, Douglas John Connah, for payment of money due him. His salary was constantly in arrears; by the time he returned from Europe the debt had reached 424 dollars. He was offered two promissory notes, due in April and October of the following year, and guaranteed monthly payments beginning December 1, 1908. When by the tenth of the month he had received no money, he threatened to quit. Now owed nearly 800 dollars, Henri failed to show up for his December 18 class.

First Henry Glintenkamp and A. S. Baylinson were sent to learn the reason for his absence, then Josephine Nivison and Martha Eckerson, and finally an eight-student delegation. A reporter from the *Herald* got wind of the story but Henri refused to be quoted. Then Connah phoned him and pledged payment in full. Henri replied: "If not paid January 4 I will be open for other business in the teaching line outside and will proceed against the school to collect what is due."

Before the deadline Connah called again, offering him 350 of the 850 dollars, but Henri refused, stating that if the entire amount was not paid as agreed, "he would publicize the reason for his leaving the school."

Connah retaliated with a base act. He immediately sent this announcement to the press:

> It is stated that the school, after backing Mr. Henri for five years, has found his influence as a teacher and his hold on pupils steadily decreasing. Unable to retain Mr. Henri at a loss which his employment entailed, it is held honorable to at once face that fact The Management has at last been compelled to get into line with the long standing and unanimous judgment of the most distinguished artists in New York. Mr. Henri's classes will be taken by Mr. C. W. Hawthorne

of New York and Mr. Eugene Paul Ulman of Paris. These gentlemen are among the best known pupils of Mr. Wm. M. Chase.[34]

Now Henri removed the kid gloves. He contacted the papers and had *his* side of the story aired, yet even in anger he admitted: "I did not wish to harm the school."

Upset by his financial plight just six months after his marriage, he was equally shocked to learn that Thomas Anshutz had never been paid for his anatomy demonstrations at the school, given the preceding January at Henri's request. "I put it in the hands of a lawyer," Anshutz informed him, "and got answers acknowledging the debt and making promises to pay which seems as far as they are able to go."[35]

Henri's students had been clamoring for him to inaugurate classes of his own. At one point a committee of sixteen pupils paid him a visit. One of them was quoted in the paper as saying:

> Here are girls from all over the country who have come to New York at great expense to study under Mr. Henri and no other teacher. If they won't let us have him at the New York School of Art, why, we'll found one of our own All of us have paid in advance a year's tuition at the school and I don't suppose we can get that back, but rather than give up the best teacher in the world, why, we'll sacrifice the money.[36]

That meeting was followed by another composed of the men from the life class, after which Henri was moved to search for a suitable site. He settled upon two rooms in the Lincoln Arcade at Broadway and Sixty-sixth Street and signed a five-month lease in January 1909. He purchased three dozen easels, chairs and stools the following day. At one P.M. on Monday, January 11, the Henri School of Art, its name freshly painted on the door panel, held its first portrait class, with an enrollment of twenty-two. The composition class began the following week with twenty-seven students, and life classes were set to begin as soon as electricians could complete installation of additional lights.

The school was located on the top floor of the building, in Studios 601 and 603. It was not a mere coincidence that George Bellows and Edward Keefe shared Studio 616 at the other end of the hall. Bellows had been housed there for over a year and had discovered Tom Sharkey's Athletic Club a block away, across Lincoln Square. There was an extra cot in Bellows' studio, which became a home for such transient Henri students as Rockwell Kent, Glenn Coleman and Rex Slinkard. A wayward twenty-year-old writer named Eugene O'Neill also shared the premises, sometimes going into the Henri School to seek out George. Healy's Saloon was located across the street, and it was during this winter that O'Neill conceived the idea for *The Iceman Cometh*.

Bellows, who had just been elected an associate of the National Academy, became one of the best advertisements for the success of Henri's pupils. He convinced Randall Davey to abandon his studies at the Art Students League in favor of the Henri School, then did the same with a basketball player named Eugene Speicher, whom he had met at the Y.M.C.A.

Henri placed ads in the papers and art magazines, and had three-by-five cards printed announcing the formation of the school. On the day the men's life class began, a procession of art students carrying paint boxes and canvases paraded down Broadway from the New York School of Art at Eightieth Street to the Henri School at Sixty-sixth. More pupils were attracted to the school from the National Academy of Design and the League. Helen Appleton Read, a Smith College graduate who had been with Chase and DuMond for a year when she made the switch, said:

> In the days when I studied with Mr. Henri it was a mark of defiance, we threw our gauntlets in the face of the old order when we packed our paint boxes and journeyed uptown from the Art Students League to join the radical Henri group.[37]

Before the men's evening life class started, Henri learned that Walt Kuhn was planning to organize a similar class. Kuhn, an artist for the *New York World*, was known to him through Rudolph Dirks and Luks, who had also worked there, so he offered to delay the formation of his group until Kuhn's had gotten under way. When Henri learned that Kuhn might lead his students en masse to the New York School of Art and teach there, he gave appropriate warning. Kuhn responded:

> Don't let me interfere with any of your plans. Connah . . . gave me a sum on account and I have things fixed so that unless I am paid every week I leave on the spot The boys will all leave the minute I quit, so you see things are the same, only there they are to my advantage—Will try to see you tomorrow or next day.[38]

When Henri's evening life class did begin on February 18, its members included Homer Boss, Maurice Becker, Harry Daugherty, John C. McPherson, Joseph Laub, Paul Manship and Morgan Russell, the latter having just returned from Paris. The fee was eight dollars a month, four dollars for the composition class and ten dollars to study portraiture, with a ten-percent discount for students enrolling in two or more courses. Henri hired Carl Sprinchorn as manager and housekeeper of the school and A. S. Baylinson as secretary; Russell and Slinkard were the monitors. Among the pupils were Henry Glintenkamp, Walter Pach, P. Scott Stafford, Edward Hopper, Clara Tice, Hilda Ward, Julius Golz, Bernard Karfiol, Guy Pène du Bois, Clara Greenleaf Perry, Patrick Henry Bruce, Amy Londoner, Adolph Treidler, Manual Komroff, Andrew Dasburg, Stuart Davis and Robert McIntyre, the nephew of William Macbeth.

During the first semester there were over one hundred students. Dasburg recalled:

> He [Henri] was an excellent, an exceptional teacher. I studied at the Art Students League with DuMond and Kenyon Cox before coming to Henri, but Henri was of a different caliber entirely. He had imagination which most of the other teachers were lacking. They would make corrections, yes, but they wouldn't inspire you. It's the interest that he created for you that stimulated you, that was so important, I thought. Henri had a

very liberating influence on me. Mine was a feeling of enthusiasm and great respect for Henri.[39]

Studios 601 and 603 soon looked lived-in. One wall that served as a repository for leftover paint had a layer four inches thick in some places as students threw wads of pigment at it from several feet away. On another hung a group of Henri's eight-by-ten-inch sepia photographs of paintings by Manet, Hals, Velázquez and Goya, a display, changed weekly, to which Henri would occasionally refer in order to show how the masters had worked. Across from them were drawings chosen from the various classes.

The atmosphere was informal; there was no roll call. Horseplay was kept to a minimum, although new students were still expected to provide a treat for the class. Once, instead of the usual beer-and-cheese setups, an Oriental student led the entire class to a Chinese restaurant for dinner. That newcomer was Yasuo Kuniyoshi.

Henri continued to urge his pupils to employ the simple palette consisting of light red, yellow ochre, terre verte, blue, black and white. This was especially helpful for the night students: "We couldn't tell much about fancy colors in those lights," Eugene Speicher remarked. "Some of the fellows painted on stiff cardboard covered with egg white, and we used big boards for palettes."[40] They painted with a standard medium of two-thirds linseed oil and one-third turpentine, then employed Soehnée Frères Retouching Varnish or Devoes's Mastic Picture Varnish just as their teacher did in his own work.

Evening students often resorted to drawing the figure rather than using oils because the incandescent bulbs tended to alter the color. The atmosphere was stifling, and when a model, often someone from the theater or a dancer from Isadora Duncan's troupe, posed near the pot-bellied stove, there was a warm glow on the figure.

Most of the thirty or so persons in the evening class had jobs during the day but Henri quickly imbued them with a sense that art was life and a fundamental necessity for each of them. Although the class was scheduled from seven to ten P.M. it always ran over, after which the students would congregate on the corner to discuss what the master had said.

Henri's paint dealer, Nathan Rabinowitz, opened a small store on the premises where he sold charcoal supplies, Winsor & Newton oils and a card of assorted Rubens brushes for $1.98. The set included two brushes, a one-and-a-half and a two-inch bristle brush; tiny sable brushes seemed inappropriate for Henri students. No one made use of a maulstick, a prop associated with velvet-jacketed academicians. Occasionally someone without a flair for spontaneous painting would do a fairly tight rendering of the model, then drag a dry brush over the surface in imitation of the so-called "Sargent stroke." But Henri was on to the trick, and although his critiques were scheduled for Tuesday and Friday nights, he would drop in unpredictably to keep the class on its toes.

As a result of the widespread use of the slashing brushstroke, splattered pigment was everywhere.

Stuart Davis said: "Paint was all over the place; the students' smocks were heavily armored with it."[41] Davis was only fifteen when he quit high school to study with Henri. In pursuit of his teacher's directive, he and the others toured public markets, burlesque houses and saloons in search of humanity in the raw. Even the female students from well-to-do families, such as Helen Appleton Read and Dorothy Rice, were inspired by Henri to paint breadlines and derelict women. Goya prints were used to illustrate the universality of the downtrodden, causing Bellows to produce a drawing entitled *Dance in a Madhouse*, a recollection of his visit to a mental hospital. This in turn moved Henri to have his students visit an asylum. Bellows made sketches and took it in stride, but for others, like Speicher, the experience proved to be too depressing.

In one corner of the classroom stood an old phonograph, which was sometimes pressed into service. The total collection of records consisted of two popular songs plus Ippolitov-Ivanov's *Caucasian Sketches*, a Romantic suite in the exotic mode of Rimsky-Korsakov's *Scheherazade*. When the days were rainy or so cloudy that insufficient light penetrated the soot-laden skylight, Henri would say: "Clean off your palettes and let's go to the Metropolitan." At the museum he would lecture on the majestic stillness of Egyptian art, the simple elegance of Chinese painting and whatever else stimulated him as they strolled through the galleries. He would never miss an opportunity to pause in front of *Boy with a Sword*, the museum's lone Manet.

The Lincoln Square Theatre was in the same building as the school, so Henri was constantly urging his flock to see the Moscow Art Theatre, the Irish Players, Ibsen, Chekhov and performances by the great vaudevillians Harry Lauder and Vesta Tilley.

On March 6, 1909, Henri held the first student exhibition. A large attendance, one estimated by him as "perhaps eight hundred people," crowded into the two rooms, and that interest caused him to organize another men's life class and to divide the portrait class into two sections. A Sunday class was also formed but Henri, already devoting more hours to teaching than he preferred, did not participate. "This class I have given free into the hands of [Homer] Boss. They pay their own model. It is to be used for the students whether they work in the school or not."

Among the crowd at the student show was Mary Fanton Roberts of *The Craftsman*, who was so impressed by what she saw that she predicted: "This is the thing from which the American art of the future is to spring."

The National Academy of Design annual opened on the weekend following the School exhibit. Henri's painting *The Picador* was admitted jury-free, yet, despite his discussions with Harrison Morris prior to the last Academy show, his full-length canvas was ignominiously hung in the South Gallery, far removed from the Vanderbilt Gallery's places of honor. A second canvas was rejected outright. Although Sloan, Glackens and Lawson were represented, Henri students were turned down in record numbers,

with Kent and Bellows virtually the only ones accepted.

The Academy's conciliatory attitude of the previous year was apparently only temporary. When Henri learned of the jury decisions he was moved once again to action, as noted by Sloan: "Henri broached our old scheme of getting up a permanent Show Room or Gallery—for about fifteen men's work—to run for a whole year."[42] A week later Sloan "spent most of the day with him talking over the Permanent Exhibition Gallery scheme."[43] Any such facility would be open to the disenfranchised "younger or 'outside' artists," as Henri put it, and not restricted to The Eight. Their show had been an accident, with the number of artists limited solely by the size of the Macbeth Gallery. The ultimate goal had been established by Henri as early as the fall of 1907, as evidenced by a letter he received from another artist:

> A few months ago during a conversation you explained a scheme of yours of getting a large gallery for independent exhibitions and inquired if I could find men to join in one There are painters here who would gladly join me in an exhibition on the lines you suggested If I can manage that, with your approval, I may not have worked altogether in vain.[44]

Even now there were individuals seeking to identify with the group; one of them was Marsden Hartley, sent to Henri by Prendergast with some of his Maine canvases. A dubious Sloan asked: "Why would a big man come to New York and dangle around waiting for us to say 'come in to the "eight" show' supposing there was such a thing this year [1909]."[45] But, of course, there wasn't, so Hartley became aligned instead with Alfred Stieglitz's 291 Gallery.

The idea of establishing a permanent New York gallery came to the fore once again during the spring of 1909 even as The Eight traveling show was touring its final two cities. On May 8 Henri and Sloan spent the day "looking at top floors which would be possible situations for a gallery"; a loft at 11 West Thirty-sixth Street with "good skylights" seemed the most desirable.[46] It rented for two thousand dollars a year; Henri took Davies to see it and he approved. Now the Morgan stable on Madison Avenue became available with a three-year lease at a bargain rate. Before either prospect could be finalized, however, the paintings from The Eight traveling show were returned—a year-long exhibition without benefit of a single sale. Enthusiasm for the gallery plan dissipated.

During the first half of 1909 Henri had little time to devote to painting, what with his new school and bride. He was spending much of each day with Marjorie and becoming a homebody in the evenings. He had originally envisioned married life as synonymous with home-cooked meals, since his mainstays, chicken and lamb chops, did not necessitate the talents of a gourmet cook. But Marjorie's experience in the kitchen was practically nil, and when she placed her first chicken in the oven without having cleaned it, he determined that they had better dine out.

Throughout that period, most of the paintings he *did* produce were classroom demonstrations using student models. When Edith Haworth, monitor of the portrait class, stopped by just prior to leaving for Europe, Henri created a spontaneous likeness on a two-by-three-foot canvas in an hour and a half.

His most significant paintings during this time were three full-lengths: a wistful-looking *Ballet Girl in White* of a dancer from Anna Held's musical play *Miss Innocence* and two versions of an opera singer, Mademoiselle Voclezca, who starred in the title role of *Salome.* Henri painted her at the time that Richard Strauss's opera, based on Oscar Wilde's play, was still scandalizing some of the audiences in New York. When it had first been performed in America two years earlier, certain critics took it upon themselves to force cancellation of some shows at the Metropolitan Opera House and its entire run in Boston. In these six-and-a-half-foot-high canvases Henri caught both the seductive look and captivating pose in a flash of brilliance seldom equaled (see color plate).

Henri played golf with Sloan, attended a few boxing matches at Sharkey's with Bellows, often dined at Carmalucci's, a new Italian restaurant, in the company of Mary Fanton Roberts and her husband, through whom he met John Butler Yeats. The occupants of a table for ten varied—the Sloans, Bellows, Sprinchorn, Louise Pope, Fred King and other artistic and literary personalities—with the Henris and Robertses regularly on hand.

Yeats, father of the Irish poet William Butler Yeats and a splendid painter in his own right, had come to New York for a lecture tour, less to speak of his work than to read his son's poetry and that of Lord Dunsany. When he became a lodger above Petitpas's French Restaurant on West Twenty-ninth Street, the group that had dined with him at Carmalucci's merely changed locations.

Henri enjoyed Yeats's company and praised his art; for his part, Yeats considered Henri "the best painter in America" and told his son, "I am not sure if he is not one of the finest painters anywhere, and he is the most delightful companion anywhere."[47]

In December Henri painted Yeats's portrait, revealing a kindly face on the verge of a smile, framed by gray hair and a beard. He is shown wearing a dark blue suit coat and is placed against a deep brown background, contrasting warm and cool, with one hand dangling a pair of eyeglasses over the back of a chair. During the same month Yeats gave a lecture at Henri's studio, where he read his son's verses and portions of John Synge's *The Playboy of the Western World,* published two years before. Tickets sold for one dollar, with the proceeds going to Yeats. Isadora Duncan, whose imminent departure for Europe prevented her appearance, purchased ten tickets and distributed them to friends.

Henri met Isadora in November at a party given for her by Mary Fanton Roberts, and was present at her performance at the Metropolitan Opera House. He looked upon Isadora as an outspoken rebel and said of her: "Back of her gesture I see a deep philosophy of freedom and of dignity, of simplicity and of order"[48] He held a reception in his studio attended by Miss Duncan, Mr. and Mrs. Roberts, the actress Dorothy Wagstaff Arnold, critic Byron

Stephenson and others. It was Mary Fanton Roberts who had arranged one of Isadora's first public appearances the year before, when she danced at the Opera House and Walter Damrosch conducted the New York Symphony.

Just prior to the start of his classes in the fall of 1909, Henri learned that the New York School of Art had gone into receivership. Among the faculty who were listed in a newspaper article as unpaid were F. Luis Mora, J. Carroll Beckwith, Howard Chandler Christy and Edward Penfield. The headline tended to exonerate Henri in the previous year's battle:

RECEIVER FOR ART SCHOOL

Which Henri Left Last Year
Because He Wasn't Paid[49]

For a few weeks that fall the Henris lived at the Hotel St. Paul until Henri's new studio, at 10 Gramercy Park South, was ready for occupancy. Upon entering the new quarters he found a telegram from the Dallas Art Association offering to purchase his *Happy Hollander* and a letter from the Philadelphia Art Club informing him that *The Blue Kimona*, a portrait of a Japanese-American woman named Waki Kaji, had received the gold medal. The contrasting coloration in these two paintings illustrates a major change in his work. The earlier canvas, produced in The Netherlands in 1907, is done with the simple palette of subdued earth tones that he had employed since his turning away from Impressionism and toward Manet in 1896. But the portrait of Miss Kaji, painted toward the end of August 1909, shows the first results of a full range of intense hues following a summer of experimentation with the newly available Maratta system.

Hardesty G. Maratta was a Chicago painter of city scenes who arrived in New York just as classes at the Henri School had begun. He met Henri toward the end of March 1909 and presented him with a set of his recently manufactured colors, which included all the hues of the spectrum. Henri spent countless hours testing the paints, producing small panels with horizontal bands of blue, purple, red, orange and green. On one twelve-by-fifteen-inch board, a figure sketch was repeated against six different-colored backgrounds.

The Maratta palette was based on the primary and secondary hues of the spectrum: red, orange, yellow, green, blue and purple, and the half-dozen tertiary colors of red-orange, orange-yellow, yellow-green, green-blue, blue-purple and purple-red. The so-called bi-colors were placed in between, resulting in a palette of red, red-red-orange, red-orange, red-orange-orange, orange, orange-orange-yellow, orange-yellow and so forth. This arrangement provided a palette of twenty-four hues, with a graduated sequence of bright colors and a corresponding set in low intensity.

Maratta referred to this "perfect palette" as "Maratta Scales" or a "Color Piano" because the twenty-four equally spaced hues corresponded to the twenty-four major and minor triadic chords on a piano keyboard. Just as in music, where such chords are comprised of unequally spaced notes, so with the Maratta system; a popular color chord, for instance— red, yellow-green and blue—would be colors number one, eleven and seventeen on the color wheel.

The system was appealing to Henri for several reasons: it related art to music, represented an intellectual challenge and provided an opportunity for a more vivid palette along the lines of van Gogh's. Henri became such an avid devotee of the system that he promoted it among his students and artist friends, beginning in the summer and fall of 1909.

By the fall thoughts turned once again to a permanent gallery and the plan for large exhibitions. Many New York artists received an announcement that the Municipal Art Society of Baltimore would hold an exhibit of contemporary American paintings at the Fifth Regiment Armory in that city. The previous year the National Sculpture Society show had been seen by sixty-five thousand persons at the same site, and was referred to as "the finest collection of American sculpture ever brought together." An article in *The Craftsman* that described the setting as consisting of plots of grass, growing plants and flowers, pointed out that "New York had no place, so it was said, large enough and dignified enough to afford an opportunity for showing the four hundred and sixty-one sculptures"[50]

Now Albert Ullman, a self-styled promoter, conceived plans for a large-scale exhibition in which he would place "a huge collection of good, young healthy pictures into Madison Square Garden, a band of one hundred pieces. Newspapers astounded! . . . it required for a week about $9,000!!"[51] But the problem of financing proved insurmountable.

On December 21 Henri and Sloan met to discuss a scaled-down version of Ullman's extravaganza and the next day they returned to a building at 29–31 West Thirty-fifth Street that had been considered earlier. The two lower floors were ideally suited for a gallery and the rent for five weeks was six hundred dollars.

A renewal of interest in an exhibition plan was due to the results of the recently judged National Academy winter exhibit. Although Schofield, Redfield and Glackens were on the jury, their numbers were insufficient to turn the tide; Henri's *Girl with Parasol* was his only work hung. Sloan had three paintings rejected outright and a fourth placed high on the wall in the artificially lighted "overflow" room. Walter Pach had submitted six works, all of them accepted but none hung.

By having the jury accept large numbers of entries that could not be shown, the Academy continued to argue that their plight was lack of space rather than the quality of what they *did* display. If the city would only build them a larger structure they would love to hang everything! Henri reiterated to Sloan his theory that a place "rented by the year for a continuous series of exhibitions would be the best scheme to start a society of artists." He had already chosen a name— Independent American Artists—and suggested that patrons could fund the project, then select from the exhibits paintings valued at the amount of their

contribution. Initially, twenty individuals would each have to provide a hundred dollars.

Now Jerome Myers approached Sloan with a similar proposal; having heard that the Academy was securing a site for larger galleries, Myers encouraged demonstrating against it. He was opposed to Henri's plan for asking the wealthy for assistance and was also against having young artists participate. "He certainly gives evidence of antagonism to Henri," Sloan noted.[52]

Davies favored group financing and was ready to put up his share of the money. A meeting was held at Henri's on January 10, attended by Henri, Sloan, Luks, Shinn, Myers and Walter Pach. Glackens sent regrets. They discussed Henri's plan for a twenty-artist organization but no action was taken; Henri, for his part, observed "how little spirit there seemed to be in the meeting, that is, real 'do something' spirit."

When entries for the Academy's spring annual were accepted in February 1910, Henri sent two imposing, life-size paintings, *Salome Dancer* and *Lady in Yellow*, modeled by Marjorie; and a small *Portrait of Miss Patricia Roberts*, the year-old grandniece of Bill and Mary Fanton Roberts. The latter was his only picture

accepted. Glackens and Lawson plus a few Henri students, notably Bellows and Speicher, were included. After Sloan's two entries were cast out Sloan wrote: "It looks as though they had cut me off from the exhibition game: must find some way to show the things."[53]

Out of the frustration felt by Henri, Sloan and others, action came quickly. Two days before the Academy's opening, a meeting at Henri's was attended by "a great crowd." After the rest had left, Henri, Sloan, Davies and Walt Kuhn considered a plan advanced by Kuhn—that four of them back the exhibition with two hundred dollars apiece, then charge each exhibitor according to his ability to pay.

Henri, Sloan and Kuhn settled on the Thirty-fifth Street location previously considered but learned that the rental had increased to a thousand dollars. Dorothy Rice, a Henri student whose father edited *The Forum*, donated two hundred dollars, as did Gertrude Vanderbilt Whitney and Walt Kuhn's wife Vera. Other students chipped in as well.

Less than three weeks remained before the April 1 target date for the show.

Untitled (dancer, possibly Isadora Duncan), n.d. Pen-and-ink, 5" × 5³⁄₁₆" (12.7 × 13.1 cm.). Photograph by Walter Russell; courtesy of Chapellier Galleries, Inc., New York.

CHAPTER 15

THE INDEPENDENT MOVEMENT AND CONSPIRACY

THE 1910 EXHIBITION of Independent Artists had its roots in the Paris Independents of the 1870s, as did the no-jury concept. The Allied Artists Association of London also predated the American group; in fact, the first use of the term "Independent" as applied to U.S. art occurred in an 1894 article in *The Critic* headlined "The Independents," which referred to "Some of the 'Independents' who are holding an exhibition at 819 Broadway."[1] One of the exhibitors at that time was Arthur B. Davies.

The 1910 Independent was scheduled from April 1 to the 27th, dates deliberately selected to overlap the Academy annual, which ran through April 17. A general committee for the Independents was speedily formed. It consisted of Sloan, Glackens, Walt Kuhn, Ben Ali Haggin and five Henri students: Coleman, du Bois, Dorothy Rice, Clara Tice and P. Scott Stafford. Members of the hanging committee were Henri, Sloan, Glackens, Davies, Kuhn, Bellows, du Bois and the sculptor James E. Fraser.

A list was compiled of the artists "whose work we thought of interest and lacking in certain academic stiffness," and each of the nearly eighty artists was sent an invitation to exhibit. It was the first large-scale exhibition in America without the sanction of a jury.

Another innovation—no prizes—was Henri's idea. He said:

> To award prizes is an attempt to control the course of another man's work. It is a bid to have him do what *you* will approve The pernicious influence of prize and medal giving in art is so great that it should be stopped. You can give prizes justly for long distance jumps, because you can measure jumps with a foot-rule. No way has been devised for measuring the value of a work of art.[2]

Because the three-story building rented for the show had never served as an art gallery, one hundred tungsten lights were purchased and the structure was rewired. Draperies were also bought. Henri students pitched in; Bellows repainted the woodwork, Coleman

and Stafford placed cheesecloth over the walls. When the material proved to be too white, 640 yards of a grayer fabric were purchased.

On the days set for entries, dozens, then hundreds of works poured in. The hanging committee assembled. Unlike the Academy's counterpart, it installed all of the show in alphabetical order—dissonances of color, subject and size notwithstanding. Although Henri did not favor it, he yielded to this act of impartiality.

Two of his four paintings included were *Lady in Yellow* and *Salome Dancer,* both recently rejected by the Academy. Some two hundred sixty-five paintings, three hundred forty-four drawings and twenty-two pieces of sculpture by one hundred and three artists were listed in the catalog. Nearly half of the exhibitors were Henri students.

On the morning of April 1, 1910, the customary private press viewing was held. "They are at a loss for the big stand-by names and so they fall back on *us* as the big men," Sloan observed.[3] By "us" he was referring to The Eight, all of whom were represented but Luks, whose one-man show opened at Macbeth's the same month.

That evening a reception was held. The crowd came surging in. According to one newspaper's estimate, a thousand persons were soon in the building with fifteen hundred more outside. No one had dreamed of such a crush of humanity at an art exhibit. People spilled into the street. An excited patron called a policeman and reinforcements were summoned from the Tenderloin station. A panic was averted when the police initiated a system of traffic regulations on the stairs. And during all the excitement the National Academy's exhibition rooms were silent.

To celebrate the sensational event, twenty Henri students triumphantly paraded to Petitpas's. "Panic Averted in Art Show Crowd" was the headline of the *Mail and Express.* Joseph Chamberlin wrote in the *Evening Mail:* "It was a very good thing to get up this

show. It gives struggling talent a chance; and it has produced a very strong and interesting exhibition."[4] The *New York American*'s Guy Pène du Bois wrote:

> The vulgar insurgents, unable to keep themselves longer in leash, have been permitted to divulge their own sordid secret New York has received their exhibition with open arms The Independents' show, with its record-breaking attendance, is epoch-making—it has revived a faded interest in American art.[5]

It was enough to make even the most hardened academician burst into tears. Courtenay Lemon of the *New York Call* singled out Kent, Coleman and Dorothy Rice as "the most striking" of the new talents."[6] The *Evening Mail*'s critic cited Henri's *Salome Dancer* as "perhaps the most remarkable" work.[7]

As was his custom, Henri used the opportunity to laud exhibitors to members of the press. He called Glenn Coleman "an artist of rare promise" and of Jerome Myers he said: "His work is beautiful because it is close to life." Although he was constantly mentioned as the force behind the Independents, Henri said: "The exhibition . . . is not a movement headed by any one man or small group of men. I think that one of the most damaging things that could happen to the progress of art in America would be to personalize this movement in any way."[8] Despite his words, Robert Henri was the hero of the moment.

The attendance continued unabated, and, when the show closed on April 27, Henri recorded in his diary: "The exhibition was a great success as far as general notice and attendance Financially, nothing happened." Only five small drawings were sold, one each by Henri, Coleman, Clara Tice, Edith Haworth and Edith Barry. During that month in New York the Charles T. Yerkes collection of European Art was sold at auction for over two million dollars, with ten thousand dollars being paid for a single Bouguereau.

Perhaps the most profound statement came from Henri:

> As I see it, there is only one reason for the development of art in America, and that is that the people of America learn the means of expressing themselves in their own time and in their own land. In this country we have no need of art as a culture; no need of art for poetry's sake, or any of these things for their own sake. What we do need is art that expresses the *spirit* of the people of today.[9]

And yet, as he was winning the battle against the Academy, a larger struggle was brewing. Almost unnoticed in the triumph of the Independent Show was an observation by James Huneker:

> As for novelty, at Alfred Stieglitz's Photo-Secession Gallery a week ago there was a grouping of the minor spirits of the Matisse movement that were actually new, not mere offshoots of the now moribund impressionists as are the majority of the Independents.[10]

That exhibition of nine young American painters included such figures as Marsden Hartley, Arthur B. Carles, Arthur Dove, John Marin and Max Weber, but it was virtually ignored.

Although there is no evidence that Henri saw this or other shows at the 291 Gallery, he constantly urged his students to do so. Stieglitz' efforts to win recognition for photography as a fine art paralleled Henri's battle. When Stieglitz' early photograph, *Winter—Fifth Avenue*, was first reproduced in his quarterly publication, *Camera Work*, in 1905, Henri noted its resemblance to his painting *West 57th Street* and pasted the photo in his scrapbook. The year before he had been one of twelve artists to jury the American Photographic Salon, the first national photography exhibit ever held in the United States. Within a few years, however, the Henri and Stieglitz groups were stealing each other's thunder. In 1909 Eugene Higgins, omitted from The Eight, was given a one-man show at 291, and Edward Steichen, who first suggested to Stieglitz that "if artists won't admit us to their gallery, we'll admit them to ours,"[11] recommended that they utilize 291 to hold an American version of the Salon des Refusés of works rejected by the Academy. The 1910 Independent beat them to it.

As a result of Henri's becoming the most powerful influence in the New York art world, his paintings were now regularly sought for exhibitions in the U.S. and abroad. When a collection of American art was sent to Munich and Berlin—the first comprehensive display to be seen overseas—Henri's *Dutch Fisherman* and *Portrait of Mrs. William Rockwell Clarke* were included. The *Young Woman in Black* was sent to a show in Venice and *Willie Gee* was exhibited in the U.S. section of the International Fine Arts Exposition at Buenos Aires, Argentina, and Santiago, Chile, where it was awarded a silver medal.

After the American Federation of Arts was founded in Washington in 1909 with one of its announced goals the organizing of exhibitions in various parts of the country, Henri was consistently included in its shows of representative American artists.

Such regional exposure resulted in sales as well. Within a few months *Young Woman in Black* was purchased by the Art Institute of Chicago, *The Equestrian* by the Carnegie Institute in Pittsburgh, *Dancer in Yellow Shawl* by the Columbus Gallery of Fine Arts and *Spanish Gypsy Child* by the New Orleans Art Association.

In New York, the Henri School was rounding out its first full season. The classrooms had become a bit shabbier and the scrapings left by students cleaning their palettes made the "paint wall" a little thicker. Across a long row of wooden lockers someone had lettered in red: "Lights are generally cool—shadows warm." In the life class, Henri had begun to suggest that students "concentrate on just the movement" of the model, an influence of Isadora Duncan, whose performances he continued to attend. He saw her dance to Bach at Carnegie Hall and was present for her first interpretation of Wagner's prelude and finale to *Tristan und Isolde*.

He was sympathetic to Isadora's aim "to rediscover the beautiful, rhythmical motions of the human body" and urged his students to see her dance. She in turn would bring her troupe to view his student exhibitions. Sometimes Mary Fanton Roberts provided him with several dozen tickets to distribute to his pupils

for Isadora's next performance, and it was not unusual to see artists in the front row making quick sketches during the dance.

Enrollment at Henri's school was on the decline during the spring of 1910. He had lost money from the start, owing in part to his allowing students to pay on a monthly basis rather than by the year, and also to the number of poor pupils he permitted to study free. Henri spoke with Julius Golz about taking over the school the following season; when no decision was reached he approached Homer Boss, who had been providing the life class with anatomy demonstrations.

On June 1, 1910, Henri signed a secret agreement to the effect that all school equipment—stools, easels, chairs, model's stand and lighting fixtures—would become the property of Boss. The name of the school was to remain unchanged and Henri consented to provide weekly critiques for a hundred dollars per month. Shorty thereafter he and Marjorie left for a summer in Europe, this time without an accompanying class.

They spent the first six weeks in Haarlem, at the same hotel and studio Henri had occupied three years before. There he painted "many canvases on near the same theme . . . playing one canvas off on the other, progressing them together." He replaced his previous models, Cori and Martche, with a Dutch boy and girl who both smiled incessantly. They were among "the group of children who were my friends and models and who lived in and made lively an alley near my studio." The boy, Jopie van Slouten, was "the ring leader in many a charge on my studio door"[12]

Henri could paint only one youngster at a time but he allowed the others in "for the sake of atmosphere of a noisy and hilarious sort which they never failed to supply in abundance" Jopie thought it a great joke to pose and the artist "thought him a great, real human character to paint, and my interpretation of him was as frank and as honest as I could make it."[13]

A serious side of Dutch life was revealed in the faces of two workingmen whom Henri painted several times. His sparse, spontaneous brushwork was never better than in *Blue-Eyed Man*, *The Workingman* and *Head of a Man (The Stoker)*—the first of these showing a worn yet resolute face, its ruddy complexion a foil for the bluest of eyes and a blue work shirt. (See color plate.)

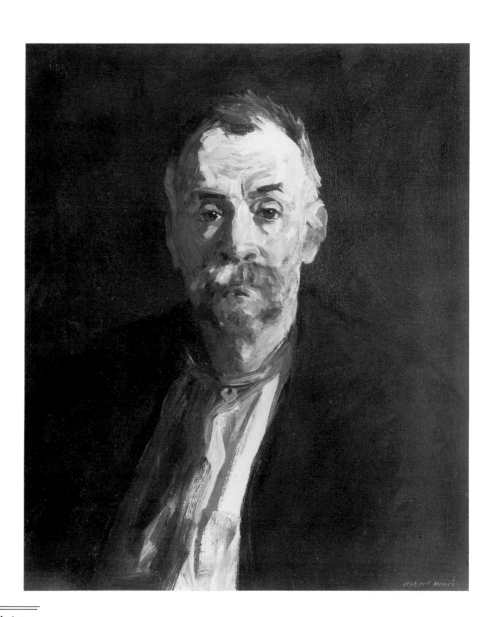

Head of a Man (The Stoker), 1910.
Oil on canvas, 24″ × 20″
(60.9 × 50.8 cm.).
Arnot Art Museum, Elmira,
New York.
Photograph by Walter Russell.

Some sixty canvases were produced in the six weeks before he moved on to Madrid, where bullfights and painting shared his attention. He posed a number of dancers, his favorite being a fifteen-year-old, La Madrileñita, in whom he sensed "much of the spirit and dignity of old Spain."

On his way home in October, Henri visited Patrick Henry Bruce in Paris and viewed the Autumn Salon. He was pleased to find that two other former students, Morgan Russell and Louise Pope, were both represented, but Russell's Cézanne-inspired *Nude Men on Beach* was difficult for Henri to appreciate, and the "Matisse Movement" at the exhibition was still beyond his comprehension. Of the Autumn Salon, he wrote cryptically in his diary: "Saw it (No Comment!)."[14]

Back in New York, Henri found a "goodly number of students at the school." The intensity of his charisma, which still captivated them, may be sensed in his opening words to the composition class:

> Those pictures interest me. They interest me very much. They do not look to me like things that belong to some movement of art; they do not look to me like specimens to show how far the student has progressed, but like things that have come from the heart as properly and naturally as a sob comes from distress or a smile comes from great gratification[15]

During October an exhibition of work by Rockwell Kent's students was held at the Henri School, for during the previous summer he and Julius Golz had organized an art class on Monhegan Island. "I did not see the show up but have since seen much of the stuff and think it fine . . . ," Henri wrote to Kent, whom he now recommended for a teaching job at the Columbus (Ohio) School of Art. Kent refused the offer, so Henri approached Golz, who accepted.

One of Julius Golz's first acts after taking on the tasks of both teacher and director at the Columbus School was to seek the 1910 Independent Show for Columbus, but when he learned that artists would have to be invited individually, he asked his former mentor to make the selections. Henri agreed, even visiting some artists' studios in order to earmark works.

An exhibition of sixty-one paintings and seventy-four drawings and prints resulted, but an hour before Henri was to leave for the January 17 opening at the Carnegie Library Gallery, he was informed that a librarian and the art supervisor for the public schools, acting as censors, had removed two of Davies' works from the show because they contained nudes that were considered offensive.

Henri's reply was swift. He sent an ultimatum regarding the vice committee's action: the paintings must be rehung or Henri's scheduled lecture in Columbus would be canceled.

Puritanical censorship was nothing new to Henri in the art world and elsewhere. It was a time when ministers were preaching against the wickedness of croquet because lady players often lifted their skirts sufficiently high to show their ankles; a time when magazines refused to accept advertisements that pictured a woman's mouth open. An article in his scrapbook dealt with a protest in Boston against holding a Y.M.C.A. reception at the Museum of Fine Arts: "[It was] a place hardly proper for a mixed social gathering of young men and young women, because of the presence there, in many parts of the building, of large numbers of fully developed and entirely nude masculine statues."[16]

In New York, Anthony Comstock, a post-office inspector and secretary of the Society for the Suppression of Vice, made periodic raids to keep society pure. He had confiscated an issue of the *American Student of Art,* a publication of the Art Students League, because it reproduced drawings of undraped nudes. And when Comstock passed the Macbeth Gallery and saw Bryson Burroughs' idyllic scene of five nude children exploring a bubbling brook, he labeled it "wicked and illegal" and declared: "It is highly improper to present such a picture as that to the public gaze. It must be removed at once."[17]

On January 24 a telegram informed Henri that the Davies paintings had been restored to the show. The next day he left for Columbus, but while he was en route, another purge was going on at the exhibit; this time the removal involved *Men and Mountains* by Rockwell Kent, *A Knockout* by Bellows, a nude by P. Scott Stafford and four of Sloan's New York City etchings, including *Turning Out the Light* and *Man, Wife and Child.* None of Henri's six entries was involved.

When he arrived, he was furious and threatened to withdraw the entire show if the works were not rehung. The reinstallation was reluctantly agreed to, but the "offending" works were placed in a separate room quickly dubbed the "Chamber of Immorality," available for viewing by men only. It was decided, however, to bar Bellows' large drawing from the show entirely because, boxing being illegal in Columbus, a picture of it would be illegal as well.

Kent's "objectionable" canvas shows two naked men wrestling against a serene backdrop of grassy hilltops and mountains. The censors were immune to the knowledge that the landscape suggested Mount Olympus and the figures represented the struggle between Hercules and Antaeus. It is interesting to speculate whether a classical title would have protected the painting from the self-appointed experts.

As for the Sloan etchings, some of the same ones had been deemed by similarly pure minds to be "too vulgar" for public display at the American Water Color Society exhibit in New York five years earlier.

Henri gave his lecture on "The Modern Movement in Art" at the Chamber of Commerce and, after two days of receptions and another talk on Spanish art, was eager to return East, where he was confronted by still another problem: the staging of a 1911 Independent show.

He and Sloan had spoken of it while the 1910 Independent was still on display, and in January 1911 Rockwell Kent, a neighbor of Sloan's, expressed interest in such an exhibit. Sloan replied that he was "in a state of grouch about the whole exhibition game and did not feel disposed to go in to get up another show"[18] Undaunted, Kent proceeded on his own.

At the time he was working as a draftsman for the

architectural firm of Ewing and Chappell, whose first commission was the design of his mother's house. George Chappell, a director of the Society of Beaux Arts Architects, obtained the large gallery at their headquarters for Kent's use rent-free. Ironically, the previous year Henri had provided Chappell, known to him as "a friend of Kent's," with the "full particulars of a scheme" for a gallery, but nothing came of it at the time.[19]

Kent hastened to Henri's studio to share his plan for the second Independent show, hoping for his teacher's support. But the impetuous Kent stated that his condition for inclusion would be to "force these men to come out and not show their pictures at the Academy." Henri was angered. "We never put the screws on anybody," he argued, and refused to be associated with it. He resented his pupil's telling *him* the rules for the show. As the hot-tempered Kent left in a huff, running down the five flights of stairs, Henri came out on the landing and called after him: "When you have done as much for art as I have, you'll have a right to talk."[20] Then he wrote in his diary: "I hope it is 'youth' and that he may see as he grows older that the great thing is to give your view and then let people decide for themselves—but at the present he is rather too much of a tyrant."[21]

Sloan, who had indicated a few days earlier that he might participate, changed his mind after hearing Henri's explanation. In desperation, Kent approached Davies, who jumped into the breach, promising to persuade other members of The Eight to show and to obtain funds for a catalog. Davies' initial support of Rockwell Kent had occurred in April 1907 when, after viewing Kent's first New York exhibit, he had written to Henri:

> . . . I think [Kent's paintings] are really *great*: poetic, sincere, and beautifully painted. I wish we might include him in our group [The Eight].[22]

Now Davies relished the thought of organizing an Independent show without Henri's help. He considered being the mastermind behind the event without exhibiting in it; his name did not appear on the catalog cover nor were his works listed inside, despite the fact that he did ultimately show sixteen paintings and eight drawings. Davies delivered Prendergast and Luks while Kent received assurances of participation from Boss, Golz, du Bois, Coleman and McPherson; in spite of loyalty to Henri by his former students, Kent won them over as their former classmate. Davies also suggested inviting John Marin, Alfred Maurer and Marsden Hartley from the Stieglitz camp.

Skillfully pacifying Henri, Davies said he understood his refusal to exhibit and made no attempt to change his mind. Henri declared himself "out of the exhibition entirely unless Kent comes to me and makes a satisfactory explanation"[23] At one point it was reported that Kent was ready to drop his demand that the exhibitors boycott the Academy, but when Henri showed no signs of relenting, the restriction remained. On March 6 Davies wrote to Kent:

> I think now that the March Squall has passed, we had better get down to work on our canvases and the necessary preliminaries for the exhibition. Henri, Sloan, Bellows and possibly Glackens are out but we can go ahead with the men we have agreed with and I am sure the exhibition will be interesting and keep alive a spirit that should never die.[24]

Henri, gracious as ever, "delivered to Coleman the draperies from the [1910] Independent Exhibit to be used in hanging walls of the Kent Exhibit."[25]

"An Independent Exhibition" opened with a reception at the Society of Beaux Arts Architects gallery on March 24, 1911. Stieglitz attended but Henri was noticeably absent. One hundred fifty works were included, with each artist allocated twenty-five running feet of wall space, an arrangement not unlike Henri's plan for the show of The Eight. George Luks, the absentee from the 1910 Independent, was represented here by fifteen of his strongest canvases, including *The Spielers* and *The Little Milliner*.

Newspapers referred to the exhibitors variously as "The Twelve" or the "Kent Tent," and reviews were mixed. The *New York Sun* stated: "The general impression aroused is of dull, muddy paint, blackest of shadows and a depressing absence of reverberating sunlight Such first class men as Robert Henri, Ernest Lawson, Glackens, Sloan, Jerome Myers and a few others are absent."[26] But another paper contended that: "The new show is saner and more reasonable than any previous exhibition of the new movement presented here."[27] Henri called it "a fine show . . . the Davies are splendid. Likewise Prendergast, beautiful watercolors, anyone should be delighted and will understand them. Luks, etc., etc.—all the stuff good."[28]

A week before the opening of the Kent Independent, Henri was asked to organize "an exhibition to suit ourselves"[29] at the Union League, a Democratic club whose monthly exhibits in past years had included paintings of early Italian and Spanish schools, French masters of the seventeenth and eighteenth centuries and the canvases of Bouguereau, Boudin and Jozef Israëls. But the chairman of the Union League, who was also secretary of the National Academy of Design, Harry Watrous, had promised to give the "insurgents" their day, providing them with a second, simultaneous Independent show.

Henri, not one to bear a grudge, included Arthur B. Davies on the exhibition committee. Davies wrote to Kent: "You are on the list, canvas and frame about 60 inches length on the line Exhibit opens April 13"[30] As was the Union League's custom, the exhibition lasted three days only, in this case April 13, 14 and 15. There were twenty-four works by fifteen artists, including all of The Eight and Kent, Bellows, Walt Kuhn, James Preston, May Wilson Preston, Edith Glackens and Max Weber. Henri was represented by *The Blue Kimona* and *The Brown Wrap*, a painting of Marjorie Henri.

When the show opened on Thursday afternoon, club members were outraged. The *Press* reported that "until late last night a babble of rebellion pervaded the art gallery of the Union League Club." One member was quoted as saying: "Well, I call this a joke"; another remarked: "If this is art I guess I'm not up to it."[31]

Academician George DeForest Bush joined the disapproving chorus, insisting: "The 'insurgents' exhibitions should be closed by the police."[32] The *Herald,* however, called the show "the finest assemblage of independent art yet seen in this city."[33]

As late as 1911 the Henri men, as artists and teachers, were still unacceptable to the conservative mind. Bellows had taken over F. Luis Mora's men's life class at the Art Students League, instructing in the manner of his mentor. When Henri saw the League's student exhibit he noted that Bellows' pupils were "a great departure from the other classes, under DuMond, Bridgman and others. All the work except Bellows' class (and perhaps that of Chase) is terrible. A sad thing to see students so misled." Although Bellows' students won nearly all the prizes, George was dropped from the list of teachers for the next year.

As for Henri's own teaching, he continued to make a strong impact on those enrolled at his school through his regular Friday criticisms. On one occasion he commented on an assemblage of drawings produced during an Isadora Duncan performance:

> The Isadora Duncans are very good today. I find this collection very, *very very* interesting. Unusually so. It means that the march on toward individual vision, individual thought, is increasing As long as you make your work, your ideas, your sensations and do not pander to the taste of other people, your work will be great[34]

His words were often magical. Standing before a painting of the Brooklyn Bridge executed in a Turneresque style, he said: "It is a painting. It has paint quality. But a bridge isn't like that. A bridge is like a great big, dark animal which crouches on one side of the river and then jumps across."[35]

He could still inspire, but his idols were beginning to show their age. In 1911 he continued to refer to Manet, Puvis de Chavannes, Rodin and Whistler as "the moderns," while around the walls were hung Henri's framed sepia prints of paintings by Manet, Velázquez, Hals and Goya. As one of his students put it: "Manet was already a little bit on the candy box side for us."

Since Henri no longer taught the life class, where he used to give frequent classroom demonstrations of portrait and figure painting, he now asked certain pupils to pose in his studio; one of these was Aline Bernstein, who sat for three portraits in 1911, years before she became a leading fashion and scenic designer. The hours spent at Henri's helped her to understand his ideas of life more fully. Miss Bernstein greatly admired her mentor, so that her words sometimes sound like his:

> It takes strength to be an artist, strength of body, of will and of spirit; so that to have the creative mind alone is not enough An idea is useless buried in the mind of its creator, a seed without a flower, as a wasted talent is a sin.[36]

It was such beliefs that she would one day pass along to Thomas Wolfe, often quoting Henri and citing him as an example to the writer, who she worried was wasting his talent. Her inspirational role was recognized by Wolfe, who dedicated *Look Homeward, Angel* to her.

Another student of Henri's was Carmel White, who as Mrs. Carmel Snow would become editor of *Harper's Bazaar.* She came regularly to his critiques, and "though my talent for drawing was nil, my personality attracted Henri's attention. I used to pose for him in his big studio apartment on Gramercy Park I hadn't yet developed a fashion style of my own, but my evening dresses, always of chiffon, were in the most lovely colors. I had a . . . dress that Henri adored to paint me in."[37] The result was *Girl in Rose and Grey,* a symphony of subtle shades, one of his outstanding life-size portraits (see color plate).

During the spring of 1911 Henri also painted other students, including Dorothy Rice, Carl Sprinchorn and Randall Davey. Despite the energy consumed by his exhibition activities and teaching, he managed to produce some seventy paintings during the first six months of the year, among them several stunning full-lengths, including the almost ethereal *Lady in Black Velvet,* a portrait of the artist Eulabee Dix; and *The Masquerade Dress,* a likeness of Marjorie in a white, low-cut evening gown with pale, vertical, blue-green stripes. He also painted a twenty-four-by-twenty-inch canvas of William Glackens' four-year-old son Ira wearing a sailor suit, where the solidity of the small body and sleeves beneath a wistful head dissolves into a glorious network of pure brushwork.

Since his marriage to Marjorie, he had become more orderly in his living habits and better dressed; he began to wear tailor-made clothes, the finest woolen suits and handmade silk underwear. He painted in a silk smock worn over a suit, and in the evenings would change to a mohair smoking jacket. The new image was consistent with advice he gave to his students: "An artist should dress like a businessman. An artist should not look like an artist."

Visitors to 10 Gramercy Park would ascend the five flights to the top floor, usually pausing at the last landing to gaze at his imposing copies of the Prado's Velázquez paintings. The studio consisted of one good-sized room; a large easel was placed squarely beneath the skylight, beside a model's stand and a table topped by a large glass palette. Paintings, books and furniture were all quite neatly arranged around the perimeter. When someone posed for him, Henri would look through his drapery collection, then try various materials behind the figure until he thought the contrast of color and texture was just right.

During June and July he remained in New York for a portrait commission, also devoting time to a series of color experiments with the Maratta palette. By now Hardesty Maratta had become a constant caller, sometimes visiting Henri on a daily basis for consultation. Henri produced a still life of flowers and a vase, a unique subject for him; another study in color and form combined a figure with several trees placed in the remaining negative space, a flat-pattern approach to design showing at least an awareness of the Post-Impressionists. The culmination of these experiments was a large painting of a figure surrounded by tree branches and blossoms.

By August, Henri was becoming restless. Having decided to forgo another summer in Holland or Spain, he suddenly determined to take Marjorie to Monhegan. Bellows, who was edgy because his wife was seven months pregnant, jumped at the chance to get away too, and Randall Davey also joined them.

They stayed at Monhegan House, one of the three facilities for visitors to the island, which was a two-hour boat ride from Boothbay Harbor on the mainland. Henri, in a yellow slicker and a lobsterman's hat, would tote easel and paints to favorite spots: the boat landing, a ledge overlooking the headlands, and the dense virgin forest known as Cathedral Woods. As a precaution, the three artists rented studios for rainy days.

Henri now worked feverishly, virtually from dawn to dusk, but still found some time for relaxation—cardplaying, conversation and lobster parties at the studio of George Everett, a fellow artist.

Sometimes, as in the case of the woodland compositions, he would produce several at the same location, beginning with a fairly realistic treatment, then simplifying the forms with each successive effort. In some paintings he employed a palette knife, a technique he had not used for two decades.

After Bellows left in August to be with his wife when the baby arrived, the Henris stayed on for another month and, by the time they headed back to Boothbay, he had produced 290 oils in less than two months!

In New York he continued his Friday-evening critiques at the Henri School, and by November was engaged to teach an additional evening class at the Modern School of the Ferrer Society. It was there that he had met Emma Goldman the month before and reported: "She wants me to help them in the art side of the school. Interesting interview."[38]

Henri's and Goldman's paths had initially crossed in January 1911 completely by chance. Having gone to Columbus in connection with the Independent exhibit there, Henri made a side trip to Toledo at the request of his student Helen Niles, who had arranged a talk by him, and the following afternoon they went "to hear Emma Goldman lecture on 'Tolstoi.' A woman of remarkable address, convincing presence. I never have heard so good a lecture. This is a very great woman."[39]

Attracted by her imagination and courage in speaking out on unpopular subjects, Henri left a note requesting that she inform him of any programs planned for New York. On the train back from Ohio he read her book, *Anarchism and Other Essays*, which he had purchased at the talk. For her part, Emma Goldman "had heard of Henri, had seen his exhibitions, and had been told that he was a man of advanced social views." When she next spoke in New York he was indeed on hand and said to her: "I enjoy your magazine *Mother Earth*, especially the articles on Walt Whitman . . . I follow everything that is written about him."[40]

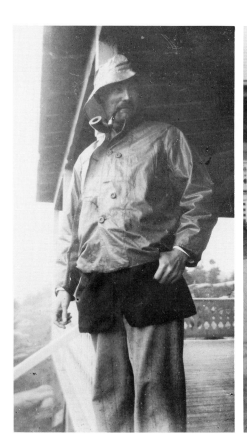

LEFT: Henri on the steps of Monhegan House, Monhegan, Maine, 1911. CENTER: George Bellows, Monhegan, Maine, 1911. RIGHT: Randall Davey, Monhegan, Maine, 1911. Photographs courtesy of Dr. Alta Ashley.

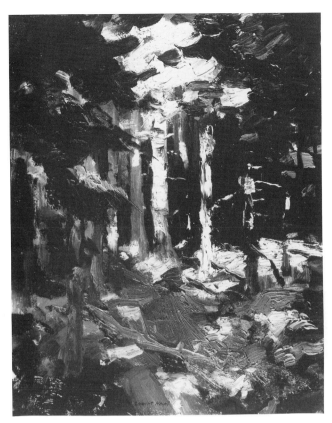

Cathedral Woods, 1911. Oil on canvas, 32″ × 26″ (81.2 × 66.0 cm.). The Toledo Museum of Art, Toledo, Ohio. Frederick B. Shoemaker Fund.

The Ferrer School, as it was popularly known, was named for Francisco Ferrer, the Spanish educator and anarchist who, beginning in 1901, founded over one hundred schools along libertarian lines, a system that challenged church and state and threatened the status quo of both. He was eventually arrested, tried and shot in 1909; the school in New York was established the following year to further his ideals.

Toward the end of October 1911, Henri heard another Goldman lecture, after which she asked him if he would provide evening art instruction at the school and he agreed.

There was an effort in New York at the time to bring culture to the underprivileged, a goal favored by Henri, who lent paintings to exhibits at the Rand School and the Educational Alliance for this purpose. His willingness to be associated with the Ferrer School now had to do with his belief in the principle of freedom of expression espoused by Emma Goldman and practiced at the school, rather than any allegiance to the organized anarchist movement. As Carl Zigrosser, who studied with him there, stated, it was "his fervent belief that only freedom can bring out the best in the individual."[41] This was why he had spoken of The Eight as having "come together because we're so unalike,"[42] and why he had no desire to create a school of imitators among his students.

After John and Dolly Sloan joined the Socialist Party, Henri went with them to lectures and was present at the Sloans on occasions when "the talk was socialism."[43] About one such evening Henri recorded in his diary: "Sloan—socialist . . . William Butler Yeats, sympathetic socialist because of breaking away for the desired condition. I sympathetic socialist as intermediate for greater freedom of the individual."[44] When Sloan became acting art editor of *The Masses,* a liberal literary and art magazine with a socialist outlook, he selected two of Henri's cartoon drawings for publication. But *Judging Art,* a pen-and-ink carica-ture of the 1907 Academy jury, had little in common with most of the publication's illustrations, which regularly featured poor working conditions, the un-employed and the downtrodden.

Henri's method for emphasizing individuality at the Ferrer School was to allow the class "to develop whatever is in them. I merely answer questions or give suggestions on the solution of their more difficult problems," he said. In order to minimize any influence from his own approach to art, he abandoned class-room demonstrations.

Simultaneously he began lecturing at the posh MacDowell Club, many of whose members were socially prominent and well-to-do, the antithesis of Emma Goldman and the Ferrer School. Throughout 1911 Henri devoted much of his time and energy to the MacDowell Club's consideration, and eventual acceptance, of his long sought-after exhibition scheme for a year-round art gallery.

His initial contact with the club came through Mary Fanton Roberts, who had been elected to its board the previous year. Henri was included on a committee charged with staging a play for Christmas, 1910. Performers included Mr. and Mrs. Walter Hampden, the English actress Katherine Kidder Clarke, and artist Ben Ali Haggin, with Henri in the role of Robin Hood.

Early in 1911 Mrs. James Haggin, Ben Ali Haggin's mother, an influential member of the club, sought Henri's help on an exhibition plan for its new quarters on Fifty-fifth Street. He had always dreamt that his group-exhibition scheme would take place in a build-ing sufficiently large to accommodate several gal-leries, but now he had to adjust to the reality of a single room. "I suggest my 20 group plan," Henri said, alluding to his idea for twenty groups of eight to twelve artists each, who would show throughout the year without a jury or prizes. The plan "was favorably received as being a way through which the club might make itself really of service to the rising generations. It yet remains to be seen if there will be the courage to carry it through."[45]

Henri visited the club's new quarters, attended a dozen meetings on the subject and lobbied for his plan with members of the exhibition committee headed by artist Paul Dougherty, who offered to relinquish his post to Henri so he could get the project accepted. "I refused," Henri reported, "as it was not necessary for me to be chairman to carry it on."

At a meeting on May 3 some club members opposed the idea of exhibits on grounds that it would dis-criminate against the other arts in favor of painting. As he was in the habit of doing, Henri waited until everyone else had had his say, then explained why a

single gallery could not succeed if it attempted to accomplish too much. Mrs. Haggin voiced approval of his plan, as did the widow of Edward MacDowell, and Guy Pène du Bois revealed the decision in the *American*:

New York, next winter, will realize an art ideal. An ideal that painters have looked forward to for centuries. A national art passed on parade—that is the ideal—a parade in which the good and the bad and the mediocre are presented and where fly the flags of the conservatives as well as the red flags of the radicals; a parade that is comprehensive and unprejudiced and has not, waving at its head a banner to which every parader must pledge allegiance[46]

Henri stressed that the groups of artists were to organize themselves with each set of exhibitors acceptable only to the members within it. He sent out the call for group applications and the first one was soon submitted, including the names of Jerome Myers, Elmer MacRae and Henry Fitch Taylor. Someone suggested that the first exhibition should involve members of the MacDowell Club's art committee, and when the forty works were installed on November 1, 1911, the exhibitors were Henri, Bellows, Haggin, Dougherty, Putnam Brinley and John C. Johanssen, all committee members; plus Jonas Lie, M. Paul McLaul and Irving Wiles. Henri was represented by his *Lady in Black Velvet* and *The Red Top*.

Among the laudatory reviews was one by Hutchins Hapgood in the *New York Globe*:

If the exhibitions that follow that of the first group of painters at the MacDowell Club, keep to the same high level, we are liable to have a distinct departure in an art way in this city By Mr. Henri there is one of his best achievements—a lady in black velvet wearing a large picture hat. It is full of character, and a quite remarkable rendering of flesh and blacks, so subtle and so refined as to rank with the good portraiture of modern times[47]

Henri had designated Sloan as the organizer for one of the exhibitions and by mutual consent Sloan invited Davies, Luks and Prendergast, the three members of The Eight who had participated in the Rockwell Kent Independent earlier in the year. Davies replied that "he wished to be free from the 'dreadful thought of an exhibition' so would not go in the MacDowell scheme."[48] Prendergast, writing from Venice, also declined, and Luks said he would speak with Davies, after which he, too, said no. Then Henri issued an invitation to Walt Kuhn, who was also negative. Sloan eventually filled the empty slots, but it was evident that The Eight were now unalterably divided into two camps.

Nonetheless, the MacDowell Club plan appeared a success and in November 1911 Henri wrote of his triumph:

Things have gone fine with the MacDowell exhibition—the first of the series The idea is well launched. Things worked out well in the opening and the Gallery is a beauty—scarcely any gallery in New York equal to it. Light, decorations, space—all splendid. I am mighty well pleased, for it is really the beginning of a new era[49]

But unknown to Henri, who labored for the good of all, conspirators lurked in the shadows. Unlike Julius Caesar, who refused the crown, Henri was suspected by some of the intent to make himself king. Spurred by jealousy and critical of his leadership role, they set about to organize their own show, one in which *they* would be in the limelight.

At the time that the initial exhibition was being staged at the MacDowell Club, a show called "Selected Paintings by Noted American Painters" was on display at the Madison Art Gallery. Fourteen artists were represented, including Glackens, Bellows, Lawson and Samuel Halpert. The day prior to its close, three of the exhibitors—Myers, Kuhn and MacRae—were discussing their plight with Henry Fitch Taylor, the gallery director. Bemoaning the emptiness of the exhibit rooms and the lack of sales, they pondered a bleak future. Kuhn had seen the first MacDowell show and characterized it as "a lot of soft boys Can't see much in it for me."[50]

All three artists had exhibited in the 1910 Independent and now began to think in terms of another major show along those lines, but better. The plan began to evolve, and when the Academy's winter annual opened, Kuhn, observing that "it's very rotten, worse than ever," informed his wife: "It seems that all hands have been 'fired' again, and it only needs a match to set off the founding of a new Society."[51] Kuhn's own one-man show was now on display at the Madison Gallery, but, being overshadowed by the Academy exhibit, its publicity was minimal. "The Times article was spoiled by the opening of the Academy," he wrote her, "so of course they crowded out my photo to make room for the 'beautiful portrait group' From what I hear it's quite likely that there will be a revolution this winter and that a new society will form."[52]

At this same time Henri was having his own one-man show at Macbeth's, a collection of thirty-nine of the Monhegan oils. Huneker of the *Sun* drew a comparison, calling Kuhn's efforts "brilliant transcriptions" and Henri's "more sombre and varied studies."[53] Referring to the article, Kuhn rejoiced: "I bet Mr. Henri had a fit when he saw it. Guess we've got his goat after all."[54] Then Kuhn, who devoted most of his time to producing newspaper cartoons, "grinding away at comics praying to the Lord that it will soon be over with . . . ," revealed his idea:

Now here's what I've been thinking. We certainly made good this time, but what we need now is *publicity* Beginning the first of Jan. [1912] I am going to organize a new Society the plans are still in embryo state but clear enough in my mind's eye to spell positive success—No one is in on it except Gregg [Frederick James Gregg, the art critic] and he's "mum," and the best advisor I could get. As soon as I have it thoroughly planned we are going to give it to *all* the papers, and they'll jump at it. Of course Henri and the rest will have to be let in—but not until things are chained up so that they can't do any monkey business. He's so wrapped up in the MacDowell Club that he is off guard, and I'll put it over before he knows it, and in such a way that he can't make a single kick.[55]

Kuhn's notion that this would be *his* society, with

him in charge of the publicity, had stemmed from a rebuff by Henri the previous year regarding the 1910 Independent. Kuhn had confided to John Sloan that "going into a show with Henri we are all the 'tail of his kite.' "[56] Kuhn employed Sloan as an intermediary to ask Henri if he would name Kuhn to head the publicity, but Henri had rejected the idea. Now Kuhn would orchestrate and publicize the new organization himself.

Jerome Myers, who may still have been feeling the hurt of being excluded by Henri from The Eight, held a meeting at his studio attended by Kuhn, MacRae and Taylor, and on December 19, 1911, the first official gathering of the Assocation of American Painters and Sculptors was held. Thirteen of the sixteen artists invited to be charter members were in attendance: Glackens, Davies, Luks and Lawson had all been asked, but not Henri. At that meeting the Association's goals were determined: "For the purpose of developing a broad interest in American art activities, by holding exhibitions of the best contemporary work that can be secured, representative of American and Foreign Art."[57] It was then agreed to extend an invitation to Henri, who accepted with a typically optimistic reply to Kuhn: "Success to the young Society, may its youth have a long life! Will be there with pleasure Jan. 2 at 8 P.M."[58]

At the get-together additional members were proposed, including Sloan, Bellows, Prendergast and Shinn. Henri recommended Henry Reuterdahl, an illustrator and painter of impressionistic harbor scenes and seascapes. He came to realize that officers had already been elected and a constitution drawn up prior to his presence, and that "Davies is very active in it." He concluded: "I am not interested in this society except as it may be useful to check the National Academy of Design. Otherwise it is too much of the old thing—judging others and not working to the opportunity for others to exhibit and judge themselves."[59]

The following day Henri learned that the Association's president, J. Alden Weir, had resigned because the new group was "openly at war with the Academy of Design." Gutzon Borglum, the vice president, phoned Henri and asked whether he would "accept the presidency of the Society—if it was offered me. Answered no—would accept presidency of nothing."[60] Then Elmer MacRae called to ask whether he would support Davies for president, and he said he would. Henri attended another meeting of the Association on January 23 and concluded: "They are in slight prospect of doing anything. Not practical."[61] The prophecy would go down as one of Henri's most imperfect judgments.

As Walt Kuhn had predicted, Henri was kept preoccupied with the MacDowell Club, where he found "much to do and practically all to be done through my hands." An article concerning Henri in the April 1912 issue of *Current Literature* stressed the point: "Just at present he is deeply interested in an attempt being made by the MacDowell Club of New York to provide a substitute for the existing academic jury system."[61]

For all of his past embarrassments and rejections by the Academy, Henri sought only to improve it. Being

of the opinion that "the most advanced, broadest and biggest influence in modern art is in the step taken by the MacDowell Club," he reasoned:

> What a masterpiece it could be to make the old academy young and strong and magnificent—which would be the result if they would but adopt this fair-chance-for-all plan. In this new society the Association of American Painters and Sculptors there may develop the self-judging group idea. I'm hoping[63]

The early months of 1912 were filled with good news. Henri's paintings were included in a record number of exhibits outside of New York: the Chicago Portrait Show, the Art Association of Indianapolis, Boston Art Club, Charcoal Club of Baltimore, Art Club of Philadelphia, the Pennsylvania Academy, Carnegie Institute, Worcester Art Museum, Cornell University and the inaugural exhibit of the Toledo Museum of Art. In addition, he was represented in two American Federation of Arts circulating exhibitions that toured cities in Minnesota and Indiana.

These shows were coupled with a healthy number of sales, including the purchase of *Girl with Fan* for the permanent collection of the Pennsylvania Academy, and the Boston Museum's acquisition of *Laughing Girl*. Henri craved more time to paint and, after having agreed to serve on the Pennsylvania Academy jury in January, he wrote the director that "if there is any escape . . . please let me off from that . . . I should like to stay at home and work."[64]

In the studio he continued his color studies, producing two dozen panels, some as tiny as three by four inches, with bands of varied combinations of hues. He also painted an experimental series of figure compositions, using his wife as model, in which striking juxtapositions of colors were emphasized. In one, Marjorie is seated so that her red hair is seen against an orange background with a wall beyond painted blue to the left, gray to the right. It was as though his earlier awareness of van Gogh had finally given way to Matisse and the Fauves, and an attempt to incorporate their freedom of color into his style of casual brushwork.

The major canvas among his portraits was *Mrs. Charles Coburn,* showing the actress Ivah Coburn as Rosalind. Henri had met her and her actor husband the previous year, when he saw them perform at Columbia College in *As You Like It.* Now they dined together with the Robertses at Mouquin's, after which Henri led the assemblage to his studio to view the painting.

In the full-length portrait, Shakespeare's popular heroine appears disguised as a man in "doublet and hose," leaning against a tree in the Forest of Arden. Though the head is painted in traditional Henri style, the rest of the work gives evidence of greater spontaneity through the brilliance of his brush: masterful strokes provide highlights along the length of the jacket, becoming even freer in the foreground, where there is no attempt to disguise thinly brushed, dripped paint in the lower left-hand corner. But it is the background on the right where Henri's bravura becomes almost violent—slashing, scumbling, spontaneous—suggesting a distant tree so vigorously

that Rosalind's arm is partially dissolved in the process.

Henri's early love for the stage was rekindled by his association with the Coburns, and he began attending a variety of plays, from *Cousin Kate,* featuring John and Ethel Barrymore, to *Over the River* with Eddie Foy.

He continued to pay weekly visits to his former school and provide the expected stimulus, but student unrest had begun to surface. Some of the pupils expressed dissatisfaction over his lack of emphasis on anatomy, which they had to learn on their own or through Homer Boss's demonstrations. Boss would roll out plasticene on a drawing board like cookie dough, then shape each muscle and place it in the appropriate spot on a skeleton that hung in a corner. The method was the one used first by Eakins, then Anshutz, but since Boss's anatomy lessons were limited to an hour a week, it took two months to complete the entire process.

The other sore point with the students was Henri's stress on the Maratta system. Although many considered it too technical, he nonetheless continued to urge the class to utilize its color harmonies: "There is nothing more important than a full understanding of the work of Maratta," he maintained.[65]

By spring the situation had come to a head and, following Henri's April 12 critique, the student body took a vote. When it became clear that a majority were opposed to using the Maratta palette, Henri agreed to step down. The next week a sore knee prevented him from going to the school, so the composition class received its criticism in his studio, and that proved to be his final session. There were no recriminations, only the obvious feeling of hurt.

His departure from the school coincided with the sinking of the *Titanic,* which overwhelmed him with grief. "I have never felt a tragedy strike home more," he said, and his personal trauma was suddenly forgotten.

The following month his former students replaced the words "Henri School of Art" with "The Independent School of Art," with several classmates vying for the honor of painting the new name on the glass panel in the door. Boss continued to operate classes for several more years at the same location, but eventually it simply became a cooperative arrangement, with everyone sharing the cost of utilities and a model.

Now Henri directed his attention to the Ferrer School, where his art class had grown in popularity, along with offerings in literature and philosophy. The school attracted a large number of immigrants, but Henri's fatherly encouragement transcended the language barrier. Each week his classroom represented a microcosm of the Lower East Side's polyglot population, typifying the words of Emma Lazarus inscribed on the base of the Statue of Liberty: " 'Give me your tired, your poor,/Your huddled masses yearning to breathe free' " And it was the principle of freedom that he taught.

Since most of the students were too poor to afford paints and the classes were held at night, they worked in pencil or charcoal, eliminating any possible conflict over the Maratta palette. Morris Kantor, Robert Brackman, Samuel Halpert, Harry Wickey and Ben Benn were in the Henri class, as was William Gropper, who was greatly influenced by the Goya prints that his teacher brought for all to see. Gropper recalled, "I never forgot anything that he said."[66]

Tuition was only three dollars per month but most of those enrolled were unable to afford even that and studied without charge. At the same time Henri's reward was limited to personal gratification, for he received no salary.

The art class was inaugurated while the Ferrer School was on Twelfth Street, and when it moved into a brownstone on 107th Street Henri continued the lessons, meeting on the first floor above a lunchroom. There were usually about twenty pupils, the youngest of whom, a thirteen-year-old named Ida Kaufman, had wandered into the building one day while playing hookey from public school. A year later she married the school's substitute philosophy instructor, Will Durant, who changed her first name to Ariel. When Henri inaugurated a life class in January 1912 she attended eagerly, and once, when the model failed to appear and everyone's eyes fell upon her, the teacher led the youngster to a little closet and she reappeared nude, ready to pose.

For Ariel Durant, the Henri class was her "first impression of freedom, of respect, of education, of beauty, of the world."[67] Their drawing boards were propped up on chairs and they would line the drawings along the wall for the awaited critique. Speaking about a group of figure drawings, Henri referred to the model as "God-given, as the height of creation," and greatly impressed the young artist:

> He talked so beautifully and he was so sincere about his concept of what a human being was. Nobody had ever spoken to us like that before—we were kids who knew poverty and harassment and all of a sudden we were thought of as creators and told we were great.[68]

Sometimes Henri would ask the students not to draw but just to observe as a model disrobed before them, then redressed, and at this point he would tell them to sketch what they had seen.

Another Henri student was Emmanuel Radnitsky, who, after receiving his first few lessons there, changed his name to Man Ray. He was working as a calligrapher and layout artist for a technical publishing house, and his initial efforts showed detail and finish. Henri paused in front of him and remarked: "This is the sort of thing most people would understand and like; however, we should try to assert our individuality even at the risk of being misunderstood." Man Ray recalled that on "other evenings he would talk without paying much attention to the members' work, and I found his ideas more stimulating than any direct criticism."[69]

Henri's commonsense directives were obviously falling on receptive ears; he was able to ignite a spark in the case of Moses Soyer, who attended but a single session. Eventually Henri shared his teaching duties with George Bellows and, as Emma Goldman stated: ". . . together they helped to create a spirit of freedom in the art class which probably did not exist anywhere else in New York at the time."[70]

Henri held his final class at the end of May 1912, then left with Marjorie and fifteen students for Spain. The entourage was composed primarily of his former pupils, including Wayman Adams and Clara Greenleaf Perry, with Randall Davey managing the business end of the class for him.

In Gibraltar they inspected the Moorish market and in Granada they watched Gypsies dance outdoors at night. At Seville they toured the museum and listened to Henri's lecture on Zurbarán and El Greco; and in Cordova, sketched the mosque. On the evening of June 25, in Cordova, the group was joined for dinner in their hotel by two Americans, Gertrude Stein and Alice B. Toklas. Any meaningful conversation that passed between them remains unrecorded. The class entrained for Madrid that night, and four days later Gertrude Stein wrote to Henri from Seville, expressing appreciation for his having suggested the Hôtel de la Paix, where "the eating is the best in Spain."[71]

In the Spanish capital the Henri group stayed near the Prado; studios were rented on the top floors of several houses. The students were sent to the museum to copy, and out into the streets to draw the shoppers or clusters of children in Retiro Park. Alice Klauber filled ten sketch books with observations of the city. Some nights they went dancing; on others everyone congregated in a single room where Henri would talk about the MacDowell Club exhibits until nearly midnight, or they would sing such popular favorites as "Oh, You Beautiful Doll, You Great Big Beautiful Doll," with Davey plunking out the rhythm on his guitar.

Henri's critiques continued to stimulate: "Bouguereau could have done masterpieces but he did sugar and plums Bouguereau is popular with the weak—A man like Manet who comes with something strong—people say out with this blasphemer!"[72] Henri's advice, often stated in a single sentence, had a sense of spontaneity as if being uttered for the first time:

> Forms are not a reproduction, but a shorthand of nature.
>
> Get something of the fire and strength of the model—not the drawing of her eye.
>
> Sacrifice little things—ornament—to the big subject, to the structure.[73]

In his own painting, he still employed the Maratta color schemes and his hues were varied and bright, but the compositions became more formal and the brush strokes less pronounced. His most moving subject that summer was a portrait of a blind woman playing the guitar, a street singer whom he had brought into the studio. During the five hours that he painted her, she played and sang but then, when she rested, "it was terrible—" Henri said; he suddenly realized "there was no rest from being blind."[74] Henri accomplished "a big season of work" in Spain, producing some three dozen canvases, mostly of Gypsies.

In September he and some of the class visited Paris, where they viewed his favorite paintings by Manet, Velázquez, Rembrandt and Besnard in the Louvre and Luxembourg museums. By coincidence, Henri met his former student Walter Pach at the Petit Palais and they saw the Autumn Salon together. Unbeknown to Henri, Pach was in the French capital to locate some avant-garde works for the Association of American Painters and Sculptors exhibition scheduled in New York's Sixty-ninth Regiment Armory in February 1913. Two weeks after Henri planned to depart, Pach was to be joined by Davies and Walt Kuhn, and they would visit the studios of Marcel Duchamp, Jacques Villon, Odilon Redon and Brancusi, and the apartment at 27 rue de Fleurus that housed the Stein Collection.

The Autumn Salon of 1912 was the exhibit's tenth anniversary. The milestone was noted by a historical survey of over two hundred nineteenth-century portraits, which Pach immediately translated into a plan to be duplicated at the Armory Show. Included in the Paris display were canvases by Delacroix, Courbet, Corot and Puvis de Chavannes. As Henri and Pach walked beyond them from gallery to gallery, and then past works by Manet, Monet and the Impressionists, followed by van Gogh and Gauguin, the styles became increasingly radical. Finally, in the contemporary section, were Matisse and Picasso, the Fauves and Cubists. "Henri was taken aback by the Cubist work there," Pach reported. "He had tremendous reservations about them." But then his insight rose to the occasion. Looking briefly at a delicately executed study by the conservative Boutet de Monvel, he turned to Pach and said: "If it's a choice between the Cubists and that, I'm for the Cubists."[75] That week Henri and Marjorie went calling on Gertrude Stein, where a second dose of Picasso and Matisse was forthcoming.

In the privacy of his hotel room, Henri made a copy of Cézanne's palette; then, on a sepia postcard reproducing Cézanne's *The House in Provence*, he used colored pencils and employed parallel-line shading in imitation of the Frenchman's brush stroke. On the other side of the card Henri wrote:

> The color is from memory—and limited by the dark tones of the photo and the medium used. I have just seen the picture at Vollard's The sense of the original is powerful, it all works, everywhere it is sensible of its own strength, its living existence The warms, neutrals and cools play successively and unite all.[76]

Henri arrived in New York in late October, still unaware of the size and scope of the exhibit being planned by Davies, Pach and Kuhn. Nor was he privy to the depth of the negative feelings that Davies harbored for him, an attitude that had motivated the organizers of the Armory show from the start. As Davies wrote to Kuhn in the same month:

> Clarke [J. Mowbray Clarke, a vice president of the Association] has promised to work on the second circular, but I am inclined to work with Glackens on it. He has more horse-sense than any of the other fellows, even with the shadow of the "Blackest Henri" over him
> Yesterday we had a little gathering in Myers' studio

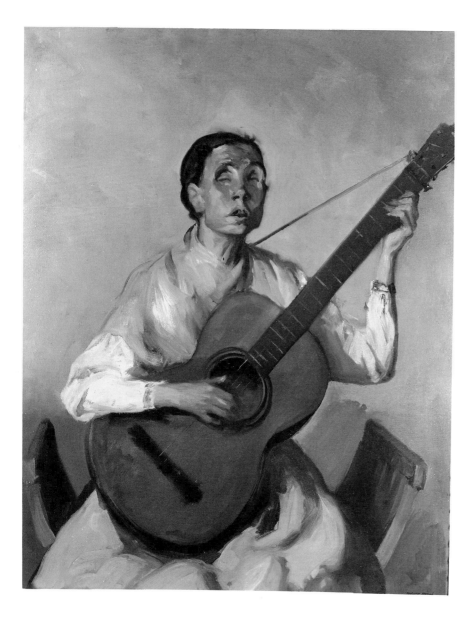

Blind Spanish Singer, 1912.
Oil on canvas, 41" × 33⅛"
(104.1 × 84.1 cm.).
National Museum of American Art,
Smithsonian Institution,
Washington, D.C.;
gift of Mr. J. H. Smith.

to decide on the contents of the second circular and to settle if possible our attitude with the newspapers and general public Clarke received a note and signed card from Henri from Paris, Hotel de Portugal, which Clarke considers a complete backdown so don't rub it in now, he is weak artistically, God knows! and his faculties are not for art by any means I enclose a ground plan for the arrangement of the Armory. Please make suggestions and practical improvements. It has made some eyes bulge Do not forget we want a roomful of Futurists and another of Cubists.[77]

The reference to Henri's "complete backdown" concerned his having been approached before leaving for Spain to aid in the acquisition of European art for the show. His refusal had given cause to alienate him still further from the show's organizers, who were aware that Henri's taste for art did not conform to their own. A front-page article in the *New York American* on June 27, 1912, headlined "'Progressives' in Art Counted Out by Reactionaries, Robert Henri in Revolt," told the story:

Robert Henri, who has been called "high priest of the seditionists," finds that it [the forthcoming Armory Show] is too much like the academy. Recently a few members of the society called at his studio, No. 10 Gramercy Square, and invited him to become one of its trustees.

He refused flatly. He is one of the charter members of the society. As he was to be in Paris this summer he was asked if he would consent to help gather foreign works while there. He implied, so the report goes, that he would do nothing unless given full authority. That did not forthcome. He remains, however, a member of the society. Mr. Henri's exhibition scheme, which does not coincide with that of the "American Society," is exemplified in the shows which have been given at the MacDowell Club.[78]

Exactly because Henri was considered the "high priest of the seditionists" as a result of his previous leadership roles with The Eight, the 1910 Independent and the MacDowell Club exhibits, he had come to believe that no similar effort could succeed without him at the helm. Primary among those who thought

otherwise, of course, was Davies, who had been long tired of Henri calling the shots and receiving the credit.

Resentment had been quietly building for years; it was Davies who had obtained the Macbeth Gallery for The Eight show, and in Henri's absence planned the catalog only to have Henri criticize the effort. Davies had likewise been involved in planning the 1910 exhibition, had even backed it financially while being witness to Henri's once again becoming the hero of the day. And what of the 1911 Rockwell Kent Independent, which had to be held over Henri's objections? By now Davies was convinced that there was no place for Henri in his scheme of things.

On Henri's return from Europe he found his mother quite ill and devoted himself entirely to nursing her back to health. For two weeks he "attended to nothing else," not even meeting at "our old haunts" such as Petitpas's. By early November, though, he was able once again to submerge himself in Maratta-inspired color studies: "I have been having a fine time of late—," he wrote a former student, "simply wallowing in color—I have little other idea than just study—experiment and adventure in paint and drawing this winter—if in the efforts there comes a picture now and then I shall not throw it out, but it will have to come of itself."[79]

Soon after his arrival in Manhattan, Henri was contacted by Dr. Albert C. Barnes, Glackens' former high-school classmate from Philadelphia, who was now a millionaire through his marketing of an antiseptic called Argyrol. A portion of Barnes's impressive collection of Impressionist and modern art had been purchased for him by Glackens in Paris earlier in the year.

In April 1912 Barnes had offered Henri five hundred dollars for his portrait of a Dutch child called *The Red Top* but Henri refused, "requiring the price I asked, $800."[80] Now Barnes purchased another work for two thousand dollars and by November Henri could report that "The Doctor has the Ballet Girl in White and he says it is all to the good—says it is perfectly hung and perfectly lighted in his gallery, along with the Cézannes, van Goghs, etc. He owns some of the best of the modern men's works."[81]

At the time of the purchase, Henri had given Barnes a Dutch landscape entitled *Dune,* but in December the collector informed him:

> I would prefer a head to your landscape in my collection. If you will make the exchange, I shall be very much pleased
> I got some important Cézannes and Renoirs a few days ago in Paris and brought them back on the steamer with me. There are six Cézannes—and four Renoirs that equal the master's best. I got also two very typical Daumiers, some early Picassos and the Matisse still-life and landscape which I believe you saw at Stein's apartment in Paris.
> All these new ones will soon be on my walls and when they are, I shall ask you to come over and see me and them.[82]

In reply to Barnes's request, Henri swapped his *Dutch Girl with Sailor Hat* for the landscape.

At a meeting of the Association of American Painters and Sculptors on December 17, Arthur B. Davies, the president, succeeded in blocking Henri's effectiveness by excluding him from the Committee on Domestic Exhibits, to be chaired by Glackens. Instead he was assigned to the Committee on Foreign Exhibits, a meaningless post since the European works had been selected and many of them were already on their way across the Atlantic.

Glackens' willingness to accept the chairmanship from Davies, in seeming opposition to Henri, was caused in part by his growing appreciation of modern art; he realized that Davies was more sympathetic to that cause than Henri. After all, the first canvases by Renoir, van Gogh, Gauguin and Cézanne in the Barnes Collection had been selected by Glackens.

Henri continued to devote time to the MacDowell Club. In December he met Ruth St. Denis to rehearse for a dance they planned to perform at the club's Christmas Ball; on the 26th there was a new exhibit by eight Henri students; and two weeks later a pair of Henri paintings were included in the next show, which also featured works by Bellows, Hopper, Glintenkamp and Randall Davey.

During December and January, Henri chose canvases to submit to several major exhibits: the Charcoal Club of Baltimore's "Exhibition of Contemporary American Art," which would bring together canvases by The Eight (except for Shinn and Prendergast), plus Bellows, Boss, Davey and Patrick Henry Bruce; the Corcoran Biennial; the Pennsylvania Academy annual; and the National Association of Portrait Painters' exhibition at Knoedler's.

For the Armory Show, Henri designated *Figure in Motion,* a just-completed full-length of a nude placed against a blue background and a purple-and-green floor; *The Gypsy,* painted in Spain the previous summer; and *The Red Top,* the 1910 canvas that Barnes had sought to purchase. There were also two drawings: a pen-and-ink from 1896 of a sidewalk café in Paris' Latin Quarter and a sketch in sanguine of a seated nude.

The decision makers organizing the Armory Show had sets of postcards printed, featuring sepia reproductions of works designated for the exhibit. The idea was borrowed from the Sonderbund (Separatist Group) Exhibit in Cologne, Germany, which Kuhn had visited the previous September. By January each member of the Assocation of American Painters and Sculptors had received the postals, which were slated to be available without charge at the show. *The Red Top* by Henri was included in the set, together with paintings by Davies, Kuhn, Glackens, Prendergast, Bellows, Augustus John and Francis Picabia and sculpture by Jo Davidson and Wilhelm Lehmbruck. Only through the picture postcard of Picabia's cubist *Dance at the Spring* could Henri even begin to fathom the scope and avant-garde nature of what by now was being billed as an "International Exhibition of Modern Art."

How would his work, and all of the American art, fare? The question began to nag at him. Shortly before the February 17 opening Henri would learn the answer.

CHAPTER 16

THE ARMORY SHOW
AND BEYOND

PUBLICITY FOR THE ARMORY SHOW had begun in mid-December. "Show of Advanced Art Promises a Sensation" was the bold headline in the *New York Sun;* "Revolution in Art to Sound Its Note Here in February" announced the *Globe and Commercial Advertiser;* "Works Worth $2,000,000 Will Be Seen at Art Show" claimed the *New York Press.*

On January 22 a meeting of the Association was held to approve, after the fact, Davies' policy in the selection of paintings and sculpture. Henri was present but not active in the proceedings; for the first time he witnessed someone else in charge of a fledgling art organization planning an exhibition. Now he sat in silence, an observer to history in the making. The *new* avant-garde would make his pioneering role in art, as well as his art itself, passé.

At the meeting Henri did vote with the majority to pass the following resolution:

> That the policy expressed by Mr. Davies in the selection of the paintings and sculpture be approved by the members. That improved plan of arrangements as submitted on this date, as well as Mr. Davies's policy regarding the distribution of works be approved.[1]

Four days later an article appeared in the *New York American* in which Henri was openly criticized as a conservative. At Davies' urging, Alfred Stieglitz made a public statement meant to promote the forthcoming event. By now a widening circle had become aware of Stieglitz' exhibits of contemporary European and American art at his Fifth Avenue gallery, "291"; for his part, Stieglitz used the newspaper interview to publicize a one-man show by John Marin that was about to open at his establishment.

Under a six-column headline, Stieglitz expressed his contempt for the schools of painting that would go on "breeding little Chases, little Henris and little Alexanders"[2] The charge hurt Henri to the quick; "Have I really become as conservative as William Merritt Chase and John Alexander?" he must have wondered.

Art circles buzzed in anticipation of the great event, and on February 15, 1913, two days before the opening, Henri could wait no longer. Accompanied by Manuel Komroff, one of his students, Henri entered the nearly new armory of the New York National Guard at Lexington Avenue and Twenty-sixth Street and found the vast drill floor transformed by burlap-covered partitions into eighteen spacious galleries. Bellows and other Henri students had helped with the carpentry work and the hanging. Garlands of greenery and festooned ceiling decorations were provided by courtesy of Gertrude Vanderbilt Whitney and her sister-in-law, Dorothy Straight, who each contributed a thousand dollars.

Paintings and sculpture were strewn everywhere. Henri and Komroff walked past the portraits by Ingres, Delacroix, Courbet and Manet, oblivious to the hubbub reverberating through the great hall. Proceeding along the Impressionists and beyond the still lifes of Redon, they came to the Cézannes, then the eighteen works by van Gogh. "Who can see the Whistlers for the Cézannes, Rousseaus and van Goghs?" Komroff asked, half speaking to himself. Then, turning to his teacher he inquired: "What do you think of van Gogh?" There was a pause. "If you don't mind, I'd rather reserve my opinion," Henri replied.[3] Further conversation seemed fruitless, and when they reached the area designated for the Fauves and Cubists, not a word passed between them.

As Henri rounded the corner of a partition, there, squarely before him, were Arthur B. Davies and Walter Pach! For a brief moment they stood face to face, and for the first time in his life Robert Henri was speechless. Finally he said: "Don't you think these pictures are hung a little low?" There was an embarrassing silence in the midst of the racket in the armory. Then Henri added: "If they were raised ten, eight or even six inches, the visitors could see them better." The suggestion appeared to be directed at Davies, but with a turn of the head it was ignored.

Henri looked down at the dramatic color and distorted form of some Fauve paintings leaning

against a partition. Then he gazed at Pach. "I hope that for every French picture that is sold, you sell an American one," he asserted. Pach looked at his former teacher and replied: "That's not the proportion of merit." Henri stood for a moment with head bowed and then, as Pach and Davies began to drift away, called after them: "If the Americans find that they've just been working for the French, they won't be prompted to do this again."[4]

The formal opening of the Armory Show was at eight P.M. on February 17, 1913, with admission by invitation only. After that the display was available to the public from ten A.M. to ten P.M. with tickets at one dollar for adults and twenty-five cents for children; a band of ushers guided the mass of visitors through the maze. Twenty-five thousand buttons with the Association's pine-tree emblem and the words "The New Spirit" were distributed free. A temporary post office was installed near the entrance for mailing Armory Show postcards.

Thousands of people crowded into the armory, there to gawk and laugh or learn. Henri's largest painting, the full-length *Figure in Motion*, depicted a standing female in unabashed nakedness, a straight-forward statement unlike the idealization of a Bouguereau Venus. But those who were told "Don't miss the nude" looked not for Henri's but for another figure in motion, Marcel Duchamp's Cubist, multiple-image *Nude Descending a Staircase*. An "explosion in a shingle factory" was what one paper called it; a *Rude Descending a Staircase* according to another. The American public was scandalized. It was a circus, some said, associating the show with the Barnum and Bailey elephants kept in Broadway Alley, a block from the armory.

Enrico Caruso entertained the crowds by drawing caricatures of the avant-garde art and tossing them to an adoring audience. Former President Theodore Roosevelt appeared at the show on Woodrow Wilson's inauguration day and wrote a magazine article on the subject:

Take the picture which for some reason is called *A naked man going down stairs*. There is in my bath-room a really good Navajo rug which, on any proper interpretation of the Cubist theory, is a far more satisfactory and decorative picture.[5]

American Art News offered a prize of ten dollars to the person who submitted the best explanation of Duchamp's painting. The Wanamaker department store held a fashion show in which the gowns showed evidence of Cubist and Futurist color. Henri returned a number of times and urged his students to do the same, emphasizing that they should not miss the Manets, Monets and Renoirs, and the American paintings. By now Henri's longtime comparison of Manet and Bouguereau had really become old hat; there were only four Manets on display, as opposed to nineteen works by Matisse.

As for the U.S. art, Glackens was quoted in *Arts and Decoration* as saying: "I am afraid that the American section of this exhibition will seem very tame beside the foreign section"—a gross understatement. Only

James Britton, in *American Art News*, wrote perceptively about the native productions: "The characterizing power, both with line and color, of Henri and Luks, the imaginative versatility of Davies, the tonal ingenuousness and technical fluency of Bellows, are qualities undimmed in the international maze."[6]

Henri annotated his catalog, placing a circle beside the names of thirty-nine exhibitors who were his students or former students, and the letter "F" next to each of the foreign artists. His hope that sales by Americans would equal the number of European works sold was never realized. While his own painting *The Red Top* and a drawing were purchased, and Edward Hopper registered the first sale of his career, there were only thirty-five American works bought, compared to one hundred and thirty by European artists. Henri's worst fears had come true; this *was* a foreign invasion.

The absence of a Henri diary for 1913—he either discontinued writing one or destroyed it—prevents us from learning the depth of his feelings; perhaps he reasoned that all of those summers spent in Holland and Spain had unintentionally shielded him from the evolution of art being pioneered in Paris. And though he preached freedom of expression to his cadre of students, Henri had shielded them as well. His rich and stimulating philosophy had simply developed early and remained frozen in time.

When the Armory Show traveled to Chicago in March, only his *Figure in Motion* was sent, and in Boston the American section was eliminated altogether because of a lack of space in Copley Hall.

New York critics were nearly unanimous in their denunciation of the Armory Show, with the conservative Royal Cortissoz characterizing it as "some of the most stupidly ugly pictures in the world."[7] When it was installed at the Art Institute of Chicago it was called "nasty, obscene, indecent, immoral, lewd and demoralizing" by the *Record-Herald*,[8] which suggested that the city's teachers might urge the public-school children to stay away from the exhibition.

In Manhattan the exhibit had its most devastating effect upon the academicians, who were still reeling from the results of The Eight and the 1910 Independent. Kenyon Cox, in *Harper's Weekly*, actually warned art students: "If your stomach revolts against this rubbish it is because it is not fit for human food."[9] Chase branded Cézanne an "idiot" and, lecturing in Baltimore a year after the event, still spoke out against Cubism and Futurism as "insane movements."[10]

Henri maintained his public image of tolerance, yet the frustration, the pain, went deep, causing him to write a bitter, satirical letter under a fictitious name:

To the Editor of the Evening Sun.
Dear Sir,
I am surprised that my work should be overlooked by every N.Y. critic who has written a line about this ultra-modern Armory Show—My work—the work of the only Post-Futurist in the show, has been overlooked—that my name is not in the catalog—nor the title of my work—and that the work is not visible to the ordinary use of the eye is no excuse—Post-Futurism can use no such ordinary devices to obtain

attention. My picture is one that should not be seen—
it should be sensed. And your critic, if he be astride
with Post-Futurism, should have sensed it and re-
ported as best he could with what sensations he had.
Regretfully yours,
P. Jozkifsowk P-F[11]

Perhaps it was just as well for Henri that the Fellow-
ship of the Pennsylvania Academy, which had sched-
uled a lecture by him on the subject of the Armory
Show, canceled it and substituted a somewhat less
controversial event—an hour of song by a local tenor.

Before the show closed in New York it was seen by
ninety thousand people. On the last evening, after the
doors had been shut at ten o'clock, there was a jubilant
celebration, some of the Association, ticket sellers,
ushers and members of the Sixty-ninth Regiment
joining in an impromptu snake dance that swept
through the drill floor amid laughter, singing and the
beat of the regimental fife and drum corps. Henri was
not among the celebrants. When one of the artists
made a champagne toast "To the Academy!" John
Quinn, the Association's legal adviser, repeated the
words of the captain of the battleship *Texas* as it
steamed past a burning Spanish ship during the Battle
of Santiago in 1898: "Don't cheer, boys; the poor
devils are dying."[12]

A final celebration was held on March 8, when the
Association sponsored a beefsteak dinner for its
"Friends and Enemies of the Press" at Healy's restau-
rant. Davies, Kuhn and Pach were enthroned at the
head table, with Henri, Sloan and Bellows toward the
rear of the room. The wounds were still too fresh for
much in the way of speech making, although Cor-
tissoz did offer a word of praise and advice: "It was a
good show but don't do it again."[13] Then frivolity
reigned briefly as two artists, a sort of Mutt and Jeff
team, entertained by dancing the turkey trot, tango
and cancan, and toastmaster Frederick James Gregg
read fictitious telegrams from Gertrude Stein, Anna
Held and Mayor William J. Gaynor that had actually
been penned by Kuhn.

At Homer Boss's Independent School of Art the
students had derisively toasted Henri with the words:
"The King is dead; long live the King."[14]

Like many of Henri's former pupils, Stuart Davis
was impressed by the European art at the Armory
Show. "Talks with the other students about it left me
with the realization that the Henri school . . . this
American free naturalism wasn't the answer, that all
kinds of new areas were opened up."[15] Although
Davis was not alone in his reaction, Henri heard about
his remarks and was hurt. Afterward, when Davis
visited him, Henri said: "I didn't know you were
interested in this type of thing."[16]

In his subsequent teaching, Henri updated the old
comparison between Manet and Bouguereau in favor
of a more contemporary version:

Cézanne threw his canvases away or used them to
stop up chinks in the walls of his hut; he was scorned
or pitied or ignored by all. Bouguereau, the learned
academician, on the other hand, was given every
possible mark of esteem. Today, Cézanne lives for
us . . . while Bouguereau is dead[17]

For many of his students at the Ferrer School, the
Armory Show had likewise superseded Henri as their
artistic stimulus. On the other hand, the MacDowell
Club exhibitions made the transition and turned
modern following the Show, with Neo-Impressionist,
Post-Impressionist and Futurist-inspired paintings
dotting the walls; Henri's former student Andrew
Dasburg exhibited five color improvisations in one of
the exhibits. But the paintings of Henri included in the
final exhibition of this third season appeared largely
unaffected.

Despite outward appearances, he now tried des-
perately to absorb the essence of modernism into his
art through secret studio experiments, but he never
succeeded. His first painting after the Armory Show
was a still life on cardboard, a blue vase of roses with
"a few spots of color . . . floating, fairly flat shapes" of
blue, green and purple "scattered here and there."[18]
Then a landscape was attempted that contained blue
clouds, a pure yellow streak across the horizon and a
purple tree stump. Though these and other, similar
tests did not result in a modification of his style, they
did bring about a further heightening of hue in his
portraits. The small Maratta-inspired studies, begun
prior to the Armory Show, continued uninterrupted.

It would be another year before Henri added to his
library any books dealing with modern art. When he
purchased Arthur Jerome Eddy's 1914 volume *Cubists
and Post-Impressionism*, it may have been for the color
plates of works by Duchamp, Picabia and Kandinsky
or simply because his name appeared in the text as
"another strong Virile-Impressionist."

On the final page of Henri's 1912 diary he had
written "Miss Bracters studio to let at Woodstock.
20 × 50 $100 for summer—150 for year." But any
earlier thought of being so near New York City had
been dashed by the Armory Show and his resultant
embarrassment. Henri now sought a distant land as
his refuge and the choice was Ireland.

Charles FitzGerald and Frederick James Gregg,
both Dublin-born, had often recommended it, as had
John Butler Yeats, and Henri's great-grandmother
had been Lady Fingall of Killim Castle. But the
clincher was the fact that Marjorie, now twenty-
seven, had never returned to the land of her birth.

The couple sailed in June 1913 alone, without a
specific destination. They visited Blarney Castle,
where Henri could not be induced to be lowered by the
heels to kiss the Blarney Stone; he kissed Marjorie
instead. The couple settled on Achill Island, near the
fishing villages of Keel and Dooagh, which Henri
simply "picked out by just looking at the map." The
landscape was breathtaking, with cliffs, sheer and
lofty, rising up out of the sea and a lake that appeared
to be set in the crater of a volcano. There were bogs
and fields of potatoes and cabbage, wild goats jumping
from crag to crag and beautiful, friendly people to
paint.

They rented a mansion containing ten bedrooms,
three reception rooms, a greenhouse, coach house and
stable. Henri took pride in the fact that his was the
home built by Captain Charles Cunningham Boycott,
the nineteenth-century land agent whose refusal to

reduce rents for tenant farmers spurred them to protest in a fashion that made his name a household word. Boycott's abode was only fifty years old, but the thatched houses, the simple farming tools and the Celtic language of the area harkened back to a much earlier era.

Henri's removal to Achill Island on the west coast of Ireland, in the wake of the Armory Show, was more than a mere search for family roots or subject matter akin to Monhegan Island or the craggy coast of Maine. Like Winslow Homer, who had been a near-recluse at Prout's Neck, Henri's withdrawal to Ireland, and to a seldom-traveled region at that, made *his* seclusion complete.

Some of his first paintings were of the nearby Meenaune Cliffs. Although initially sketched in watercolor, there were also several versions in oil, bearing such titles as *Meenaune Cliffs, Achill Island, County Mayo, Ireland* or simply *Irish Landscape*. The

simplified compositions are intriguing as powerful land masses juxtaposed against placid water and a cloud-swept sky. But with the exception of these and a few panel paintings of neighboring villages and of Captain Boycott's house, Henri devoted all his time to painting the people.

There was the lean, weathered face of Brien O'Malley, a tireless teller of Gaelic tales and local gossip who would lead Henri and Marjorie up the steep heights of Croaghan Mountain, where St. Patrick was said to have meditated; and Johnnie Cummings and his wife, a robust-looking couple, whose portraits were titled *Himself* and *Herself* in recognition of the Irish manner of speech. A second likeness of the ruddy-faced Mr. Cummings, entitled *Old Johnnie*, is as free and masterful a face as any by Henri. Utilizing the Maratta palette provided the artist with several dozen variations of flesh tones that were laid on the canvas with a renewed feeling

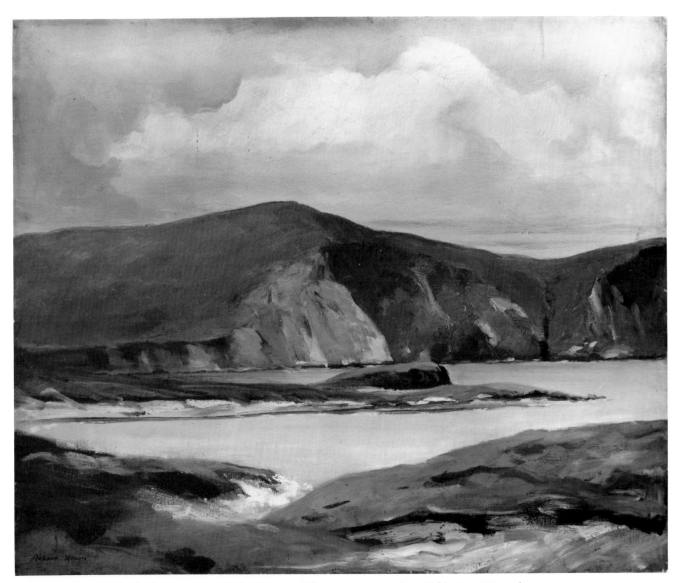

Meenaune Cliffs, Achill Island, County Mayo, Ireland, 1913. Oil on canvas, 26¼″ × 32″ (66.6 × 81.2 cm.). Photograph by Walter Russell; courtesy of Chapellier Galleries, Inc., New York.

for impasto painting, yet so skillfully placed that each anatomical nook and cranny of the face is suggested.

Grownups and children alike would hike the two miles up to Henri's Corrymore House from the villages below to have their likenesses painted, to be provided with tea or whiskey, according to their ages, and be entertained by American music or Harry Lauder's "Roamin' in the Gloamin'" emanating from the Henris' victrola. In the end it was the children whose carefree, sparkling faces the artist would come to paint and love the most. Never having had children of his own, Henri, at forty-eight, emitted a fatherly warmth that attracted the youngsters to him. For Henri, the numerous youths who came to sit for their portraits filled an obvious void.

A favorite model was Mary O'Donnel, who helped to tend the farm around Corrymore House. She would work in the fields, cutting and harvesting turf in a red sweater and blue jumper that she had made herself from wool spun and dyed by her own hands. Henri had her pose in the great front hall and never tired of recording her dimpled cheeks and infectious smile in paintings such as *Achill Girl* (Mary) and *Mary;* or the stark innocence of other lads and lasses in canvases titled *Little Irish Girl, Michael, Patrick* and *Ann of Achill.* There is in Henri's Irish portraits the freshness of shy youth who never spoke above a whisper, children for whom Marjorie made peanut butter and jelly sandwiches and handkerchiefs out of Henri's paint rags to wipe their runny noses.

When the Henris left Achill Island toward the end of September 1913 they made a point of stopping at the Municipal Gallery in Dublin to view the portraits by John Butler Yeats, whom Henri immediately called "the greatest British portrait painter of the Victorian era."[19]

Within a month of their return to New York, Henri was once again involved in the task of selecting paintings for an exhibition, in this case for the

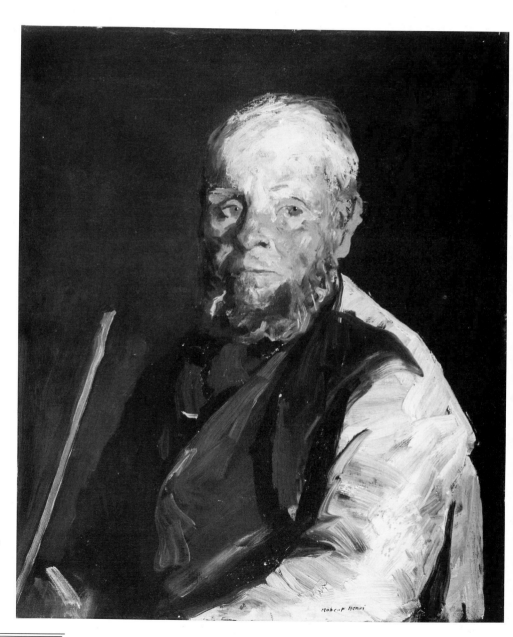

Old Johnnie
(Johnnie Cummings), 1913.
Oil on canvas, 24⅛" × 20⅜"
(61.2 × 51.7 cm.).
The Baltimore Museum of Art,
Gift of Adelyn D. Breeskin
in memory of her father
Dr. Alfred R. L. Dohme.

Gargoyle Club of Wilkes-Barre. Thirty-five oils were to be exhibited by him, Sloan, Bellows, Glackens, Prendergast, Randall Davey and, yes, Arthur B. Davies. It was typical of Henri's character that he showed no vindictiveness toward Davies when he wrote to William Macbeth that "the collection of pictures for Wilkes-Barre exhibition will be Sat. Nov. 8. Please have the Davies and Prendergast pictures ready."[20]

Two months later Henri, Bellows and Redfield constituted the jury for the Charcoal Club of Baltimore's annual show, presenting another opportunity to cast out Davies' paintings; however, they were included, and placed among those by Sloan, Luks, Homer Boss and others.

Henri was anxious to show his new Irish portraits. In the fall of 1913 he and Bellows, Eugene Speicher and Leon Kroll met informally at each other's studios to view the summer work, a procedure that would become an annual ritual. Now, six months after the Armory Show, Henri chose this trio of young artists, two of whom were his former students, to replace some of the older colleagues of The Eight as members of his inner circle.

Kroll had been brought into the fold by virtue of his having met Henri at one of the MacDowell Club exhibits. "I was walking around with [Randall] Davey, and then I left," Kroll recalled. "I was just a short way down the street when Davey came running after me and said, 'Oh, Henri wants to meet you.' So I went back with him and met Henri, and he told me how much he liked my picture. The whole group . . . took me right in"[21]

Henri invited Albert Barnes to view the new paintings too, after which he received a letter from him:

> I like the Irish work of yours better than your previous fine things. I'd hate to have to choose one from those I saw last night—Herself, Himself, Irish lad, The Guide. The 20 × 24 girl in red, bigger one of red-gowned girl with green background.

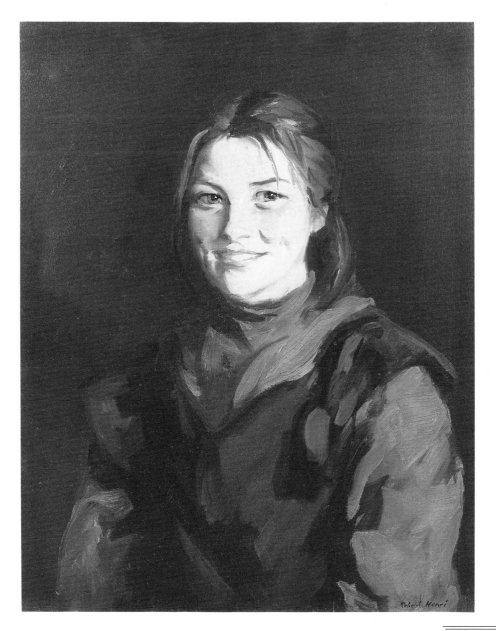

Achill Girl (Mary), 1913.
Oil on canvas, 24" × 20"
(60.9 × 50.8 cm.).
Private collection, Michigan.
Photograph by Helga Photo
Studio, Inc., New York;
courtesy of Hirschl & Adler
Galleries, Inc., New York.

I'd like to see another one of yours in my collection (I'm still lamenting the loss of "Red Top") and if you'll send me the prices of each of the above, I'll see if I can work it in with my finances that are now being severely strained by building four big houses on my lane.

Be sure and say which of the lot you'd rather see in what is going to be the best modern collection in America.

<div align="right">Sincerely,
A C Barnes[22]</div>

It was not until more than a year later that Barnes acquired his third Henri, *A Bit of Ireland*, of a little blond-haired girl, barefoot, wearing a shawl and seated on a rock. The subject is surrounded by bushes and an abundance of red flowers; this time the price *was* eight hundred dollars.

At the time that Barnes viewed the new canvases, Henri suggested to him that he should also consider adding an Eakins to his holdings. Barnes took the advice and the following month acquired the oil study for Eakins' *Agnew Clinic*. "Congratulations!" Henri wrote, "I was cursing the luck that no big museum was forthcoming with the sense or courage to buy Eakins' great masterpiece Now I am happy that you have it"[23] The purchase caused a mild furor because, at four thousand dollars, Barnes paid nearly triple the amount Eakins had ever received for a painting and this was two years before the artist's death.

Four of Henri's Irish subjects were exhibited in the Pennsylvania Academy annual and on February 7, 1914, he received a telegram from the institution:

CAROL BECK GOLD MEDAL AWARDED
FOR YOUR PORTRAIT HERSELF.

It was his sixth prize in thirteen years and he hastened to "write this news to the dear old lady in Ireland" who posed for the painting.

During the winter and spring of 1914 he showed twice at the MacDowell Club, together with Bellows, Hopper, Stuart Davis, Andrew Dasburg, Theresa Bernstein, C. K. Chatterton and, for the first time, Marjorie. Her eleven drawings included Dutch and Spanish children, and a Gypsy "as devoid of the picturesque as though a tambourine had never existed,"[24] according to the *New York Times*. Henri was also represented by a portrait in The Artists' Club in Denver, by his *Lady in Black Velvet* and *Portrait of Miss Mildred Sheridan* in an Anglo-American Exposition in London and at a benefit exhibit at Gertrude Vanderbilt Whitney's studio in MacDougal Alley in New York, one of a series of such shows she was inaugurating at this time to aid various charities.

He journeyed to Pittsburgh to serve on the Carnegie Institute jury with William Merritt Chase, who was still embittered by the Armory Show; upon Henri's return he attended a meeting of the still-intact Association of American Painters and Sculptors. No financial statement had ever been forthcoming concerning the Armory Show and several members were upset. The treasurer revealed that "one phase of the accounts of the Association with the Copley Society of

Boston remained to be adjusted," after which a complete financial report was to be submitted at the annual meeting. But the meeting was postponed for half a year.

Prior to the gathering, finally called for May 18, 1914, Henri and others met at Bellows' studio to map their strategy. A new election of officers was scheduled and it was decided that Henri's name would be placed in nomination. At the appropriate point in the meeting this was done, but Davies, with six proxy votes in hand, was reelected. When the belated financial report was circulated, it became apparent that no records had been kept of the money spent in Europe. Guy Pène du Bois took one look at it and said: "I resign"—an action repeated by Henri, Sloan, Bellows, Lawson, Jerome Myers, Leon Dabo and Jonas Lie. Though President Davies was quoted in the papers as stating that the wholesale resignations were "the best thing that has happened to the Association since its formation,"[25] the action unofficially sounded the death knell for the organization. A much-discussed project, that of an Oriental exhibition to follow the Armory Show, never materialized.

Henri planned to spend the summer in Southern California, a decision made at the urging of his former student Alice Klauber. In March he had written her: "Westward ho! We intend to come to California this summer—some time early, I hope, in May we shall start."[26] But a portrait commission delayed him, as well as the saving of seventy-two dollars on the train ticket if he left after June 1. Together with Marjorie's sister Violet, they departed on the journey, made nearly unbearable by intense heat and drifts of anthracite-coal smoke that filtered through the pullman-car window's dust screen and covered their clothes. Upon arriving in San Diego, Henri expressed enthusiasm for "a place where the sun will warm me up to the right heat of production."

Alice Klauber had obtained a small cottage for them at Richmond Court in La Jolla, virtually at the ocean's edge and a dozen miles from San Diego. The one-story stucco structure contained a single picturesque palm tree beside a patio. Late-afternoon wading in the ocean became a daily ritual until Henri's sister-in-law had to be rescued from the surf because she could only dog-paddle. Henri, the hero, was fully clothed when he dove in after her.

He painted a striking portrait of Violet that summer, and in *Viv in Blue Stripe* the last vestiges of his dark palette are eliminated, silhouetting the figure in a black-and-white-striped jacket instead against a light, varicolored background.

Miss Klauber had been a member of Henri's summer class in Spain and now, in the evenings, she and her guests listened to records of their favorite street songs of Madrid. "Shut your eyes," Henri would say, "and you can hear the *olé's* of the Lance Café in the little passage of the Plaza St. Anne, or the old fellows singing in the streets at the side of the Hotel de Londres."[27]

Henri had come West to paint and told Alice: "I don't care whether [the studio is] in town or out of town, just so the models are available." He had become interested in the Indians of New Mexico and Arizona

on the way out, and now produced several canvases of Yen Tsi Di (Ground Sparrow) wearing a feathered headdress and Po-Tse (Water Eagle) with long plaits and a richly decorated vest. Henri also used Mexicans as models, including Ramón Vásquez and Rita Pérez, and he painted portraits of his Chinese vegetable man, Jim Lee, and his lovely daughters, who posed in traditional Chinese costumes.

Just as Henri had depicted his New York newspaper boy, Willie Gee, a decade before, now he painted Sylvester, the youngster who sold papers at the train depot. The artist found his subject "irresistible" although he usually fell asleep while posing. In one portrait, *Sylvester Smiling*, Henri "caught his grin in all its zest," in another, titled simply *Sylvester*, the newsboy sits erect; but the third, *The Failure of Sylvester*, shows him seated, yet fast asleep.

Henri painted Marjorie wearing a yellow beach hat with a purple band, of which a second version was presented to Alice Klauber as a souvenir of the summer. In September he exhibited fourteen of his La Jolla portraits at the year-old Museum of History, Science and Art in Los Angeles and was well pleased that they "looked strong and brilliant in color" in the spacious gallery.[28] A reviewer said: "The Indian studies are so typically what Indians ought to be, tall, straight, domineering . . . [the] fourteen canvases should be studied, and studied deeply and long by every artist and art student in Los Angeles."[29]

Through Alice Klauber, Henri met the director of the American School of Archeology in Santa Fe, Dr. Edgar L. Hewett, who was in charge of the Art and Science displays for the forthcoming Panama–California Exposition in San Diego, to celebrate the completion of the Panama Canal and its importance to the state's progress. This new era of commerce began when the first ship passed through the canal on August 3, 1914, ironically the same day that Germany declared war on France.

At Hewett's suggestion, Henri helped with the exhibition, providing the names of artists and suggesting that five works be solicited from each. Back in New York, where he continued to coordinate the project, he wrote Dr. Hewett that he would contact Sloan, Glackens, Lawson and Carl Sprinchorn, but that Hewett should invite Davies, from whom a negative reply could be expected. The prediction was borne out by a telegram:

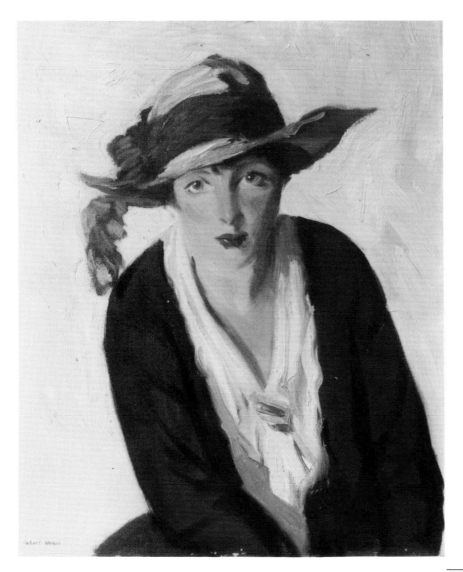

The Beach Hat (Marjorie Henri), 1914.
Oil on canvas, 24″ × 20″
(60.9 × 50.8 cm.).
The Detroit Institute of Arts,
City of Detroit Appropriation.

Later that month Henri wrote Hewett that he had not
seen Davies personally "and I will not unless he should
come to me. I shall be sorry if he is not represented.
But anyway he is not essential to the success of the
exhibition."[30]

Henri's fear that Davies would convince Prender-
gast not to participate turned out to be unwarranted.
The final group included Henri, Sloan, Glackens,
Luks, Lawson, Prendergast, Bellows, du Bois,
Sprinchorn and two choices of Dr. Hewett's, Childe
Hassam and Joseph Henry Sharp, the latter a cele-
brated painter of Indian subjects, one of the first
artists to work in Santa Fe.

Henri cautioned that confusion might arise be-
tween the San Diego Exposition and its larger counter-
part, the Panama–Pacific International Exposition
planned for San Francisco. He had been asked the
summer before he met Hewett to serve on the New
York Advisory Committee for the San Francisco
affair; as a result he was represented in both exhibits.

The San Diego Exposition opened on January 1,
1915, in Balboa Park, just north of downtown. The
Henri-organized exhibition of "Modern American
Art" was housed in a long, one-story gallery and,
together with a display of Southwest Indian Art, was
the only art there. On the other hand, the exposition
in San Francisco involved artists from many countries
ranging from the academic to avant-garde post-
Impressionists and Futurists. Henri's suggestion that
no prizes should be awarded in San Diego made yet
another contrast with San Francisco. He wrote Alice
Klauber: "I have heard . . . that I received a silver
medal at the San Francisco fair, which, if it's true, is
part of my price of independence—If I were not
independent I should have a gold medal—I prefer
independence."[31]

At the conclusion of the year-long San Diego
Exposition, the art show was circulated to the Seattle
Fine Arts Society, to the Portland Art Association and
to Pullman and Spokane, Washington; it was heralded
as the first "Modern Art" exhibited in that part of the
country.

Henri was also involved in the exhibition scene back
East. During November 1914 he had a one-man show
of his California paintings at Macbeth's and though no
sales resulted, which Henri attributed to the unsettled
wartime conditions, it was well received. The *New York
Press* said that his canvases "represent the extraor-
dinary mixture of races that dwell along 'the Coast'
and its hinterland, and which, curiously enough, none
of our painters who have gone west and come back
again have thought to paint." His recent work was
referred to as "more solidly brilliant than anything
that has gone before," and one portrait of an elderly
Chinese woman was called "a miracle of painting."[32]

He was included in a MacDowell Club exhibition,
the Corcoran Biennial and the Art Institute of
Chicago annual. Writing in *The Little Review* about the
Chicago show, William Saphier criticized the prize-
winners, wondering "why anybody ever took the

trouble to paint them," and compared them with
Henri's *Thomas and His Red Coat:* "What simple forms
and colors—what a thorough understanding of a child
and his world!" he wrote.[33]

Early in 1915 Henri engaged in a new type of
experimentation with composition and color. He
painted a dozen variations of two figures, Florence
Short and Edna Smith. In half of these they posed
partially nude, with their red hair and loosely placed
red skirts in striking contrast to a vigorously brushed
background of blue-green and orange. In several of
the canvases the subject matter and arrangement are
reminiscent of a Delacroix odalisque, at once colorful
and sensuous.

Soon the half-nude compositions began to find their
way into exhibitions, which moved Marjorie to issue a
disclaimer in the society column of *Town & Country:*
"Mrs. Robert Henri wishes to take advantage of this
occasion to announce that, although she herself has
red hair, she does not pose for her husband's red-
haired paintings."[34]

Henri had reduced his teaching at the Ferrer School
to every other week but never one to be without a
project, he determined it was time to embark upon a
new crusade, the application of the MacDowell Club
exhibition principle on a more ambitious scale. After
all, this had been his original goal before the club
facility had become available three and a half years
earlier and caused him to scale down the initial
concept.

He wrote an article, "An Ideal Exhibition Scheme,"
which appeared in the December 1914 issue of *Arts and
Decoration.* After stating that "artists today are almost
unanimous in condemning the present jury systems
for the selection of pictures and the award of prizes,"
he unfolded what he considered the solution:

> I believe that with an adequate building containing
> suites of galleries, suitable for the exhibition of oil
> paintings, sculpture, architecture, drawings, pastels,
> water colors and various crafts, New York should
> offer to the art world and to the public a new field
> open to self-organizing and self-judging groups of
> artists.

Always a gracious peacemaker, he added:

> I should be glad if such an institution as the National
> Academy would take to itself this form of exhibition
> and I believe that in so doing, the National Academy
> would relieve itself of what is today a most ungrateful
> situation And then the National Academy would
> become the dignified social organization that it so
> desires to be.[35]

As soon as the magazine appeared on the news-
stands, Henri wrote to John W. Alexander, president
of the Academy. "It's worth study—and why shouldn't
the Academy do this thing?" he asked. "In the history
of academies why shouldn't this one rise and become
young again and, in spite of the custom of academies,
step forward and lead in the progression. I do believe
that here is a chance for the institution to make
history."[36] But the National Academy of Design was
not inclined to make history, so this proved to be
Henri's final conciliatory gesture toward it. He now
began to look elsewhere.

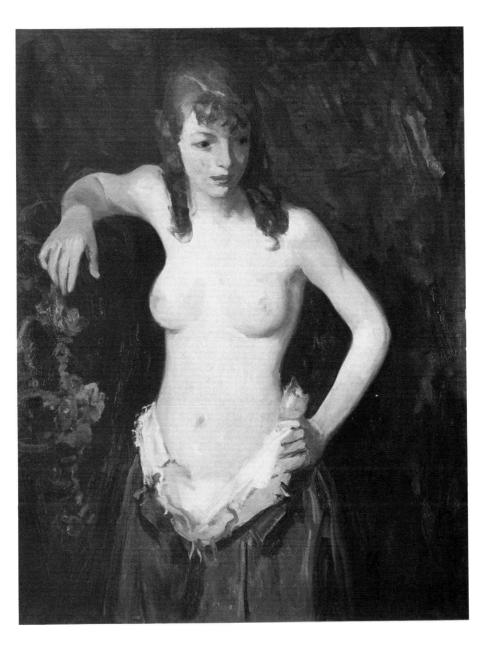

Edna Smith, 1915.
Oil on canvas, 41" × 33"
(104.1 × 83.8 cm.).
The Regis Collection, Minneapolis.
Photograph courtesy of
Chapellier Galleries, Inc., New York.

The following May, he, Bellows and Birge Harrison met to write a proposal to the city's Board of Aldermen for a municipal gallery. Henri approached the head of New York's Department of Parks and shared with him all the data and arguments favoring such a plan, hoping that he could convince the city fathers. The old arsenal in Central Park came under consideration, but after months of optimism on Henri's part, he was informed that "this building was put up temporarily in the first place under an agreement to remove it as soon as the new Arsenal, further downtown, [was] completed."[37]

The death of the plan came in a year when other tragedies were affecting Henri's life: The fierce fighting of World War I taking place in France, where Captain Elmer Schofield was "trying to prevent Germany [from] goose-stepping over the world . . ."[38] and the sinking of the *Lusitania* by a German submarine with a loss of twelve hundred lives (Henri wrote fifteen hundred in his diary, based upon first reports). "I

wonder if you have felt the war out there as we have here—," he inquired of Alice Klauber in March 1915. "It's been all about us like something dark." He donated a painting to the Red Cross for a benefit sale and another to aid the Permanent Blind Relief Fund for soldiers and sailors. Yet the most heartbreaking news that year for Henri was the death of his only niece, twenty-two-year-old Jane Southrn, from leukemia.

Gertrude Vanderbilt Whitney began organizing the Friends of Young Artists at this time and she turned to Henri for help with an unusual idea:

Dear Mr. Henri,

I have lately become interested in the Society for the Americanization of Immigrants in America, and have decided to hold a competition and offer prizes for the best expression, through an artistic medium, of the meaning of America to the Immigrant. The exhibition will be held in November, and I should be so glad if you would consent to act as a judge on that occasion.[39]

Henri, Sloan and Bellows served on that jury and awarded eleven hundred dollars in prizes donated by Mrs. Whitney.

During the spring of 1915 Henri painted an additional group of little color experiments, some of them abstractions devoid of subject matter, with shapes resembling a jigsaw puzzle. ". . . I never accomplish many pictures but I study all the time . . . ," he noted.[40] Like his earlier trial paintings, these never left the studio.

His most significant works at this time were three portraits of Emma Goldman produced during late March and April, just after she was released from jail for lecturing on the subject of birth control. When Henri asked her to sit for a portrait, she initially refused, stating that others had tried without success, but when he said he wished to depict the "real Emma Goldman," she agreed to pose. "There were talks on art, literature, and libertarian education," she wrote. "Henri was well versed in these subjects; he possessed, moreover, unusual intuition for every sincere striving."[41]

As time passed, the subject of the painting "was naturally anxious to see the portrait, but, knowing Henri's sensitiveness about showing unfinished work, I did not ask for it." When the sitter left New York, Henri completed the paintings from memory, much the way Picasso had finished his famous portrait of Gertrude Stein without viewing the subject. Emma Goldman never did see the works before she was

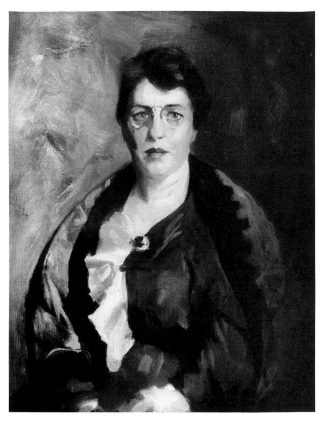

Emma Goldman, 1915. Oil on canvas, 32" × 26" (81.2 × 66.0 cm.). Photograph courtesy of Peter A. Juley & Son Collection, Smithsonian Institution, Washington, D.C. (Painting destroyed March 7, 1934.)

exiled to Russia at the end of World War I, but "I prized the memory of the sittings," she later stated, "which had given me so much of value."[42]

While Goldman was posing for Henri, Isadora Duncan, whom they both admired, gave her farewell performance at the Metropolitan Opera House before departing for Europe. There were tributes galore and Henri agreed to write a salute, titled "Isadora Duncan and the Libertarian Spirit," for the April issue of *The Modern School,* a publication of the Ferrer Society. He likened her to "the great voice of Walt Whitman":

> Back of her gesture I see a deep philosophy of freedom and of dignity, of simplicity and of order. She is one of the prophets who open to our vision the possibility of a life where full natural growth and full natural expression will be the aim of all people. When I see her dance it is not only the beauty of her expression that fills me with emotion, but it is this promise she gives of a full and beautiful life for those who are to come.[43]

He observed a parallel between his own teaching and that of Isadora. In *Dionysion,* a publication of the "Committee to Further the Work of Isadora Duncan," he stated:

> Our hope in America for a great art and a great life depends upon the free development of our youth Children must be free We have commenced to give them free bodies, but we are still disciplining their spirits I was tremendously impressed one day in Isadora Duncan's Studio, by the look in the faces of the children. As they passed me in the dance I saw great dignity, balance, ease The true teacher is one who awaits with deep interest the first sign of the birth of the new spirit, seeing in every child a new prophet.[44]

Like Isadora, he was preparing to leave New York; he wanted a summer away from recruiting posters, men in uniform and other grim reminders of the war. He suggested to Bellows that they and their wives return to the isolation of Monhegan, but the plan was rejected by Emma Bellows, who feared a U-boat attack during the two-hour voyage through the open sea. Although newspapers in May 1915 carried the headline "No Confirmation of a U-Boat Off Maine Coast," when Emma read that three fishermen "sighted from two different points what they believed to be a German submersible,"[45] that was sufficient evidence for her. They decided upon Ogunquit, Maine, instead.

By July the Henris and Bellowses had settled there with some former Henri students. Henri described the place as "a sort of straggling village made up of quiet-seeking respectables and natives and a considerable artists' colony" He shared a studio with Lucie Bayard; as for models, "there were plenty of children ready to earn the money, but they were . . . not inspiring [The] villagers . . . lack definition of character, they are too composite . . . impersonal."[46]

It seemed that little painting would be done, for Henri remarked that "it certainly is not Spain or Holland but we are making it do."[47] Then a band of Gypsies saved the day. They brought their tangle-haired, unkempt children to the studio from a nearby encampment. Henri enjoyed capturing their expres-

sions, the alert face of Nelson who "has a wrist watch he consults every minute to see how much money he has earned," and the broad smile of Lily cradling her doll in a painting called *Lily and the Queen*. (Of her, Henri said: "No regular Methodist-born Maine child can dare to laugh with such freedom.") The same child as *Little Country Girl* is more serious, staring off into space, her intense blue jacket in marked contrast to a background of autumn foliage (see color plate). And then there was little Sam, a three-year-old dynamo who wiggled and squirmed all the time his mother held him. Marjorie, as usual, did everything she could to make him "look at the man" while Henri "grunted like a pig, cackled like a hen, ventriloquized a dog in a box and imitated a frog in a pond . . . as the rain beat down on the roof" and Robert "painted like mad."[48]

In the evenings the Henris relaxed in the hammock on their mosquito-proof veranda, partied with their friends or enjoyed the town's only movie. By September the crowd had been joined by more friends, including the Sloans, who had come up from Gloucester, so the social activity, the singing and dancing, increased at night and there was more lolling on Wells Beach during the day. Maurice and Charles Prendergast paid a visit, too, as did Albert C. Barnes and his wife, who dropped in unexpectedly. "Barnes was his usual important self," observed Lucie Bayard, "and his wife, a dry woman, had a good time complaining about 'the help' who wanted the same food they had, thus forcing her to lock the refrigerator."[49]

Henri might have stayed on well into fall except for an obligation to teach at the Art Students League in October. Just the previous summer Henri was quoted as saying he "is not going to teach everywhere, nor indeed anywhere, any more,"[50] but that changed when the League extended the invitation.

Henri probably would have refused the offer had Chase still been on the faculty there, for he was not about to repeat the situation that caused Chase to resign from the New York School of Art. But the way was clear now because Chase had failed to teach at the League ever since the Armory Show.

Henri taught a portrait class and gave critiques on compositions. On the first day of his painting course there were forty-eight students enrolled and a long waiting list. And with the exception of two eternal pupils, Clara Field and Amy Londoner, the other members of his classes came to him for the first time, among them Vaclav Vytlacil, Waldo Pierce, Margery Ryerson, Elizabeth Olds, Richard Lahey, George B. Wright and many others.

Vytlacil found Henri "very eloquent and very emotional . . . I studied with him in the Composition lectures. Jack Sparrow and Waldo Pierce were also there. All of us were involved in the same kind of restless, nervous energy . . . wanting to go beyond Sargent . . . I was all with him."[51] The portrait class was scheduled from one to four-thirty P.M. but, as had been his custom, Henri usually stayed on later, sometimes until seven. "Regard the head as a gesture," he would say. "Often the rise of the forehead is as though it were a surprise Feel the sweep back under the eyebrow A pair of lips is not enough It takes all the lower part of the face to make a

mouth The simpler a background is the better the figure in the front will be, the better the figure is the less the observer will need entertainment in the background." And he always emphasized: "Work with great speed."[52]

His domain at the League was studio Number 5 on the top floor, a bright room with a skylight that could be cranked open, rows of lights suspended from a grid of pipes and a half-dozen windows. Although the studio measured twenty-five by thirty-five feet, it became packed when occupied by four dozen students and their easels. The class size necessitated two models, and Fred Nagler, the monitor, posed them at opposite ends of the room, placing an appropriately colored piece of drapery on the wall behind their heads.

High up on the wall Henri installed five of his sepia reproductions of Velázquez paintings, the mats, glass and two-inch black frames giving them the appearance of permanence. While he could never speak of the "ultra-moderns" with complete enthusiasm and conviction, now more than two years after the Armory Show, he did occasionally refer to Cézanne and Matisse as "highly intelligent men; great students along a different line."[53] Of Picasso's painting Henri would say, "To some it is simply crazy. To others it seems great art,"[54] but his own opinion was never voiced.

He continued to encourage the use of Maratta colors, which were now available in twelve hues instead of the original six. The League's handyman, Chris Buchheit, constructed a set of one hundred twenty tiles, each one inch square, which Henri painted, noting on the back the proportion of the colors used in mixing them; he recommended that the students make a corresponding chart on canvas. As World War I continued, the quality and intensity of the Maratta-manufactured Margo paints diminished, causing them to be abandoned by many pupils and professionals alike.

With so many men having enlisted or been drafted, "most of his students were old, retired school teachers who couldn't learn a thing,"[55] according to Margery Ryerson, who had come to Henri straight from Vassar. Although he seldom discussed politics of the war in class, his few remarks led students to consider him "definitely anti-war."[56] "War deals with man's power—his control over others," he would say. "Art deals with man's control over himself. Art's desire is to give, war's desire is to possess."[57]

Henri was not opposed to airing his opinions on other current events as well. During the month he began teaching, Marjorie and other artists' wives marched with the suffragettes. On women's right to vote, Henri stated, "there is every reason they have the right to it, and there's no excuse for any man, who votes, to vote against it If men vote the right to her it will show that men have progressed."[58] And he expressed his sympathy for labor when, referring to a painting of a factory, he paralleled the monotony of the long rows of windows on the building's facade with the monotony of workers' jobs. Of course, talk in the Henri class was still largely centered on Velázquez, Frans Hals and Walt Whitman.

Now going on fifty-one, Henri remained a hand-some, dynamic figure; adoring women would gather about him in the Art Students League lunchroom as they had done at the Women's School of Design nearly twenty-five years before. At one point a rumor circulated that he was the illegitimate son of a French prince and Henri, perhaps enjoying the mystery, did nothing to squelch it.

During the 1915–16 season he continued to exhibit widely, beginning in September with a one-man show of twenty-five oils in Chicago, Columbus, Indianapolis and Cincinnati, and other exhibitions in Washington, Philadelphia, New York (at the Daniel Gallery, Milch Galleries and the MacDowell Club), Pittsburgh, Denver and San Francisco, among other cities. He was also invited by C. K. Chatterton, one of his former students who was now an art instructor at Vassar, to show there, but the conditions were contrary to Henri's ideals:

> Don't think it advisable to ask the exhibitors to pay to give Vassar a show. It's likely they would not respond. There are two reasons why they should not, one is that it is an expense and there are expenses enough. The other is that it's a bad principle to encourage I should be pleased to send any time because of the public there . . . but . . . the poverty of Vassar is the same kind of poverty I have met with in many millionaires So much for the philosophy of the case My conditions would be all expenses paid by Vassar and insurance 2/3 value.[59]

The logic of Henri's argument won out, the ground rules were changed, and he agreed to be represented in the show.

Within a period of four months he also had works purchased by the Minneapolis Museum, the Buffalo Fine Arts Academy and the Oberlin College Art Association, and made a number of sales to individuals. There were three canvases sold for 2,500 dollars to Mrs. Marshall Field, which resulted in commissions to paint the portraits of Massachusetts Senator Albert Beveridge's children, the great-niece and great-nephew of Mrs. Field. These canvases were shown the following year at Gertrude Vanderbilt Whitney's Portrait Exhibition in her newly refurbished Whitney Studio at 8 West Eighth Street, which would become the first location of the Whitney Museum of American Art.

After his return from Massachusetts, Henri began a full-length portrait of Betalo Rubino in Spanish costume. He had first seen her dance a few months earlier at the Union Square Theatre, where he was asked to make suggestions "as to accent of postures, entries and exits." Now he depicted her in a dramatic, standing pose, the long line of her leg providing a strong diagonal highlight on a lengthy black skirt with gold stripes, which becomes a foil for the opposing diagonal of a mantilla.

In December, Gertrude Vanderbilt Whitney requested that Henri paint her portrait, a significant offer considering her social status. The work proved to be one of his last full-length compositions. He began with a series of small oil sketches on paper and cardboard, some being merely color notes with a slight indication of the figure, others more detailed. Because of the extent of his color and compositional planning—untypical of Henri—and the busy schedule of the sitter, the Whitney portrait took six months to complete.

Mrs. Whitney chose to wear a brightly colored Chinese costume that she had purchased in San Francisco—a blue jacket with red decorations and yellow lining over a loose-fitting pale blue-green blouse, and silk pants of a darker blue-green that were gathered at the ankle just above flesh-colored stockings and embroidered Chinese slippers. Behind the figure, which is shown reclining on a gray sofa, is a tapestry that provides a mass of decorative foliage to frame her bobbed hair, rouged cheeks and the elegant features of her face. One arm resting along the back of the sofa repeats its gentle, curving line, while below, a purple drapery produces a countercurve. A bracelet, four rings and a string of pearls are the finishing touches of this portrayal, at once sumptuous and provocative.

Henri personally delivered the completed canvas, measuring fifty by seventy-two inches, to her Old Westbury, Long Island, estate but her husband Harry Payne Whitney would not allow it to be hung in the house; he could not stand the sight of a lady posing in a pair of pants. As a result the painting, for which Henri received twenty-five hundred dollars, was displayed in her Manhattan studio.

Soon after completing that commission, Henri produced *The Laundress,* a straightforward portrayal of a day laborer at the opposite end of the social scale, a black woman, her hair covered by a bandanna, carrying the daily wash—her plain blue work blouse a far cry from Mrs. Whitney's expensive Chinese jacket. Henri captured the laundress as some of the clothes appear to be tumbling from her basket, yet she nonetheless holds them, unashamedly, toward the viewer.

During the time that he was working on Mrs. Whitney's portrait, she was beginning to sponsor exhibits at the Whitney Studio "to give young artists in this country the opportunity to show their work" and, as was the custom, such competitive exhibitions provided cash prizes. Henri apparently spoke with her about his concept of "no jury, no prizes" because she subsequently announced a policy change, eliminating both the jury and awards from future exhibits. As he probably suggested to her, money thus saved could be earmarked for art purchases.

In February 1916, Henri became involved with another kind of art show, "The Forum Exhibition of Modern American Painters." Held at the Anderson Galleries, it was the brainchild of Willard Huntington Wright, art critic of *Forum* magazine and brother of Stanton MacDonald-Wright, and had as its primary aim "to put before the American public in a large and complete manner the very best examples of the more modern American art." It sought to bring artists and the art-buying public together without benefit of a commercial gallery acting as intermediary. Henri was most in favor of an additional goal: "To turn public attention for the moment from European art and

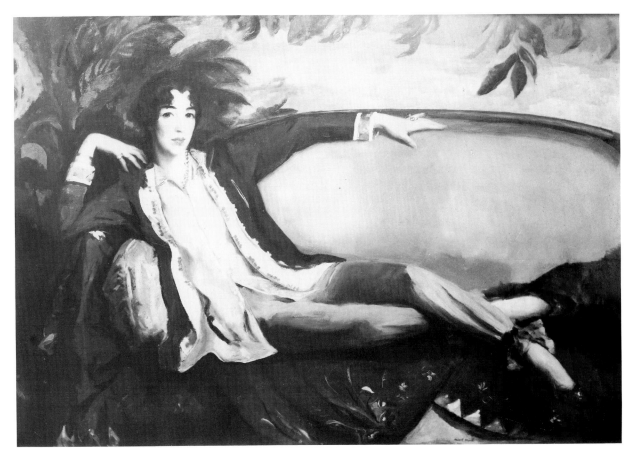

Gertrude Vanderbilt Whitney, 1915–16. Oil on canvas, 50″ × 72″ (127.0 × 182.8 cm.). Whitney Museum of Art, New York, Promised Gift of Flora Whitney Miller. Photograph courtesy of Peter A. Juley & Son Collection, Smithsonian Institution, Washington, D.C. BELOW: *The Laundress*, 1916. Oil on canvas, 35¾″ × 29¼″ (90.88 × 74.13 cm.). Phoenix Art Museum, Phoenix, Arizona, Gift of Mr. and Mrs. Norman Hirschl.

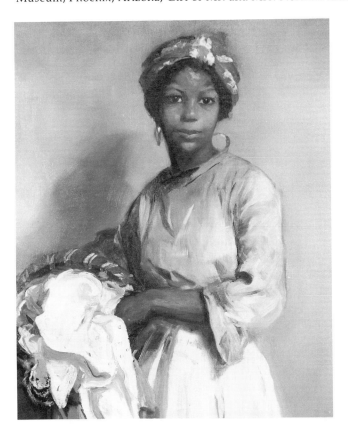

concentrate it on the excellent work being done in America."[60]

The previous year Willard Huntington Wright had written *Modern Painting: Its Tendency and Meaning,* and the book, a copy of which was in the Henri library, was devoted largely to the Synchromist movement and the works of Stanton MacDonald-Wright and Morgan Russell. There is a reference to Henri, Russell's teacher, as "one of the most sincere and intelligent products of American art"; actually Henri had some influence on S. MacDonald-Wright as well, having taught his teacher, Warren T. Hedges.

One of four color plates in the volume was a Synchromist painting by MacDonald-Wright that appears to have served as an inspiration for Henri's experimental color studies of 1915 and 1916. He drew pencil lines over certain portions of the reproduction to emphasize segments of the composition and apparently referred to this page of the book many times, because the volume readily falls open to it.

Inside the front of Henri's copy he pasted the catalog of the 1913 Synchromist Show in Paris, on which Morgan Russell had written:

A mon cher mentor
Robert Henri

Morgan Russell
Paris, Dec. 6, 1913

Years later Russell would acknowledge his debt to Henri: "You are the man who had more to do with the tempering of my character (if indeed it is tempered!) than any other."[61]

For the Forum Exhibition, Wright chose six individuals prominent on the American art scene to serve as a committee charged with selecting the artists from a list of fifty. When Henri and Alfred Stieglitz accepted committee appointments, some concluded that the breach between the two had finally been healed, but this was not the case; in actuality the Forum Exhibition was chosen by Stieglitz and John Weichsel, president of the People's Art Guild, aided by Willard Wright. The other three—Henri, Christian Brinton and W. H. Nelson—were represented on the committee in name only and forced to go along. Each committeeman wrote a foreword to the catalog; in Henri's case this proved to be virtually his only contribution.

The exhibition ultimately consisted of works by only seventeen artists, among them former Henri students Morgan Russell, Andrew Dasburg, Man Ray and Ben Benn, all considered modernists, who were therefore more readily acceptable to Stieglitz than to Henri. The Stieglitz camp was represented by Hartley, Marin, Maurer, Dove and Abraham Walkowitz.

While it appeared that Henri and Stieglitz had shared the committee work with the other four members, in actuality it was Stieglitz who played the key role; organizer Wright requested that he invite eight of the artists personally and provided him with the stationery to do so. With the exception of Ben Benn's flat, figurative style and George Of's brand of Impressionism, every painting was either Cubist-, Fauve- or Synchromist-inspired.

Henri wrote in the catalog foreword: "As to my impression of the works in the present exhibition, I will simply say that I like, enjoy and receive inspiration from many of them."[62] When he attended the March 9, 1916, press reception, he referred to the entire exhibit as "ultra-modern work."

That spring he had two one-man shows at Vassar and Syracuse, then he and Marjorie made preparations for their first summer in the Southwest. (It was just four years since New Mexico had joined the Union and only four months since "Pancho" Villa had raided a border town and killed sixteen Americans in the attack.) Henri wired Dr. Hewett that he could arrive in July, to which the director of the American Archeology School replied:

For something more than personal reasons I have hoped that you might come to Santa Fe this summer. We are just building our new Art Museum and . . . before things get much farther along, I am tremendously anxious to have the ideals in Art that you stand for brought into the ken of our people.[63]

When Henri arrived, Hewett offered him studio space in the Palace of the Governors, an adobe structure built by the Spaniards in 1610 and recognized as the oldest government house in the country. Although lacking the lighting he would have preferred, Henri quickly turned it into his workshop and produced some twenty portraits in two months. There was Chief Water Eagle and the young Florencia clothed in a ceremonial blanket, and Maria and William Virgil who came from their pueblo a few miles north of Santa Fe to pose for him. Marjorie had begun studying conversational Spanish but she gladly interrupted the lessons when her husband required her to entertain a young model such as Manuel, a little wide-eyed Mexican boy. (At times she entertained Henri as well by making quick ink and pastel studies of him around the house.)

In contrast to the previous summer's paintings, which had included smiling Gypsy children, many of these portraits have a dour look; in such canvases as *Indian Girl* and *Ricardo* there is a haunting seriousness that makes the sitters appear older than their years. In addition, focusing attention on Ricardo's face is challenged by an eye-catching blanket of red-purple, black and white that envelops his body; here most of the paint is thinly applied, with only his hair and head feathers represented by pigment that totally covers the weave of the canvas. On the other hand, *Indian Girl* is broadly brushed with heavily laden strokes throughout, and while the blanket is virtually devoid of Indian designs, its bright orange hue contrasts sharply with the complementary blues to be found in the background.

In September Henri produced his Santa Fe masterpiece, a portrait of a Tesuque drummer named Dieguito Roybal or "Po-Tse-Nu-Tsa." He had originally made a memory sketch of him as he appeared drumming and chanting the eagle dance during a rehearsal for a performance that was held on the patio right outside of the artist's studio. In the finished portrait the old Indian, a black headband around his graying hair, stares straight at the spectator as he sits in green-colored leggings and red blanket, with a ceremonial drum held between his moccasined feet. Henri presented the work to the Museum of Art and Archeology immediately after its completion, and Dieguito would sit by the hour staring solemnly at his likeness, oblivious to anyone else in the gallery.

In his Art Students League class that fall, Henri explained the motivation behind his Indian portraits:

I was not interested in these people to sentimentalize over them, to mourn over the fact that we have destroyed the Indian . . . I am looking at each individual with the eager hope of finding there something of the dignity of life, the humor, the humanity, the kindness, something of the order that will rescue the race and the nation.[64]

As Henri rounded out a quarter-century of teaching, certain changes began to come into his approach. While he refused to draw or paint on any student's work, as was common in other classes, he commenced placing more emphasis upon personal housekeeping and cleanliness. When he entered the League studio the first year he declared it to be one of the dirtiest, dreariest rooms he had ever seen, and refused to teach in it unless a fresh coat of light blue paint was applied over the dingy green and brown. Such details had been of no concern to him in the past.

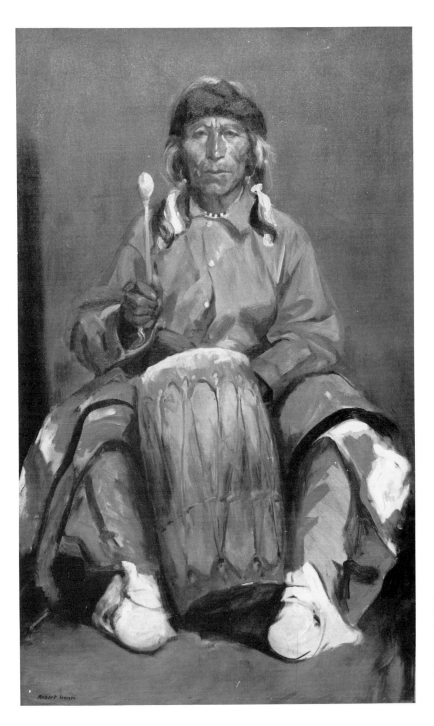

Dieguito, Drummer of the Eagle Dance,
San Ildefonso, New Mexico, 1916.
Oil on canvas, 65″ × 40⅛″
(165.1 × 101.9 cm.).
Museum of New Mexico, Santa Fe.
Photograph by Bob Nugent.

As for the students, if their palette, brushes or painting knives were not clean he would pass them by without criticism. Orderliness was not only next to godliness but an orderly work area was a reflection to him of an orderly mind. "To study art is to study order," he would now say. The alternative was art students who "instead of thinking and searching order, dash at their work in a wild splashing frenzy, without reason, without an interest in finding the way, just wanting the goal, screaming and stamping their feet to get it."[65]

The irony, lost on Henri, was that when he first began painting spontaneously in the 1890s, the academic artists and critics accused him of the very same thing.

Peppino Mangravite now studied with Henri; their association lasted only a few months but it was long enough for Mangravite to be strongly influenced by him. As he put it:

First and foremost, Henri was a very sympathetic man. He was never harsh or egotistical with students. He was one of the very first painters of the New York scene who was interested in what he would call the figure, the portrait, the face, the family—all painters before that concentrated on landscape and still-life. He asked students to do painting from life and make painting a part of daily life.[66]

At the Ferrer School he continued with the evening class, always attracting new followers. Niles Spencer

was a student that fall, having come to Henri by way of the Rhode Island School of Design and the Art Students League. In the words of Spencer's wife:

It was entirely through Henri that Niles escaped the stifling of the academic, got his first vision of the widest horizons, and of the possible richness of a life filled with study, travel, work, friends and beyond these, faith in himself as an individual and sincere artist Henri had opened the door.[67]

Another newcomer to Henri's class early in 1917 was a bespectacled young man with reddish hair, mustache and beard who held down a job as a political journalist; his art studies were abruptly interrupted after only a few lessons, though, when news came of the Bolshevik Revolution and he quickly departed for Eastern Europe. His name was Leon Trotsky.

Sometimes, after his class at the League, Henri would write his thoughts about painting and have them typed, duplicated and distributed the following week. The instructions, running from a single page to several, explained palette arrangements, procedures for painting the head, body and background in a portrait and how to choose a color scheme. One of the students, Margery Ryerson, found Henri so fascinating that when he spoke to the class she would regularly conceal herself behind a canvas in order to record his every word unobserved. Several years later these notations, together with Henri's instruction sheets, formed the nucleus of a book about his philosophy and teaching. Entitled *The Art Spirit*, it would serve as a stimulus for future generations.

As World War I dragged on and the United States stood on the threshold of entering it, there were few activities that could provide any kind of escape. "I just cringe when I think of the horrors that are going on,"[68] Henri would tell his League class. In this regard, his distaste for war had not changed since his early student days at the Académie Julian, when he wrote his parents: "War has always been made glorious by literature and art and Verestchagin* makes it horrible, ghastly, murder and serves to teach us of what it really is, and that it should be avoided."[69]

In November 1916 the Henris attended the "Ten Allies Ball," a charity affair for which Robert dressed as an East Indian potentate and Marjorie as his concubine. "I'm to brown my face and neck and anything else that shows," Marjorie wrote a friend, "and it will be fine fun. Up to now the Master has urged my matchless complexion as reason for not browning up—but at last I have his consent and approval."[70]

Three months later Henri participated in another aspect of the war effort, a propagandistic volume of art and literature assembled by Charles Towne, of *McClure's Magazine*, to be entitled *For France*. There were writings by Vachel Lindsay, Booth Tarkington, Edgar Lee Masters and William Dean Howells, with an introduction by Theodore Roosevelt. Among the art

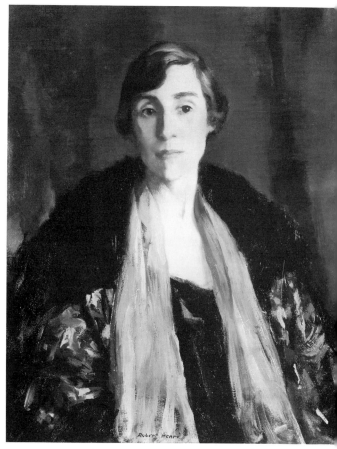

Mary Fanton Roberts, 1917. Oil on canvas, 32" × 26" (81.2 × 66.0 cm.). Photograph courtesy of Peter A. Juley & Son Collection, Smithsonian Institution, Washington, D.C.

reproduced were a pen-and-ink drawing by Gibson and a painting by Sargent, along with many others. Henri's contribution was his twenty-year-old composition of a Bastille Day celebration, *14th of July—"La Place."*

During the winter of 1916–17 Henri had done virtually no painting, complaining first about having the grippe "like almost everybody else in New York," and then the bad light for painting:

This is the blackest winter . . . there is no use to try to paint I have three unfinished things and I have no doubt the unfinished ladies are thinking angrily about my procrastination but I neither made the grippe nor the dark winter days. I suspect they are burning soft coal this winter for even when the sun shines it's not light.[71]

One of those "unfinished ladies" was Mary Fanton Roberts, whose portrait Henri failed to complete until March. His half-length painting is of a full-face view with her hair, black touched with gray, in a short bob, set off by a bright green, blue-purple and red-orange background. The figure is swathed in a sizeable black fur cape, separated from a black dress by a red-orange scarf.

Another of the incomplete portraits, a reclining figure wearing a grass hula skirt in a provocative pose

*Vasili Verestchagin (1842–1904), a Russian artist who painted large compositions on the horrors of war. He died fighting in the Russo-Japanese War.

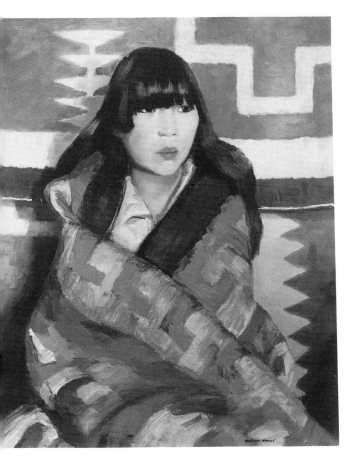

Julianita, 1917. Oil on canvas, 32" × 26" (81.2 × 66.0 cm.).
Photograph courtesy of Kennedy Galleries, Inc., New York.

and not unlike that taken by Gertrude Vanderbilt Whitney, was of Peg Rafferty, a professional dancer.

Despite his small production of paintings, Henri continued to exhibit extensively. In January 1917 he had a one-man show at Knoedler's, an event that prompted Eugene Higgins to write him:

> I went down yesterday and saw it. The room was one of somber richness You have caught to a great degree the silent immobility that we associate with the American Indian, a thing that seems to have escaped the other painters that have tackled the subject The world is sadly in need of an artist to record the dying race, and I feel you are the man, so God speed to you.[72]

The following month he was exhibiting at the MacDowell Club again but the most significant exhibition that spring was the initial showing of the Society of Independent Artists, and it took place without Henri's participation. Opening at the Grand Central Palace on April 10, four days after the United States entered the war, it had as its slogan "No Jury, No Prizes," the stance long advocated by Henri. With over twelve hundred entries on display, it was slightly larger than the Armory Show. In addition to Glackens, Charles Prendergast, Walter Pach and John Covert, who were the president, vice president, treasurer and secretary, respectively, the Independent's directors

included Bellows, Kent, Maurice Prendergast and Arnold Friedman. Managing director was Walter Arensberg.

Henri's disagreement with the Society organizers was based on the following premise, stated in the introduction to their catalog:

> A third and important measure for obtaining equality of opportunity for all exhibitors . . . consists in hanging all works in alphabetical order, thus relieving the hanging committee of the difficulties raised by their personal judgments as to the merits of the exhibits.[73]

When this had been tried at the 1910 Independent, Henri had objected. Now, apparently harassed for an explanation about his failure to exhibit, he explained his point of view in an article for *The Touchstone*:

> In the 1917 Salon of New York the directors of the Society, with the best of intentions, but in my opinion with little foresight, devised the scheme of doing away with the hanging jury and putting in its stead the plan of hanging the pictures according to the names of the artists, alphabetically, and the result, as might have been expected, was a disastrous hodge-podge. If we resent dictation from a jury why should we not resent dictation from an alphabet? . . . Nothing could be more obvious than that pictures should be presented in homogeneous arrangement.[74]

When Sloan became president of the Society the following year, lots were drawn to determine the gallery location of the letters of the alphabet. By 1919 Henri backed down, joined the group and exhibited his portrait of Sloan; he also agreed to serve on the organization's advisory board. Two years later he became a director, and served until his death.

During the summer of 1917 the Henris returned to Santa Fe, renting a home near the Mexican Quarter at 601 Palace Avenue. "We like this old place better than ever," he confessed, especially the grounds outside of the aging, vine-covered adobe. Henri enjoyed gazing at the house from a wooden swing under some large trees near the back hills, where burros would eat among the thistle. "If I should sell a picture or two now I would buy this place," he said later that summer, after having converted the largest room in the rambling one-story structure into a studio complete with skylight.

Once again he began a series of portraits of Indian and Mexican children, but this time with a difference; after several canvases incorporating the traditionally plain background, including the striking *Miguel of Tesuque* (see color plate) and *Indian Girl in Blue Wrap (Gregorita)*, he began a group of paintings of the same model, Julianita, in which brilliantly colored and patterned Indian blankets embellish the area behind the sitter. In *Julianita—Indian Girl in White Blanket* the background is red with black, orange and green stripes; *Julianita* contains red-orange and light orange-yellow; and *Indian Girl* shows the figure against a blue-green blanket with a white design. This was an interesting departure from Henri's long-held view, as expressed in the classroom, that "a background is good in color and form when it is so certainly there that you do not think of it."

The tribal designs introduce a wonderfully abstract element, as if the artist were taking to heart Teddy Roosevelt's Armory Show comment that a Navajo rug was a far more satisfactory and decorative picture than Duchamp's famed nude. Perhaps Henri also reread the December 1913 article in *American Art News*, carefully pasted in his scrapbook, in which an art instructor in the U.S. Indian Service claimed that " 'cubist' art originated with the American Indian some two hundred years ago."[75]

As a continuing diversion, the Henris saw three or four movies a week, often featuring such stars as Charlie Chaplin, yet even in Santa Fe the war was with them, as was the case when a cowboy ball was held to benefit the navy. "It was a success and the costumes make a good spectacle," Henri reported, "notwithstanding my own opinion that having a cowboy costume party in a cowboy country is like taking coals to Colgate." He and other members of the artists' colony made posters which were awarded to those with the best costumes.

The Henris' mobility was vastly increased with the purchase of an automobile, a Ford five-seater dubbed "Henrietta," which allowed them to travel to Acoma, where they witnessed the ceremonial corn dance, and to the San Geronimo Fiesta in Taos. Henri's only complaint about the car concerned the crank used as a starter, which "no one but a strong-armed youngster" should attempt to operate. "As it is, my left arm can paint while my right arm aches."

Henri received word that George and Emma Bellows, who had been vacationing in California, were to come to town with their Buick, which arrived ignominiously tied to a railroad flatcar. Now Henri and Bellows drove some thirty or forty miles into the countryside every morning and returned at night, each with two or three paintings or drawings of the pueblos and hill villages. Henri devised a hinged aluminum palette divided into one hundred twenty compartments, which allowed the Maratta colors to become portable. Bellows brought along an invention of his own, a miniature version of a washing-machine wringer, permitting the very last vestige of pigment to be squeezed from a tube.

Between painting on trips and in the studio, Henri had been meeting with Dr. Hewett concerning the opening exhibit at the new museum, which was nearly finished by the beginning of August; architecturally it was a virtual duplication of the New Mexico Building at the San Diego Exposition. Its irregular walls and rough-beam construction, with a two-story loggia and bell towers flanking the entrance, skillfully combined Indian and Spanish influences. As Henri noted:

> Most museums are glum and morose temples looking homesick for the skies and associations of their native lands—Greek, most likely. The museum here looks as though it were a precious child of the Santa Fe sky and the Santa Fe mountains. It has its parents' complexion.[76]

As the first artist to serve as adviser to the museum, Henri was honored with a special exhibition during the dedication, which included ten paintings of Indian and Mexican children and his imposing portrait of Dieguito Roybal. During opening-day festivities there was a display by some forty artists in what was heralded as the first representative exhibit of Southwest art, and over two thousand visitors attended. Henri had been asked to speak on that occasion but declined, citing his long-held belief that his talks were reserved for the classroom and were successful only when given spontaneously and not according to a set program at a given hour.

The Henris' stay in Santa Fe was cut short by his commitment to teach the composition class and give a series of lectures on composition at the League. In addition, he had exhibitions to assemble for Vassar and Chicago in January and for the Milch Gallery and Columbus the following month.

His appearance at the League was eagerly anticipated: "Next week Robert Henri lectures on composition. I am quite anxious to see Henri,"[77] Adolph Dehn wrote to his parents. He and Arnold Blanch had previously studied at the Minneapolis Art Institute before winning scholarships to the League and enrolling in Henri's class. According to Blanch:

> His class was jammed with three tiers of painters . . . he'd come in, usually at 10 in the morning and he had a wonderful personality He pointed at a portion of a painting and he would say "I would have been proud to have painted that." . . . We'd all gather in back of him whenever he criticized and listen to him because he was a man of great dedication.[78]

Another student, Julie Mathilde Morrow, wrote him:

> I like so much your lecture . . . your breadth of vision and the reverence evident in your statement that *all life is art* You wisely drew attention to our present 'ordinariness' and our lack of the fervor of a Patrick Henry in the realm of art as well as politically But, oh, how glad I was to hear you speak so earnestly and fervently in real appreciation of realities.[79]

Henri's crusade that winter was to establish a permanent gallery of the work of Thomas Eakins, who had died the previous year. Upon viewing an Eakins Memorial Show at the Metropolitan Museum during the month he returned from Santa Fe, Henri wrote to the Pennsylvania Academy: "The Eakins exhibition is a glory. His work makes the room at the Metropolitan look vast and austere. If I were a rich man I should like to put my money into making such a collection permanent in its place"[80]

To his students at the League he said:

> The exhibition of the works of Thomas Eakins at the Metropolitan Museum should be viewed and studied by every student, and, in fact, every lover of the fine arts. Thomas Eakins was a man of great character. He was a man of iron will, and his will was to paint and to carry out his life as he thought it should go. This he did. It cost him heavily, but in his works we have the precious result of his independence, his generous heart and his big mind Personally, I consider him the greatest portrait painter America has produced . . . but he died practically unknown and received only an "honor" or two.[81]

Henri's statement to his pupils appeared in the February 1918 issue of *The Conservator*, a Philadelphia monthly founded by Horace Traubel, Whitman's biographer. The next year Henri spoke at the Pennsylvania Academy, where he suggested that the city of Eakins' birth and life should gather his masterpieces together as a permanent memorial. Afterward he wrote again to the Academy: "I am happy that you all thought my talk worthwhile. I hope there will be an Eakins Gallery in Philadelphia. I feel keen about that. I like to think of beautiful things and I like to see them done."[82]

But the gallery as Henri envisioned it would never come to pass. Unbeknown to him, back in the 1914 Pennsylvania Academy annual—the very show from which Albert Barnes purchased an Eakins painting at Henri's urging—an Academy official had refused to hang one of Eakins' portraits. This was the same person with whom Henri was now corresponding to further the Eakins Memorial plan.

The winter of 1917–18 found Henri enlarging his compositional vocabulary by studying the principles of "Dynamic Symmetry" being advocated by Jay Hambidge, a former law student and newspaper reporter who claimed to have discovered the arrangement of organic structure, "the inner law by which things grow in proportion." Hambidge had initially come to Henri's attention when he wrote an anti-Modern Art article on "The Ancestry of Cubism" in the April 1914 issue of *Century Magazine*, a copy of which was placed in Henri's scrapbook:

> After a clear examination, it becomes evident that Cubic iconoclasm is, after all, superficial, even if we consider only its leaders With design for a lever, the Cubists wish to break completely the grip of realistic art. Yet what do they give us in return? Try as we may, we cannot but consider their own design ill digested and chaotic The Cubist's criteria of design are purely subjective. They rest less upon original, well-ordered, and deep foundations than upon old studio formulae Cubism is at bottom not radical, but blindly, haltingly conservative.[83]

Henri learned from Bellows that Hambidge was giving weekly lectures on Dynamic Symmetry and they both began to attend. Hambidge revealed that "the history of design shows us beyond question that symmetry and rhythm are consciously used by artists who are real masters of composition,"[84] the use dating back to the ancient Greeks.

Hambidge's theory involved ratios employed in elementary mathematics. For instance, one would draw a diagonal between two opposite corners of a canvas, then a second line beginning at another corner and running perpendicular to the first. A vertical would then be placed at the point where the second line reached the edge of the canvas, and the major shapes in the painting would be placed along this series of lines.

To Henri, the Hambidge theory was a challenging mental exercise, an extension of the scientific approach found in Denman Ross's *Theory of Pure Design* which he began recommending to his students follow-

ing its publication in 1907. However, he discovered that the principles of Dynamic Symmetry were better suited to multiple-figure compositions of a more complex nature than his single, straightforward portraits.

Henri's homage to the Hambidge theory was a canvas painted in February 1918 of *Fay Bainter as the "Image" in the "Willow Tree,"* with its opposing verticals and diagonals (see color plate), and a companion painting of the actress in a tan dress completed shortly thereafter.

Henri produced fewer than a dozen paintings during the three months following his return from Santa Fe, so that in his one-man show in March, most of his thirty canvases were from previous summers. Nonetheless, the exhibit was roundly applauded. "It is no disparagement of anything Robert Henri has done before to say that the exhibition he now has in the Milch Galleries is his best," the *New York World* reported. "In the portraiture of gypsies, Indians, children of the street, Chinese youngsters and the like, there is no one quite like him."[85] Several of his 1915 paintings of the red-haired model Edna Smith prompted the *Herald* to call Henri "an artist of strong individuality, which in this show finds its most pronounced expression in paintings of the female nude."[86]

Despite plaudits from the press, no sales resulted; in fact, there was nothing sold from any of his exhibits that spring, including a display of eight canvases in Cincinnati and Columbus, and individual works at Knoedler's, the Art Association of Newport and the Canadian National Exhibit in Toronto.

Also included in the Knoedler show was work by Rockwell Kent; for the occasion he borrowed a painting from Henri which he had presented to his teacher some years before, a 1907 Monhegan scene entitled *Winter*. When the canvas was purchased by the Metropolitan Museum, Henri, despite his own financial plight, insisted that Kent retain the entire eight hundred dollars from the sale. Henri was never given another work to replace the one sold.

He had come upon hard times. "There has been a practical stoppage for the last year in any picture sales," Henri informed his brother Frank in explaining his decision to remain in New York City for the summer of 1918. As a consolation, Frank invited him to take a cruise on his sailboat, and during July and August the brothers and their wives enjoyed the tranquil waters in and around Chesapeake Bay, remaining close to shore because "we are so very near the war here."

On impulse a few days after the voyage, the Henris, accompanied by former students Lucie Bayard and Ruth Jacobi, nevertheless departed for Monhegan Island, arriving by mail boat after an apprehensive crossing of the open sea. "The place is almost wholly ours," Henri announced, "only a few artists have been here this season and the submarine reports have kept down the number of summer visitors"

Robert and Marjorie rented living quarters and a studio with a large picture window, from which they could look down upon the pounding surf and "see the great combers rolling in and then the smash and the

white confusion which follows on the rocks."[87] The studio contained no skylight, so the illumination, coming from three windows and oil lamps, proved inadequate for portraiture. As a result, virtually all of Henri's art that summer was produced outdoors.

Working mostly in pastels, he sketched the random patterns of sunlight flickering through the trees with an occasional figure of Marjorie, Lucie or Ruth shown drawing or reading. In contrast to his 1911 paintings of similar Monhegan subjects, there was an attempt this time to place less emphasis on subject matter, to simplify to the point of partial abstraction. Though a work such as *The Sketchers in the Woods* is compositionally reminiscent of Winslow Homer, the pastel medium is utilized with greater abandon, each color being laid down directly without subsequent shading and detail. In *Laird* a brown-and-white pet collie is hardly discernible, appearing as an outgrowth of the knoll on which it sits; here Henri has reduced the ground and underbrush in the lower portion of the picture to mere textures and calligraphic effects, coming closer to nonfigurative art than at any time in his career.

The liberal use of intense colors in these drawings, however, especially the reds, yellows and oranges, was inspired by nature, for "all trees not evergreens are turning—There are places that flame with color."[88]

Now the titles of his sketches suddenly become more poetic as well: *Where There Is Green Moss, At the Place of the Three Trees* and *They Might Dance Here,* the latter depicting a clearing in the woods perhaps awaiting human or mythological forms.

As fall chased the last vestiges of summer visitors from Monhegan, Henri enjoyed the solitude of this primitive island discovered by Captain John Smith in 1614, six years before a European foot was set on Plymouth Rock. Yet even this tranquil splendor was occasionally broken by reminders of the war: the visit of a squad of marines, welcome searchlights playing on the water in a quest for German submarines, or a friendly ship passing nearby, for which Henri critiqued the painted camouflage disguise, observing that "they had made the darks too dark."

One day in mid-October he was drawing in the woods when a couple came by with the exciting news: "Germany has surrendered!" Of course, the word spread quickly among the few residents on the island and was verified by the Coast Guard, though the real truce would not take place for three weeks.

Henri, overjoyed, arrived in New York with nearly a hundred pastel drawings. But there he learned of tragedy in the war's aftermath: a former student, Rex Slinkard, had been struck down by the influenza epidemic while awaiting troop shipment to France. Another young artist, Morton L. Schamberg, who religiously sent Henri a Christmas greeting each year, had also died of the flu.

Because of his late return from Monhegan, Henri's

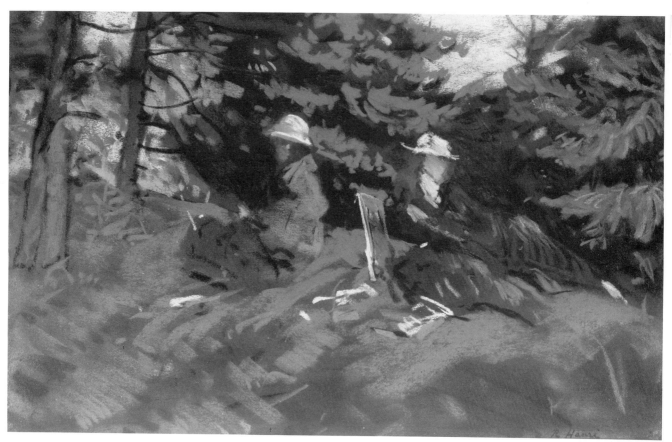

The Sketchers in the Woods (Ruth Jacobi and Marjorie Henri), 1918. Pastel on paper, 12½″ × 20″ (32.1 × 50.8 cm.). Collection of Rita and Daniel Fraad. Photograph by Walter Rosenbluth.

League class had been canceled, which only added to his continuing financial woes. "It does not matter if I get near the edge now and then," he confided, ". . . having painted to suit myself and not others for the last eighteen years."[89] Poverty or no, Henri was adamant on the subject of pricing his works, refusing to reduce them even when times were bad. On such occasions he would say that while the wolf was at his door, it had not yet gotten inside and, besides, he knew of no law prohibiting him from starving.

Then his luck changed and, by the end of January 1919, three of his pastels were sold for fifteen hundred dollars from an exhibition at the Montross Gallery, followed by the thousand-dollar sale of *The Rain Storm—Wyoming Valley* by Knoedler to Adolph Lewisohn. At last Henri could report: "The crisis has been bridged for the time."[90]

During the war years his interest in theater and the dance had been largely restricted to assembling scrapbooks in which he mounted newspaper and magazine photographs of Anna Pavlova, Nijinsky, John and Ethel Barrymore, Theda Bara, Irene and Vernon Castle, Anna Held and the Dolly Sisters. But now the stage lights brightened again for the Henris, who watched their actor friends, Charles and Ivah Coburn, star in *The Better 'Ole,* and attended recitals of the Isadora Duncan Dancers and a production of Barrie's play *Dear Brutus* in which "a very remarkable feature in the acting was the performance of [eighteen-year-old] Helen Hayes in what was really the most important part."[91]

Henri was also on hand when Ruth St. Denis opened at the Palace in February 1919 performing the exotic Peacock Dance, based on a legend from India about a woman whose excessive vanity caused her to be transformed into a gorgeous peacock. For an hour or so each morning before departing for the matinee performance, the dancer posed for Henri in her elaborate costume of lavender peacock feathers. His painting depicts the long-necked dancer's graceful head and body forming a sensuous ogee curve, her bare arms and waist in stark contrast to the green and purple costume and the background, which suggests a landscape at night.

In April the canvas was exhibited at the National Portrait Association show, where it was hung in the place of honor. The following month Henri proposed to Frank Crowninshield, editor of *Vanity Fair,* "a mighty propaganda for some sort of theatre in New York for just such great artists as Ruth St. Denis" Henri objected to the fact that she and similar talents now played in theaters where they were "hampered by vaudevillians and sandwiched between imitators of George Cohan A pure art needs backing. Can't you inspire some backers to action? The Dance must come. It is too great an art for us, through our inertia, to miss."[92] At the same time Henri was pursuing the possibility of a combination repertory theater and art gallery, a novel idea in 1919.

In the spring of that year his concern for the acting profession, urgent as it was, took a back seat to a renewed interest in having a liberal jury system adopted for the National Academy of Design annual.

It had been nine years since Henri had submitted a painting to the Academy or attended one of its meetings, but the subject arose again because of the demise of the MacDowell Club exhibitions.

After eight full seasons of self-organized group shows held according to Henri's plan, he reluctantly announced:

> The Group exhibitions will not continue at the MacDowell Club hereafter. I think Harry Watrous has captured the club—at any rate it will step back and the Group Scheme will be for the present without a home. There are many who want it to go on so I suppose it will break out elsewhere.[93]

Appropriately, the final show contained seven works by Henri: four pen-and-inks of nudes, two paintings of Edna Smith and a pastel. Sloan, Bellows, Chatterton, Gifford and Reynolds Beal, Leon Kroll and the late Rex Slinkard were also represented in that exhibit. It was to Henri's credit that the last exhibition maintained the same ground rules as the very first one: a self-selected group organized by the artists themselves, whether members of the MacDowell Club or not, who were solely responsible for the selection and the hanging of pictures.

Henri had long advocated that the Academy modernize from within so that it would become a vital force on the American scene. Having failed in past attempts to have its officers spearhead any reorganization, Henri now helped to establish a committee of associate members and academicians who could do the job themselves. Besides himself, the group of twelve included Bellows, Speicher, Gifford Beal, A. Stirling Calder, Paul Dougherty, Jonas Lie and Childe Hassam, who served as chairman.

A letter was sent to all members of the Academy over the committee members' signatures asking that they attend a meeting at the American Fine Arts Society Building to discuss some vital topics, among which were the complete revamping of the jury system, which would substitute proportional representation for majority rule, and the selection of jurors from among the Academy membership on a rotating basis for the present self-perpetuating elective system.

Forty-nine artists came and the various proposals were published in a small booklet. But the Academy officers challenged the ideas. Without commenting on the validity of the suggestions, they admonished the committee for publishing the plan "in the form of a booklet, with arguments set forth in the first person plural; to which, instead of signing their own names only, they have appended all the names of the forty-nine members attending the meeting, thereby giving the impression that the 'forty-nine' were presenting and endorsing the plan."[94] Thus Henri learned, once and for all, that his time and effort on behalf of the National Academy of Design was unwanted; the staid institution continued on its singular course.

Henri spent the summer of 1919 painting portrait commissions of children: two canvases of three-year-old Edward Herbert Bennett, Jr.; in Lake Forest, Illinois, and six likenesses of Jean and Kitty McVitty in

Falmouth, Massachusetts; and in the fall he helped found a Painters, Sculptors and Gravers Society which held its first annual exhibition in October at the Gimpel Wildenstein Galleries on Fifth Avenue. A direct result of the loss of the MacDowell exhibits and the rebuff by the Academy, the organization, which would change its name to The New Society of Artists the following year, included Henri, Sloan, Glackens, Lawson, Prendergast, Bellows, Speicher, Kent, du Bois, Davey, Halpert, Manship, Myers, Schofield, Beal, Pennell, Hassam, Lie and Mahonri Young.

Henri returned to teach a portrait class at the League in the fall. He alternated each week between using portrait and nude models, and regularly posed a male at one end of the room and a female at the other. His catalytic ability appeared as vital as ever. Sidney Laufman said:

> Henri would simply inspire you It wasn't anything he told you precisely He would talk about all kinds of things; he'd talk about books, about the theatre, about some dancer he had seen—he would just work you up to a pitch of excitement about what a work of art should be, so you'd go to work in a sweat and really feel as though you might be able to do something.[95]

Although Henri still spoke of the Maratta palette, he mentioned it now as something the student should know but did not enthusiastically promote its use. This change was due in part to the continued decline in the quality of the Maratta pigments, especially the lessening of intensity in the yellows, to which he himself objected.

Still, the fruits of Henri's years as a teacher were contantly in evidence, in those who corresponded with him from distant places and had attained professional status by virtue of their exhibition records. The 1917 edition of *Who's Who in Art*, for example, included well over one hundred of his pupils, many of whom were already established as teachers in New York City and beyond.

In the twenties Henri devoted more time to leisure activities. He and Marjorie had perfected their talents at ballroom dancing and, thanks to the two long mirrors placed for that purpose in his studio, would do the tango, one-step and hesitation waltz in imitation of Vernon and Irene Castle, or revert to the hip-swinging, arm-flinging, elbow-raising turkey trot that had been so popular a decade before. Marjorie, the perfect wife, remained fully responsive and supportive of Henri in both work and play.

The war had terminated Henri's weekly open house, and because it was not revived the couple seemed to appear self-centered and secretive. Some of their friends complained that no one ever dropped in on the Henris. He spent an ever-increasing part of each day answering correspondence and compiling over a dozen scrapbooks on composition. These scrapbooks, each indexed and with photographs, covered the subject in such subdivisions as works by various artists (Manet, Sargent, Chase, Henri Rousseau, Odilon Redon), interior decoration, and (one volume each) North Africa, Black Africa and the South Seas. And he was still involved in organizational matters, serving with Bellows and Charles Sheeler (his choices)

on a committee that organized an exhibition of contemporary American art for the Luxembourg Museum in Paris in the fall of 1919.

While his own creative output was to have some lean periods—in all of 1919, for instance, he produced fewer than three dozen works—during the 1920s he painted nearly eight hundred canvases, an average of two each week over the entire decade.

Though there were times when activity in the studio was stilled, he continued to exhibit with the same fervor, having one-man shows circulated by the American Federation of Arts and being included in major exhibitions. During 1919 he had solo exhibits in Springfield (Ohio), Chicago, Milwaukee, St. Louis and Buffalo; and he still took personal charge of all arrangements for crating, shipping and record keeping.

Although sales began to improve, certain paintings by Henri continued to be controversial, in subject matter if not in technique. In December 1919, his 1904 masterpiece *Willie Gee* was finally sold to the Corcoran Gallery of Art for fifteen hundred dollars, but the alert, wide-eyed countenance of the little black youngster must have proven to be too much for the nation's capital; it was returned to the artist in exchange for another portrait a few years later. And once again Columbus, Ohio, showed itself to be the Boston of the Midwest as four of Henri's nudes were banned from an exhibition there because some "violent criticism" had developed on the part of a few people. Upon being informed of the censorship, Henri could only respond to a city official that "some day the whole world will learn to respect the human body, will cease to see in it a cause for shame, and then the world will be cleaner in mind and spirit."[96]

In 1920 his painting *Jean* won the Portrait Prize of the Wilmington Society of Fine Arts, which also purchased his *Little Girl of the Southwest* for its permanent collection. In April of that year the Montross Gallery held a nostalgic show featuring the early works of four of The Eight: Henri, Glackens, Davies and Prendergast. Among Henri's several canvases, dating from as far back as 1897, only his *Dutch Fisherman* had been included in the original show at Macbeth's. Each of the other exhibitors was represented "by canvases as old as these of mine . . . attracting a good deal of interest."[97] The show must have caught the attention of the National Academy, too, for Henri was extended an invitation to serve as a juror for its forthcoming annual.

His most notable studio painting at this time was a portrait of financier Bernard Baruch, produced as a commission for a foundation. When the organization failed to pay for the work he reclaimed it and had the canvas exhibited at the John Levy Gallery in June. Henri reported that "Mr. Baruch has repeatedly expressed himself to me and to others as highly satisfied with the portrait,"[98] which depicts the future adviser to American presidents as a distinguished man in midcareer.

Henri and Marjorie were planning to travel west for the summer but his mother became ill, and then painting the portraits of Arthur D. Bissell in Buffalo and little Fayette Smith on Cape Cod made a visit to

New Mexico or California impossible. "As you know there was once a chance that we would drop in on you all at Santa Fe," he wrote to John Sloan, who had begun spending the summers there at Henri's suggestion. "The chance has passed. We haven't dropped in anyplace at all."[99]

A winter of exhibits, lectures at the League and billiards with Bellows at the National Arts Club was capped by a great testimonial dinner at the Salmagundi Club in April 1921 in honor of Henri. The toastmaster stated:

> Instead of standing aloof from the young of the land, who, as is the practice of youth, exercise freedom of speech and action and even irreverence, this man actually gives them the glad hand of fellowship, the cheer of his countenance and actually admits that he is still willing to learn his métier with them.
>
> And this is the man you would make a Saint in Paint. The Hell he is. But I will admit that he is a devil of a good fellow.[100]

One after another the artists rose to pay him homage, to recognize the contributions of the individual who had done so much for so many. That Henri was embarrassed by the eulogies brought some of the speakers to the brink of tears, but the spell was broken by Glackens when he stood up and said: "Henri's all right. But what are we going to do about Prohibition?"[101] bringing an end to the seriousness of the occasion, to the relief of Robert Henri.

He and Marjorie spent the summer with the Bellowses, Speichers and Leon Kroll at Woodstock, a two-hour train ride from the city. Although the League's summer school was located there, Henri did no teaching, devoting himself entirely to painting. He initially had a difficult time getting started so he "lazed, smoked and read 'The Lost Girl' by D. H. Lawrence" until the spirit moved him.[102] But when it did, he produced multiple portraits of several child models: Agnes Sleicher and her brothers, Carl and John; and a single canvas of Boby, a blond youngster whose wide-eyed, elfin glance to one side of the composition is balanced by a pink geranium placed on the other. Henri also painted some landscapes and thought most highly of *Summer Storm*, created in the doorway of his studio while the tempest was breaking over a darkened countryside.

In the evenings the artists and their wives would congregate, the men playing poker or making sketches of each other before the customary nightcap. When Henri returned to New York he had nearly a hundred paintings to show for his efforts.

That fall a monograph was published entitled *Robert Henri: His Life and Works*, by William Yarrow and Louis Bouché, the latter a former student in his composition class at the League. Planned as the first of a series dealing with living American artists, the oversized volume, its text supplemented by forty illustrations, was limited to nine hundred and ninety numbered

Summer Storm, 1921.
Oil on canvas, 26" × 32"
(66.0 × 81.2 cm.).
Vassar College Art Gallery,
Poughkeepsie, New York,
Gift of Mr. and Mrs.
Charles J. Malmed.
Photograph by
Walter Russell.

copies and sold for ten dollars, a price too steep for most of Henri's pupils. The following year another book about him appeared; essentially a collection of sixty-four reproductions of his paintings, it included a brief introduction by Nathaniel Pousette-Dart.

During 1921 and 1922 Henri's League class still attracted many newcomers. Now Adolph Gottlieb was among the fifty or so students who crowded into the second-floor lecture room and paid one dollar per class for the master's inspiring directives. Margery Ryerson was beginning her fourth season with Henri and it was with some trepidation that she sent the following letter to him:

My dear Mr. Henri,
During the whole three years that I was in your class at the Art Students League I took notes on your criticisms. Since then they have been invaluable to me, for when I get into trouble with a painting I read them over, and always come to something that helps me. I should like to publish them but want to consult you about it first, lest in some of the notes I have misquoted you[103]

On two previous occasions his students had come forward with a similar plan: as a result of his 1912 class in Spain, Clara Greenleaf Perry had written twelve pages of Henri comments from her class notes the following winter, which occasioned him to remark that they "seemed so very good and to the point" that he hoped "she would continue the work and make a book of it";[104] then in April 1913 Alice Klauber had revealed her own thirty-eight-page version about which his only reservation was that "the work should not be presented as though I were the author."[105]*

At the time he had questioned whether such a volume should appear while he was still actively teaching but now, eight years later, his ideas on the subject had changed.

"I would never have taken the time to put the Henri notes together if I hadn't been sick with the measles," Margery Ryerson confessed, "and Henri would never have worked on the book if he hadn't been sick."[106] Henri's illness was a nasty back sprain and the doctor prescribed that he do no painting during the fall and winter of 1922 because it necessitated long periods of standing before the easel.

The preceding summer he and Marjorie had headed for Los Angeles, where portrait commissions were waiting, then revisited Santa Fe so he could paint another complement of children: Bernadita, with striking black eyes and black hair parted down the middle, and wearing a red coat and gold earring; Chico Lucera in a green cap, posed against a black and red Indian blanket; and Juan Francisco, a Mexican boy bedecked in a red-orange scarf, blue shirt, blue-purple jumper, red coat and purple cap. Henri continued to employ a wide variety of hues, often of great intensity, thereby surrounding the figures in his paintings with exciting color patterns.

The Sloans were in Santa Fe that summer, too, having returned annually since 1919 when the initial visit was made at Henri's urging. Though the old

friends were as cordial as ever, John had been drifting away from Henri ever since the Armory Show; even now their art interests were different, with Sloan concentrating on the "fine geometrical formations" of the New Mexican landscape while Henri continued to focus on faces.

Back in New York in the fall, Henri's studio production was limited, by doctor's orders, to quick sketches from the figure in ink, pencil and pastel. It was during this period of general inactivity that he agreed to work with Margery Ryerson on the book, poring over her classroom notes, editing them and arranging their sequence. He also took excerpts from letters to former students for inclusion in the book.

Henri's decision in favor of a book was made, in part, because the California portrait commissions had come from a reader of the Yarrow and Bouché volume. By early 1923 he was totally absorbed by the project as Ryerson "sewed it together like a patchwork quilt." One publisher proposed that it be a limited edition at ten dollars but Henri said "it had to be a price that the poorest student could afford." *The Art Spirit* was chosen as the title, Lippincott as the publisher, and the price was set at two dollars; it appeared, two hundred eighty-one pages in length, in the fall of 1923, six months after a profoundly sad day for Henri, February 15, when his mother died in her sleep at the age of eighty-seven.

Perhaps aware of her impending demise, Mrs. Lee, shortly before her death, had dared for the first time to refer to Henri in a letter to him as "My dear Son," acknowledging in writing what had been a carefully guarded secret for four decades.

The body of Theresa Gatewood Cozad was cremated three months later and her ashes placed in an urn at the Swan Point Cemetery in Providence, Rhode Island, beside those of her husband's. His body had been exhumed from the May's Landing Cemetery in New Jersey some years before and also cremated.

In April, Henri experienced "just a slight heart flutter, my pulse a bit off," causing the doctor to recommend less smoking, but Henri eliminated it completely. "I have not smoked for seven weeks," he told his brother and confessed that it "seems more like seven years."[107]

Henri's inheritance gave him financial independence for the first time in his life. He planned for a year in France, his first trip there in a decade. He and Marjorie arrived in July and "revisited their pet places" with James Wilson Morrice, but after two weeks in Paris they went on to Madrid.

Occupying the former studio of the artist Joaquín Sorolla y Bastida, Henri painted dozens of portraits of Andalusian Gypsies, beggars and children. In contrast to the bright apparel and fabrics of Santa Fe, Spain appeared somber, with colors all gray and brown, causing Henri to revert to the old, subdued palette. His *Girl of Andaluz* is dominated by a brown background, as is *El Segoviano,* an aged Spaniard in a crumpled hat.

Henri frequented his old haunts, especially the Prado. "I know no place where seeing pictures is so agreeable," he said. "We have found some of our old

*See Appendix I.

Spanish friends here the same as they were in the old days" But "the girls wear their hair in the abominable modern fashion which they have got from the movies, that old wonderful hair dressing which fit them so well is gone—The men dress New York."[108]

After eight months in the Spanish capital, during which time Henri experienced "heat such as I never saw in Madrid," reaching 118 degrees for a spell, the couple moved on to Ireland, where Corrymore House was available for rental at one pound per week. After cosmopolitan Madrid, with its rush of city life and twice-weekly vaudeville shows, Achill Island appeared all the more isolated and tranquil. Here the Henris remained for the rest of the year 1924, and he set apart a section of wall in his studio for memories of home: a faint newspaper reproduction of Bellows' portrait of his wife and children, etchings by Sloan and a head "in Greek stillness" by Eugene Speicher.

It was a leisurely existence. Henri alternated between trout fishing and painting the neighborhood youngsters: Mary O'Malley, a ruddy-faced beauty; Birdeen, a cherubic little redhead (see color plate); Michael MacNamara sitting with his hat askew; John Lavelle with his arms folded. Like other subjects in San Diego, Madrid and elsewhere, the Irish children were referred to by Henri as "My People," persons without designations as to land or race:

> My love of mankind is individual. I am patriotic only about what I admire, and my devotion to humanity burns as brightly for Europe as for America. It flames up swiftly for Mexico if I am painting the peon there; it warms towards the bull fighter of Spain if in spite of its cruelty there is that element in his art which I find beautiful; it intensifies before the Irish peasant whose love, poetry, simplicity, and humor have enriched my existence just as completely as though these people were of my own country and my own hearthstone. Everywhere I see at times this beautiful expression of the dignity of life to which I respond with a wish to preserve this beauty of humanity for my friends to enjoy[109]

Back home, Henri's name and his paintings had continued in the limelight: while he was away during 1923 he had a one-man show at the Ainslie Galleries on Fifth Avenue, was represented at the Milch Gallery, and one of his several portraits of *Mary O'Malley* was reproduced in full color on the cover of *Harper's*. But now, a full decade after the Armory Show, Henri's subjects, style and palette remained virtually unchanged. With works by such modernists as Lyonel Feininger and Karl Schmidt-Rottluff appearing in the same issue of the magazine, his painting appeared all the more dated.

Henri had been in Spain when *The Art Spirit* was published toward the end of 1923, and upon receiving a copy from Margery Ryerson he wrote that "It is fine, simple, dignified and a most readable printing. The paper is good to eye and feel—I like the title page and I like the cover."[110] It had been his idea that sales would be encouraged by his not teaching at the League at the time of publication. Lippincott mailed a brochure to the six thousand subscribers of *The Touchstone* from a list supplied by Mary Fanton Roberts, who had also provided a statement for the dust jacket. The flyer contained a picture of Henri and a quote from Bellows:

> I would give anything to have come by this book years ago. It is, in my opinion, comparable only to the notes of Leonardo and Sir Joshua [Reynolds]. But infinitely more suggestive than either of these to the artists of today. A rare book.

Bellows also sent Henri a note: "Your book is a beauty. I read it often. It seems to me a very unique thing in literature and increasingly valuable."[111] He wrote a review of it, as did Vachel Lindsay.

On the strength of the book, Henri was offered the presidency of The Blake Society in London. Letters began to reach him in Ireland from artists whose careers had been affected by the publication. Jerry Farnsworth wrote from North Truro, Massachusetts: "I have never met you except in your pictures and your book 'The Art Spirit' It has been worth more to me than all the days spent in art schools"[112] *Cosmopolitan* cover artist Harrison Fisher commented: "Have just finished reading your book 'The Art Spirit' it has given me much joy—and I am honestly inspired to work and do something worthwhile."[113] Sloan predicted that it "should become a classic," and it did, being earmarked as required reading for art students and professionals everywhere during the 1920s and 1930s, and in many circles it still is; over 200,000 copies have been sold in hard cover and paperback since the initial printing.

Henri decided to return to America at the end of 1924, for as he wrote to Sloan: "We think of lots of fine times we are missing and are mighty sorry that we were not with you all at the Kennedy Thompson party which followed the New Society dinner"[114] He had also missed his one-man show at Macbeth's, about which Helen Appleton Read, of the *Brooklyn Eagle*, wrote that "he can still get the essence, the individuality of a sitter with a freshness and verve"[115]

After a delay of several months, caused by negotiations to purchase Corrymore House, the greenhouse, coach house and stable together with fifteen acres of land for two hundred pounds (eight hundred seventy dollars at the time), Henri and Marjorie finally sailed for New York in November 1924.

One of his first acts was to hire a stenographer in order to clear the huge mounds of correspondence which had gone unanswered during many previous months. Then he plunged into the life of Manhattan, seeing shows, including *Desire Under the Elms* at the Greenwich Village Theatre—"I was so impressed by its beauty . . . I felt that we were being raised to a higher plane . . ."—and giving a New Year's Eve dinner party attended by Glackens, Speicher, Kroll, Bellows and their wives.

George Bellows was his usual, entertaining self, donning some old clothes and imitating Queen Victoria. He descended the stairs of 10 Gramercy Park at three A.M. on January 1 and no one could have suspected that it was his farewell to Henri, for suddenly, tragically, seven days later, Bellows died of a ruptured appendix at the age of forty-two. "This is the most overwhelming grief that has ever come to me," Henri said. "I have lost my pupil, my friend, my son."[116]

He was one of the pallbearers, along with members of The Eight, excepting Davies and Shinn. The coffin, mantled with Ascension lilies, was carried out into the rain from a Fifth Avenue church. "To observe Henri at George's funeral was a tragedy in itself,"[117] Lucie Bayard noted. In some ways Henri never recovered from his grief. He said: "It is terrible to think we will never have George with us again in fun, and play, and serious moments . . . we will never cease to feel the loss."[118]

With portrait commissions again awaiting him in California, Henri accepted them now, perhaps out of some subconscious need of a release from his mourning, made more painful by the scenes of the wonderful times he and Bellows had enjoyed together. After producing several paintings there and spending a few days in Tijuana, he returned to New York in time to attend the opening of yet another one-man show at Macbeth's. The financially unsuccessful exhibition coincided with an additional money problem: a disagreement with Dr. Albert Barnes that prompted Henri to repurchase the three works sold him between 1912 and 1915 and pay Barnes the 2,800 dollars he had originally received. Although there is no record of the nature of the disagreement, it may have stemmed from Dr. Barnes's failure to allow art students free access to the paintings in his collection, especially since he had established the Barnes Foundation three years earlier.

Henri was still unable to dismiss grievous thoughts of Bellows; often he remembered that it was George who "ordered" him to Ireland the year before "to the exclusion of everything else." Now he would follow that advice in what was to become an annual sojourn to the Emerald Isle. For the next four years he and Marjorie would spend up to five months there, always certain first to order an adequate supply of paints and canvases from Winsor & Newton in London.

Henri's stay in Ireland caused him to miss the opening of the Bellows Memorial Exhibition at the Metropolitan Museum but he returned in time to view it in November 1925. He wrote to George's widow, Emma: "I wish, as I wished in the case of Eakins, that it could remain permanently there." He became a second father to the Bellows children, bringing the two little girls gifts and affection, trying to fill the void for them.

In 1926 the Eakins Gallery idea was revived when the Philadelphia *Public Ledger* printed a letter from Henri based on his earlier plea, suggesting that a group of pictures could be purchased from the Eakins estate. But when the newspaper had the notion that contributions should be sought from artists, Henri, in his fervent, long-held belief, informed them that he was "very much against collecting and using the pittance artists and students could give. I think the artists' and students' money should be expended on their own needs—they have little enough."[119]

In his final years, Henri was still the fighter, speaking out for unpopular causes and always quick to lend his support. When Nicola Sacco and Bartolomeo Vanzetti were tried on questionable evidence for killing a paymaster and his guard in South Braintree, Massachusetts, Henri was moved to write to Gover-

nor Fuller expressing his belief that the two men "are victims of a miscarriage of Justice" and requesting "a public investigation of the entire case."[120] When he was asked to serve as a director for a society seeking a Bureau of Art in Washington, he declined, saying: "If you wish a suggestion from me . . . don't be too sure mixing art with politics will prove beneficial to artists . . . as things are now art mixed with politics might prove a very negative compound."[121] And in February 1927, when a Midwest museum wanted one of his paintings for an important show, he refused because the exhibitors were asked to pay for shipping. "It's enough for artists to paint pictures, frame them and have them ready to send out. We need some time to paint and write these damnable letters. The art societies can and should do the rest."[122]

The 1927–28 season was Henri's last for his composition-class lectures at the League. His audience was still running to capacity, about fifty at each session, and now the students were reading *The Art Spirit* to supplement the semimonthly offerings. When the League held a series of exhibitions to mark its fiftieth anniversary, Henri was one of the three dozen artists selected for the inital group; at least eight of the other exhibitors were his former students. There were also the usual number of jury obligations in which he continued to participate, serving with Charles Dana Gibson and Joseph Chapin of *Scribner's* for the Art Directors' Club annual awards, then with Sloan and Speicher to choose the first *Scholastic Magazine* art prizes for teenage talent. And prior to departing for Ireland in May 1928 for what would prove to be his last summer there, Henri proofread the preface to a fifth edition of *The Art Spirit*.

While in New York, Henri's painting rate dropped to only one canvas a week but during the summer and fall of 1927 and again in 1928 he produced some one hundred forty portraits of his young friends on Achill Island. Henri had his studio at Corrymore House enlarged and now set about the joyful task of painting the children by day and fishing on the lake each evening. At age sixty-three his paintings showed no signs of a lessening vitality; in fact, the spontaneous brushstroke was just as deft as ever: here was Bridget O'Malley posed in red with a doll in her lap and Mary Ann MacNamara wearing a ruffled apron; Anthony Lavelle, a redhead, holding an apple in his left hand while sucking the thumb of his right; Michael Lavelle wearing a blue sweater and plaid scarf. And in a canvas such as *An Irish Lad*, the brush is used to delineate a marvelous visual journey over the surface rather than merely describing the folds of a white shirt (see color plate).

One painting of Thomas Cafferty was titled *The Brown-eyed Boy* in deference to his uniqueness among the mostly blue-eyed Irish; the work is virtually monochromatic, composed of only browns and oranges in the clothing and background. By contrast, a likeness of the subject's sister, *Mary Anne with Her Basket*, features a backdrop at once ablaze with color, with reds, yellow and blues, all serving as a darkened foil for the subtle pink ribbon in Mary Anne Cafferty's hair and her pink apron over a dark blue dress.

The youngsters who sat for their portraits re-

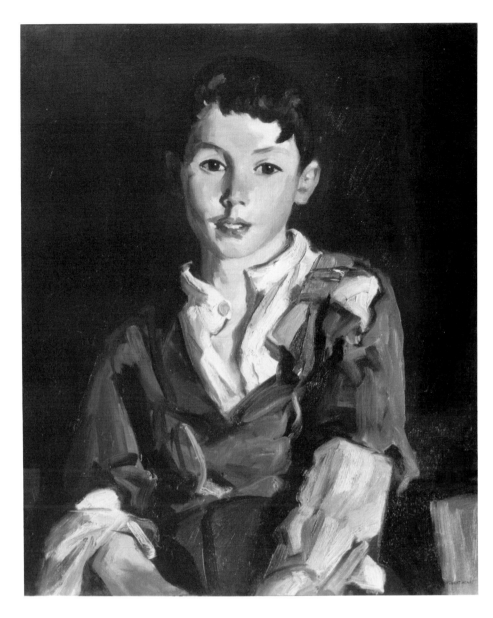

The Brown-eyed Boy
(Thomas Cafferty), 1926.
Oil on canvas, 24" × 20"
(60.9 × 50.8 cm.).
The Baltimore Museum of Art.
Photograph by William McKillop.

sponded to the childless artist's sincerity, warmth and friendship; for Henri's part, the conversations they had together were informative to both parties, which is why he became particularly annoyed when a policeman visited his studio in search of one of his little models because she was delinquent from school. "I am here to paint, not to pass my time," Henri wrote in July 1928, "and I must have models. The few days that any one child comes up here are certainly more educational than the days they lose at school, by so doing."[123]

Beginning in September there was a series of sudden, violent storms, several of which caught Henri out on Keel Lake fishing. He blamed the weather and a resulting cold for an attack of neuritis that crippled his left leg during the return trip to New York in November. Henri entered St. Luke's Hospital for what he thought would be a brief stay, but he was destined never to leave. "I don't feel sick now but neuritis is hell," he wrote the following month,[124] and although he only complained of pains in his left hip, the radiologist's report showed that he had prostate

cancer, which had spread to his pelvis and the lower spine. The patient was never informed.

When word of Henri's whereabouts began to circulate, friends sent cards and gifts. "I am in the midst of Voltaire and before me are the beautiful flowers you sent," he wrote in thanking Emma Bellows. As the Christmas season approached, Henri became restless at being bedridden. When he expressed his chagrin at not being able to attend the opening of Speicher's one-man show at the Rehn Galleries, his former student's first such exhibit in three years, Speicher and Frank Rehn transported the entire exhibition of twenty canvases to Henri's bedside and provided him with a private showing.

Visitors beat a path to Room 521 at St. Luke's, with Marjorie orchestrating the traffic flow. She did her best to make him feel at home, placing one of his paintings on the wall opposite his bed and changing it on a regular basis. Słoan brought a few of his own recent works, as did Richard Lahey and many others. And while Henri confidently informed Carl Sprin-

chorn that "my neuritis shows some improvement—it may be wearing away," the hospital X-rays revealed considerable bone change in the pelvis.

His spirits were buoyed, as was intended, when his canvas *The Wee Woman* won the Temple Gold Medal at the Pennsylvania Academy annual. In acknowledging the award—the Academy's top prize, which had so long eluded him—Henri wrote: "This neuritis business is a great cause of interruption but in time I think I should be back to normal"[125] He would never paint again.

During the spring of 1929 the Arts Council of New York compiled and publicized a list of the hundred most important living American artists, the result of a poll taken among America's museum officials, dealers, collectors and artists. As might be expected, Henri was one of the top vote-getters.

On June 24, 1929, his sixty-fourth birthday, he complained to the physician for neglecting him by taking a short vacation. But Dr. Sam Lambert had a ready reply, as related by Marjorie:

Do you think for a moment that I'd go off on a fishing trip—or leave your side for an hour—if I didn't know you were mending and convalescing as fast as can be expected? After what you've been through? No Sir, I went because you don't need me—or any other Doctor—You're coming out of this top-notch. Why, you've got a heart, and other vital organs of a man of 35.

Robert believed him, and has been happy and reassured ever since. I almost believe him myself—until we go out the door together and I see how he wilts and says "My God—it breaks my heart to lie to him, but I've got to do it."[126]

As Henri's strength ebbed, he lingered for two more weeks: "Most of the time he is in a happy, drowsy, drugged state. Then there are days when for a few hours he appears as well as months ago—Today, June 25th, he insisted on writing out a cheque—and though it took longer, still the writing was normal."[127]

The end came on July 12. Marjorie wrote to Edith and William Glackens in Paris:

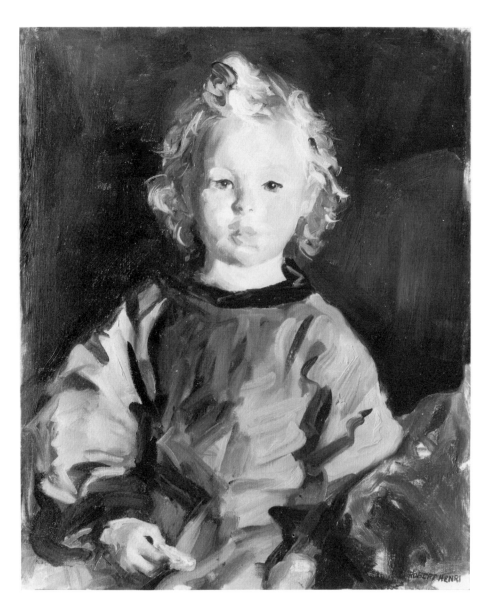

The Wee Woman, 1927.
Oil on canvas, 24" × 20"
(60.9 × 50.8 cm.).
Campanile Galleries, Inc., Los Angeles.
Photograph courtesy of
Peter A. Juley & Son Collection,
Smithsonian Institution,
Washington, D.C.

It is true Bob had neuritis caused by this thing leaning on the sciatic nerve so the thing to do was to make it neuritis Robert was so sure July 6th that we were going some place near a trout stream . . . then suddenly one night he wasn't so strong in his "Good Night" and "Take care of yourself!" The next morning a slight state of coma which grew, and from which he never woke up.[128]

The funeral service was private. The coffin, covered with larkspur, smilax, spirea and a wreath of red roses, was taken from an Eighth Avenue funeral parlor to a Bergen, New Jersey, crematory.

In its obituary notice, the *New York Times* reported that the ashes would be interred in the family vault in Philadelphia. Poor Henri. Even in death there was the white lie to conceal his true identity and final resting place. The cremation took place all right, but the ashes were placed beside his father's and mother's remains at the Swan Point Cemetery in Providence, Rhode Island.

Marjorie notified the art dealers to stop all sales of his work immediately; the paintings were returned to the studio and to her possession. Sloan, in Santa Fe when Henri died, was informed of the tragedy by telegram. Within hours of his learning the news he was organizing a Robert Henri Memorial Association, "an effort to fulfill his life dream in the founding of a memorial hall, consisting of a series of galleries for unrestricted exhibitions," as the *Santa Fe New Mexican* announced.[129] Sloan quickly established a committee consisting of Speicher, Luks, Davey, Dasburg and John Marin, which encouraged nationwide participation. But Marjorie squelched the idea, refusing to give her permission for the two-million-dollar structure because she felt Henri would not approve of money being taken from artists and art students for such a project.

Marjorie used Emma Bellows as an intermediary, and Emma wrote Sloan:

> Knowing your great love for Robert Henri, I understand your wish to do him honor and assure for him the high place he earned and won. The idea for the $2,000,000 Art Gallery is a great one and so like you to think of it directly. To me raising the money seems the least part and the wise directing the most difficult I know Mr. Henri drilled into me that an exhibition at the Metropolitan was the important event for George and to wait until that happened before planning anything else. I believe a list of artists' names had to be handed in petitioning the Directors to give such an exhibition.[130]

Rebuffed by Marjorie, Sloan did nothing for the moment.

Henri's memory was honored by his fellow artists when five of his paintings formed a small memorial exhibition as part of the Society of Independent Artists' annual show, and they cited him as "a great and an important factor in the development of an American art"[131]

The Macbeth Gallery clamored to obtain Henri's canvases to sell to numerous museums and collectors now requesting his work, and the Pennsylvania Academy sought to arrange a memorial show for the coming season, but Marjorie, overwhelmed by the task of decisions about the selection and pricing of paintings, put them off. She had lost weight during the final weeks of her husband's eight-month ordeal and went off with her sister Viv to Atlantic City for a rest. Unbeknown to her, two weeks before Henri's death she was diagnosed at the hospital as having uterine cervix cancer, but she was treated and listed as improved.

For Marjorie the studio at 10 Gramercy Park became Henri's memorial. During the following winter she filled her days by looking at his hundreds of oils and drawings. "It's been an immense job—," she observed on Christmas Eve, 1929, "but full of interest—seeing old canvases, long forgotten, and full of memories of times and things we did together—Bringing them back as though they only happened yesterday."[132] Yet by the next spring the job of marketing Henri's paintings was still undone and his wife finally confessed to Margery Ryerson that "This is all I have of him, and I can't bear to part with one of them. He left me more than enough money to live on so I have no need to sell them."[133] But such a stance did little to enhance Henri's reputation.

The artist's will provided that all of his nearly seventy thousand dollars in cash and securities, plus the unsold art, be left to his wife; he apparently reasoned that any provision for his brother was unnecessary.

Now Marjorie began complaining to Emma Bellows, as early as two months after Henri's death, about "This rheumatism of mine which comes and goes in various parts of my legs and arms It seems rotten luck, when I was so full of vim, vigor and vitality . . . to be stopped in what was going along at great speed—Destroying letters, etc.—Thousands of them—and really getting a start on things"[134]

By the spring of 1930 she had begun to walk with a slight limp. "As long as I don't have cancer I don't care what I have,"[135] she told Leon Kroll's wife, Yvette, but of course she did, and finally learned the truth from her doctor in May 1930. She died two months later, leaving the entire estate to her sister.

With Marjorie's passing, John Sloan began organizing the long-delayed letter-writing campaign urging the director of the Metropolitan Museum of Art to plan a comprehensive memorial show of Henri's art. Through his efforts the exhibit was agreed to, and from March 10 to April 19, 1931, seventy-eight Henri canvases were put on display. The earliest example was the *Woman in Manteau*, painted in Paris in 1898; the most recent, a group of Irish portraits from 1926. Two years before he died Henri had prepared a list of what he considered his best work "for an imaginary retrospective show," and his choices formed the basis for the exhibition. Sloan produced an etching of Henri, done from a drawing of him sketched thirty years before, which served as the frontispiece for the Metropolitan's catalog. Appropriately, Sloan wrote the introduction:

> . . . Robert Henri gave as much of his life to helping others to free self-expression as he gave to his own work. His thirty years of teaching were devoted to the emancipation of the art spirit in the United States. His work and his inspiration as a teacher were factors in

preparing for the earnest and growing interest in art which is so clearly in evidence in this young country today.[136]

The exhibit traveled from New York to Baltimore, where it closed in May 1931.

Three years later a tragic irony occurred. Henri's sister-in-law, living in his former studio and heir to his small fortune, determined that she would review the large cache of unsold paintings and destroy the ones of "inferior quality." Since Henri had produced some four thousand oils during his lifetime, his canvases would be more in demand, she reasoned, if there were fewer of them.

Throughout 1934 and again in 1937 and 1938, Violet Organ, with the help of her friend and former Henri student Lucie Bayard, destroyed an estimated five hundred fifty of his works that had been in the Gramercy Park apartment and at the Manhattan Storage Company. Among them were his portraits of Emma Goldman and Bernard Baruch, as well as many of the nudes. The canvases were slashed and ripped in order to fit them into the fireplace, and then were burned in the artist's own studio!

As the sole heir to the Henri estate, Violet was unprepared for the task of properly nurturing her brother-in-law's reputation during the Great Depression and beyond; for twenty-five years she had no dealer to promote him. Having somewhat of a talent for short stories, Viv toyed with the notion of authoring a biography, but in 1954, two and a half decades after Henri's death, she was still writing and rewriting limited segments of it on her aged Underwood typewriter.

Since 1954 Henri has had representation by New York art dealers: first the Hirschl & Adler Galleries, then Chapellier Galleries and later Berry-Hill, each contributing to a renewed interest in the artist and his work. During the 1960s and early 1970s Henri's nephew, John C. Le Clair, administered the estate from his home in Glen Gardner, New Jersey. (His widow, Janet Jacobsen Le Clair, is the heir today; she resides in the old Gramercy Park studio.) Jack often wholesaled Henri drawings for five and ten dollars apiece, yet despite this the increased visibility of paintings by Henri has caused them to greatly appreciate in value: Irish subjects that Le Clair sold for as little as a thousand dollars in the late 1960s regularly reach the mid and high five figures now, and a full-length canvas has already topped the half-million-dollar mark.

Within the past decade there have also been a growing number of exhibitions, including a Henri retrospective of one hundred canvases that toured five museums during 1984–85.

For some, Henri will always remain a teacher first, just as he was to the newspaper writer who concluded: "Robert Henri might have developed into America's greatest painter had he not chosen to become America's greatest art teacher."[137]

Yet the voice that uttered those classroom directives has long since been stilled; what remains today is his art, the tangible, living evidence of his hand. Perhaps at last Robert Henri's greatest wish will be realized: "I would like to be known for my paintings"[138]

APPENDIX I

THE TEACHINGS OF ROBERT HENRI:
THE ALICE KLAUBER MANUSCRIPT

ROBERT HENRI became one of this country's most influential art teachers by combining a willingness to impart his knowledge, philosophy and opinions with a classroom delivery that was both emotional and poignant.

In 1912 one of his students, Alice Klauber, transcribed Henri's critiques, lectures and reminiscences during a series of his classes. A similar record made by Margery Ryerson, another pupil who studied with him a few years later, was published in 1923 under the title *The Art Spirit*.

While there are some similarities in the two sets of classroom notes, the earlier version has the advantage of reflecting Henri's attitudes and ardor in the year prior to the Armory Show and before the outbreak of World War I.

The complete text of the Alice Klauber manuscript,† in the collection of the Klauber family, is presented here for the first time. To read these words, imagining them being articulated by Robert Henri before an assemblage of eager youth, provides some sense of his wide popularity in a day when most art teaching was far less dramatic and relevant.

ADVICE TO ART STUDENTS FROM ROBERT HENRI

Rembrandt was worthy of the beggar; Velasquez was worthy of the dwarf. He was even worthy of the king. What sympathy, what understanding; what understanding of the best possible side of the poor king! He was humble before the child. In him you always find what he liked. A something sad in the relation to humanity. In Goya you do not always find that he painted what he liked. He painted what impressed him most strongly. Greco did what he felt most deeply. It is not because they were such clever people or because they had such a sense of drawing; they were great, they were worthy of the best in themselves.

†A few fragmentary, now-incomprehensible passages have been omitted and a few obvious errors silently corrected.

You must get the principle of control over your faculties, over your sight, over your materials. A prejudice in favor of one thing is so valuable. Each person's valuation of things in this life is what we value. The beautiful thing is the thing created through an individual sight—the thing which to him is the sum of the whole. I like a prejudice. How valuable is a prejudice in favor of one thing. The great of the world were strong in prejudices. They each one had their incorruptible vision.

In knowing the great masters I have the benefit of other creative powers working through me to create things of my own. I do not wish to hand you my intelligence—I only wish to hand you my prejudices in order that you may discover yours. I want to see you expose them in your work. The more you express yourself, the more you make me live—the more you give everyone a heightened sense of life. Cultivate your individual vision. Don't think as I think, but think as you think and tell me as clearly as you can. And it is not easy to know what you see. If I can ever find out what my vision is, I shall produce a thing that could not be otherwise, a thing that will be a masterpiece.

A picture must be a complete organization. No part of the canvas must be vacant.

You must manage through your creative faculties to express your motives.

A thing is only beautiful when it is strong in its kind.

The head is one thing. You'd be surprised to see how little the features are needed if the head is right.

Every part should look as if a special palette were made for it.

Don't mean to reduce everything to rule, but express the feeling of co-related activity of muscle.

Background and head together produce a solid head, the background is the color you see when looking at the model's head with the greatest interest.

You must not paint like a copyist, but as a constructor in paints. In places of climax you must be severe—other places, nothing. Show your conception a limited appearance of the model. Paint but one prejudiced view. Study big direction. The eye never crosses the line, it must follow it. Sacrifice little things, ornaments to big subject in structure. Command materials so as to give the best you have to give. Forms are not a reproduction but a shorthand of Nature.

You must ascend to mastery of yourself and your material.

Produce a work, the thing the word opera means. The word composition has lost its good significance. Build a series of emotions with a climax. Wagner, Grieg, Beethoven were philosophers.

Underlying principles, not rules—underlying principles that leave the painter freer than ever before. That is my criticism of almost all painters and of almost all palettes—that they should be so that they seem to have been arranged for that model. Yet for each study a different arrangement. This prevents falling into conventions.

The arts and all of the sciences are means of recording the findings of those who seek and see beyond—of those not satisfied.

Of the masters, they did not put off; they said "To-day."

Imitation in art is like the barnyard symphony.

Be a master, not like anyone else, but like yourself. You were meant to be.

Get that equal to itself.

You can bear this ignorance and poverty because you have your ideals.

If troubled with dryness, brush over your canvas with water and let it dry before using it. To oil out a canvas, use turpentine, oil and water, equal proportions. If Mastic varnish has a bloom on it, take two ounces of turpentine and add enough sicatif† so as to feel the sicatif in the turpentine by putting your finger in it. Then take a smooth cloth without lint or a smooth piece of chamois and rub over the surface. To clean a dirty canvas use raw potatoes and wash off with water afterwards.

Any one of you may paint your masterpiece tomorrow if you will. The trouble is you are not working with the whole of your strength, with the whole of

your courage. You are using only a part of your faculties. You are not trying to express yourself—your own translation of that thing before you. You make up your mind the night before. You may even lie awake as I do and say to yourself, "I will do the thing to-morrow." Then you come here and you stand before your easel and you forget.

You don't will it hard enough! It it not the one thing any longer you care about, and you very soon niggle the old way and you put it off again and forever. Do it now. You have the technique—you have more of it than many who have painted the great things. Look at Whistler! In many ways he did not have the technique, so called, of many a clever student in the academies, but he had something to say and he painted great pictures.

Technique—real technique—is a thing of the mind, is a thing of the will. If you love the thing enough, if you feel it enough, you can do it. It takes imagination, it takes greatness.

You can apply the very same principles to life. Thousands of people have fine ideals, but see how they live! They use only a part of themselves and not their whole judgment. It's all a question of great judgment and then the will to do the best thing you know. Don't drop below that. Don't get discouraged. You can't afford that. Work all the time and save your studies. You can get more out of your own work than you can out of anyone else's. Respect yourself, respect your work. You have ability; you have the faculties; now have the will. That's all.

There are no rules. I give you no rules, I only want to help you.

We don't need any government or any churches, we need more imagination; more need to help and not to interfere; we need to think more. The people should be taught to think. Ferrer† believed that, and in Barcelona they killed him for it.

Wouldn't I be a better painter if I had to get up in the morning and dig potatoes for two hours? I certainly would, and I would be a better man.

Do the necessary that is beautiful.

Never change the direction of a line unless you have to; never change or break a curve.

Get your center of interest and hold to that. Everything else will be a little out of focus. In this foreground I feel too many little things. They disturb the eye. The same in the sky. One big, loose, simple cloud would be better.

You look too much at your model. Look and get the impression, then work a long time in a big way.

You've got a good thing. Now proceed carefully. Thousands of people can do a good thing up to a

†A dryer.

†Francisco Ferrer, Spanish educator who, beginning in 1901, founded over a hundred schools along libertarian lines.

certain point; but now you must use your very finest, your best judgment. In the next hour you need to do but three or four strokes; get away back and consider well what they shall be. You can make a great thing of that.

<hr/>

I don't care for drawing. I don't care for color; I don't care for composition, excepting as they serve me as servants, helping me to carry out my purpose which is not to do any of these things well, but to express myself when I see most truly and most simply.

<hr/>

The more definite the person is about where he is going, the better he can judge the right direction.

<hr/>

The speed that places a thing wrong is wrong speed. You are painting several different directions at once.

<hr/>

The trouble is we have so little time—let's do the thing now. It's a curious thing that the strength of youth is nearly always wasted. When a man grows as old as I he tries to exercise the strength that he had in his youth. I'm passé, as far as athletics are concerned, but I can do more because I won't waste my time.

I'd like to have the inexperience and innocence of youth because in youth you are free. Lack of freedom begins with your change from baby clothes. A man at twenty ought to have a good deal of his maiden originality. Most men at thirty are very set, respectable members of a very unrespectable society. They've lost all insight and they've lost all courage.

<hr/>

Too much the result of slavishly painting away, too little actual declaration—putting on a highlight is something like opening a window.

<hr/>

I rarely ever have been a good enough artist to finish as much as that.

<hr/>

Something of the power of seeing beyond the limitation should be conveyed in the landscape—something of the charm of the open road.

<hr/>

Whenever Sargent presents the spirit of a person and uses his technique for that he is great. Most of the imitators of his technique do not understand his mental attitude. They are far from successful portrait painters.

<hr/>

Hold yourself firmly to the subject in hand. Say, "This is my subject; I am to see the whole world, the secrets of Nature through this model.["] You ought to be able to paint the same person several times and get a great variety of results; yet all should be easily, deeply recognizable.

<hr/>

Don't get a certain way of making a nose or making an eye.

<hr/>

We, as artists, aren't concerned with getting before the world as persons who have said one good thing, but as persons who are worth hearing again and again, expressing new thoughts each time. Develop wits, not

technique—a mind full of various thoughts about various things—wit.

<hr/>

There are lots of true things that are not worth noting. Yours should be an important truth or it should be omitted.

<hr/>

Oh! People are more interesting! It isn't the dead, dull color of copying. It's an effort in the spirit of expression!

<hr/>

Use the shawl, use the hair to tell something about that gypsy! I learn through these the proud, fine creature she is.

<hr/>

Paint the hair in accord with the model's gesture—a symphony with other forms in the body, a history that is desirable. Choose the thing in accord with the past, present and the future of the model. If the accidents of the hair are painted without intention, it looks like hair in disorder. It looks out of relation and harmony unless it means something in accord with the model. Gestures of the hair can be taken in harmony with the person which will be an interesting expression of action, rather the humor of disorder than the awkwardness of it. Get the nature of the hair—its looseness, its stringiness, its beauty—certain movements in accord with the way it springs from its roots.

<hr/>

I am not dealing with your progress in art, but with your progress in yourself, because your progress in art is dependent on yourself.

<hr/>

People who can't be afraid, can't suffer or be happy or definite, might just as well be not alive; people who are not conscious that they are swallowing soup like a saw-mill.

<hr/>

People who are most easily embarrassed are people who require most of themselves. It springs from their demand of the highest in themselves. Some people say, "Is this worthy of me?" Whistler must have been wilful, generous—must have had all splendid play of emotions—easily disturbed, thrown off his balance. Also easily moved to great appreciation. Why, he must have been frightened when he started painting—the fright that made him feel the terrible necessity of all his power!

<hr/>

Zorn† was a bull, a "whoop" painter. The men that can't sense fear have no courage.

<hr/>

Reduce a thing to the simplest phrase possible.

<hr/>

Read Guy de Maupassant. He's a little immoral. You'll like him. Wicked enough to be interesting—frank, generous, strong, kind, appreciator of phases of life; makes you see as much in ten days as others in years. He's a master of wit, a literary descendant of Edgar Allan Poe.

<hr/>

Have a simple conception and express it simply.

<hr/>

†Anders Zorn, the Swedish painter, etcher and sculptor.

Manet was simpler than Velasquez, but Velasquez was a great man, a great originator! The original man has invariably taken and borrowed most from other men. The greatest taker of other people's goods is the greatest giver.

———

Painting in the Prado by Goya in blue dress, in about two colors, is a tremendously simple thing.

———

A wriggle is a good thing, but where it all wriggles there is no wriggle. A room that is all light has no light.

———

It's not the uncertainties of a person's head we are after. Just standing before a canvas, painting, I consider industrious idleness!

———

No artist gets anywhere without work.

———

I want first to see a color space. No detail until the beauty of big masses is shown. The decoration put into a house that hasn't been built would blow away—doesn't amount to anything! It is not necessary to paint finished.

———

Master work, the observation of big construction, is both drawing and color. Make first its building force, its construction. If this thing once gets you, you'll go sailing. You have a beautiful sense of color, memory of life, which you've shown many times.

———

A sense of light, same as a sense of color. Add the idea of form with the same color and it would be a hundred times more beautiful. The character you feel would be given expression, given body. When a thing is being finished, it's being put together. You may dump eyes, high lights, fractions of a face onto a canvas and it doesn't begin to be finished. Make fundamental, big things do everything that can be done with them to produce illusion of finely finished heads, instead of just adding details. It's terribly worthwhile, whether to use in your art or in your life. The grip—gathering yourself together.

Know how to begin. We want to finish features before starting from the ground up. An artist painting a picture has got to have the strength of his own will and Nature combined. An architect is forced by Nature to be reasonable, otherwise he'd be up in the air doing some ornamentation he is interested in. The secret of all master work is that its construction begins with big planes.

———

Landscape is a record of personal emotion. It lives, breathes, has feeling—passion in the sky—stone is a live thing—a tree grows, has life—active existence, suffers, draws its sap. I remember a tree of Courbet's in Philadelphia which takes hold of the ground, grows. A state is established between tree and the earth. The sun caresses people; they bask in it. Profound character lies in a strong sense of your points of view. It can be in the lightest subject. The slightest with interest produces gesture.

———

A picture is the result of one motive; everything has meaning. When interest ceases, it is like a conversation that wandered. You must feel that a garment wraps around the person. Make the onlooker's eye see what you wish him to see. All the muscles of the face connect with movement of the eyes. A big artist will make it look like sensation, sense of a human being—and yet be normal. Not hit you in the eye.

———

Shadow is absence of form, detail, difference in texture.

———

In a head, let the power find one place and be therein the dominating force.

———

Produce a sense of the solid severity of the form of the head. The shadow side of the head wants to produce the same form as the side of the head in light. No matter what the head's shape may be, there are factors in the shadow side to indicate what the large form of the head should be.

———

If you don't have knowledge of the normal while painting deviations in the model, your drawing will be thrown out, unless you recognize the importance or unimportance to you as you work.

———

The way to learn grammar is to express an intention. All the great educators have awakened a general suspicion that the best way to learn how to express grammatically is to have something to say. A person with the need to express will select with care his proper terms. When Doré† was a boy from five to seven, he did some of the best work he ever did. He never hit the mark any nearer. He had a necessity, a bent, a tendency and he jumped all the fences. He did in art what would be jumping over the moon to the average art professor.

Intention, motive, is the rare and difficult thing. Thousands of people have industry. Know what you've got to say about your model—know it so well that there will be no confusion, so that it will not be a discourse where the speaker is talking about a lot of things at once. The model is one of God's works. The good painters are not the people who can draw. Few have the rare and wonderful thing to say.

Poor Kenyon Cox! He has to take the place of Bouguereau,‡ you know. He is industrious but he has no wit, no will. He could draw wonderfully if he had anything to draw. Bouguereau could have done masterpieces, but he did sugar and plums. Bouguereau is popular with the weak; a man like Manet who comes with something strong, people say, "Out with this blasphemer!" Are you studying life or are you studying technique? Which interests you most?

———

Standing in front of an easel is not studying, it is perhaps work. You have to stop work to study. Set it up away from your easel.

———

A master in the school once told me that I must give

———

†Gustave Doré, the French illustrator and painter.
‡William-Adolphe Bouguereau, French academician and one of Henri's former teachers.

up my ideas and work for ten years to learn how to draw, and where would I have been then?

I have to fight for every common thing. These tables I have to fight for. I condemn the condition of your palettes. You want to keep it so as to do what you want to do, not be dependent on accident. You must have room for a big bunch of background, for a big bunch of each supply.

When you are on a diet you don't keep mince pie on the table.

First establish your palette so that the colors will produce the sensation of light and shade, of the cool and the warm in their play on each other.

Heads—When they are half way, they are no way at all. Give a lively intention in some way or other; don't be dull and dry. How does the model as an evidence of life impress you as an evidence of life?—This, tinged with a certain passion, is beautiful.

That, up there, what a slight thing it is and what a tremendous sensation! That could never have been done by one who had lived a long while in that place. That is the new, fresh idea of the raw American, seeing it for the first time.
People wrongly think that you have to know a person a very long time before you can paint him. It is very likely that the very best things you have to say about a person will be the first things you will find to say. Whenever you feel an interest, express that interest. Don't wait to know more. We want your sensation now, not eighty years from now.

There are times when you must walk straight and there are times when you may wobble. Integrity is not in being hard but in being precise at the right time.

There are many points of view, many ways of seeing things, all interesting. Some people feel a landscape and seem to compass the whole thing and never touch their feet to the ground. Some look at a landscape patched over with hills where he never sees the fields. Don't be called by man-made duty. Don't leave your own natural self. Your power of seeing the vital thing—to see what anybody can see.

Don't stop so long with the houses. Give us more of the expanse, more of your greatest activity of mind about it. It would have been better if you had caught the spirit of the movement of the road, not so much the actual, concise surveyor's incident of the road. The way the road makes the land, the way it draws the land. My criticism is against an obvious too-much-expected sort of thing. Ibsen is so great because his work is so full of surprises.

The very great thing in life is to pick out the thing important to you. Leave out the collections of things.

The thing to-day seems to be to cry as loud as you can and be as agreeable as you can, and I believe it will be better to be as agreeable as you can and to cry as loud as you can.

All I can hope to do for you is to incite you to do something for yourself—to create something. What it is, I can't guess. I'm eager to see.

American art can be produced just as well in Spain as New Jersey; if seen through American eyes, it is American art.

In trying to make it so much like life we are liable to see how far removed from life it is.

If you were a prizefighter, a fellow half your size and a fourth of your skill would whip you because he meant it.

There is an old woman sitting in the Forum at Rome. She's sitting there on a broken column, trying, trying to think what a relative of hers who had been there, whom she had met in childhood, said about this place. He was a learned man and travelled much, and he wrote beautifully about this. She would like to remember, too, some of the poetry she had read about it. But it won't come, and a chill is creeping up into her body from this dead column of the past, as she sits there, trying, trying to think what it was this man, this relative of her childhood had said. She has a Badaeker [sic] open on her lap and "Well, well, she'll go home and get *some* enjoyment out of the poetry which she will read over again and which will help her to appreciate the things she has seen."

The making of a good portrait is the use of intelligence of what is essentially the features of that person, the gesture to be painted. By that I mean the something that enables you to recognize your friends a block or two away.

If you have red and you put green next to it, each will make the other stronger. Then suppose you are on a brilliant street full of people and someone in the foreground is in red. She will make all the reds everywhere about her answer the note. You will not see the green, so much red being your key-note. In using the dominant you reduce the complement all through. Use your orange to serve you in the sight of blue. After you have taken all the common sense about color you can get, it's a principle rather than a set of laws. Its beauty comes of the right relation.

Whenever you find people who are not slaves to their palettes, who are rather painting the thing they see, you will find them more vigorous. Their individual power is more accurate.

Using Maratta colors should give greater liberty, greater freedom, more opportunity to draw instead of having all your time taken up in mixing paint. Suppose you go out and paint a sketch of a lot of houses and the effect is orange. You can paint it and almost record what you painted it with. You have done so little mixing. You could paint it with an orange or blue

palette just as you painted it with no fixed palette.

A palette is more open to varieties of action. In an orange palette look out for black—it will look blue. Suppose you are making a decoration and you want it in a yellow room. To put a sketch painted to melt into the wall, you make a yellow analogy of a certain strength; you must count twelve yellows to one orange. You could make a 1/3 analogy or a 1/5. I have peculiar sensations in changing from one palette to another. You are invited to the orange or blue oftener than to the yellow or green palettes.

There are hundreds of palettes. In taking orange, green and blue-green you have a chord. These above all used as red, yellow and blue. And from them you mix the others in that palette. The difficult thing is to see the colors when you are painting as you saw them when you liked the thing. You can't, in anything, do just what you saw. You've got to translate. Why, to paint a beautiful woman, must you always have a beautiful woman to paint? There is a vast difference when you get your impression and when you paint what is before you.

———

A model is a very poor mannequin of himself. I have had to paint my best portraits from memory, somewhat helped by the man who sat before me—an active, alert, businessman, keen and full of intelligence, will pose as a self-conscious, inert mass.

———

I feel like asking you to be more sure to get what you want. Hold yourself to it. Get at it! You can get it in half an hour if you will it enough!

———

Don't look at the model all the time. What spoils half of my painting is looking at the model. Look at the important thing for your idea. Do the rest without seeing it apart.

———

I'd like to see you get into a trance, if you could, over this woman. I'd like to see you carried away by her character. I've done something pretty good of her† but I didn't get her wonderful nature and her very foreign nature. I want you to feel the rich, foreign, warm nature of this woman. I feel her going away back to the ancient Egyptians.

———

It requires a sense of the cooperation of things to work their effect on the mind. The beautiful thing in art is the thing created in the mind.

———

Yours is the work of a professor, mine of an anxious student. Judgment is always subject to intuition.

———

Some day you'll come to the appreciation of how little time there is to deliver the goods. The thing we want is to be true to the nature and essence of the thing. Instead of going through to the essential things (which are the ideas which *only you* can arrive at), we give all the details which could be left to the wit of the other person.

———

†A reference to Henri's own painting of the model, a Gypsy mother.

When you begin to control color, you begin to get power. Work it in broadly, not broad brush strokes and broad color, but broad understanding. Drawing that is broad in its understanding, not in its physical utterance.

———

Art is an absolutely personal affair and independent of teaching and schools.

———

Use your own judgment to the limit and after exhausting all your power, call for your own help.

———

You must use wit in painting. One way of painting clothes to keep them down in importance is to paint the whole in lower value, remembering that the body is round; also the arms are round, with the light catching on one side, and that one arm is always more important than the other. You can't look at both with equal interest. The light and shadow on a body take big forms. Eliminate folds except those that are useful, and make the material look as if it would take folds. Make the lights and shadows that give the important shapes take big directions of the large lines.

———

An eyebrow depresses or uplifts because muscles pull up or down, also usually to make the turn of the skull over the eye. But dominating all these things is their indication of the state of the mind. An eyebrow to anyone wanting to represent life, represents the emotions, state of the mind. A thing is only beautiful as manifesting a state of mind, the temperament, the inside—an outer expression of the inside. You select, as an artist, that which will identify the meaning. Put down those things that will faithfully present the meaning.

———

Life studies usually lack declaration in character and color.

———

If you introduce new notes in a scale already established, it may spoil the head and make it look dirty.

———

Painting is a matter of composition, and relation of lights in different parts produces entirely different effects.

———

The telling of things must lead to some conclusion desirable to know.

———

A nude young girl in the light is a mystery. I wish to know and could understand the reason for my great pleasure—the thing that causes an activity in my mind, to understand what I see and feel, and be able to paint the sensation. The feeling that life is beautiful—to manifest my understanding. Then I might do it oftener!

———

Don't only paint a shell of a thing.

———

A soldier marches because something inside him organizes his sprightliness of movement in response to music.

———

Progress comes only through changes in the causes of painting.

———

My prize is to be given to one whose intention, when he draws, is to express some idea—to have a purpose—some thought about life.

⸻

One must understand a general kinship between people, of things and Nature. Things are related—that a flower is an organization akin to some people; that there is a state of mind, a temperament in the elements.

⸻

Get your pleasure through intense living. If you'd only put down things of value to you! Put down the things that express only that!

⸻

We want progression, not equalization. We must go beyond what we now are. Look at a thing and say "In what way does this thing express my fine feelings of this nature?" The person who loses his life, in speaking the important thing he thinks, has got his money's worth! I want to know what is the sum of all my knowledge and then express it—to reveal the thing I am capable of seeing. I want to implant in you courage and pride—the courage that fights! A person must dare to go down into his own nature to find the rare things there and express them. Art comes from strong, fearless natures. The beautiful thing I ask for is the original human evidence—the thing you have to give.

⸻

You must hold yourself firmly to the subject in hand. See the whole world through this model. Don't disregard the meaning of this model but be big enough to get the realization of the meaning of the person. We as artists are desirous of appearing as people with understanding—the power to demonstrate differences of meaning—not to have only one formula—but to have sense, active minds, new ideas at the sight of new things, and to invent technique to express them.

⸻

Have love of the sparkle of life; do the things that spring from the appreciation of the model.

⸻

Truth is a common, ordinary thing, but the thing that you say must be a *specific* truth—an important one.

⸻

Mushy heads are unsatisfactory.

⸻

I want to suggest to you the use of a table as a big instrument—a place to mix paint. Make an effort for the spirit of expression. Look for the meaning—what a thing signifies. Don't look for a red spot one inch from the eye, two inches west of the ear, but for the meaning it conveys to you of youth, health, beauty of a young girl—to express what you see in woman.

People are interesting as this woman is interesting, and she is an interesting woman! The way she sits in state and the elegance of the carriage. There was purpose back of doing this thing! I like the feeling of night. She carries it off well.

⸻

The head is weak in substance, but I like the way the red in the cheek goes into the eye—like the nose—all

the things are *used*. Rich, strong, powerful, beautiful! She is ready to destroy, brutal!

⸻

No use pointing out things except to say that there is in what I see the revelation of certain things that are desirable.

⸻

A person is beautiful to us as representing things we like—the sign of these things. Even to see frivolity balanced by integrity is beautiful. What a wonderful thing to think as Whistler did when he painted a certain mouth—the beauty of it, the dignity of it! The very things one would want to have attention called to! If you have no dominant idea, if only you are making a collection of disassociated things, you can't make a good thing.

⸻

Gustave Doré, as a boy, was clairvoyant because of his need. A person who has something to say will learn quickly, if he is young enough. You must have such a strong reason to paint a model that there will be no confusion in your picture, as though there were a lot of people talking at once! But the terms you use will only be applicable to what you have to say on the subject. Intention, motive, is the rare thing!

⸻

Men like Manet and Rodin have something great and serious to say—the full daring to express their ideas.

⸻

The machine as it's marching is making a commonplace crowd.

⸻

If art is to continue to enrich the world as in the past, artists must develop the richness of their natures. The things that spring from the strength of your nature, its great passions of life, must come into your work at last!

⸻

The one who studies technique to use some day when he may have something to say—the hunter after something that may be wanted—is like Mrs. Toodles and her door plate with "Thompson" printed on it, "cause some day her daughter might marry a man named Thompson who spelled it with a 'p.' " I only want words and technique to express *me*. I want to be a free, creative, active human being, who can forget yesterday's words to invent to-day's! Have a renaissance every day! Be still active and creative!

⸻

This painting lacks explosion; this other has too much.

⸻

A feeling of a man for a woman with a child in her arms. It passes beyond class and gets to the great human feeling—the real beautiful thing! The love of a mother for her child; something far beyond the incident of this mother and child—elements way beyond!

⸻

Study the edges—lost and found—humors of movement and hair. Never break a mass or bend a line until you have to. Never put anything on a canvas until you *have to*.

The way Old Masters used their masses produces illusion of things slipping together without actually slipping them; like the man who is making a statement—becomes so interested in tributary phrases that you lose the conclusion.

In painting the impression of a white shirt, you want to paint it white all over rather than insert too many colors when it is necessary to you as a white shirt.

I want you to go in very strong for the preservation of great big masses! A picture should look best from the middle of a room or any reasonable distance in a reasonable room. If you're apt to paint canvases a little dark, it's a good thing to turn your canvas a little from the light instead of using the bright light, the illumination being artificial to the painting.

There is no nature to me unless I understand.

You want to do what you want to do and not be controlled by your palette.

A thing could be all wrong excepting the principal thing and then it would be all right—like Rodin's "Eve."

Here's paint put on in a way that doesn't apologize in any way—has positive differences of color; the shapes are made to express living houses in the air enveloped in the same color of light. Form a complete organization—the painting wills that a certain sense of Nature shall be given! The sky looks as if seen by a living creature! An emotional sky. I can't get away from a rich, mysterious thought that excites my memories of landscapes, my intelligence! In the painting of those other houses I'm able to stop and criticize the architecture.

The value of your description of interesting things is in the richness of what they mean to you. How a man in the evidence of his life impresses you.

Some people draw a road as though they were plodding on it; some as though their feet touched occasionally, some stepping only at rest moments.

Pick out the beautiful wherever it is unexpected!

The sense of a place must be gotten if you have to paint it Nile green where it is pink!

Things are not the same all over; they accumulate at some center which *you illuminate.*

In composition it is demonstrated that where we *will* to have beauty, sensation of space and association of forms of life, we have these! There's a horrible curse hanging over art schools where the use of paint for personal demonstration is not allowed.

You can produce in a high key light and shade by the placing of cool color against warm.

In painting heads you must *use* the background; they often look like dead, empty spaces. They should be simple and have a get-out-of-the-way character.

You travel to foreign countries and say, "How wonderful! How beautiful the architecture is!" You paint it. Then you take your pictures home and wonder why people aren't more interested.

When I was a young man in Paris—lonely—working sometimes in hope, sometimes in despair, I had a view from my window of chimney pots in the snow—very moving, very different. It was a casement window. How I tried one day to paint it! I found it among my things many years after—a nice matching of chimney pots against snow! No notation of my sensations! My rich life filled with high hopes, questioning, doubting, hoping.

Only one reason to look out of the window—to see what one *wants* to see across it. The things across the street are only agents—they must express your emotions. Go out and get the emotions of all these things and express the emotions you have from these things. In the things that have self-expression, you feel that you had life open to you and a greater field of vision given to you.

The greater an artist is, the greater his prejudice in favor of the thing which he sees.

You don't look at a person to see action—but emotion!

You never get the eyes, nose and mouth to co-operate unless you make them for a certain purpose. Never get drapery unless you do it to express its beauty on a woman.

In making a graceful line, you must paint the grace of the mind back of it. The reason Franz Hals has been the upsetting of so many imitators is that they do not use his broad painting to express something. There's only a vulgar walloping when it doesn't reach a warm understanding of life.

In galleries you always stop in front of a thing that touches your heart rather than your mind.

Hals knew how the sculpture of the nose was made, when it turned under, and the other features as well; knew the normal and rational and put down the deviation. He shows deviation with such wit it is always interesting. You must show that you have a knowledge of the normal while painting any variations.

Each man needs what he needs, not what another needs.

All need common sense and a knowledge of the

normal. The good understanding of balance, rare in modern art; a sense of the relation of things to each other. Every one of the masters knew how a head is made—how the features are placed and the portrayal of character is the conscious marking of deviation.

One of the explanations of the great ability of Franz Hals was his knowledge of the normal. He was a greater master of paint to express life than Velasquez. Velasquez was a master of paint over temperament. In Velasquez we sometimes see his fatigue in his effort to make paint express what he wants, while with Hals he was always at top speed, able to make paint express life and form. He knew what form was, how a head was constructed and could put in simplest painting any variation from normal.

There was a distinct difference in temperament between Velasquez and Greco. He *could* put an eye in the top of a head and it *could* look like bad drawing; but with him this is not important as it is not what he was interested in. If Greco had not been an artist he would have destroyed half the things he did. You can study his great portraits of men and see in their hands and gestures the struggle and search and questioning into the great mystery of life.

The head is one thing.

You can see a person is mad by looking at the back of his neck. You can recognize a person three blocks away by the gesture—showing how much the big form is necessary to your sense of a thing.

Everything depends on your vision, your worthiness. To those who see comes the means of expression. Be worthy of yourself. Some see a hundred things instead of one.

The vital thing is a head with one big organization.

Velasquez looked for the thing loved. Goya looked both ways. Sometimes it would be his love of a child, sometimes you would hear the voice of a critic. Velasquez looked always for what he liked. You see his admiration for the dwarfs and his defense of them. In his "Surrender of Breda" you see he had as much sympathy and brother-feeling with the defeated as with the conqueror.

Art divides into two fields—one expressive of the human heart, the other sense of things; the other deals with material of things; both employ material and express through it, but any part of material can be kept silent or brought as the essential sign of a thing to be expressed.

The greater idea, the greater artist.

There can be expressed through the lightest things the most profound thought.

A true artist is not satisfied with things about right!

The struggle and work of individuals, their using their power to the utmost because the arts have always been the sense of recording what has been found, is as in music, art of interpretation rather than imitation. As in painting it is not the things you see but what you project from them.

You should organize to a certain force—must not wander away into facts of things rather than their sensation. In opposition to a collection of things assembled on a canvas, you want to produce an organization climaxing like an opera that builds to its climax a series of emotions.

Get Nature true to the nature of a place and of life rather than as it happens. You are neither an imitator nor a geographer.

The beautiful thing in art is the thing created by the mind. It requires a sense of the cooperation of things to work their effect on the mind.

Art is the thing; invention is the thing!

I want to represent the *idea* a thing in Nature declares to me, not the thing! The indication, which does not materialize Nature but brings back to one's mind what he cares about in Nature. Get the spirit and sense of the thing. Understand the attitude of life in general, not the description of things seen, but the use of them to express the relation of the person to them. It is not what you say but what that which you say springs from!

You should have great consideration, warmth, humility before life—the humility not of self-abnegation, but of self-assertion and in justification of self-assertion you must see more than the passing individual. You must reach down into the heart, find the deeper meaning of things. Have something of value to say to enrich humanity, some big thought!

Painting is not a realization of the thing itself but the expression of it!

I like it, its Dickens-like interest in the people and their life, the point of view of a lover and respecter of humanity. I meant a great deal when I said that it was Dickens-like. I didn't mean his errors but his sympathy with human beings.

At night there is always a sense of the solidity of things seen through a mist or fog. It's in the feeling, the manner of painting. Sometimes it's in the thickness and heaviness of paint.

Now listen a moment, please, all of you. I want to tell you something important. I want to ask you when you are working to take your studies away from your easels and hang them on the blank wall or take them into the other room. You can't keep a fresh eye for the life of the thing before you while you stand there by the hour working for it. The freshness of it, the sparkle of it, will disappear or it will divide into separate little things. I know what I'm talking about. You may take it from me!

APPENDIX II

A CHECKLIST OF PAINTINGS BY ROBERT HENRI
IN PUBLIC COLLECTIONS

ADDISON GALLERY OF AMERICAN ART, PHILLIPS ACADEMY, Andover, Massachusetts 01810
 1. *Mary* [Mary O'Donnel] (1913). Oil on canvas, 24" × 20".
AKRON ART INSTITUTE, Akron, Ohio 44308
 1. *Spanish Shepherd* (1912). Oil on canvas, 40" × 32½".
ALBRIGHT-KNOX ART GALLERY, Buffalo, New York 14222
 1. *Tam Gan* (1914). Oil on canvas, 24" × 20".
AMHERST COLLEGE, Amherst, Massachusetts 01002
 1. *On the East River* (1900–2). Oil on canvas, 26" × 32".
 2. *Salome* [Mademoiselle Voclezca] (1909–10). Oil on canvas, 77" × 37".
AMON CARTER MUSEUM, Fort Worth, Texas 76101
 1. *The White Schooner, Concarneau* (1899). Oil on wood panel, 5" × 6½".
 2. *Portrait of Jean McVitty* (1919). Oil on canvas, 24" × 20".
ARNOT ART MUSEUM, Elmira, New York 14901
 1. *Head of a Man* [The Stoker] (1910). Oil on canvas, 24" × 20".
THE ART INSTITUTE OF CHICAGO, Chicago, Illinois 60603
 1. *Young Woman in Black* [Jesseca Penn] (1902). Oil on canvas, 77" × 38½".
 2. *Himself* [John Cummings] (1913). Oil on canvas, 32¼" × 26⅛".
 3. *Herself* [Mrs. John Cummings] (1913). Oil on canvas, 32" × 26".
ATKINS MUSEUM OF FINE ARTS, WILLIAM ROCKHILL NELSON GALLERY OF ART, Kansas City, Missouri 64111
 1. *Portrait of an Irish Boy* [Thomas Cafferty] (1926). Oil on canvas, 24" × 22".
 2. *Girl in a Green Coat* (1927). Oil on canvas, 24" × 20".
THE BALTIMORE MUSEUM OF ART, Baltimore, Maryland 21218
 1. *The Red Shawl* [Betalo Rubino] (1909). Oil on canvas, 77" × 37".
 2. *Old Johnnie* [John Cummings] (1913). Oil on canvas, 24⅛" × 20⅜".
 3. *The Brown-eyed Boy* [Thomas Cafferty] (1926). Oil on canvas, 24" × 20".
MUSEUM OF FINE ARTS, BOSTON, Boston, Massachusetts 02115
 1. *Café Bleu, St. Cloud* (1895–96). Oil on wood panel, 3¼" × 6".
 2. *Sidewalk Café* (1899). Oil on canvas, 32¼" × 26".
 3. *Irish Girl* [Mary O'Donnel] (1913). Oil on canvas, 24" × 20".
 4. *Gypsy Girl* (1915). Oil on canvas, 24" × 20".
 5. *Thammy* (1915). Oil on canvas, 24" × 20".
 6. *Stephen Green* (1924). Oil on canvas, 24" × 20".

 7. *The Pink Ribbon* [Mary Anne Cafferty] (1927). Oil on canvas, 24" × 20".
BOWDOIN COLLEGE MUSEUM OF ART, Brunswick, Maine 04011
 1. *The Coal Breaker* (1902). Oil on canvas, 26" × 32".
THE BROOKLYN MUSEUM, Brooklyn, New York 11238
 1. *Woman in Manteau* (1898). Oil on canvas, 56¹¹/₁₆" × 28⁷/₁₆".
 2. *The Man Who Posed As Richelieu* (1898). Oil on canvas, 32" × 25⅝".
 3. *Laughing Girl* (1910). Oil on canvas, 24" × 20".
 4. *Portrait of Patricia Roberts* (1915). Oil on canvas, 24" × 20".
THE BUTLER INSTITUTE OF AMERICAN ART, Youngstown, Ohio 44502
 1. *The Little Dancer* (1916–18). Oil on canvas, 40½" × 32½".
CANAJOHARIE LIBRARY AND ART GALLERY, Canajoharie, New York 13317
 1. *Moira* (1924). Oil on canvas, 24" × 20".
CARNEGIE INSTITUTE MUSEUM OF ART, Pittsburgh, Pennsylvania 15213
 1. *The Equestrian* [Miss Waki Kaji] (1909). Oil on canvas, 77" × 37⅛".
CAROLINA ART ASSOCIATION, GIBBES ART GALLERY, Charleston, South Carolina 29401
 1. *Girl of Toledo*, Spain (1912). Oil on canvas, 41½" × 33".
CHRYSLER MUSEUM AT NORFOLK, Norfolk, Virginia 23510
 1. *Gypsy with Guitar* (1906). Oil on canvas, 78" × 37¾".
CINCINNATI ART MUSEUM, Cincinnati, Ohio 45202
 1. *Patience Serious* (1915). Oil on canvas, 23⅞" × 20".
 2. *Beatrice* [Beatrice Whittaker] (1919). Oil on canvas, 32⅛" × 25¹⁵/₁₆".
 3. *Agnes in Red* [Agnes Sleicher] (1921). Oil on canvas, 24" × 20¼".
THE COLUMBUS MUSEUM OF FINE ARTS, Columbus, Ohio 43215
 1. *Miss Jesseca Penn* (1907). Oil on canvas, 32" × 26".
 2. *Dancer in a Yellow Shawl* [Betalo Rubino] (1910). Oil on canvas, 42" × 33½".
CORCORAN GALLERY OF ART, Washington, D. C. 20006
 1. *John Sloan* (1904). Oil on canvas, 56½" × 41".
 2. *Indian Girl in White Ceremonial Blanket* [Julianita] (1917). Oil on canvas, 32" × 26".
 3. *Seated Nude* (1918). Oil on canvas, 32" × 26¼".
CORNELL UNIVERSITY, HERBERT F. JOHNSON MUSEUM OF ART, Ithaca, New York 14853
 1. *Portrait of Carl Sprinchorn* (1909). Oil on canvas, 24" × 20".

CROCKER ART MUSEUM, Sacramento, California 95814
1. *The Romany Girl* (1912). Oil on canvas, 24″ × 20″.
CUMMER GALLERY OF ART, Jacksonville, Florida 32204
1. *Guide to Croaghan* [Brien O'Malley] (1913). Oil on canvas, 41″ × 33″.
CURRIER GALLERY OF ART, Manchester, New Hampshire 03104
1. *Mary Anne with Her Basket* (1926). Oil on canvas, 23½″ × 19″.
DALLAS MUSEUM OF FINE ARTS, Dallas, Texas 75226
1. *Dutch Girl Laughing (Happy Hollander)* [Cori Peterson] (1907). Oil on canvas, 32″ × 26″.
DARTMOUTH COLLEGE MUSEUM & GALLERIES, Hanover, New Hampshire 03755
1. *Portrait of Captain H. G. Montgomery* (1921). Oil on canvas, 32″ × 26¼″.
DEERFIELD ACADEMY, Deerfield, Massachusetts 01342
1. *The Janitor's Daughter* (1913). Oil on canvas, 16″ × 12⅝″.
DELAWARE ART MUSEUM, Wilmington, Delaware 19806
1. *Old Brittany Farm Houses* (1902). Oil on canvas, 26″ × 32″.
2. *Little Girl of the Southwest* (1917). Oil on canvas, 24″ × 20″.
DENVER ART MUSEUM, Denver, Colorado 80204
1. *Au Jardin du Luxembourg* [In the Garden of the Luxembourg], 1899. Oil on canvas, 32″ × 25½″.
DES MOINES ART CENTER, Des Moines, Iowa 50312
1. *Ballet Girl in White* [Miss Zella] (1909). Oil on canvas, 77⅛″ × 37¼″.
THE DETROIT INSTITUTE OF ARTS, Detroit, Michigan 48202
1. *Boy and Rainbow* (1902). Oil on canvas, 26″ × 32″.
2. *Stormy Weather, Pennsylvania* (1902). Oil on wood panel, 8″ × 10″.
3. *The Beach Hat* [Marjorie Henri] (1914). Oil on canvas, 24″ × 20″.
4. *The Young Girl* [Edna Smith] (1915). Oil on canvas, 41″ × 33″.
EVERHART MUSEUM OF NATURAL HISTORY, SCIENCE AND ART, Scranton, Pennsylvania 18510
1. *Portrait of Miss Edith Reynolds* (1908). Oil on canvas, 57½″ × 38″.
EVERSON MUSEUM OF ART, Syracuse, New York 13202
1. *West Coast of Ireland* (1913). Oil on canvas, 26″ × 32″.
CHARLES AND EMMA FRYE ART MUSEUM, Seattle, Washington 98114
1. *El Picador* [Antonio Banos (Colero)] (1908). Oil on canvas, 87″ × 37″.
2. *The Stoker* (1910). Oil on canvas, 24″ × 20″.
GEORGIA MUSEUM OF ART, THE UNIVERSITY OF GEORGIA, Athens, Georgia 30602
1. *Sissy* (1924). Oil on canvas, 24″ × 20″.
THOMAS GILCREASE INSTITUTE OF AMERICAN HISTORY AND ART, Tulsa, Oklahoma 74127
1. *Gregorita* (1917). Oil on canvas, 36″ × 26″.
GRAND RAPIDS ART MUSEUM, Grand Rapids, Michigan 19503
1. *Portrait of Young Girl Wearing a Bonnet* [Gertrude Kaske] (1904). Oil on canvas, 23″ × 19½″.
HARVARD UNIVERSITY, FOGG ART MUSEUM, Cambridge, Massachusetts 02138
1. *Carleton Eldredge Noyes* (1903). Oil on canvas, 31¼″ × 25¼″.
2. *Portrait of Eakers* (1904). Oil on canvas, 29¼″ × 23¼″.
THE HIGH MUSEUM OF ART, Atlanta, Georgia 30309
1. *Lady in Black Velvet* [Mrs. Eulabee Dix Becker] (1911). Oil on canvas, 77″ × 37″.
2. *Kevin, an Irish Lad* (1928). Oil on canvas, 24″ × 20″.
HIRSHHORN MUSEUM AND SCULPTURE GARDEN, SMITHSONIAN INSTITUTION, Washington, D. C. 20560
1. *Normandie Interior* (1899). Oil on canvas, 25½″ × 32″.

2. *East River Embankment, Winter, New York* (1900). Oil on canvas, 25¾″ × 32″.
3. *Portrait of George Luks* (1902). Oil on canvas, 31½″ × 25½″.
4. *Woman in White* [Eugenie Stein] (1904). Oil on canvas, 77″ × 38″.
5. *Celestina* (1908). Oil on canvas, 24½″ × 20″.
6. *John Butler Yeats* (1909). Oil on canvas, 32″ × 26″.
7. *Girl in a Checkered Blouse* (1910). Oil on canvas, 24″ × 20″.
8. *Segovia Girl in Festival Costume* [La Montera] (1912). Oil on canvas, 32″ × 36″.
9. *Blind Singers* (1912). Oil on canvas, 33″ × 41″.
10. *Thomas Cafferty, a Fisherman's Son* (1925). Oil on canvas, 24″ × 20″.
THE MUSEUM OF FINE ARTS, HOUSTON, Houston, Texas 77005
1. *Antonio Banos* (1908). Oil on canvas, 33¾″ × 26⁄₁₆″.
2. *Manolita Marequis Bailarina* (1908). Oil on canvas, 31¾″ × 26⅛″.
HUNTER MUSEUM OF ART, Chattanooga, Tennessee 37403
1. *Woman in Pink on Beach* (1893). Oil on canvas, 18″ × 24″.
2. *Pet* [Wee Annie Lavelle] (1927). Oil on canvas, 24″ × 21″.
HUNTINGTON GALLERIES, Huntington, West Virginia 25701
1. *Kathleen* (1924). Oil on canvas, 24¼″ × 20¼″.
HUNTINGTON LIBRARY AND ART GALLERY, SCOTT COLLECTION, San Marino, California 91108
1. *Orientale* [Florence Short] (1915). Oil on canvas, 41″ × 33″.
INDIANA UNIVERSITY, Bloomington, Indiana 47401
1. *Edith Haworth* (1909). Oil on canvas, 31⁷⁄₁₆″ × 25″.
INDIANAPOLIS MUSEUM OF ART, Indianapolis, Indiana 46208
1. *Nude* [Grace Hoerger] (1911). Oil on canvas, 30″ × 24″.
2. *Scottish Girl with Japanese Wrap* [Edna Smith] (1915). Oil on canvas, 24″ × 20″.
3. *Maria and Baby* (1917). Oil on canvas, 32″ × 26″.
4. *Indian Girl* [Julianita] (1917). Oil on canvas, 32″ × 26″.
5. *Helen* (1919). Oil on canvas, 32″ × 26″.
JOSLYN ART MUSEUM, Omaha, Nebraska 68102
1. *Portrait of Fi* (1910). Oil on canvas, 24¼″ × 20⅛″.
THE UNIVERSITY OF KANSAS, HELEN FORESMAN SPENCER MUSEUM OF ART, Lawrence, Kansas 66045
1. *Laughing Girl* (1910). Oil on canvas, 24″ × 20″.
KEARNEY STATE COLLEGE, Kearney, Nebraska 68847
1. *Girl at Desk* (1900). Oil on canvas, 18″ × 12″.
LA SALLE COLLEGE, Philadelphia, Pennsylvania 19141
1. *Paris, Rain Clouds* (1902). Oil on canvas, 25¾″ × 32″.
LAUREN ROGERS LIBRARY AND MUSEUM OF ART, Laurel, Mississippi 39440
1. *The Brown Wrap* [Marjorie Henri] (1911). Oil on canvas, 32″ × 26″.
LEHIGH UNIVERSITY, Bethlehem, Pennsylvania 18015
1. *Café at Night, Paris* (1899). Oil on canvas, 32″ × 25½″.
LOS ANGELES COUNTY MUSEUM OF ART, Los Angeles, California 90036
1. *Edna* (1915). Oil on canvas, 34″ × 28″.
2. *Pepita of Santa Fe* (1917). Oil on canvas, 24″ × 20″.
3. *Portrait of Mrs.* [William Preston] *Harrison* (1925). Oil on canvas, 52″ × 40″.
MEMPHIS BROOKS MUSEUM OF ART, Memphis, Tennessee 38112
1. *Cori with Cat* [Cori Peterson] (1907). Oil on canvas, 24″ × 20″.
2. *Surf and Rocks* (1911). Oil on wood panel, 11¾″ × 15″.
THE METROPOLITAN MUSEUM OF ART, New York, New York 10028
1. *Paris Night* (1898). Oil on canvas, 25¾″ × 32″.
2. *Dutch Girl in White* (1907). Oil on canvas, 24″ × 20″.
3. *The Masquerade Dress: Portrait of Mrs. Robert Henri* (1911). Oil on canvas, 76½″ × 36¼″.

4. *The Spanish Gypsy* (1912). Oil on canvas, 41″ × 33″.
5. *Portrait of Mary Fanton Roberts* (1917). Oil on canvas, 32″ × 26″.
6. *John* [Hans Sleicher] (1921). Oil on canvas, 24″ × 20⅛″.

THE UNIVERSITY OF MIAMI, THE LOWE ART MUSEUM, Coral Gables, Florida 33146
1. *Tillie* (1917). Oil on canvas, 24″ × 20½″.

MILLIKIN UNIVERSITY, Decatur, Illinois 62522
1. *Indian Girl in Blue Wrap* [Gregorita] (1917). Oil on canvas, 32″ × 26″.

MILWAUKEE ART MUSEUM, Milwaukee, Wisconsin 53202
1. *Study for "Factories at Manayunk"* (1897). Oil on wood panel, 3³⁄₁₆″ × 6⅛″.
2. *Factories at Manayunk* (1897). Oil on canvas, 23¾″ × 32″.
3. *Street Corner* (1899). Oil on canvas, 32⅛″ × 26″.
4. *Wyoming Valley, Pa.* (1903). Oil on canvas, 26″ × 32″.
5. *The Art Student* [Josephine Nivison] (1906). Oil on canvas, 77¼″ × 38½″.
6. *Dutch Joe* [Jopie van Slouten] (1910). Oil on canvas, 24″ × 20³⁄₁₆″.
7. *The Rum* (1910). Oil on canvas, 24″ × 20¼″.
8. *Chinese Lady* (1914). Oil on canvas, 40½″ × 22½″.
9. *Betalo Nude* (1916). Oil on canvas, 41″ × 33″.

MINT MUSEUM OF ART, Charlotte, North Carolina 28207
1. *My Friend Brien* [Brien O'Malley] (1913). Oil on canvas, 41″ × 33″.
2. *Sarah Burke* (1925). Oil on canvas, 20″ × 24″.

MISSISSIPPI MUSEUM OF ART, MISSISSIPPI ART ASSOCIATION, Jackson, Mississippi 39205
1. *Jesseca Penn in Yellow Satin* (1907). Oil on canvas, 77″ × 37″.

THE MONTCLAIR ART MUSEUM, Montclair, New Jersey 07042
1. *Portrait of John Sloan* (1909). Oil on canvas, 24″ × 20″.
2. *Jimmie O'D* (1925). Oil on canvas, 24″ × 20″.

MONTGOMERY MUSEUM OF FINE ARTS, Montgomery, Alabama 36104
1. *Young Chevass* [Mary Anne Cafferty] (1925). Oil on canvas, 24″ × 20″.

MOUNT HOLYOKE COLLEGE, ART MUSEUM, South Hadley, Massachusetts 01075
1. *Girl in Pink* [Anne Lavelle] (1928). Oil on canvas, 28⅜″ × 20½″.

MUNSON-WILLIAMS-PROCTOR INSTITUTE, Utica, New York 13502
1. *Dutch Soldier* (1907). Oil on canvas, 32⅝″ × 26⅛″.

NATIONAL ACADEMY OF DESIGN, New York, New York 10028
1. *Girl in Blue, "Mata"* (1903). Oil on canvas, 32″ × 25½″.
2. *Elmer Schofield* (1903). Oil on canvas, 32″ × 26″.
3. *Charles Grafly* (1904). Oil on canvas, 32″ × 26″.
4. *Alexander Stirling Calder* (1910). Oil on canvas, 32½″ × 26″.
5. *George Bellows* (1911). Oil on canvas, 32″ × 26″.

NATIONAL COWBOY HALL OF FAME AND WESTERN HERITAGE CENTER, Oklahoma City, Oklahoma 73111
1. *La Trinidad* (1906). Oil on canvas, 76½″ × 38″.
2. *Tesuque Buck* [William Virgil] (1916). Oil on canvas, 24″ × 20″.

NATIONAL GALLERY OF ART, Washington, D.C. 20565
1. *Snow in New York* (1902). Oil on canvas, 32″ × 25¾″.
2. *Young Woman in White* [Eugenie Stein] (1904). Oil on canvas, 78¼″ × 38⅛″.
3. *Edith Reynolds* (1908). Oil on canvas, 78⅛″ × 37¼″.
4. *Volendam Street Scene* (1910). Oil on canvas, 20⅛″ × 24″.
5. *Catherine* (1913). Oil on canvas, 24″ × 20⅛″.

THE NATIONAL GALLERY OF CANADA, Ottawa K1A OM8, Canada
1. *Portrait of George Luks* (1904). Oil on canvas, 76½″ × 38¼″.

NATIONAL MUSEUM OF AMERICAN ART, SMITHSONIAN INSTITUTION, Washington, D.C. 20560
1. *Portrait of Dorothy Wagstaff* [Mrs. Edward W. C. Arnold] (1911). Oil on canvas, 77¼″ × 37¼″.
2. *Blind Spanish Singer* (1912). Oil on canvas, 41″ × 33⅛″.

THE UNIVERSITY OF NEBRASKA AT LINCOLN, SHELDON MEMORIAL ART GALLERY, Lincoln, Nebraska 68588
1. *Fourteenth of July—"La Place"* (1898). Oil on canvas, 32″ × 25¾″.
2. *Quay at Concarneau* (1899). Oil on canvas, 25¾″ × 32″.
3. *Boothbay Harbor* (1903). Oil on canvas, 26″ × 32″.
4. *Self Portrait* (1903). Oil on canvas, 32″ × 26″.
5. *Portrait of Richard H. Lee* [John J. Cozad] (1903). Oil on canvas, 32″ × 26″.
6. *Portrait of Frank L. Southrn, M.D.* [John A. Cozad] (1904). Oil on canvas, 32″ × 26″.
7. *Portrait of Edith Dimock* [Mrs. William J.] *Glackens* (1902–4). Oil on canvas, 76¾″ × 38⅜″.
8. *Portrait of William J. Glackens* (1904). Oil on canvas, 78″ × 38″.
9. *Maria y Consuelo* (1906). Oil on canvas, 78″ × 38″.
10. *Portrait of Mrs. Richard H. Lee* [Mrs. John J. Cozad] (1914). Oil on canvas, 32″ × 26″.
11. *Old Spaniard* (1924). Oil on canvas, 32″ × 26″.
12. *The Pink Pinafore* [Mary Anne Cafferty] (1926). Oil on canvas, 24″ × 20″.

THE NEWARK MUSEUM, Newark, New Jersey 07101
1. *Portrait of Willie Gee* (1904). Oil on canvas, 31¾″ × 26¼″.
2. *Portrait of Mary Gallagher* (1924). Oil on canvas, 24″ × 20″.

THE NEW BRITAIN MUSEUM OF AMERICAN ART, New Britain, Connecticut 06052
1. *Head of a Woman* (1894). Oil on canvas, 24″ × 20″.
2. *Notre Dame and the Seine* (1900). Oil on wood panel, 6″ × 9″.
3. *Spanish Girl of Segovia* (1918). Oil on canvas, 40″ × 32″.
4. *An Imaginative Boy* [Tom Cafferty] (1922). Oil on canvas, 23½″ × 15½″.

MUSEUM OF NEW MEXICO, Santa Fe, New Mexico 87503
1. *Portrait of Dieguito Roybal—Po-Tse-Nu-Tsa of San Ildefonso, N.M.* (1916). Oil on canvas, 45″ × 40⅛″.

UNIVERSITY OF NEW MEXICO, UNIVERSITY ART MUSEUM, Albuquerque, New Mexico 87131
1. *Ricardo* (1916). Oil on canvas, 24″ × 20″.

NEW ORLEANS MUSEUM OF ART, New Orleans, Louisiana 70179
1. *Laughing Spanish Gypsy Child* [Cinco Centimo] (1908). Oil on canvas, 24″ × 20″.
2. *The Blue Kimona* [Miss Waki Kaji] (1909). Oil on canvas, 77″ × 37″.

THE NEW YORK PUBLIC LIBRARY, New York, New York 10018
1. *Portrait of Ivah Wills* [Mrs. Charles] *Coburn as Rosalinda in "As You Like it"* (1912). Oil on canvas, 77″ × 37″.

THE UNIVERSITY OF NORTH CAROLINA AT GREENSBORO, WEATHERSPOON ART GALLERY, Greensboro, North Carolina 27412
1. *Portrait of a Child in Red* (1896). Oil on canvas, 23⅝″ × 17⅞″.
2. *Wind Blown Trees* (1899). Oil on canvas, 26″ × 32″.
3. *Nude* [Emma Webb] (1916). Oil on canvas, 32″ × 26″.

NORTON GALLERY & SCHOOL OF ART, West Palm Beach, Florida 33401
1. *Portrait of a Boy* [Sonny Mac] (1926). Oil on canvas, 24″ × 20″.

OBERLIN COLLEGE, ALLEN MEMORIAL ART MUSEUM, Oberlin, Ohio 44074
1. *The Gypsy Girl* [Barbina] (1912). Oil on canvas, 24″ × 20⅛″.

MUSÉE D'ORSAY, 75007 Paris, France
1. *La Neige* [The Snow] (1899). Oil on canvas, 26″ × 32″.

THE PARRISH ART MUSEUM, Southampton, New York 11968
1. *Lady in Black* [Portrait of Linda Henri] (1904). Oil on canvas, 78¾″ × 38½″.

THE PENNSYLVANIA ACADEMY OF THE FINE ARTS, Philadelphia, Pennsylvania 19102
1. *Girl with Fan* [Betalo Rubino] (1910). Oil on canvas, 72″ × 50″.
2. *Ruth St. Denis in the Peacock Dance* (1919). Oil on canvas, 85″ × 49″.
3. *Wee Maureen* (1926). Oil on canvas, 24″ × 20″.

THE PENNSYLVANIA STATE UNIVERSITY, MUSEUM OF ART, University Park, Pennsylvania 16802
1. *Sansom Street, Philadelphia* (1897). Oil on canvas, 32″ × 26″.

PHILADELPHIA MUSEUM OF ART, Philadelphia, Pennsylvania 19101
1. *Boulevard—Wet Weather, Paris* (1899). Oil on canvas, 25⅞″ × 32⅛″.

THE PHILLIPS COLLECTION, Washington, D.C. 20009
1. *Little Dutch Girl* (1910). Oil on canvas, 24″ × 20″.

PHOENIX ART MUSEUM, Phoenix, Arizona 85004
1. *Beach at Atlantic City* (1893). Oil on canvas, 11¾″ × 17½″.
2. *The Laundress* (1916). Oil on canvas, 36″ × 29″.
3. *Indian Girl of Santa Clara* (1917). Oil on canvas, 32″ × 26″.

PRINCETON UNIVERSITY, THE ART MUSEUM, Princeton, New Jersey 08540
1. *Mildred Clarke von Kienbusch* (1914). Oil on canvas, 24″ × 20″.

RANDOLPH-MACON WOMAN'S COLLEGE, Lynchburg, Virginia 24503
1. *Tom* [Tom Cafferty] (1926). Oil on canvas, 24″ × 20″.

RHODE ISLAND SCHOOL OF DESIGN, MUSEUM OF ART, Providence, Rhode Island 02903
1. *Mary with the Red Ribbon* [Mary O'Malley] (1926). Oil on canvas, 24″ × 20″.

JOHN AND MABLE RINGLING MUSEUM OF ART, Sarasota, Florida 33578
1. *Salome (No. 2)* [Mademoiselle Voclezca] (1909). Oil on canvas, 77″ × 37″.

UNIVERSITY OF ROCHESTER, MEMORIAL ART GALLERY, Rochester, New York 14607
1. *Tom Cafferty* (1924). Oil on canvas, 24″ × 20″.

THE ST. LOUIS ART MUSEUM, St. Louis, Missouri 63130
1. *Portrait of Carl Gustave Waldeck* (1896). Oil on canvas, 55½″ × 39¾″.
2. *Betalo Rubino, Dramatic Dancer* (1915–16). Oil on canvas, 77″ × 37″.

SAN DIEGO MUSEUM OF ART, San Diego, California 92112
1. *Portrait of Mrs. Robert Henri* (1914). Oil on canvas, 24″ × 20″.
2. *Mukie* (1914). Oil on canvas, 25″ × 20″.
3. *Bernadita* (1922). Oil on canvas, 24¼″ × 20⅜″.

THE FINE ARTS MUSEUMS OF SAN FRANCISCO, San Francisco, California 94118
1. *Portrait of Marjorie Henri* (1910). Oil on canvas, 77″ × 37″.

SANTA BARBARA MUSEUM OF ART, Santa Barbara, California 93101
1. *Summer Evening, North River* (1902). Oil on canvas, 26″ × 32″.

SCRIPPS COLLEGE, LANG ART GALLERY, Claremont, California 91711
1. *Jimmy* (1921). Oil on canvas, 22″ × 17⅛″.

SEATTLE ART MUSEUM, Seattle, Washington 98102
1. *Portrait of Margaret Gove* (1909). Oil on canvas, 24″ × 20″.

THE ARTS COUNCIL OF SPARTANBURG COUNTY, Spartanburg, South Carolina 29301
1. *Girl with Red Hair* [Bertha Morelle] (1903). Oil on canvas, 32″ × 26″.

THE J. B. SPEED ART MUSEUM, Louisville, Kentucky 40208
1. *Machu* (1914). Oil on canvas, 24″ × 20″.

TACOMA ART MUSEUM, Tacoma, Washington 98402
1. *Jesseca Penn in Brown* (1907). Oil on canvas, 31″ × 25″.

THE TATE GALLERY, London SW1P 4RG, England
1. *Breton Market Scene* (1899). Oil on wood panel (recto), 6¼″ × 8⅜″.
2. *Sailing Boats in a Bay* (1899). Oil on wood panel (verso), 6¼″ × 8⅜″.

TELFAIR ACADEMY OF ARTS & SCIENCE, Savannah, Georgia 31401
1. *La Madrilenita* (1910). Oil on canvas, 41″ × 33″.

TERRA MUSEUM OF AMERICAN ART, Chicago, Illinois 68611
1. *Figure in Motion* (1913). Oil on canvas, 77″ × 37″.

THE UNIVERSITY OF TEXAS AT AUSTIN, ARCHER M. HUNTINGTON ART GALLERY, Austin, Texas 78712
1. *East River, Snow* (1900). Oil on canvas, 25¼″ × 32″.
2. *The Big Hat* (1903). Oil on canvas, 28⅛″ × 23⅛″.
3. *The Old Model* (1912). Oil on canvas, 23¹⁵⁄₁₆″ × 20¹⁄₁₆″.

THE TOLEDO MUSEUM OF ART, Toledo, Ohio 43697
1. *Cathedral Woods* (1911). Oil on canvas, 32″ × 26″.

HARRY S TRUMAN LIBRARY AND MUSEUM, Independence, Missouri 64050
1. *Fisherman's Boy* [Denny] (1926). Oil on canvas, 24½″ × 20¼″.

VASSAR COLLEGE, Poughkeepsie, New York 12601
1. *Rue de Rennes* (1899). Oil on canvas, 25⅝″ × 32″.
2. *Summer Storm* (1921). Oil on canvas, 26″ × 32″.

VIRGINIA MUSEUM OF FINE ARTS, Richmond, Virginia 23221
1. *Martche with Hat* (1907). Oil on canvas, 32″ × 26″.

WALKER ART CENTER, Minneapolis, Minnesota 55403
1. *Big Rock and Sea* (1903). Oil on wood panel, 7½″ × 9½″.

WASHINGTON COUNTY MUSEUM OF FINE ARTS, Hagerstown, Maryland 21740
1. *Michael* (1913). Oil on canvas, 18″ × 14″.

WASHINGTON STATE UNIVERSITY MUSEUM OF ART, Pullman, Washington 99164
1. *Mercedes* (1908). Oil on canvas, 24″ × 19½″.

THE WESTMORELAND COUNTY MUSEUM OF ART, Greensburg, Pennsylvania 15601
1. *Picnic at Meshoppen, Pa., July 4, 1902* (1902). Oil on canvas, 26″ × 32″.
2. *Dutch Fisherman* (1907). Oil on canvas, 24″ × 20″.
3. *Madre Gitana* (1912). Oil on canvas, 41″ × 33″.

THE WHITE HOUSE, Washington, D.C. 20500
1. *Gypsy Girl with Flowers* [Patience] (1915). Oil on canvas, 24″ × 20″.

WHITNEY MUSEUM OF AMERICAN ART, New York, New York 10021
1. *Blackwell's Island, East River* (1901). Oil on canvas, 20″ × 24″.
2. *Storm Tide* (1903). Oil on canvas, 26″ × 32″.
3. *Laughing Child* [Cori Peterson] (1907). Oil on canvas, 24″ × 20″.
4. *Sammy and His Mother* (1915). Oil on canvas, 32″ × 26″.
5. *Gertrude Vanderbilt Whitney* (1915–16). Oil on canvas, 50″ × 72″.
6. *Portrait of Tillie* (1917). Oil on canvas, 24″ × 20″.

THE WICHITA ART MUSEUM, Wichita, Kansas 67203
1. *Twilight on the Seine* (1896). Oil on canvas, 25¼″ × 31½″.
2. *Eva Green* (1907). Oil on canvas, 24⅛″ × 20³⁄₁₆″.

WILLIAMS COLLEGE MUSEUM OF ART, Williamstown, Massachusetts 01267
1. *Breaking Storm, Monhegan* [Cloud Effect—White Head] (1903). Oil on wood panel, 8″ × 10″.

YALE UNIVERSITY ART GALLERY, New Haven, Connecticut 06520
1. *West 57th Street, New York* (1902). Oil on canvas, 26″ × 32″.
2. *Little Girl* (1928). Oil on canvas, 33½″ × 25½″.
3. *Johnnie Manning* (1928). Oil on canvas, 28⅜″ × 20⅛″.

APPENDIX III

CHRONOLOGY OF ROBERT HENRI'S
LIFE AND ART

1865 *June 24.* Born Robert Henry Cozad in Cincinnati, Ohio.

1868-72 Lives in Cozaddale, Ohio, a town founded by his father.

1872 Enrolls in Cincinnati Public Schools.

1874-76 Summers spent in Cozad, Nebraska, another community established by his father.

1875 *Fall.* Enrolls in the Chickering Classical and Scientific Institute, Cincinnati; becomes interested in writing.

1876 *Fall.* Continues at Chickering.

1877 Writes a school play.

1879 *Summer.* Henri and family move to Cozad. Prints posters to attract settlers; begins keeping a diary and illustrating his *Runty Papers* with comic figures and decorative letters.

1880 *Summer.* Placed in charge of his father's hay press at Cozad.

1880-81 Does not attend school; tutored by his mother.

1881 *August.* Henri and family move to Denver; father engages in real estate.
September. Enrolls in Denver Public Schools.

1882 *October.* Henri's father shoots one of his employees; the man dies.
December. His father is indicted for murder; an arrest warrant is issued.

1883 Family assumes new identities; Robert Henry Cozad becomes Robert Earle Henri, later drops his middle name.
Fall. Placed in boarding school in New York City; parents settle in Atlantic City.

1884 Joins parents. Decorates his scrap books with pen-and-ink caricatures and drawings inspired by *Puck* and *Harper's Weekly.*

November. Produces his first painting, using dry colors mixed with beer.

1885 Purchases his first art book and set of oil paints.
March. Encouraged to study art by James Albert Cathcart.

1886 *October.* Enrolls at the Pennsylvania Academy of the Fine Arts, Philadelphia; fellow classmates include A. Stirling Calder and Edward W. Redfield. Studies under Thomas Anshutz, Thomas Hovenden and James B. Kelly; organizes a sketch class at the Academy. Lives with his brother in a boardinghouse at 1009 Vine Street.

1887 *January.* Helps organize a portrait class and another sketch class at the Academy.
Summer. Sketches and decorates clam shells in Atlantic City.
Fall. Pennsylvania Academy; enrolls in life class with Calder, Redfield, Charles Grafly and others. Gives first art lessons, to a neighbor in Atlantic City.
November. Moves with his brother to a boarding house at 2107 Arch Street, Philadelphia.

1888 *May.* Exhibits with fellow students of the Pennsylvania Academy antique and life classes; first press notice of his work.
Summer. In Atlantic City, painting beach scenes and portraits.
Fall. Sails for Paris with Grafly, William Haefeker, Harry Finney and James Fisher. Lives at 12 avenue Richerand; enrolls at Académie Julian, studying with William-Adolphe Bouguereau and Tony Robert-Fleury.

Continues at Julian's through 1891.

1889 *Spring.* Fails to gain admittance to École des Beaux-Arts. Visits Paris Exposition Universelle Internationale; impressed by Eiffel Tower and Javanese ballet.
April. Moves with Fisher to 72 rue Mazarine. Enrolls in a class taught by François Fleming.
Summer. To Concarneau in Brittany.
September. Visits Pont-Aven with Redfield; stays at Marie-Jeanne Gloanec's *pension*, Gauguin's meeting place.
Fall. Moves with Fisher to 12 rue de Seine, Paris.
December. Visits Brolles.

1890 *Spring.* To Barbizon; then enrolls in an evening class with Paul-Louis Delance in Paris.
June. To St.-Nazaire; visits Toulon, Marseilles.
Fall. To Monte Carlo, Rome, Florence.

1891 *January.* Returns to Paris; resides at 1 rue de Bourbon-le-Château.
February. Admitted to the École des Beaux-Arts.
March. To Brolles with Redfield and artist-naturalist Ernest Thompson Seton. Returns to Julian's; studies with Gabriel Ferrier.
May. Views Monet paintings at Durand-Ruel Galleries; to Venice with Redfield.
September. Returns to Paris, then leaves for the U.S. Lives with his brother and sister-in-law at 628 North Sixteenth Street, Philadelphia.

1892 *January.* Enrolls in portrait classes at Pennsylvania Acad-

emy; studies under Anshutz, Kelly and Robert Vonnoh.

Summer. In Atlantic City.

September. Begins teaching at the School of Design for Women, Philadelphia; instructs there through 1895. Awarded a scholarship to continue his studies at the Academy. Moves into studio at 806 Walnut Street.

December. Charles Grafly studio party, meets John Sloan.

Winter. Decorates the Chapel of Our Lady, Church of the Evangelists, Philadelphia, with three murals.

1893 *March.* Founding member of the Charcoal Club; elected its president.

May. Begins his own summer school at Darby Creek, Pennsylvania.

July. Teaches in Avalon, New Jersey.

Summer. Two of his mural studies are exhibited at the Chicago World's Fair.

September. Shares studio at 806 Walnut Street with Sloan and Joseph Laub; begins Tuesday-evening discussion group. Scholarship to the Academy; studies under Anshutz and Henry Thouron.

Fall. Begins full schedule of teaching at the School of Design for Women; instructs in portrait painting, composition and drawing from the antique.

October. Beisen Kubota, Japanese artist, demonstrates ink technique in his studio.

1894 *June.* Conducts private art class at Fisher's Station near Philadelphia.

Summer. To Concarneau with writer Eustace Lee Florance.

September. Returns to Philadelphia; shares studio at 806 Walnut Street with Sloan and Laub, then moves to 1717 Chestnut Street. Shares studio with William Glackens.

December. Production of *Twillbe* at the Academy; Henri plays Svengali.

1895 *Summer.* To Paris with Glackens, Grafly and Elmer Schofield. Bicycles through Holland and Belgium with Glackens, Schofield; impressed by Frans Hals's paintings. Meets Canadian artist James Wilson Morrice.

Winter. Organizes Paris art class, which meets in his studio for weekly critiques.

1896 *February.* To London to view a Velázquez exhibition.

April. First acceptance in the Champ-de-Mars Salon, Paris.

June. Instructs a private art class at Moret-sur-Loing, near Paris.

August. Trip through Germany and Italy with his brother.

Fall. Organizes an art class at 9 rue des Fourneaux, Paris.

December. Views Manet retrospective at Durand-Ruel Galleries.

1897 *May.* To Normandy, paints at Vétheuil on the Seine.

July. Paris.

September. Returns to Philadelphia.

October. First one-man show, Pennsylvania Academy of the Fine Arts.

November. One-man show arranged by William Merritt Chase at the Chase School of Art, New York. Formation of private art class at 806 Walnut Street; later sublets Anshutz' studio for this purpose.

December. Exhibits at the Macbeth Gallery, New York.

1898 *Spring.* First acceptance of his work in the National Academy of Design Annual exhibit, New York.

June. Marries Linda Craige of Philadelphia; honeymoon and subsequent stay in Paris, at 49 boulevard Montparnasse.

Fall. Finances cause him to organize a new art class.

November. Produces his first monotypes; to Brolles.

1899 *February.* Paints *La Neige* (The Snow).

April. *La Neige* and three other works accepted in Champ-de-Mars Salon.

May. To Concarneau.

June. *La Neige* purchased for the Musée National du Luxembourg, Paris.

September. To Alford, a Paris suburb; resides near the Edward Redfields.

1900 *January.* Forms private art class in Paris; critiques class held at the American Students' Club.

April. Trip to Madrid; copies Velázquez paintings in the Prado.

June. Returns to Paris.

August. Returns to U.S.; settles in New York, begins painting scenes of the East River.

Fall. Commences teaching at the Veltin School, New York; instructs there through 1902.

1901 *April.* Organizes group show at The Allan Gallery, including work by himself, Sloan, Glackens, Alfred Maurer and three others.

June. Rents studio in the Sherwood Building, Fifty-seventh Street and Sixth Avenue.

Summer. Awarded his first prize, a Silver Medal at the Pan-American Exposition, Buffalo.

1902 *March.* One-man show at the Macbeth Gallery.

April. Plans an exhibit of "The Four": himself, Glackens, Davies and George Luks; it does not materialize.

June. To Black Walnut, Pennsylvania, to join his wife.

July. Returns to New York.

October. Begins teaching at the New York School of Art, the former Chase School; continues as instructor there through 1908.

Fall. Publication of the romantic novel *Edges* by Alice Woods, purportedly about Henri and his fellow artists.

November. Second one-man show at the Pennsylvania Academy.

December. One-man show, Pratt Institute, Brooklyn.

1903 *April.* Elected to the Society of American Artists.

June. To Boothbay Harbor and Monhegan Island, Maine, with Redfield.

October. Returns to New York.

1904 *January.* *Girl in White Waist* purchased by the Carnegie Institute, Pittsburgh, his first sale to a U.S. museum. Organizes group show at the National Arts Club; work by himself, Sloan, Glackens, Luks, Davies and Maurice Prendergast.

May. Produces his only etching, from a Paris street-scene sketch. Wins Silver Medal for *Young Woman in Black* at the Louisiana Purchase Exposition, St. Louis.

June. Teaches at the New York School of Art's summer school at Bayport, Long Island.

Summer. To Cooperstown, New York, for portrait commissions.

1905 *April.* Elected an Associate member of the National Academy of Design.

Summer. Teaches at the New York School of Art's summer school at Bayport, Long Island.

October. *Lady in Black* awarded the Norman W. Harris Prize

at the Art Institute of Chicago.

November. Wife Linda becomes ill, dies the following month.

1906 *January.* Member of committee that recommends the amalgamation of the Society of American Artists with the National Academy of Design.

February. Exhibits at the Modern Art Gallery with Sloan, Glackens, Luks, Everett Shinn and Ernest Lawson.

March. Serves on the jury for the final Society of American Artists Annual exhibition; to Aiken, South Carolina, for a portrait commission.

May. Elected an Academician by the National Academy of Design.

Summer. Teaches a New York School of Art class in Madrid.

October. Moves to the Beaux Arts Studio building, Fortieth Street and Sixth Avenue, New York.

December. Serves on the National Academy of Design's Winter Annual jury. Father dies.

1907 *March.* Serves on Academy's Spring Annual jury; withdraws two of his paintings during the judging. He, Sloan and Glackens discuss the advisability of a split exhibition from the Academy.

April. Meets with Sloan, Glackens, Luks, Davies and Lawson to further discuss plans for an exhibit.

May. Henri announces formation of "The Eight"; includes those who attended April meeting plus Shinn and Prendergast.

June–August. To Holland with New York School of Art class; paints in Haarlem, Volendam, Amsterdam.

August. To England for a portrait commission.

October. Returns to New York; moves to 135 East Fortieth Street.

Fall. Discusses plans for a large gallery featuring independent exhibitions; the scheme does not materialize at this time.

1908 *January.* National Arts Club exhibit includes all of The Eight.

February. Exhibition of The Eight at the Macbeth Gallery.

March. The Eight show opens at the Pennsylvania Academy.

May. Marries Marjorie Organ of New York.

June. Sails with New York School of Art class to Spain; summer in Madrid.

September. The Eight traveling show opens at the Art Institute of Chicago; tours seven other cities through June 1909.

December. Resigns from the New York School of Art faculty over unpaid salary.

1909 *January.* Opens the Henri School of Art in the Lincoln Arcade, Broadway and Sixty-sixth Street; teaches there through 1912.

May. He, Sloan and Davies consider locations for a permanent gallery in New York.

August. Begins painting with the color theories and palette arrangement developed by Hardesty G. Maratta.

October. *The Blue Kimona* is awarded the Philadelphia Art Club's Gold Medal; moves to 10 Gramercy Park South, his New York residence for the next twenty years.

Fall. He and Sloan renew interest in an exhibition plan.

1910 *March.* Rejection of his full-length portraits, *Salome* and *Lady in Yellow*, from the National Academy Annual results in the Exhibition of Independent Artists.

April. Exhibition of Independent Artists held at 29–31 West Thirty-fifth Street, New York; 103 artists exhibit 631 works.

June. *Willie Gee* is awarded a Silver Medal at the International Fine Arts Exposition, Buenos Aires. Secretly relinquishes ownership of the Henri School to his student, Homer Boss; continues providing classroom critiques.

Summer. Holland and Spain.

1911 *January.* Organizes an Independent Show for the Carnegie Library Gallery in Columbus, Ohio; works censored.

March. Declines invitation to exhibit in Rockwell Kent Independent show; organizes an exhibition at the Union League of New York.

May. Presents a year-round, jury-free, artist-organized exhibition plan to the MacDowell Club of New York.

August. Monhegan Island, Maine with George Bellows and Randall Davey.

October. Returns to New York.

November. Begins instruction at The Modern School of the Ferrer Society; teaches there through 1916. Included in first group show at the MacDowell Club.

December. Invited to join the Association of American Painters and Sculptors, the group that was to sponsor the Armory Show of 1913.

1912 *Winter.* Included in record number of exhibits in New York, Chicago, Boston, Philadelphia, Baltimore and other cities.

April. Teaches his last class at the Henri School.

June–August. In Spain with art class from his former school.

September. To Paris; visits the Autumn Salon and Gertrude Stein.

October. Returns to New York; preoccupied with nursing his mother back to health.

1913 *January.* Attends meeting of the Association of American Painters and Sculptors, in preparation for the Armory Show.

February. Armory Show opens in New York; Henri represented by five works.

June. Sails with Marjorie for Ireland; settles on Achill Island, in the former home of Captain Boycott.

September. Returns to New York.

1914 *February.* Awarded the Carol Beck Gold Medal at the Pennsylvania Academy for his portrait *Herself.*

June. To San Diego and La Jolla, California; serves as coordinator to plan an art exhibit for the forthcoming Panama-California Exposition in San Diego.

October. Returns to New York.

1915 *January.* Participates in Panama-California Exposition in San Diego and the Pan-Pacific Exposition in San Francisco; awarded a Silver Medal at the latter.

May. Submits his ideal exhibition scheme to New York's Department of Parks.

July. Ogunquit, Maine, with Marjorie, George and Emma Bellows.

October. Begins teaching portraiture and composition at the Art Students League of New York; continues instruction and lectures there through 1927.

1916 *March.* Helps plan The Forum Exhibition of Modern American Painters with Alfred Stieglitz and others.
July. Santa Fe.

1917 *Summer.* Returns to Santa Fe; serves as adviser for the new museum there.
Fall. Crusades for the City of Philadelphia to establish a permanent gallery for the works of Thomas Eakins.
Winter. Begins studying Jay Hambidge's theory of Dynamic Symmetry.

1918 *August.* Monhegan Island, Maine.

1919 *May.* Participates in the final group show at the MacDowell Club.
Summer. Serves on the committee that organizes a Contemporary American Art Exhibition for the Musée National du Luxembourg, Paris; portrait commissions in Lake Forest, Illinois, and Falmouth, Massachusetts.

Fall. Founding member of The New Society of Artists, New York.

1920 *April.* Awarded portrait prize at the Wilmington Society of Fine Arts for his painting *Jean.*

1921 *Summer.* Woodstock, New York, with Marjorie, George and Emma Bellows, Eugene and Elsie Speicher and Leon Kroll.
Fall. Publication of *Robert Henri: His Life and Works* by William Yarrow and Louis Bouché.

1922 Publication of *Robert Henri* by Nathaniel Pousette-Dart.
Summer. Los Angeles and Santa Fe, portrait commissions at the former.

1923 *July.* To Paris.
August. Madrid; remains through April of the following year.
Fall. Publication of *The Art Spirit,* edited by Margery Ryerson.

1924 *Spring and summer.* Achill Island, Ireland.
November. Returns to New York.

1925 *February.* To Los Angeles.
Spring. New York.
June–October. Ireland.
October through spring of the following year. New York.

1926 *May–June.* Spain.
July–November. Ireland.
December through spring of the following year. New York.

1927 *May–October.* Ireland.
November through spring of the following year. New York.

1928 *May–September.* Ireland; returns to New York, is admitted to St. Luke's Hospital.

1929 *January.* *The Wee Woman* awarded the Temple Gold Medal at the Pennsylvania Academy.
Spring. Selected one of the top three living American artists in a poll by the Arts Council of New York.
July 12. Dies of cancer at St. Luke's Hospital.

1931 *March 9–April 19.* Robert Henri Memorial Exhibition, Metropolitan Museum of Art, New York.

NOTES

Abbreviations:
AAA = Archives of American Art
DAM = John Sloan Archives, Helen Farr Sloan Library, Delaware Art Museum
Yale = Collection of American Literature, Beinecke Rare Book and Manuscript Library, Yale University

Chapter 1: Family Ties

1. Theresa Gatewood Cozad diary, 1874, n.p.

Chapter 2: Growing Up in the West

1. Theresa Gatewood Cozad diary.
2. Theresa Gatewood Cozad notebook (Yale).
3. Theresa Gatewood Cozad diary.
4. Robert Henry Cozad scrapbook, 1876.
5. Notation by Robert Henry Cozad in his mother's scrapbook, n.d. [1876-77].
6. Robert Henry Cozad diary, Sept. 15, 1880.
7. *Same*, Sept. 20, 1880.

Chapter 3: Murder and a New Life

1. Letter to the author from Dora Scrutchfield, granddaughter of Alfred Pearson, March 21, 1978.
2. The State of Nebraska vs. John J. Cozad, Indictment for Murder, Dec. 9, 1882, Dawson County, *District Court Journal*, vol. 1, p. 400.
3. Violet Organ, "Robert Henri," unpublished biography, p. 11.
4. J. P. Glass, "The Finding of Robert Henri," ("Discoveries of Genius") (Republic Syndicate, n.d. [1925]). Henri scrapbook.
5. Letter from Robert Henri to Thelma Anthony, n.d. (Yale).
6. "How a Milkman Started Robert Henri on His Career," *St. Louis Post-Dispatch*, Aug. 25, 1929.
7. Robert Henri record book, 1885.

Chapter 4: Student Days in Philadelphia

1. Robert Henri, *The Art Spirit* (Philadelphia, 1923), p. 87.
2. Henri letter to his parents, Feb. 17, 1887.
3. *Same.*
4. Henri diary, Nov. 10, 1886.
5. *Same*, Jan. 24, 1887.
6. *Same*, Nov. 16, 1886.
7. *Same*, Nov. 17, 1886.
8. *Same*, Feb. 17, 1887.
9. *Same*, Dec. 1, 1886.
10. *Same*, Jan. 14, 1887.
11. *Same*, Jan. 25, 1887.
12. *Same*, Dec. 28, 1886.
13. *Same*, Nov. 29, 1886.
14. *Same*, Feb. 7, 1887.
15. *Same*, Jan. 1, 1887.
16. *Same*, March 22, 1887.
17. *Same*, April 7, 1887.
18. *Same*, March 6, 1887.
19. *Same*, April 18, 1887.
20. *Same*, Summer, 1887.
21. *Same*, Oct.-Dec., 1887.
22. *Same.*
23. Henri notes, Dec. 2, 1887 (Yale).
24. Henri diary, March 11, 1888.
25. *Same*, Oct.-Dec., 1887.
26. *Same*, March 27, 1888.
27. *Same*, April 7, 1888.
28. *Same.*
29. "Life & Antique," *Philadelphia Call*, May 10, 1888.
30. "Academy Students' Exhibition," *Philadelphia Public Ledger*, May 10, 1888.

Chapter 5: An American in Paris

1. Henri diary, Sept. 20, 1888; Henri notes, Sept. 21, 1888.
2. Henri diary, Sept. 23, 1888.
3. Robert Henri, *The Art Spirit*, p. 22.
4. Henri letter to his parents, Oct. 26, 1888 (Yale).
5. Henri diary, Oct. 1, 1888.
6. Charles Grafly diary, Nov. 22, 1888.
7. Draft of Henri letter to his parents, n.d. [Jan. 1888].
8. "Philadelphians Won Honors in Paris," newspaper article, unidentified publication, n.d. [Jan. 1889], Henri scrapbook.
9. Document contained in the Henri dossier, Musée d'Orsay, Paris.
10. Henri letter to his parents, March 20, 1889.
11. Henri diary, June 5, 1889.
12. *Same*, April 25, 1889.

Chapter 6: Impressionism and Venice

1. Robert Henri, "Nude in Art," manuscript, n.d. [1890s].
2. Henri letter to his parents, Sept. 16, 1889.
3. "The Storm's Ruin," *The Philadelphia Record*, Sept. 13, 1889.
4. Martine Herold, "The Académie Julian Is One Hundred Years Old," unidentified publication, n.d. [1968], p. 2. Collection, Bibliothèque Historique de la Ville de Paris.
5. Henri letter to his parents, Dec. 14, 1889 (Yale).
6. Henri diary, Dec. 23, 1889.
7. Henri letter to his parents, March 30, 1890, as quoted in Violet Organ, "Robert Henri: Journal of Student Days," unpublished manuscript, p. 87.
8. Henri diary, March 30, 1890.
9. *Same*, May 24, 1890.
10. *Same*, March 23, 1890.
11. *Same*, July 24, 1890.
12. *Same*, July 22, 1890.
13. Letter to the author from Edward W. Redfield, Sept. 8, 1956.
14. Henri letter to his parents, July 4, 1890 (Yale).
15. Henri diary, Oct. 22, 1890.
16. *Same*, Jan. 20, 1891.
17. *Same*, April 1, 1891.

18. *Same*, April 8, 1891.
19. *Same*, March 2, 1891.
20. *Same*.
21. Ellwood Parry, *The Image of The Indian and The Black Man in American Art*, (New York, 1974), p. 163.
22. Henri letter to his parents, March 5, 1891 (Yale).
23. *Same*.
24. *Same*, Feb. 23, 1891.
25. *Same*.
26. *Same*, March 21, 1891.
27. Henri letter to his parents, Sept. 1, 1889 (Yale).
28. Henri diary, Feb. 23, 1891.
29. Letter to the author from Edward W. Redfield, Sept. 8, 1956.
30. Henri letter to his parents, Aug. 31, 1891 (Yale).
31. Henri diary, Sept. 12, 1891.

Chapter 7: Return to America

1. Henri letter to his parents, n.d. [1892], as recorded in Violet Organ, "Robert Henri," unpublished biography, p. 36.
2. Letter to Henri from Frank Southrn, Nov. 12, 1891.
3. "Bisbing's Great Work," *Philadelphia Item*, Feb. 14, 1892.
4. "Pictures at the Academy," *Philadelphia Times*, Jan. 21, 1892.
5. "Home Impressionists," *Philadelphia Times*, Feb. 14, 1892.
6. Henri letter to William Haefeker, Feb. 14, 1892 (Yale).
7. Letter to Henri from Edward W. Redfield, n.d. [1892] (Yale).
8. Henri letter to his parents, March 6, 1892 (Yale).
9. Letter to Henri from Ernest Thompson Seton, Jan. 7, 1892 (Yale).
10. "The Philadelphia School of Design for Women," announcement, 1892–93, p. 7.
11. *Same*, 1894–95, p. 6.
12. Letter to Henri from William Haefeker, Sept. 18, 1890 (Yale).
13. *Philadelphia Times*, May 31, 1894.
14. *Same*, no date [ca. 1894], Henri scrapbook.
15. Conversation with F. R. Gruger, Sept. 8, 1952.
16. "Charcoal Club," *Philadelphia Times*, April 8, 1893.
17. Henri's Charcoal Club notes, June 1893.
18. *Same*.
19. Henri letter to Charles Grafly, n.d. [April 1893] (Yale).
20. Letter to Henri from Milton Bancroft, Pennsylvania Academy, June 5, 1893 (Yale).
21. Henri letter to his parents, July 2, 1893 (Yale).
22. Henri diary, April 30, 1890.
23. Statement to the author by Harriet Sartain, May 29, 1956.
24. "Local Art. Decoration of a Chapel in the Church of the Evangelists," *Philadelphia Inquirer*, April 1893. Henri scrapbook.
25. "World's Fair Art Show," *Philadelphia Record*, Jan. 15, 1893.
26. *Chicago Tribune*, May 11, 1893.
27. Henri letter to Charles R. Harley, April 8, 1894 (Yale).
28. William Morris Hunt, *Talks on Art* (Boston, 1884), pp. 79, 81, 3, 11, 29.
29. George Moore, *Modern Painting* (New York, 1893), p. 78.
30. *Same*, p. 118.
31. Newspaper article, unidentified publication, n.d. Henri scrapbook.
32. Thomas Anshutz letter to his wife, Oct. 18, 1893 (Anshutz letters, AAA).
33. Thomas Anshutz letter from Paris to his brother Edward, 1893 (Anshutz letters, AAA).
34. "The Students of the Academy," newspaper article, unidentified publication, March 5, 1894. Henri scrapbook.
35. Henri diary, April 9, 1894 (Yale).
36. *Same*, April 13, 1894 (Yale).
37. *Same*, April 4, 1894 (Yale).
38. "The Academy Stag," newspaper article, unidentified publication, n.d. Henri scrapbook.

Chapter 8: Abroad Again

1. The address of the studio has often appeared as 1919 Chestnut Street, an error first recorded in Yarrow and Bouché's *Robert Henri, His Life and Works* (1921). However, Henri's diary, his mother's diary and the faculty records of the Philadelphia School of Design for Women indicate that 1717 is the correct address.

2. Henri letter to Charles R. Harley, April 8, 1894 (Yale).
3. *Same*.
4. Henri diary, Fall, 1894 (Yale).
5. "A Philadelphia Girl Mystifies The Art World by a Unique Technique in Water Colors," newspaper article, unidentified publication, n.d. Henri scrapbook.
6. Letter to Henri from M. Adele Hess, Jan. 18, 1895 (Yale).
7. Letter to Henri from Ernest Thompson Seton, May 17, 1895 (Yale).
8. Henri letter to his parents, June 16, 1895.
9. Léonce Bénédite, "Harpignies," *Gazette des Beaux Arts*, 13 (1917), p. 207.
10. William Morris Hunt, *Talks on Art* (Boston, 1884), p. 27.
11. Henri manuscript, 1896, n.p.
12. Henri letter to his parents, June 19, 1896.
13. *Same*.
14. Henri diary, Jan. 25, 1897.
15. Henri letter to his parents, Feb. 17, 1897.

Chapter 9: Marriage and Exhibitions

1. "Champ De Mars Vernissage," *New York Herald*, April 24, 1897.
2. Henri letter to his parents, Sept. 1897 (Yale).
3. *Same*.
4. Henri diary, Aug. 22, 1896. Violet Organ notes.
5. *Same*.
6. "The Academy," *Philadelphia Item*, Oct. 20, 1897.
7. "Art Notes," *Philadelphia Inquirer*, Oct. 24, 1897.
8. "Interesting Pictures," *Philadelphia Record*, Oct. 25, 1897.
9. "A New Painter," *Philadelphia Ledger*, Oct. 25, 1897.
10. "Robert Henri," *Philadelphia Item*, Oct. 23, 1897.
11. Violet Organ, "Robert Henri," unpublished biography, p. 47.
12. "Robert Henri," *Philadelphia Item*, Oct. 23, 1897.
13. Henri letter to his parents, Dec. 1, 1897 (Yale).
14. *New York Commercial Advertiser*, Dec. 9, 1897.
15. *New York Times*, Dec. 9, 1897.
16. *New York Evening Sun*, Dec. 11, 1897.
17. Henri letter to his parents, Feb. 1898. Violet Organ notes.
18. Henri letter to his parents, Nov. 1897 (Yale).
19. *Same*, Feb. 5, 1898.
20. *Same*.
21. Conversation with Emma Bellows, Jan. 25, 1957.
22. "A Brown Study; Why Mr. Henri Objected," newspaper article, unidentified publication, n.d. [Jan. 1898]. Henri scrapbook.
23. Letter to Henri from William Glackens, Jan. 22, 1898 (Yale).
24. Henri letter to his parents, Feb. 23, 1898 (Yale).
25. *Same*, April 18, 1898 (Yale).
26. *Same*, April 30, 1898 (Yale).
27. *Same*, June 4, 1898, as quoted in Organ, p. 49.
28. Letter to Linda Henri from her mother, n.d. [1898].
29. *Same*, June 20, 1898.
30. Linda Craige Henri notes, n.d. (Yale).
31. Letter to Linda Henri from Elizabeth Perookes, n.d. [1898].
32. Henri letter to his parents, July 24, 1898, as quoted in Organ, p. 30.
33. Henri letter to his parents, Oct. 12, 1898.
34. Henri letter to John Sloan, Oct. 14, 1898 (DAM).
35. Henri letter to his parents, Oct. 10, 1898. Violet Organ notes.
36. Henri diary, Dec. 12, 1898.
37. Henri letter to his parents, Dec. 11, 1898. Violet Organ notes.
38. *Same*, Dec. 19, 1898.
39. *Same*, June 1899, as quoted in Organ, p. 55.
40. *Same*.
41. Henri letter to William Macbeth, July 14, 1899 (Macbeth Papers, AAA).
42. Letter to Henri from Thomas Anshutz, n.d. [1899].
43. Henri letter to his parents, Aug. 29, 1899.
44. Henri diary, Sept. 17, 1899.
45. Linda Henri letter to her parents, Dec. 16, 1899.
46. Letter from Lydia Longacre to her father, Jan. 18, 1900.
47. Linda Henri letter to her parents, Feb. 6, 1900.
48. Henri letter to his parents, Feb. 9, 1900 (Yale).
49. Anne Coffin Hanson, *Edouard Manet* (Philadelphia, 1966), p. 95.
50. R. A. M. Stevenson, *Velasquez* (London, 1900), p. 42.

Chapter 10: The New York Scene

1. "Studies of Street Scenes. Robert Henri Will Portray Life in This City," *New York Mail & Express*, Feb. 6, 1901.
2. Talcott Williams, "Art and Artists," *Philadelphia Press*, Oct. 7, 1900.
3. Henri diary, Jan. 1901.
4. Henri letter to John Sloan, April 6, 1901 (DAM).
5. *Same.*
6. "Art Notes," *New York Evening Sun*, April 11, 1901.
7. Henri letter to his parents, Oct. 7, 1901 (Yale).
8. *Same*, Oct. 24, 1901 (Yale).
9. Henri diary, Oct. 29, 1901.
10. Henri letter to his parents, April 3, 1902 (Yale).
11. Henri diary, Jan. 2, 1902.
12. "Pictures by Robert Henri," *New York Times*, April 9, 1902.
13. *New York Mail & Express*, April 8, 1902.
14. *Brooklyn Eagle*, April 4, 1902.
15. *New York Tribune*, April 5, 1902.
16. *New York Commercial Advertiser*, April 4, 1902.
17. Charles FitzGerald, "Mr. Robert Henri and Some 'Translators,'" *New York Evening Sun*, April 8, 1902.
18. Henri diary, April 12, 1902.
19. Letter to Robert Henri from Linda Henri, Feb. 17, 1902.
20. *Same*, Feb. 1902.
21. *Same.*
22. *Same.*
23. *Same*, [Feb.] 1902.
24. Charles FitzGerald, "The Society of American Artists—II," *New York Evening Sun*, April 7, 1902.
25. Henri letter to his parents, April 3, 1902 (Yale).

Chapter 11: The Artist–Teacher's Following

1. Henri diary, April 14, 1902.
2. Conversation with Everett Shinn, Sept. 12, 1952.
3. Henri diary, Nov. 13, 1902.
4. Newspaper clipping, n.d., Henri scrapbook.
5. Alice Woods, *Edges* (Indianapolis, 1902), p. 16.
6. "Robert Henri," *Philadelphia Item*, Sept. 22, 1897.
7. Guy Pène du Bois, *Artists Say the Silliest Things* (New York, 1940), p. 86.
8. Walter Tittle diary, 1902, p. 7 (Wittenberg University Library).
9. C. K. Chatterton, "There Never Was a School Like It," unpublished article, p. 5.
10. Conversation with Edward Hopper, June 3, 1962.
11. Walter Tittle diary, Nov. 13, 1902 (Walter Tittle Papers, AAA).
12. "What Is Art Anyhow?" *New York American*, Dec. 1, 1907.
13. Conversation with Frances Cranmer Greenman, March 19, 1978.
14. Henri diary, Nov. 7, 1902.
15. Robert Henri, *The Art Spirit* (Philadelphia, 1923), p. 112.
16. Talcott Williams, "Art and Artists," *Philadelphia Press*, n.d. [1902].
17. Riter Fitzgerald, "Robert Henri's Works," *Philadelphia Item*, Dec. 1902.
18. Letter to Henri from Joseph F. A. Jackson, Nov. 27, 1902 (Yale).
19. *New York Press*, Jan. 19, 1903.
20. Henri Pène du Bois, "Sage Paintings at the Society," *New York American*, March 28, 1903.
21. Charles FitzGerald, "The Last Picture-Shows of the Season," *New York Evening Sun*, April 23, 1903.
22. *New York Mail & Express*, n.d., Henri scrapbook.
23. "The Oldest Thing in Art," *Town Topics*, 49 (April 2, 1903), p. 19.
24. Chatterton, "There Never Was a School Like It," p. 2.
25. Henri, *The Art Spirit*, p. 17.
26. du Bois, *Artists Say the Silliest Things*, p. 86.
27. Letter from Kenneth Hays Miller to Irma Ferry Miller, Dec. 15, 1902 (AAA).
28. Henri, *The Art Spirit*, p. 255.
29. Letter to Henri from Edward W. Redfield, April 24, 1903 (Yale).
30. Henri letter to his parents, July 12, 1903.
31. Henri letter to John Sloan, Sept. 5, 1903.
32. Rockwell Kent, *It's Me O Lord* (New York, 1955), p. 81.
33. Newspaper article, unidentified publication, n.d. Henri scrapbook.
34. Henri address to the School of Design for Women, Philadelphia, March 29, 1901.
35. Ralph Waldo Emerson, *Essays* (New York, n.d.), p. 14.
36. Walter Tittle diary, Jan. 21, 1903 (Walter Tittle Papers, AAA).
37. *Same.*
38. Henri, *The Art Spirit*, p. 158.
39. Guy Pène du Bois, *New York American*, Jan. 10, 1904.
40. Charles FitzGerald, "In Praise of the Academy," *New York Evening Sun*, Jan. 4, 1904.
41. Letter to Henri from Patrick Henry Bruce, March 23, 1904 (Yale).
42. Charles De Kay, "Six Impressionists. Startling Works by Red-Hot American Painters," *New York Times*, Jan. 20, 1904.
43. "Six Painters in a Club Show," *New York Mail & Express*, Jan. 25, 1904.
44. Henri letter to Helen W. Henderson, Secretary, Pennsylvania Academy, Jan. 19, 1904 (Pennsylvania Academy Archives).
45. "Paintings Worth Seeing and Some Others," *New York Evening Telegram*, Jan. 21, 1904.
46. Arthur Hoeber, "Art and Artists. A Most Lugubrious Show at the National Club," *New York Commercial Advertiser*, Jan. 20, 1904.
47. De Kay, *op cit.*
48. Henri postcard to Luks, n.d. [Jan. 1904] (Yale).
49. John Sloan notes, 1949, p. 10.
50. "About Exhibitions," *St. Cloud* (Minnesota) *Times*, April 7, 1904.
51. Board Minutes, Art Students League, Jan. 20, 1904.
52. Letter to Henri from the New York School of Art, April 1904 (Yale).
53. Conversation with Walter Pach, Sept. 5, 1952.
54. Henri diary, June 3, 1904.
55. Rockwell Kent Papers (AAA).
56. Conversation with Helen Appleton Read, July 9, 1956.
57. Conversation with Carl Sprinchorn, July 16, 1956.
58. George Bellows, "Introduction," *The Art Spirit* by Robert Henri (New York, 1923), p. vi.
59. Vachel Lindsay diary, Jan. 1905, as quoted in Edgar Lee Masters, *Vachel Lindsay: A Poet in America* (New York, 1935), p. 120.
60. Letter to Henri from Vachel Lindsay, March 21, 1905 (Yale).
61. *Same*, April 7, 1905 (Yale).
62. Henri diary, Dec. 5, 1904.
63. Charles FitzGerald, "Certain Painters at the Society," *New York Evening Sun*, April 1, 1905.
64. Letter to Henri from Clyde H. Burroughs, Assistant Director, Detroit Museum of Art, Jan. 9, 1905 (Yale).
65. Henri letter to Harrison S. Morris, Dec. 10, 1904 (Pennsylvania Academy Archives).
66. Henri Pène du Bois, "Academy Hangs Its Prize Paintings for the Public," *New York American*, Dec. 31, 1904.

Chapter 12: Tragedy and a New Beginning

1. Letter to Henri from Edward W. Redfield, Oct. 22, 1905 (Yale).
2. Henri letter to Edward W. Redfield, Oct. 23, 1905 (Yale).
3. Henri Pène du Bois, *New York American*, Oct. 29, 1905.
4. Henri letter to John Sloan, Nov. 30, 1905.
5. Theresa Lee diary [Henri's mother], Dec. 8, 1906.
6. Henri letter to J. E. D. Trask, Managing Director, Pennsylvania Academy, Dec. 15, 1906 (Pennsylvania Academy Archives).
7. "Only out of Home's Narrow Confines Is Full Growth Possible for Children, Says Robert Henri," *New York Tribune*, Jan. 15, 1915.
8. Letter to Henri from Jo Nivison, Feb. 15, 1921 (Yale).
9. Henri letter to John Sloan, April 3, 1906.
10. *Same*, April 5, 1906 (DAM).
11. Henri letter to John Sloan, n.d. [April 1906].
12. Henri letter to his parents, March 30, 1906 (Yale).
13. Henri letter to John Sloan, April 5, 1906 (DAM).
14. Henri letter to John and Dolly Sloan, March 17, 1906.
15. Charles FitzGerald, "The Society of American Artists—II," *New York Evening Sun*, April 5, 1902.
16. John Sloan diary, March 8, 1906.

17. James William Pattison, "Robert Henri—Painter," *The House Beautiful*, XX (Aug. 1906), p. 19.
18. Henri diary, May 9, 1906.
19. Letter from Dean Babcock to his mother, June 9, 1906.
20. Henri letter to his parents, July 8, 1906 (Yale).
21. *Same*, July 28, 1906 (Yale).
22. *Same*, Aug. 7, 1906 (Yale).
23. *Same*, July 28, 1906 (Yale).
24. Robert Henri, *The Art Spirit* (Philadelphia, 1923), p. 142.
25. Henri letter to Helen Niles, [Nov.] 1906 (Yale).
26. Henri diary, Nov. 14, 1906.
27. Letter to Henri from Ernest Lawson, Dec. 17, 1906 (Yale).
28. *Boston Transcript*, Dec. 24, 1906.
29. Theresa Lee diary, Dec. 13, 1906.
30. Walter Tittle diary, Dec. 1903 (Wittenburg University Library).
31. Henri, *The Art Spirit*, p. 183.
32. *Same*, p. 136.
33. Izola Forrester, "New York's Art Anarchists," *New York World*, June 10, 1906.
34. Charles H. Caffin, *American Masters of Painting* (New York, 1902), p. 74.
35. Cited in Martha Davidson, "Pre-War New York: The Slice of Life at the Whitney," *The Art News*, Feb. 13, 1937, p. 13.
36. Letter to Henri from A. B. Frost, Jr., Sept. 24, 1906 (Yale).
37. Letter to the author from Edward W. Redfield, July 24, 1957.
38. *New York Sun*, Feb. 7, 1907.
39. Henri letter to Mrs. Meyer, n.d. [Feb. 1907] (Glenn Coleman Papers, AAA).
40. Henri letter to his mother, Feb. 18, 1907 (Yale).

Chapter 13: Confrontation and Leadership

1. "The Henri Hurrah," *American Art News*, V (March 23, 1907), p. 4.
2. "Angry Artist Takes Pictures from Show," *New York Post*, March 9, 1907.
3. John Sloan diary, March 3, 1907.
4. Henri letter to his mother, March 4, 1907 (Yale).
5. "That Tragic Wall," *New York Sun*, March 16, 1907.
6. "The Henri Hurrah," p. 4.
7. Henri letter to his mother, March 14, 1907 (Yale).
8. "National Academy's Scope," *New York Evening Post*, March 9, 1907.
9. *American Art News*, March 23, 1907.
10. "Hanging Committees," *New York Sun*, March 21, 1907.
11. "Freedom," *Colliers*, XXXIX (April 6, 1907), p. 12.
12. "The Henri Hurrah," p. 4.
13. *Same*.
14. *Same*.
15. *Same*.
16. "National Academy Elects 3 out of 36," *New York Times*, April 12, 1907.
17. "Doors Slammed on Painters," *New York Sun*, April 12, 1907.
18. "Art Topics of an Important Week," *New York Sun*, April 13, 1907.
19. James William Pattison, "Robert Henri—Painter," *The House Beautiful*, XX (Aug. 1906), p. 19.
20. John Sloan diary, Jan. 8, 1906.
21. Letter to Henri from Arthur B. Davies, March 9, 1907.
22. Walter Tittle diary, April 4, 1903 (Wittenburg University Library).
23. Conversation with Everett Shinn, Sept. 12, 1952.
24. Henri diary, Feb. 15, 1927.
25. "Academy Can't Corner All Art," *New York Evening Mail*, May 14, 1907.
26. Letter to Henri from Albert Sterner, n.d. [May 1907] (Yale).
27. Henri letter to Albert Sterner, May 18, 1907 (Collection of Julian J. Foss).
28. Henri letter to John Sloan, July 28, 1907 (DAM).
29. *Same*, Sept. 2, 1907 (DAM).
30. *Same*, Aug. 14, 1907.
31. Letter to Henri from Vachel Lindsay, Sept. 9, 1907 (Yale).
32. Henri letter to his mother, May 24, 1907 (Yale).
33. "Wm. M. Chase Forced out of N.Y. Art School; Triumph for

the 'New Movement' Led by Robert Henri," *New York American*, Nov. 20, 1907.
34. *Same*.
35. Henri letter to Hartman K. Harris, Nov. 22, 1907 (Yale).
36. "Academy Can't Corner All Art," *New York Evening Mail*, May 14, 1907.
37. *New York Evening Sun*, Dec. 31, 1907.
38. "Art Exhibits at the Clubs," *New York Evening Mail*, Jan. 5, 1908.
39. John Sloan diary, Jan. 11, 1908.
40. Henri letter to John Sloan, Jan. 27, 1908 (Sloan Collection, DAM).
41. Henri letter to his mother, Jan. 29, 1908 (Yale).
42. John Sloan diary, Jan. 31, 1908.

Chapter 14: "The Eight" and a Secret

1. Henri letter to Hartman K. Harris, Feb. 4, 1908.
2. William Macbeth, *Art Notes* (March 1908), p. 545.
3. As quoted in "Brooklyn Revives Memories of 'The Eight,'" *Art Digest*, 18 (Dec. 1, 1943), p. 12.
4. Giles Edgerton, "The Younger American Painters, Are They Creating a National Art?" *The Craftsman*, XIII (Feb. 1908), p. 512.
5. "Art Exhibitions," *New York Sun*, Feb. 5, 1908.
6. "Exhibition of the Eight," *Boston Transcript*, Feb. 5, 1908.
7. "Art Exhibitions," *New York Sun*, Feb. 5, 1908.
8. "Eight Painters," *New York Sun*, Feb. 9, 1908. Macbeth Gallery scrapbook.
9. James B. Townsend, "The Eight Arrive," *American Art News*, VI (Feb. 8, 1908), p. 6.
10. *New York Globe*, Feb. 6, 1908.
11. As quoted in "Brooklyn Revives Memories of 'The Eight,'" p. 12.
12. Townsend, p. 6.
13. Letter to George Luks from John E. D. Trask, Secretary and Manager, Pennsylvania Academy, Feb. 15, 1908 (Pennsylvania Academy Archives).
14. Henri letter to John E. D. Trask, March 1, 1908 (Pennsylvania Academy Archives).
15. Edward Simmons, *From Seven to Seventy: Memories of a Painter and a Yankee* (New York, 1922), p. 222.
16. Arnold Friedman, *The Original Independent Show, 1908*, unpublished manuscript, n.p., n.d. (Museum of Modern Art Library).
17. Henri diary, Nov. 10, 1908.
18. *Brooklyn Standard-Union*, May 27, 1908.
19. John Sloan diary, April 12, 1908.
20. Henri letter to Mr. and Mrs. T. Huston Craige, Sept. 6, 1907.
21. Ira Glackens, *William Glackens and the Ashcan Group* (New York, 1957), p. 110.
22. Henri letter to John Sloan, June 2, 1908 (DAM).
23. "The Romance of a Girl with Red Hair," *New York American-Examiner*, July 19, 1908.
24. John Sloan diary, Nov. 2, 1908.
25. *Same*, April 18, 1908.
26. *Same*.
27. Letter to Henri from John Sloan, July 24, 1908 (DAM).
28. "Big Sensation at the Art Museum," *Toledo Times*, Oct. 15, 1908.
29. Letter to Henri from F. B. McGuire, Director, Corcoran Gallery of Art, Oct. 31, 1908 (Corcoran Gallery Archives).
30. Letter from George Luks to John Sloan, Oct. 29, 1908 (Sloan Collection, DAM).
31. Henri diary, Dec. 13, 1908.
32. *Same*, Dec. 14, 1908.
33. *Same*, Nov. 10, 1908.
34. Letter sent to the newspapers by the New York School of Art on Jan. 4, 1909, as copied in the Henri diary, Jan. 6, 1909.
35. Letter to Henri from Thomas Anshutz, Jan. 19, 1909.
36. "R. Henri to Head School," newspaper article, unidentified publication, n.d. [Jan. 1909]. Henri scrapbook.
37. Helen Appleton Read, "'I Paint My People' Is Henri's Art Key," *Brooklyn Eagle*, Feb. 12, 1916.
38. Letter to Henri from Walt Kuhn, Jan. 1909 (Yale).
39. Conversation with Andrew Dasburg, March 22, 1977.
40. Conversation with Eugene Speicher, Jan. 26, 1957.

41. *Stuart Davis* (New York, 1945), p. 2.
42. John Sloan diary, March 7, 1909.
43. *Same*, March 13, 1909.
44. Letter to Henri from Ivan Elis Evers, Oct. 25, 1907 (Yale).
45. Letter from John Sloan to his wife Dolly, March 21, 1909 (DAM).
46. *Same*, May 8, 1909.
47. William M. Murphy, *Prodigal Father: The Life of John Butler Yeats* (Ithaca, New York, 1978), p. 360.
48. As quoted in "Isadora Duncan and the Libertarian Spirit," *The Modern School* (April 1915), p. 37.
49. *New York Sun*, Aug. 25, 1909.
50. "Notes and Reviews," *The Craftsman*, XIV (June 1908), p. 341.
51. John Sloan diary, Dec. 19, 1909.
52. *Same*, Jan. 13, 1910.
53. *Same*, March 9, 1910.

Chapter 15: The Independent Movement

1. "The Independents," *The Critic*, XXI (Feb. 24, 1894), p. 137.
2. *Same*.
3. John Sloan diary, April 11, 1910.
4. Joseph Edgar Chamberlin, "With the Independent Artists," *New York Evening Mail*, April 4, 1910.
5. Guy Pène du Bois, "Exhibition by Independent Artists Attracts Immense Throngs," *New York American*, April 4, 1910.
6. Courtenay Lemon, "Independent Art in New York," *New York Call*, May 29, 1910.
7. Chamberlin, "With the Independent Artists," same.
8. Lemon, "Independent Art in New York," same.
9. "Insurgency in Art," *The Literary Digest*, XL (Aug. 23, 1910), p. 814.
10. "Around the Galleries," *New York Sun*, April 7, 1910.
11. Conversation with Edward Steichen, June 13, 1962.
12. Henri diary, Oct. 5, 1910.
13. As recalled in a letter from Henri to Samuel O. Buckner, Feb. 15, 1916 (Milwaukee Art Museum).
14. Henri diary, Oct. 15, 1910.
15. Notes taken by student "F. M.," Henri composition talk at the Henri School, Dec. 16, 1910 (Yale).
16. *New York Evening Journal*, June 12, 1901.
17. *Providence* (R.I.) *Bulletin*, Feb. 28, 1905.
18. John Sloan diary, Jan. 12, 1911.
19. Henri diary, May 2, 1910.
20. Rockwell Kent, *It's Me O Lord*, p. 227.
21. Henri diary, Feb. 7, 1911.
22. Letter to Henri from Arthur B. Davies, April 5, 1907 (Yale).
23. Henri letter to Sloan, n.d. [March 1911] (DAM).
24. Letter from Arthur B. Davies to Rockwell Kent, March 6, 1911 (Rockwell Kent Papers, AAA).
25. Henri diary, March 20, 1911.
26. *New York Sun*, April 2, 1911.
27. "Paintings Shown by 'Insurgents,'" unidentified publication, April 2, 1911 (Homer Boss scrapbook).
28. Henri letter to Helen Niles, April 11, 1911 (Yale).
29. Letter from Walt Kuhn to his wife Vera, Nov. 18, 1911 (Walt Kuhn Papers, AAA).
30. Letters from Arthur B. Davies to Rockwell Kent, March 28, 1911 (Rockwell Kent Papers, AAA).
31. "Rap Independents' Art Works," *New York Press*, April 14, 1911.
32. Henri diary, April 7, 1911.
33. "Insurgent Art Show at the Union League," *New York Herald*, April 14, 1911.
34. Henri composition-class talk, March 3, 1911 (Yale).
35. Conversation with Manuel Komroff, Jan. 25, 1957.
36. Letter from Carole Kline, author of *Aline*, July 28, 1979.
37. Carmel Snow, *The World of Carmel Snow* (New York, 1962), p. 23.
38. Henri diary, Oct. 5, 1911.
39. *Same*, Jan. 29, 1911.
40. Emma Goldman, *Living My Life* (New York, 1970), p. 528.
41. C. A. Z. [Carl A. Zigrosser], "Henri and Manship," *Little Review*, II (Oct. 1915), p. 39.
42. "Eight Independent Painters to Give an Exhibition of Their Own Next Winter," *New York Sun*, May 15, 1907.
43. Henri diary, May 22, 1910.

44. *Same*.
45. *Same*, March 2, 1911.
46. Guy Pène du Bois, "MacDowell Club to Be Theatre of a Parade of Art," *New York American*, n.d. [May 1911]. Henri scrapbook.
47. "Art and Artists," *New York Globe*, Nov. 3, 1911.
48. Sloan diary, May 26, 1911.
49. Henri letter to his mother, Nov. 6, 1911 (Yale).
50. Letter from Walt Kuhn to his wife Vera, Nov. 18, 1911 (Walt Kuhn Papers, AAA).
51. *Same*, Dec. 9, 1911 (Walt Kuhn Papers, AAA).
52. *Same*, Dec. 11, 1911 (Walt Kuhn Papers, AAA).
53. "Seen in the World of Art," *New York Sun*, n.d. [Nov. or Dec. 1911] (Walt Kuhn Papers, AAA).
54. Letter from Walt Kuhn to his wife Vera, Dec. 12, 1911 (Walt Kuhn Papers, AAA).
55. *Same*.
56. John Sloan diary, March 16, 1910.
57. "Meeting of Association of American Painters and Sculptors" (Armory Show Papers, AAA).
58. Henri letter to Walt Kuhn, Dec. 26, 1911 (Walt Kuhn Papers, AAA).
59. Henri diary, Jan. 2, 1912.
60. Same, Jan. 4, 1912.
61. Same, Jan. 23, 1912.
62. "Robert Henri, an Apostle of Artistic Individuality," *Current Literature*, LIII (April 1912), p. 468.
63. Henri letter to Mrs. Lee Haggin, 1912 (Yale).
64. Henri letter to J. E. D. Trask, Jan. 7, 1912 (Pennsylvania Academy Archives).
65. Henri notes, Dec. 11, 1911, p. 1.
66. Interview between Robert J. Gramer and William Gropper, Oct. 11, 1974 (Columbia University Oral History).
67. Conversation with Ariel Durant, Jan. 17, 1973.
68. *Same*.
69. Man Ray, *Self Portrait* (Boston, 1973), p. 22.
70. Goldman, *Living My Life*, p. 529.
71. Postcard to Henri from Gertrude Stein, June 29, 1912.
72. Alice Klauber notes of Henri critiques, 1912.
73. *Same*.
74. Henri letter to his mother, Aug. 9, 1912.
75. Conversation with Walter Pach, Sept. 5, 1952.
76. Henri postcard, Cézanne reproduction, Sept. 30, 1912.
77. Letter from Arthur B. Davies to Walt Kuhn, Oct. 1912 (Walt Kuhn Papers, AAA).
78. *New York American*, June 27, 1912.
79. Henri letter to Alice Klauber, Nov. 20, 1912.
80. Henri diary, April 24, 1912.
81. Henri letter to Alice Klauber, Nov. 20, 1912.
82. Letter to Henri from Dr. Albert Barnes, Dec. 25, 1912.

Chapter 16: The Armory Show and Beyond

1. Walt Kuhn, *The Story of the Armory Show* (New York, 1938), p. 15.
2. *New York American*, Jan. 26, 1913.
3. Conversation with Manuel Komroff, Jan. 25, 1957.
4. Conversation with Walter Pach, Sept. 5, 1952.
5. Theodore Roosevelt, "A Layman's Views of an Art Exhibition," *The Outlook*, 103 (March 29, 1913), p. 719.
6. James Britton, "The Open Eye," *American Art News*, XI (March 8, 1913), p. 3.
7. As quoted in Arnold T. Schwab, *James Gibbons Huneker, Critic of the Seven Arts* (Stanford, California, 1963), p. 187.
8. "May Bar Youngsters from Cubists' Show," *Chicago Record-Herald*, March 27, 1913.
9. Kenyon Cox, "The 'Modern' Spirit in Art," *Harper's Weekly*, 57 (March 15, 1913), p. 10.
10. "No Freakish 'Art' for William Chase," *Baltimore News*, Jan. 25, 1914.
11. Henri letter to the *New York Evening Sun*, 1913.
12. Jerome Mellquist, "The Armory Show 30 Years Later," *Magazine of Art*, XXXVI (Dec. 1943), p. 298.
13. *American Art News*, XI (March 15, 1913), p. 3.
14. Conversation with Emil Holzhauer, Aug. 2, 1978.
15. Roselle Davis' taped interview with Stuart Davis, as reported in *The Artist in America* (New York, 1967), p. 155.

16. *Same.*
17. E. Ralph Cheyney, "The Philosophy of a Portrait Painter: An Interview with Robert Henri," *The Touchstone*, V (June 1919), p. 212.
18. Henri record book, 1913.
19. Henri letter to John Sloan, 1913, as quoted in William M. Murphy, *Prodigal Father: The Life of John Butler Yeats* (Ithaca, New York, 1978), p. 413.
20. Henri letter to William Macbeth, Nov. 6, 1913 (Macbeth Papers, AAA).
21. "The Reminiscences of Leon Kroll" (1957), Oral History Collection of Columbia University, p. 62.
22. Letter to Henri from Dr. Albert C. Barnes, Dec. 31, 1913 (Yale).
23. Henri letter to Dr. Barnes, Feb. 1914.
24. "At the MacDowell Club," *New York Times*, May 1914. Henri scrapbook.
25. "Artists at Odds," *New York Evening Sun*, June 5, 1914.
26. Henri letter to Alice Klauber, March 11, 1914.
27. Henri letter to his mother, summer, 1914, as quoted in Violet Organ, "Robert Henri," unpublished biography, p. 97.
28. Organ, p. 96.
29. Article by Alma May Cook in a Los Angeles newspaper, n.d. [Sept. 1914]. Henri scrapbook.
30. Henri letter to Dr. Edgar L. Hewett, Oct. 25, 1914.
31. Henri letter to Alice Klauber, Aug. 1, 1915.
32. William B. M'Cormick, "Mastery of Medium Show in Henri's Exhibit of Far Western Types at Macbeth's," *New York Press*, Nov. 22, 1914.
33. William Saphier, *The Little Review*, I (Dec. 1914), p. 63.
34. "About People We Know," *Town & Country*, 45 (April 20, 1916), p. 23.
35. Robert Henri, "An Ideal Exhibition Scheme," *Arts and Decoration*, V (Dec. 1914), p. 49.
36. Henri letter to John Alexander, Dec. 18, 1914 (Yale).
37. Letter to Henri from Cabot Ward, Commissioner, New York Department of Parks, Aug. 30, 1915 (Yale).
38. Letter to Henri from Elmer Schofield, Nov. 18, 1915.
39. Letter to Henri from Gertrude Vanderbilt Whitney, July 10, 1915 (Yale).
40. Henri letter to Alice Klauber, March 1, 1911.
41. Emma Goldman, *Living My Life* (New York, 1970), p. 529.
42. *Same.*
43. Robert Henri, "Isadora Duncan and the Libertarian Spirit," *The Modern School*, April 1915, p. 37.
44. Robert Henri, "Toward the New Education," *Dionysion*, I (1915).
45. "No Confirmation of a U-Boat Off Maine Coast," newspaper article, unidentified publication, May 22, 1915.
46. Henri letter to Alice Klauber, Aug. 5, 1915 (Yale).
47. Henri letter to Helen Niles, July 17, 1915.
48. Organ, p. 99.
49. Letter from Lucie Bayard to Charles Morgan, Jan. 23, 1964 (Amherst College Library).
50. "Henri's La Jolla Portraits," *Los Angeles Times* or *Express*, Sept. 20, 1914. Henri scrapbook.
51. Conversation with Vaclav Vytlacil, Aug. 31, 1978.
52. Robert Henri, *The Art Spirit* (Philadelphia, 1923), pp. 256, 259, 260, 33, 17.
53. *Same.*
54. Henri letter, Jan. 1916. Addressee unknown (Yale).
55. Conversation with Margery Ryerson, Jan. 13, 1977.
56. Conversation with Fred Nagler, Feb. 5, 1977.
57. Henri letter to Rebecca Edelson, Oct. 18, 1915.
58. Henri letter to his mother, Oct. 24, 1915 (Yale).
59. Henri letter to C. K. Chatterton, Dec. 3, 1915; courtesy of John Alan Walker.
60. Willard Huntington Wright, "In Explanation," in "The Forum Exhibition of Modern American Painters," catalog (New York, 1916), p. 5.
61. Letter to Henri from Morgan Russell, June 21, 1925 (Yale).
62. Wright, p. 31.
63. Letter to Henri from Dr. Edgar L. Hewett, July 13, 1916.
64. Henri, *The Art Spirit*, p. 148.
65. *Same*, p. 132.
66. Conversation with Peppino Mangravite, Jan. 10, 1978.
67. Letter to the author from Mrs. Betty Lockell Perry, the former Mrs. Niles Spencer, July 14, 1956.
68. Conversation with Alice Miller (Mrs. Leslie Crump), Feb. 12, 1977.
69. Henri letter to his parents, Nov. 29, 1888.
70. Letter from Marjorie Henri to Alice Klauber, n.d. [Nov. 1916].
71. Henri letter to Mrs. Eulabee Dix Becker, Feb. 1, 1917; courtesy of Joan B. Gaines.
72. Letter to Henri from Eugene Higgins, Jan. 24, 1917 (Yale).
73. "Introduction," in "Catalogue of the First Annual Exhibition of the Society of Independent Artists (Incorporated)," (New York, 1917).
74. Robert Henri, "The 'Big Exhibition,' the Artist and the Public," *The Touchstone*, I (June 1917), p. 174.
75. "Indians First 'Cubists'?" *American Art News*, XI (Dec. 13, 1913), p. 2.
76. "Museum Notes," *El Palacio*, IV (Nov. 1917).
77. Letter from Adolph Dehn to his family, Dec. 10, 1917.
78. Dorothy Seckler interview with Arnold Blanch, June 13, 1963 (AAA).
79. Letter to Henri from Julie Mathilde Morrow, Feb. 19, 1918.
80. Henri letter to John Andrew Meyers, March 23, 1919 (Pennsylvania Academy Archives).
81. Henri, *The Art Spirit*, pp. 86, 126.
82. Henri letter to John Andrew Meyers, March 23, 1919 (Pennsylvania Academy Archives).
83. Jay Hambidge and Gove Hambidge, "The Ancestry of Cubism," *Century*, 87 (April 1914), p. 869.
84. Quotation from Yale University brochure concerning Jay Hambidge, *Practical Applications of Dynamic Symmetry*, n.d.
85. "News of the Art World," *New York World*, March 3, 1918.
86. *New York Herald*, March 3, 1918.
87. Henri letter to Mary Fanton Roberts, Sept. 17, 1918 (AAA).
88. Henri letter to George Bellows, Oct. 3, 1918 (Yale).
89. Henri letter to his mother, Oct. 3, 1918 (Yale).
90. Henri letter to Frank Southrn, Jan. 27, 1919 (Yale).
91. Henri letter to his mother, Feb. 23, 1919 (Yale).
92. Henri letter to Frank Crowninshield, May 6, 1919 (Yale).
93. Henri letter to Julie Stohr, May 7, 1919.
94. Letter from the National Academy of Design to Its Members and Associates, March 14, 1919 (Yale).
95. Conversation with Sidney Laufman, Feb. 21, 1977.
96. Henri letter to Mrs. Grace R. Arnold, Dec. 2, 1919.
97. Henri letter to his mother, April 18, 1920 (Yale).
98. *Same*, June 1920 (Yale).
99. Letter from Henri to John and Dolly Sloan, Sept. 19, 1920 (DAM).
100. Salmagundi Club Dinner Speech by Lee Mielziner, April 11, 1921 (Yale).
101. Ira Glackens, *William Glackens and the Ashcan Group* (New York, 1957), p. 186.
102. Henri letter to John and Dolly Sloan, June 18, 1921.
103. Letter to Henri from Margery Ryerson, n.d. [1921] (Margery Ryerson Papers, AAA).
104. Henri letter to Alice Klauber, Sept. 23, 1913.
105. *Same*, June 4, 1913.
106. Conversation with Margery Ryerson, Feb. 11, 1977.
107. Henri letter to Frank Southrn, May 28, 1923 (Yale).
108. Henri letter to Margery Ryerson, Sept. 17, 1923 (Margery Ryerson Papers, AAA).
109. C. A. Z. [Carl A. Zigrosser], "Henri and Manship," *Little Review*, II (1915), p. 38.
110. Henri letter to Margery Ryerson, Oct. 16, 1923.
111. Letter to Henri from George Bellows, Nov. 1923.
112. Letter to Henri from Jerry Farnsworth, n.d (Yale).
113. Letter to Henri from Harrison Fisher, Nov. 26, 1923 (Margery Ryerson Papers, AAA).
114. Letter to Henri from John Sloan, Jan. 31, 1924 (Yale).
115. "Portraits by Henri," *Brooklyn Eagle*, Jan. 13, 1924.
116. Jerome Mellquist, *The Emergence of an American Art* (New York, 1942), p. 287.
117. Letter from Lucie Bayard to Charles Morgan, Jan. 23, 1964 (Amherst College Library).
118. Letter from Henri to M. F. Vetter, Jan. 25, 1925 (Yale).
119. Henri letter to Miss Butler, Feb. 11, 1926 (Pennsylvania Academy Archives).
120. Robert Henri, "Justice for Sacco and Vanzetti," n.d. (Yale).
121. Organ, p. 114.
122. Henri letter to Walter Ufer, Feb. 8, 1927 (Yale).
123. Henri diary, July 26, 1928.

124. Henri letter to Emma Bellows, Dec. 28, 1928.
125. Henri letter to John Andrew Myers, Dec. 10, 1928 (Pennsylvania Academy Archives).
126. Letter from Marjorie Henri to Emma Bellows, June 25, 1929.
127. *Same.*
128. Letter from Marjorie Henri to Edith Glackens, July 25, 1929 (Yale).
129. "Sloan Would Honor Lincoln of American Art," *Santa Fe New Mexican,* July 1929.
130. Letter from Emma Bellows to John Sloan, July 18, 1929.
131. Letter to Marjorie Henri from the Society of Independent Artists, July 13, 1929.
132. Letter from Marjorie Henri to Carl Sprinchorn, Dec. 24, 1929 (Fogler Library, University of Maine).
133. Conversation with Margery Ryerson, Sept. 11, 1980.
134. Letter from Marjorie Henri to Emma Bellows, Sept. 18, 1929.
135. Conversation with Mrs. Leon Kroll, Sept. 19, 1978.
136. John Sloan, "Robert Henri" (introduction), *The Metropolitan Museum of Art Catalogue of a Memorial Exhibition of the Work of Robert Henri* (New York, March 9–April 19, 1931), p. xxi.
137. C. J. Bulliet, in the *Chicago Daily News,* Jan. 1934, as quoted in "Henri, Teacher," *Art Digest,* VIII (Feb. 1, 1934), p. 24.
138. "Letter to the Editor," *Art News,* LIII (May 1954), p. 6. Response written by Fairfield Porter in answer to John C. Le Clair.

BIBLIOGRAPHY

UNPUBLISHED MATERIAL

Cozad, Theresa Gatewood (Henri's mother). Diaries, 1885–1899. Collection Janet Le Clair.

Gatewood, Mrs. A. Traber (Henri's aunt). Diary. Collection Dr. J. L. Dorwart.

Goodman, Helen E. "Robert Henri: The Teacher." Doctoral dissertation. New York University, 1975.

Henri, Linda Craige. Diary, 1904. Collection Janet Le Clair.

Henri, Robert. Correspondence, 1885–1929. The Beinecke Rare Book and Manuscript Library, Yale University; and Collection Janet Le Clair.

Henri, Robert. Correspondence to John Sloan, 1893–1927. John Sloan Archives, Helen Farr Sloan Library, the Delaware Art Museum.

Henri, Robert. Diaries, 1881–1928. Collection Janet Le Clair.

Henri, Robert. Record books, 1885–1928. Collection Janet Le Clair.

Henri, Robert. Scrapbooks, 1888–1901. Collection Janet Le Clair.

Organ, Violet (Henri's sister-in-law). "Robert Henri." 4 volumes. Edited from letters, diaries, family records, etc. Collection Janet Le Clair.

BOOKS BY AND ABOUT ROBERT HENRI—MONOGRAPHS

Henri, Robert. *The Art Spirit.* Compiled by Margery Ryerson. Philadelphia, 1923.

Homer, William Innes. *Robert Henri and His Circle.* Ithaca, New York, 1969.

Pousette-Dart, Nathaniel. *Robert Henri.* New York, 1922.

Read, Helen Appleton. *Robert Henri.* New York, 1931.

Sandoz, Mari. *Son of the Gamblin' Man: The Youth of an Artist.* New York, 1960.

Yarrow, William, and Louis Bouché. *Robert Henri: His Life and Works.* New York, 1921.

BOOKS ABOUT ROBERT HENRI AND THE EIGHT

Glackens, Ira. *William Glackens and the Ashcan Group: The Emergence of Realism in American Art.* New York, 1957.

Perlman, Bennard B. *The Immortal Eight: American Painting from Eakins to the Armory Show, 1870–1913.* New York, 1962; Cincinnati, 1979; New York, 1988, as *Painters of the Ashcan School: The Immortal Eight.*

Young, Mahonri Sharp. *The Eight.* New York, 1973.

CATALOGUES OF ONE-MAN SHOWS

A Catalogue of an Exhibition of Paintings by Robert Henri. Albright Art Gallery, Buffalo, New York, 1919.

A Group of Figure Subjects by Robert Henri. Macbeth Gallery, New York, 1909.

An Exhibition of Early Works by Robert Henri. Maynard Walker Gallery, New York, 1962.

Exhibition of Landscapes and Portraits by Robert Henri. Pratt Institute, Brooklyn, 1902.

Exhibition of Paintings by Robert Henri. Ainslie Galleries, New York, 1923.

Exhibition of Paintings by Robert Henri. Brooks Memorial Art Gallery, Memphis, 1920.

Exhibition of Paintings by Robert Henri. Fellowship of the Pennsylvania Academy of the Fine Arts, Philadelphia, 1902.

Exhibition of Paintings by Robert Henri. Gallery of Fine Arts and Art Association, Columbus, Ohio, 1919.

Exhibition of Paintings by Robert Henri. Milch Gallery, New York, 1918.

Exhibition of Pictures by Robert Henri. Macbeth Gallery, New York, 1902.

Exhibition of Pictures by Robert Henri. Pennsylvania Academy of the Fine Arts, Philadelphia, 1897.

Exhibition—Paintings by Robert Henri. McClees Galleries, Philadelphia, 1907.

Full-Length Portraits and Paintings of Children by Robert Henri 1865–1929. Hirschl & Adler Galleries, New York, 1960.

Guest Exhibition, Robert Henri Today. Grand Central Art Galleries, New York, 1939.

Landscapes, Figures and Marines by Robert Henri. Gallery of Fine Arts, The William Taylor & Son Co., Cleveland, 1912.

Landscapes, Marines and Wood Interiors by Robert Henri. Macbeth Gallery, 1911.

Paintings by Robert Henri, N.A. Preface by Charles C. Cunningham. Robert C. Vose Galleries, Boston, 1940.

Robert Henri. Alfredo Valente Gallery, New York, 1963.

Robert Henri. Introduction by Helen Farr Sloan, essay by Bruce W. Chambers. Berry-Hill Galleries, New York, 1986.

Robert Henri. Chapellier Galleries, New York, 1964.

Robert Henri. Montclair Art Museum, Montclair, New Jersey, 1955.

Robert Henri 1865–1929. Preface by Donelson F. Hoopes. Chapellier Galleries, New York, 1976.

Robert Henri 1865–1929. Harbor Gallery, Cold Spring Harbor, New York, 1973.

Robert Henri 1865–1929. Montgomery Museum of Fine Arts, Montgomery, Alabama, 1971.

Robert Henri 1865–1929. Preface by William Innes Homer. Sheldon Memorial Art Gallery, University of Nebraska, Lincoln, 1971.

Robert Henri 1865–1929–1965. Sheldon Memorial Art Gallery, University of Nebraska, Lincoln, 1965.

Robert Henri—A Commemorative Exhibition. Preface by Robert G. McIntyre. Hirschl & Adler Galleries, New York, 1954.

Robert Henri: An Exhibition of Paintings. Museum of New Mexico Art Gallery, Santa Fe, 1956.

Robert Henri: Early Paintings, Drawings and Watercolors, 1891–1916. Maynard Walker Gallery, New York, 1962.

Robert Henri—Exhibition of Drawings and Watercolors. A. M. Adler Fine Arts, New York, 1981.

Robert Henri (1865–1929) Exhibition of Portraits and Landscapes. Preface by Reginald Poland. High Museum of Art, Atlanta, 1954.

Robert Henri 1865–1929—Fifty Paintings. Preface by Leslie Katz. Hirschl & Adler Galleries, New York, 1958.

Robert Henri Memorial Exhibition. Preface by John Sloan. The Metropolitan Museum of Art, New York, 1931.

Robert Henri Memorial Exhibition 1931. Preface by R. J. McKinney. Baltimore Museum of Art, Baltimore, 1931.

Robert Henri: Painter. Introduction by Helen Farr Sloan, prologue and text by Bennard B. Perlman. Delaware Art Museum, Wilmington, 1984.

Robert Henri: Painter-Teacher-Prophet. Preface by Alfredo Valente. New York Cultural Center, New York, 1969.

Robert Henri Paintings and Drawings. Zabriskie Gallery, New York, 1962.

Robert Henri Today. Grand Central Art Galleries, New York, 1939.

Specially Selected Paintings by Robert Henri. Macbeth Gallery, New York, 1933.

CATALOGUES OF MAJOR GROUP EXHIBITIONS

The American Eight. Introduction by Jon W. Kowalek. Tacoma Art Museum, Tacoma, Washington, 1979.

Announcing an Exhibition of The Eight (of 1908) Thirty Years After. Macbeth Gallery, New York, 1938.

The Ashcan School. Alfredo Valente Gallery, New York, 1962.

Charles Conder, Robert Henri, James Morrice, Maurice Prendergast—The Formative Years—Paris 1890s. Introduction by Cecily Langdale. Davis & Long Company, New York, 1975.

The Eight. Macbeth Gallery, New York, 1908.

The Eight. Introduction by Everett Shinn. The Brooklyn Museum, Brooklyn, New York, 1943.

The Eight. Kraushaar Galleries, New York, 1956.

The Eight. Lakeview Center for the Arts and Sciences, Peoria, Illinois, 1969.

The Eight and Contemporaries, Loan Exhibition from the Muriel and Philip Berman Collection, Allentown, Pa. Lehigh University, Bethlehem, Pennsylvania, 1966.

The Eight: Fifty-Five Years Later. Southern Vermont Art Center, Manchester, Vermont, 1963.

The Eight (of 1908) Thirty Years Later. Macbeth Gallery, New York, 1938.

An Exhibition of Paintings by Arthur B. Davies, William Glackens, Robert Henri, Ernest Lawson, George Luks, Maurice Prendergast, Everett Shinn, John Sloan. Pennsylvania Academy of the Fine Arts, Philadelphia, 1908.

An Exhibition of Paintings by The Eight. Sordoni Art Gallery, Wilkes College, Wilkes-Barre, Pennsylvania, 1979.

Graphic Styles of The American Eight. Text by Sheldon Reich. Utah Museum of Fine Arts, Salt Lake City, 1976.

Henri—Bellows. The Cummer Gallery of Art, Jacksonville, Florida, 1981.

The Immortal Eight and Its Influence. Text by Bennard B. Perlman. The Art Students League of New York, New York, 1983.

John Sloan/Robert Henri: Their Philadelphia Years 1886–1904. Foreword by Dianne Perry Vanderlip. Moore College of Art Gallery, Philadelphia, 1976.

Loan Exhibition of Pictures by Robert Henri, W. Glackens, George Luks, Arthur B. Davies, Maurice Prendergast, and John Sloan. The National Arts Club, New York, 1904.

New York Realists—1900–1914. Introduction by Helen Appleton Read. Whitney Museum of American Art, New York, 1937.

Robert Henri and Five of His Pupils: George Bellows, Eugene Speicher, Guy Pène du Bois, Rockwell Kent, Edward Hopper. Introduction by Helen Appleton Read. The Century Association, New York, 1946.

Robert Henri and His Circle. Foreword by Leon Kroll. American Academy of Arts and Letters, New York, 1965.

The 75th Anniversary of The Eight. Text by Bennard B. Perlman. Whitney Museum of American Art, New York, 1983.

ARTICLES BY ROBERT HENRI

"An Appreciation by an Artist," *Mother Earth*, X (March 1915), 415.

"An Appreciation by Robert Henri," *New York Times Magazine*, Nov. 11, 1917. Letter to the students of the Art Students League.

"The Artist's Partnership with His Public," *Literary Digest*, LXXX (Jan. 5, 1924), 27–28.

"An Artist's Social Maxim," *Survey*, L (1923), 279–282.

"As to Books and Writers," *Conservator*, XXVI (May 1915), 40–41.

"The 'Big Exhibition,' the Artist and the Public," *Touchstone*, I (June 1917), 174–177, 216.

The Forum Exhibition of Modern American Painters. Foreword by Robert Henri (New York, 1916), 30–32.

"An Ideal Exhibition Scheme—The Official One a Failure," *Arts and Decoration.* V (Dec. 1914), 49–52, 70.

"Like Pack-Rat on a Pile of Past Collected Art," *Philadelphia Public Ledger*, April 28, 1916. Letter to the Editor.

"My People," *Craftsman*, XXVII (Feb. 1915), 459–469.

"The New York Exhibition of Independent Artists," *Craftsman*, XVIII (May 1910), 160–172.

"A Practical Talk to Those Who Study Art," *Philadelphia Sunday Press*, May 12, 1901.

"Progress in Our National Art Must Spring from the Development of Individuality of Ideas and Freedom of Expression: A Suggestion for a New Art School," *Craftsman*, XV (Jan. 1909), 387–400.

"Should American Art Students Go Abroad to Study," *Creative Art*, II (April 1928), 40.

"Thomas Eakins," *Conservator*, XXVIII (Feb. 1918), 184–185.

"To Free Art from Prizes and Juries," *Literary Digest*, XLII (Jan. 21, 1911), 114.

"What about Art in America?," *Arts and Decoration*, XXIV (Nov. 1925), 35–37, 75.

ARTICLES ABOUT ROBERT HENRI

"The Art Spirit," *Art Digest*, V (Jan. 1, 1931), 22.

Barrell, Charles Wisner. "Robert Henri: Revolutionary," *Independent*, LXIV (June 25, 1908), 1427–1432.

Bellows, George. "'The Art Spirit' by Robert Henri," *Arts and Decoration*, XX (Dec. 1923), 26, 87.

Breuning, Margaret. "Realism at the Whitney," *Magazine of Art*, XXX (March 1937), 174–175.

Brooks, Van Wyck. "The Eight's Battle for U.S. Art," *Art News*, LIII (Nov. 1954), 41–43, 69.

Brown, Milton W. "The Ash Can School," *American Quarterly*, I (Summer, 1949), 127–134.

Burnside, Maud. "Robert Henri's Death Brings Sorrow to Students of Art," *Buffalo Evening News*, July 22, 1929.

Burrows, Carlyle. "Robert Henri and His Service to Painting," *New York Herald-Tribune*, July 21, 1929.

"The Career and Work of Robert Henri," *Vanity Fair*, VI (Aug. 1916), 38.

Cary, Elisabeth Luther. "Robert Henri," *Bulletin of the Metropolitan Museum of Art*, XXVI (March 1931), 58–62.

C. A. Z. [Carl A. Zigrosser]. "Henri and Manship," *Little Review*, II (Oct. 1915), 38–39.

Cheyney, E. Ralph. "The Philosophy of a Portrait Painter: An Interview with Robert Henri," *Touchstone*, V (June 1919), 212–219.

Cournos, John. "Three Painters of the New York School," *International Studio*, LVI (Oct. 1915), 239–241.

——. "What Is Art? Answered by Henri, Art 'Insurgent,'" *Philadelphia Record*, Dec. 25, 1910.

Craven, Thomas Jewell. "Realism and Robert Henri," *Dial*, LXXII (Jan. 1922), 84–88.

Dinnerstein, Harvey, and Burt Silverman. "New Look at Protest: The Eight Since 1908," *Art News*, LVI (Feb. 1958), 36–39.

Du Bois, Guy Pène. "Exhibitions—Robert Henri," *Arts*, XVII (April 1931), 495–499.

——. "Robert Henri," *One Hundred Fiftieth Anniversary Exhibition*. The Pennsylvania Academy of the Fine Arts, Philadelphia, Pennsylvania, 1955. Pages 68–74.

——. "Robert Henri—Realist and Idealist," *Arts and Decoration*, II (April 1912), 213–215, 230.

——. "Robert Henri: The Man," *Arts and Decoration*, XIV (Nov. 1920), 36, 76.

——. "The Henri, Bellows, Speicher Union," *Harper's Bazaar*, LXXV (March 1, 1941), 64–65, 120.

Edgerton, Giles [Mary Fanton Roberts], "Is America Selling Her Birthright in Art for a Mess of Pottage?" *The Craftsman*, XI (March 1907), 656–670.

——. "The Younger American Painters: Are They Creating a National Art?" *The Craftsman*, XIII (Feb. 1908), 512–532.

"'The Eight' Stir Up Many Emotions," *Newark News*, May 1909.

Ely, Catherine Beach, "The Modern Tendency in Henri, Sloan and Bellows," *Art in America*, X (April 1922), 132–143.

"Exhibitions at the Art Institute—Sculpture by Paul Manship—Paintings by Robert Henri," *Fine Arts Journal*, XXXIII (Oct. 1915), 426–437.

"Extracts from the Teachings of Robert Henri," *Art Instruction*, III (April 1939), 5–10.

Flint, Ralph. "Robert Henri Memorial Show at Metropolitan," *Art News*, XXIX (March 14, 1931), 3, 6.

Forrester, Izola. "New York's Art Anarchists: Here Is the Revolutionary Creed of Robert Henri and His Followers," *New York World*, June 10, 1906.

F. W. [Forbes Watson]. "Robert Henri," *The Arts*, XVI (March 1930), 501–503.

Goodman, Helen. "Robert Henri, Teacher," *Arts*, LIII (Sept. 1978), 158–160.

Grafly, Dorothy. "Events and Portents of Fifty Years," *Art and Archaeology*, XXI (April–May 1926), 163–181.

——. "Robert Henri," *American Magazine of Art*, XXII (June 1931), 437–446.

Heitkamp, Ernest. "Paintings by Robert Henri," *Detroit Institute of Arts Bulletin*, I (1920), 70–71.

Henderson, Rose. "Robert Henri," *American Magazine of Art*, XXI (Jan. 1930), 3–12.

"Henri Estate to Widow," *New York Times*, Aug. 15, 1929.

"The Henri Hurrah," *American Art News*, V (March 23, 1907), 4.

"Henri Is Dead," *Art Digest*, III (July 1929), 11.

"Henri Memorial Show for Detroit," *Art News*, XXVIII (Feb. 8, 1930), 6.

"Henri Paintings to Be Exhibited at Metropolitan," *New York Herald Tribune*, March 8, 1931.

"Henri, 'Typically American,' a 'Born Insurgent,'" *Literary Digest*, CII (Aug. 3, 1929), 19–20.

Homer, William Innes. "The Exhibition of 'The Eight': Its History and Significance," *American Art Journal*, I (Spring, 1969), 53–64.

"How a Milkman Started Robert Henri on His Career," *St. Louis Post-Dispatch*, Aug. 25, 1929.

Howard, W. Stanton. "A Portrait by Robert Henri," *Harper's Monthly Magazine*, CXVII (Aug. 1908), 430.

——. "The Blue Kimono by Robert Henri," *Harper's Monthly Magazine*, CXXV (Oct. 1912), 706.

H. St.-G. [Homer Saint-Gaudens]. "Robert Henri," *Critic*, XLIX (Aug. 1906), 131.

Hunter, Sam. "'The Eight'—Insurgent Realists," *Art in America*, XVIV (Fall, 1956), 20–22, 56–58.

Katz, Leslie. "The World of the Eight," *Art Yearbook I* (1957), 56–76.

Kwiat, Joseph J. "Robert Henri and the Emerson–Whitman Tradition," *Publications of the Modern Language Association*, LXXXI (Sept. 1956), 617–636.

Lanes, Jerrold. "Robert Henri—Review," *Artforum*, VIII (Dec. 1969), 72–73.

Mather, Frank Jewett, Jr. "Some American Realists," *Arts and Decoration*, VII (Nov. 1916), 13–17.

"Metropolitan Shows Art of Henri, Leader of Independents," *Art Digest*, V (March 15, 1931), 8, 22.

"New York's Art War and the Eight 'Rebels,'" *New York World Magazine*, Feb. 2, 1908.

"Notes of the Month," *International Studio*, XCIV (Sept. 1929), 54.

"Obituary Note—Robert Henri," *Publishers' Weekly*, CXVI (July 20, 1929), 267.

"Only Out of Home's Narrow Confines Is Full Growth Possible for Children, Says Robert Henri," *New York Tribune*, Jan. 25, 1915.

Pach, Walter. "Les Etats-Unis," *L'Amour de l'Art*, XV (Oct. 1934), 465.

——. "Quelques Notes Sur les Peintres Américaines," *Gazette des Beaux Arts*, II (Oct. 1909), 334.

——. "The Eight Then and Now," *Art News*, XLII (Jan. 1-14, 1944), 25, 31.

Pattison, James William. "Robert Henri—Painter," *House Beautiful*, XX (Aug. 1906), 18-19.

Perlman, Bennard B. "Practicing Preacher" [Robert Henri], *Art & Antiques*, VII (Nov. 1990), 84-89, 108.

——. "Prophet of the New," *Artnews*, LXXXIII (Summer 1984), 94-99.

——. "Robert Henri," *Arts Digest*, XXVIII (Aug. 1, 1954), 14-15.

——. "Robert Henri, Emancipator," *Art Voices*, V (Winter, 1966), 42-47.

——. "The Years Before [the Armory Show]," *Art in America*, LI (Feb. 1963), 38-43.

"Portrait Painters of Today: Robert Henri," *Vogue*, XXIX (Jan. 3, 1907), 3.

Read, Helen Appleton. "Robert Henri," *Vogue*, LXXIV (Nov. 9, 1929), 98-99, 148.

"Robert Henri," *American Magazine of Art*, XX (Sept. 1929), 541.

"Robert Henri," *Art News*, XXVII (Aug. 17, 1929), 13.

"Robert Henri," *Broadway Magazine*, XIX (Feb. 1907), 589-590.

"Robert Henri," *Dictionary of American Biography*, VIII (New York, 1932), 544-545.

"Robert Henri," *Kennedy Quarterly*, IV (Dec. 1963), 73.

"Robert Henri," *The National Cyclopedia of American Biography*, XV (New York, 1916), 146-147.

"Robert Henri, an Apostle of Artistic Individuality," *Current Literature*, LII (April 1912), 464-468.

"Robert Henri Calls Art the Manifestation of Race," *Milwaukee Art Institute Art Quarterly*, V (Oct. 1916), 7-8.

"Robert Henri Dies; Ill Eight Months," *New York Times*, July 13, 1929.

"Robert Henri: Encourager of Individuality," *Christian Science Monitor*, May 28, 1930.

"Robert Henri, Head of Modern School, Dies," *New York Herald Tribune*, July 13, 1929.

"Robert Henri Left $122,009," *New York Times*, May 1, 1931.

"Robert Henri Memorial Exhibition at the Metropolitan Museum of Art," *Parnassus*, III (March 1931), 27.

"Robert Henri, One of the Big Figures in American Painting," *Current Opinion*, LXXI (Dec. 1921), 793-796.

"Robert Henri's New School," *American Art News*, VII (Jan. 16, 1909), 2.

"Robert Henri, Some of His Ideas," *Art Center Bulletin*, IV (Jan. 1926), 144-147.

"Robert Henri's Paintings of Monhegan Island at the Macbeth Gallery," *The Craftsman*, XXI (Jan. 1912), 454-455.

Roberts, Mary Fanton. "A Distinguished Group," *Touchstone Magazine*, VI (Jan. 1920), 200-208.

——. "Robert Henri—Great American," *Century Magazine*, CXX (Spring, 1930), 271-277.

——. "Speaking of Art; the Henri Memorial Exhibition," *Arts and Decoration*, XXXIV (March 1931), 44-45.

——. "Visiting the Art Galleries," *Arts and Decoration*, XXXII (Nov. 1929), 70-71.

Ruge, C., "Moderne Amerikanische Maler," *Die Kunst für Alle*, XXI (March 1, 1906), 249.

Ruthrauff, Florence Barlow. "Robert Henri, Maker of Painters," *Fine Arts Journal*, XXVII (July 1912), 463-466.

Salpeter, Harry. "Robert Henri: Maker of Masters," *Esquire*, VI (Feb. 1937), 53-55, 206-209.

Seckler, Dorothy Gees. "50th Anniversary for the 8," *Art in America*, XLV (Winter, 1957-58), 61-64.

S. H. [Sadakichi Hartmann]. "Studio Talk," *International Studio*, XXX (Dec. 1906), 182-183.

Shapley, John, ed., "Robert Henri—Painter," *Index of Twentieth Century Artists*, II (Jan. 1935), 49-54.

Shepherd, Richard. "Henri and His Boys," *Art News*, XLV (May 1946), 42-43.

Stern, Jean. "Robert Henri and the 1915 San Diego Exposition," *American Art Review*, II (Sept.-Oct. 1975), 108-117.

Swift, Samuel. "Revolutionary Figures in American Art," *Harper's Weekly*, LI (April 13, 1907), 534-536.

Tonks, Oliver. "Robert Henri—An Appreciation," *American Magazine of Art*, VII (Oct. 1916), 473-479.

Vaughan, Malcolm. "Eight Who Made History in Art," *New York Times Magazine*, Nov. 28, 1943.

Walter, Paul A. F. "The Santa Fe-Taos Art Movement," *Art and Archaeology*, IV (Dec. 1916), 330-338.

Watson, Forbes. "Robert Henri," *The Arts*, XVI (Sept. 1929), 2-8.

"Who's Who in American Art," *Arts and Decoration*, VI (Nov. 1915), 33.

"A Worthy Henri," *Art Digest*, IV (Nov. 1, 1929), 17.

Zabel, Morton Dauwen. "Robert Henri, 1865-1929," *New Republic*, LIX (July 31, 1929), 288-289.

Zilczer, Judith K. "Anti-Realism and the Ashcan School," *Artforum*, XVII (March 1979), 44-49.

——. "The Eight on Tour, 1908-1909," *The American Art Journal*, XVI (Summer 1984), 20-48.

INDEX

*(NOTE: APPENDIXES II AND III
ARE NOT INDEXED.)*